THE PRINCIPLES OF

HARMONY AND CONTRAST OF COLORS

AND THEIR APPLICATIONS TO THE ARTS

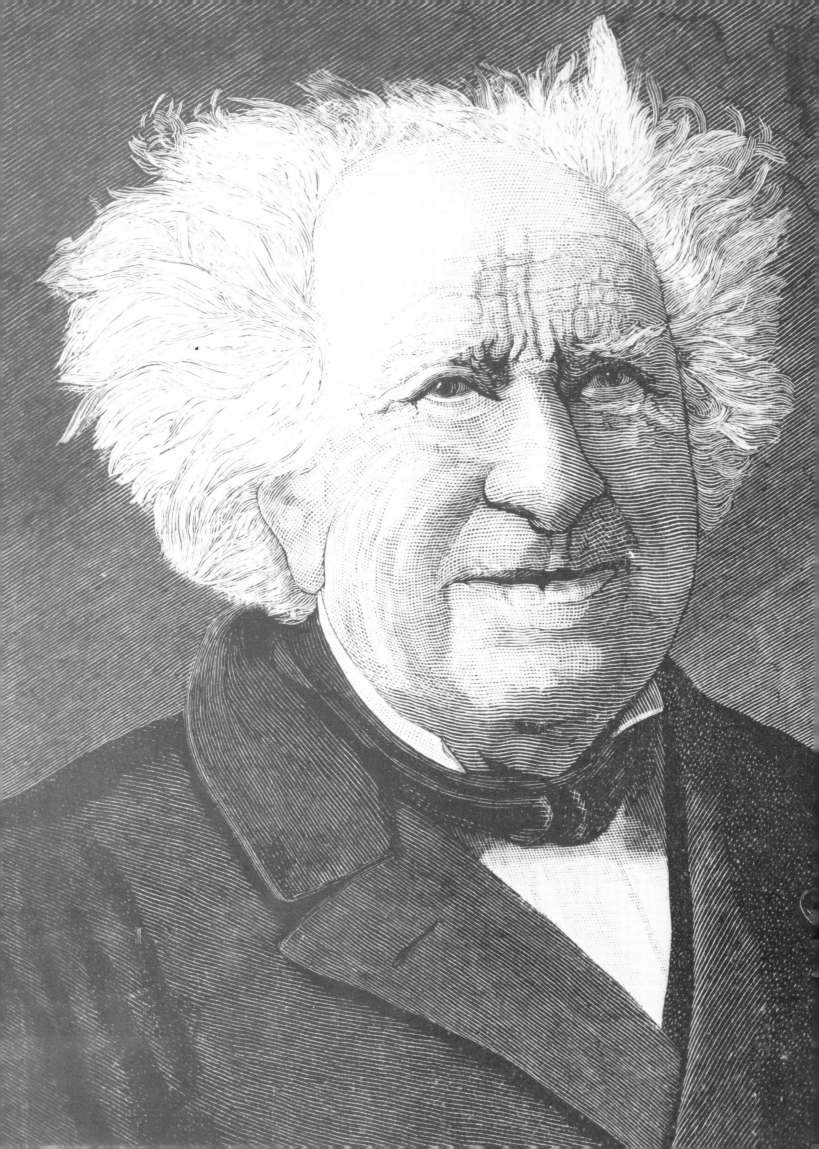

THE PRINCIPLES OF

HARMONY AND CONTRAST OF COLORS

AND THEIR APPLICATIONS TO THE ARTS

By

M. E. CHEVREUL

BASED ON THE FIRST ENGLISH EDITION OF 1854

AS TRANSLATED FROM THE FIRST FRENCH EDITION OF 1839

DE LA LOI DU CONTRASTE SIMULTANÉ DES COULEURS

A NEWLY REVISED EDITION

WITH A SPECIAL INTRODUCTION AND A NEWLY REVISED COMMENTARY

By
Faber Birren

Schiffer Publishing Ltd

West Chester, Pennsylvania 19380

Notes and Commentary copyright ©1987 by Faber Birren.
Library of Congress Catalog Number: 87-60121

Printed in the United States of America.
ISBN: 0-88740-090-6
Published by Schiffer Publishing Ltd.
1469 Morstein Road, West Chester, Pennsylvania 19380

This book may be purchased from the publisher.
Please include $2.00 postage.
Try your bookstore first.

Contents

THIRD DIVISION

COLOUR PRINTING UPON TEXTILE FABRICS AND ON PAPER

PART III.

EXPERIMENTAL ESTHETICS OF COLOURED OBJECTS

About Nadar

There is a delightful coincidence in the fact that a French photographer, G.E. Tournachon, professionally known as Nadar, took the photographs reproduced on this and following pages to mark the hundred and first birthday of M.E. Chevreul. In the history of photography this may be one of the first "picture interviews" ever undertaken. Chevreul was a famous man and worthy of the attention. Nadar himself is in most of the photographs (wearing gloves) and the camera was operated by his son. The series have been variously published in books, magazines and articles, including *Life* magazine of January, 1937.

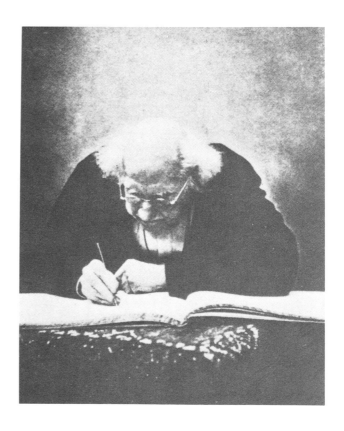

What is notable is that while Chevreul was to have great influence over the French Impressionist movement, Nadar in 1874 lent his studio for the first exhibition of Impressionism. He had frequently dined at the Café Guerbois where, among others, he probably met with young artists he admired: Pissarro, Monet, Renoir, Cézanne, men hardly known to the conventional art world at the time. According to Monet, it was Nadar who generously offered his premises without fee on the second floor of a building in the rue Daunou. As Monet declared, "Nadar, the great Nadar, as good as gold, lent us his place." To Nadar's credit it was here in his studio, a series of large rooms with russet brown walls, that a new "gang" of painters showed their work together publicly for the first time.

In his delightful book, *The History of Impressionism*, John Rewald describes this highly significant event. Announcement posters were prepared. Degas wanted to call the group *La Capucine*, nasturtium, because the flower had been chosen as an emblem. Among the artists to be represented there was a mixture of confusion, acceptance, and rejection. Artists by and large tend to be egotists and to look skeptically on the work of others. However, the "gang" (Pissarro, Renoir, Monet, Cézanne, Degas, Sisley—and others who were to see less fame over the years) was able to assemble some 165 works. A few refused to participate, Manet among them, due to personal prejudices.

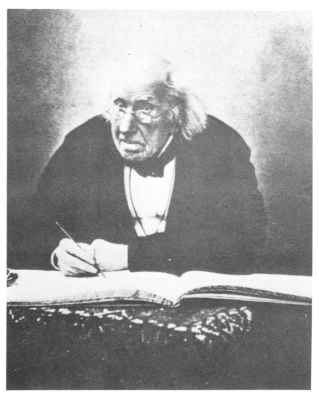

Renoir was appointed to oversee the hanging of the paintings, but members of his committee left the task mostly up to him. The opening took place on April 15, 1874 and was to last one month. There were day and evening hours for public viewing. The entrance fee was one franc, and catalogs were fifty centimes. The show was fairly well attended,

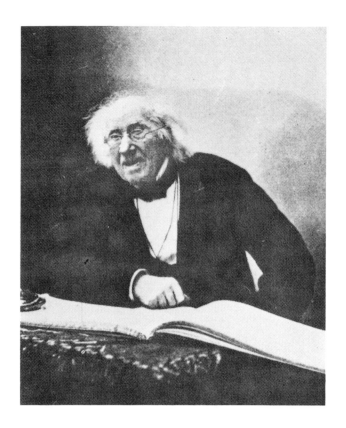

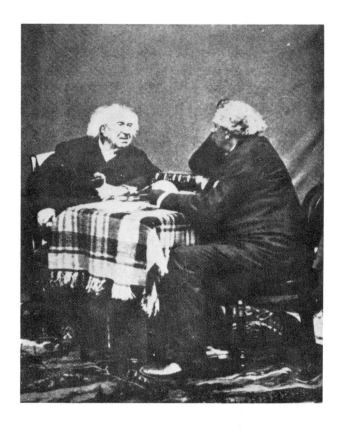

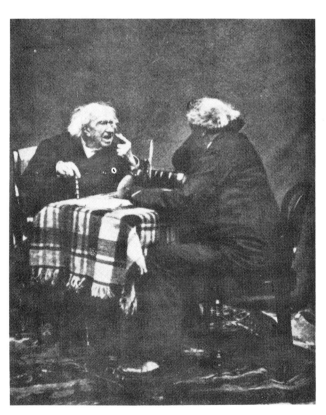

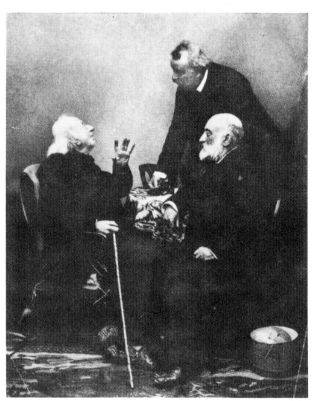

but primarily through curiosity rather than esthetic interest. Today it is difficult to appreciate that this first exposure of Impressionism led to ridicule, abuse, bewilderment, with rarely a kind word. The looseness, impulsiveness, freedom and spontaneity of the painters' styles were in sharp contrast with the formality and static art fashion of the day. With sarcasm, some critics assumed that the canvases were executec by firing paints from a pistol.

Unfortunately the individual works of the Impressionists in the early years of the movement had little financial success—often a few hundred francs, as against thousands and even millions of American dollars spent a hundred years later.

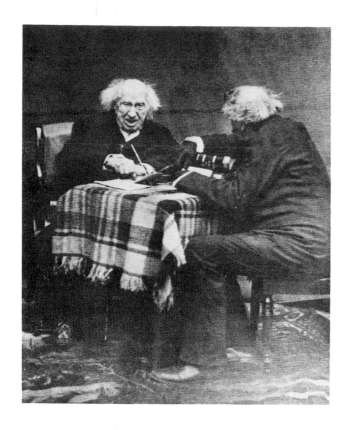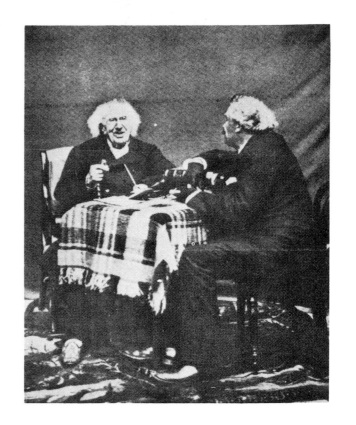

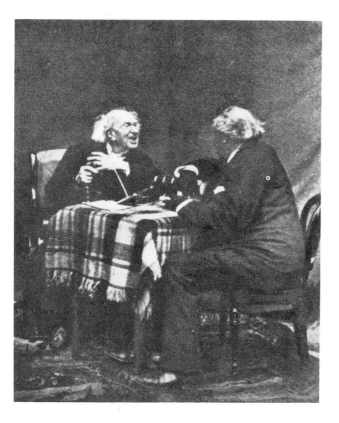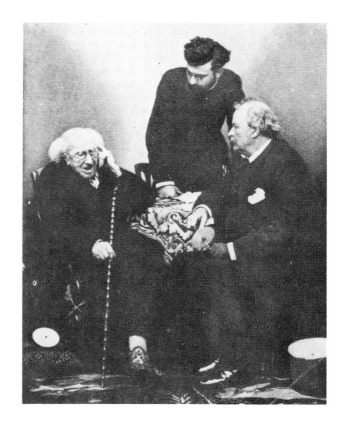

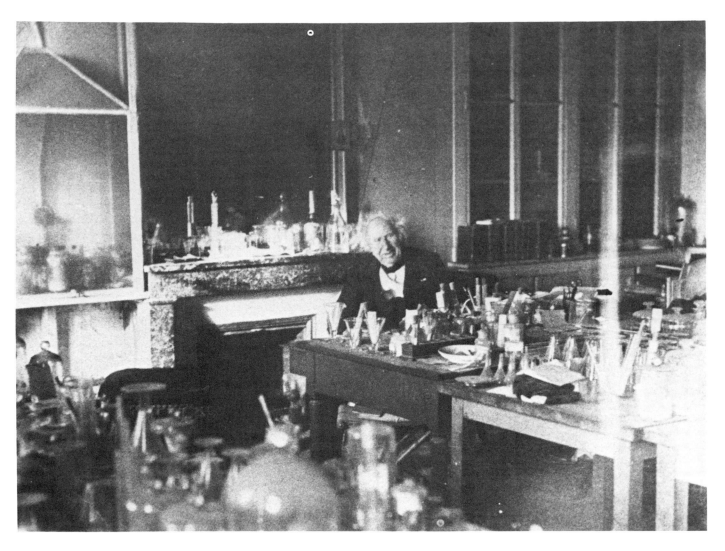

Views show Chevreul in his Gobelins laboratory and section
of dye works around 1886.

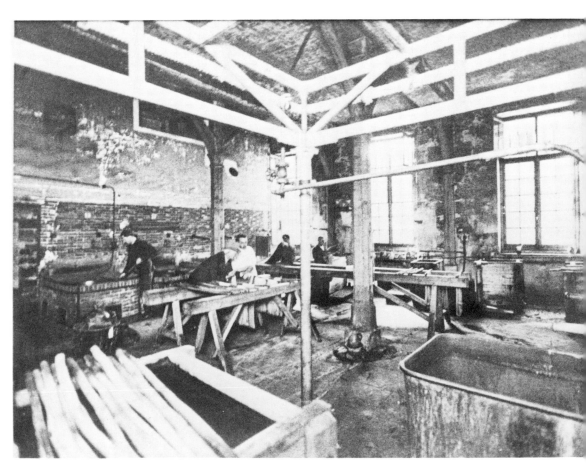

The Life of Chevreul

(1786-1889)

Michel Eugène Chevreul, better known in his writings as M.E. Chevreul or E. Chevreul, lived to be 103 years of age. His was a creative and active life and full of accomplishments. In telling of him it may be of interest to do so in terms of various achievements at various ages, beginning of course at birth. He was born on August 31, 1786 in Angers, France, in a family that had raised surgeons for three generations. Angers was an old town dating back to Roman times, was quite handsome in architecture, and had a majestic Gothic cathedral. The economy of the town was fairly substantial and came from slate quarries, distilleries, metalworks and textiles.

Part of his childhood was spent in revolutionary times. He was alert to all of this and not only witnessed the use of the guillotine, but probably saw part of a battle on the Loire River. Schools being closed because of the turmoil, he had the benefit of private tutors, his family being well able to finance this. In time he attended schools where he studied a wide range of subjects from Latin and Greek, to mathematics, physics and minerology. He was brilliant from the very first and won awards for his competence and understanding. As he grew he took on a broad spectrum of interests that had to do with natural history, philosophy, and archaeology. Aside from these he devoted himself to astrology, the occult and spiritualism. His was a big mind with many compartments and spaces for many related and unrelated topics.

Age 17, 1803. Chevreul went to Paris which was less than 200 miles away. Now he devoted himself to chemistry, a subject in which he would soon gain wide fame. At the Collége de France his erudition and talents led him to an appointment as assistant professor. This was quite unusual for a man so young. At mere age 20 he was teaching, conducting laboratory work, and beginning to write scientific papers. He was to become prolific as an author as well as scientist, and to edit journals and even compose a history of chemistry.

Age 20, 1806. He had devoted himself to organic substances and begun studies at the National Museum of Natural History.

Age 24, 1810. He was bright enough to be chosen assistant naturalist to a department, the Garden of Plants. Promptly and remarkably he took over the chair of Chemistry. This would lead to renowned discoveries and to eminence as one of France's great scientists.

Age 27, 1813. He became Professor of Physical Science at the Lycée Charlemagne. While in this good position Alexander I of Russia wanted to appoint him head of a polytechnic institute in St. Petersburg, a compliment which Chevreul declined, presumably expecting a greater future in France, and maybe for patriotic reasons.

Age 32, 1818. He married one Sophie Davallet, and from the union came a son, Henri.

Age 37, 1823. He wrote his first treatise on fats. Now he entered a phenomenally busy period. He continued his chemical investigations, wrote technical articles, edited scientific journals and contributed to encyclopedias and dictionaries. He seemed to undertake the work of a few if not several men at one and the same time. Result:

Age 40, 1826. He was elected to the French Royal Academy of Sciences, and in the same year was honored with foreign membership in the Royal Society of London. These honors were considerable for a man so young.

Age 44, 1830. Chevreul had spent busy and productive years at the Lycée. Now in 1830, at age 44, he was chosen professor of organic chemistry at the National Museum of Natural History, which he had previously attended. (Later—1860-1878—he was to become the director at ages 64-82.)

Let the reader appreciate that M.E. Chevreul, at age 40, had already lived a full and learned existence. He had won fame throughout Europe and Great Britain and recognition by scientific societies. His field had been to determine the composition of various substances which promised improvements in the making of soaps and candles. As one of his contemporary admirers wrote, "It is safe to say that, if the man had died in his fortieth year, his name and fame would still be familiar to us."

And all this recognition came before Chevreul embarked on the intriguing subject of color that was to lead to the publication of his masterwork on color contrast in 1839 at age 53!

It was apparent in 1824 when Chevreul was at the Lycée that in addition to his chemical experiments an unusual opportunity was extended to him. This is when and where special interest in color came into being. His son Henri wrote, "My father, highly regarded among scholars for his treatise on fatty substances, whose great influence on the industry could not as yet have been foreseen, was named by King Louis XVIII, on September 9,

1824, Director of Dyes for the Royal Manufacturers at the Gobelins, replacing de la Boulaye-Marillac. On the following September 16, M. Chevreul's nomination was confirmed by a well-deserved decree of Charles X."

One may assume from this overlapping of dates and ages that Chevreul remained active in chemistry and as an educator and writer, while at the same time he began to be fascinated by visual color phenomena. Notes on Chevreul's publications on color—including his 1839 work included herewith—will be discussed in detail later. The Gobelins tapestry works was state-controlled. It had been responsible for the manufacture and weaving of exquisite tapestries, textiles and carpeting, and these products had become internationally famous under Louis XIV and other French Kings. While its activities had been suspended during revolutionary upheavals, it was well active during the time of Chevreul in 1824.

According to record, the dyestuff and color laboratory were very much in a mess. Chevreul needed fresh equipment which he found difficult to secure. There was little cooperation from his immediate superiors, and for a time Chevreul even had his retainer reduced. However, in loyalty to France and out of admiration for the French Director of Fine Arts (Viscount Sosthènes de la Rochefoucauld) he worked diligently at his tasks, improved his facilities and for nearly 30 years (1824-1852) gave himself in major part to the chemistry of dyestuffs and the magic of color. Although his great book was not issued until 1839, he obviously began his color researches around 1824 at the age of 38 and carried them on for the rest of his life—as will be seen. He applied himself, continued to write books and articles, gave lectures, and otherwise devoted himself to the wonders of color that are the reason for this present volume.

He lived to the age of 103. On these pages are illustrations of himself, his laboratory and Gobelins, his equipment, library, color scales, his handwriting, the title pages of several of his works—and a reprint of his *The Principles of Harmony and Contrast of Colors* itself.

M.E. Chevreul died on April 9, 1889. His life had been one of outstanding energy and accomplishment. He had been a member of the French Academy of Science for 63 years and had been elected president on two occasions, 18 years apart. He had been a personal friend of such great men as Alexander Dumas *père*, Louis Pasteur, the French physiologist Claude Bernard, and André Ampère, physicist.

What did the French government think of him? Among numerous honors, he was given a full-length statue in the Paris Jardin des Plantes and a bronze medal on the occasion of his hundredth birthday. Particularly reverential, in 1889, the National Press of France issued a beautiful centennial edition of his major work, to be described. During the Franco-Prussian War, when the School of Impressionism was undergoing rapid development, he served in the National Guard at age 85.

Not only chemistry and color, but Chevreul in later years was attracted to the occult and mystical. He studied the history of alchemy, went to meetings of spiritualists, and wrote a book on the divining rod. Indeed, the prestigious Academy of which he had been president asked him to investigate psychic phenomena.

His wife, Sophie, died in 1862 when Chevreul was 76. His son, Henri, died on March 27, 1889, and within a month M.E. Chevreul himself died (April 9, 1889).

On his hundredth birthday, in addition to the centennial edition of his book mentioned above, much honor was bestowed upon him. The President of France paid tribute, and also many noted delegates from France and Europe. At the Gobelins scores of admirers gave flattering eulogies. As a contemporary account relates: "There came marching with banners into the great hall...2000 or more delegates from the learned societies, the museums, and the workshops in whose behalf he had labored so faithfully during many useful years." This was followed by a torchlight procession along the streets of Paris, while special performances were given in theaters.

His funeral, attended by thousands, was held at Notre Dame Cathedral.

His Influence

M.E. Chevreul was a French scientist of considerable eminence. As a chemist he was quite a prodigy and had a remarkably encyclopedic mind. As an early authority on animal fats he was honored by membership in scientific societies in France, England, Sweden, Germany and the United States. Then after a highly successful career in chemistry, he went on in middle-age to the wonders of color.

Among scientists, Chevreul is remembered as a chemist. What is curious, however, is that as an authority on color, the scientific world seems to pass him aside. It is the world of art that continues to pay tribute to him for this role. He influenced Impressionism, Neo-Impressionism and other art movements. Although few men at his time or since have devoted more study to visual demonstrations of afterimages, simultaneous and alternate contrast effects, optical mixtures of hues and induced colors, many recent dissertations on these subjects have tended to overlook Chevreul as if he had never existed. But not so among artists and patrons on art. Here the venerable Frenchman exerted wide appeal, was studied in detail, honored, and did much to guide the progress of color in art right up to present times.

In simple terms, Chevreul emphasized and explained the results of the Contrast of Colors, the title of his masterwork. He further dealt with optical mixtures of color which led to such techniques as pointillism and divisionism, and perhaps for the first time he set forth what he determined to be universal principles of color harmony. While many came to acknowledge his genius and leadership, in numerous instances his work was duplicated by others, without acknowledgment, and as if the findings were original.

Much of Impressionism and Neo-Impressionism was affected—directly or indirectly—by what Chevreul set forth in his book. On the matter of visual color mixtures (elaborately studied by Chevreul in his experiments with colored yarns at the Gobelins tapestry works) artists before him had noted and exploited what were known as broken colors. In this technique flat, mixed colors were avoided for combinations of different pigments which were applied to the canvas, without mixing, by broad brush or palette knife. French painters such as Watteau had followed this practice. So had Rembrandt in Holland and Constable in England. With Impressionism and other later schools of painting, the dramatic result of visually mixed colors introduced a wholly new art form that consigned much previous art to the historic past.

Illustrated on these pages are the colorful works of five painters, all of whom well expressed in their compositions the principles of Chevreul: Delacroix, Pissarro, Monet, Seurat, Delaunay. There are others, of course, but discussion of these five will suitably and differently pay tribute to the reknowned French author.

First Delacroix (1799-1863). See color plate page 20. Here was a man of great brilliance, an aristocrat, highly social, a friend of Victor Hugo, Stendhal, Gautier, Dumas, Chopin, and George Sand. The Impressionists who so admired him were for the most part far less well-known and cultured. As a painter, Delacroix had prodigious energy, was quite prolific and did not hesitate to devote himself to watercolors, pastels, drawings, engravings, lithographs, scores of vigorous paintings and sizable murals.

Particularly excited by color, he spent much time in North Africa where lighting effects were especially brilliant. In the early 1840's, after his African ventures, he came upon the 1839 treatise of Chevreul. He was about forty at the time and promptly gave himself to the magic of bright color. This love was set forth in numerous references in his *Journal*. A professional rival at the time was Jean Auguste Ingres who favored form over color. He opposed the election of Delacroix to the French Academy, which had appointed Ingres at the age of 44, while Delacroix had to wait until he was 60. Wrote Ingres, "A thing well drawn is well enough painted." Replied Delacroix, "I open my window and look at the landscape. The idea of a line never suggests itself to me." This debate between form and color, between Ingres and Delacroix, was widely discussed in the art press. As the world knows today, Delacroix was victorious, for color became the fascination of the Impressionists and others who came after.

Delacroix was idolized by a group of young and restless painters to become known as Impressionists. Monet sought permission to copy a Delacroix painting. Monet and Bazille gazed into the studio of Delacroix from a friend's apartment to observe how the master worked. As one critic wrote of Van Gogh, "Color drove him mad. Delacroix was his god and his lips trembled with emotion when he spoke of him." Van Gogh also copied Delacroix

and once wrote to his brother, Theo, that he wanted to go south (Algiers) "to see the stronger sun because I felt that without it I could not understand the paintings of Delacroix."

At one time, Delacroix made an appointment to see Chevreul, but the meeting did not take place because of the painter's illness. Later when Chevreul was 98, Paul Signac went to see him. The old man mentioned that Delacroix had written him for an appointment some years earlier, but the meeting had not taken place. When Signac returned later, Chevreul was incoherent and suggested that he visit Ingres (who had been dead for 20 years).

The reverence of Delacroix for Chevreul is well confirmed in various statements.

"The enemy of all color is gray."

"Banish all the earth colors."

"The elements of color theory have been neither analyzed nor taught in our schools of art, because in France it is considered superfluous to study the laws of color, according to the saying, 'Draftsmen may be made, but colorists are born.' Secrets of color theory? Why call these principles secrets which all artists must know and all should have been taught."

Then to flatter Chevreul's principles of the contrast of colors he declared, "Give me mud and I will make the skin of Venus out of it, if you will allow me to surround it as I please."

Next, Camille Pissarro (1830-1903). See color plate page 21. He was perhaps the best natured and most friendly of the Impressionists. Though born in the West Indies, he spent most of his life in and around Paris. He eagerly joined up with other young artists, such as Monet and Renoir, gave counsel to Cézanne to whom he recommended, "Never paint except with the three primary colors and their immediate derivatives."

He offered willing advice to Gauguin, and later, for a short time, embraced the rigid color theories of Seurat and Signac. During the Franco-German war of 1870, he accompanied Monet and Sisley to London where they encountered the great color art of Turner and Constable. That they were influenced can be safely assumed.

Pissarro had a passionate attraction to color. During his life he used more and more pure pigments, eliminating black, browns, and ochers from his palette. Then, as will be related later in his association with Seurat, he featured—for a limited time—spectral hues only. Of all the Impressionists, Pissarro was the most open-minded, inquisitive and freely given to experiment with color. Many of his canvases show impulsive dots and daubs of color, so typical those days to the familiar pointillist technique of Impressionism.

He was a great one to introduce his friends to new concepts of color. For a while Cézanne

declared Pissarro to be his teacher. Pissarro studied Chevreul and advised his friends to do so. Whether they did or not, the principles of color contrast and visual color mixture pervaded the French art world, for which Chevreul deserved great credit. (That Pissarro also embraced the divisionist technique of Seurat will follow.)

Claude Monet (1840-1926). See color plate page 22. He was undoubtedly the most typical of the Impressionists, and most viewers of his work today recognize his style through his pointillist technique seen in most of his paintings. In fact, the term Impressionism was devised by a Parisian editor who attended a 1874 exhibition and thus baptized the new and radical movement. Unlike Delacroix and even Pissarro, Monet was less brilliant intellectually. However, he was one of the world's great geniuses in creating a magnificent and revolutionary painting style. He seemed to be fascinated with instantaneous views of the world and with the ever-changing varieties of natural light. Just about everything he saw lent itself to shifts and changes in illumination, hour by hour. The objects and scenes of this world were not fixed like a photograph. They constantly assumed a different aspect from moment to moment. This original viewpoint was difficult at first for the public to understand and accept. Because color and light dominated form, Monet made repetitive studies of haystacks, poplar trees, water lilies, the Cathedral of Rouen. Even when he visited London with Pissarro in 1870 he painted London bridges, not as architectural structures, but as luminous fog, effects close to those of the English Turner. Oscar Wilde remarked at the time, that if art imitates nature, in any view of London fog, nature will be seen as imitating Monet.

Monet was friendly with all the Impressionists, many of whom came out of meager circumstances. In his case, however, though familiar with early poverty, he lived to the grand age of 86, had a comfortable home and garden, and shared reasonable financial success.

Georges Seurat (1859-1891). See color plate page 23. The French school of Neo-Impressionism is well represented in the work of George Seurat (and his associate Paul Signac). Here multitudinous daubs of color are applied as reflecting light sources, with only incidental concern over form. Monet had effectively anticipated this style with his friend Renoir. In John Rewald's book, *The History of Impressionism,* he relates, "Monet had already made extensive use of brushstrokes, and so had Renoir...At the Grenouillère the two friends now used rapid strokes, dots, and commas to capture the glistening atmosphere, the movement of the water." Their purpose was to convey the fugitive effects of light as it enveloped form.

In the unique school of art and color, Neo-Impressionism, the technique of painting for the first time paid obeisance to science. From fields of science and vision came the revealing work of Hermann von Helmholtz on physiological optics, the spinning discs of James Clerk Maxwell, writers like Charles Blanc, David Sutter, Charles Henry, all of whom heralded a new era for color. Of particular prominence and influence were the original views of Ogden Rood of the United States. His book, *Modern Chromatics*, issued in 1879, promptly went into the French language and was carried about like the New Testament of color expression. Rood clearly described the Neo-Impressionist technique, termed divisionism as follows: "We refer to the custom of placing a quantity of small dots of two colors very near each other, and allowing them to be blended by the eye placed at the proper distance...The results obtained in this way are true mixtures of colored light...This method is almost the only practical one at the disposal of the artist whereby he can actually mix, not pigments but masses of colored light."

Rood made the artist aware of the fact that mixtures of colored light were different from mixtures of colored pigments. No doubt his words came as a surprise when he wrote, "It was shown that while the mixture of yellow with blue pigments produced invariably a green hue of varying intensity, the mixture of blue with yellow light gave a more or less pure white, but under no circumstances anything approaching green." Indeed, the mixtures of colored light were not akin to the mixtures of pigments, a fact that was hardly appreciated at the time.

Rood confirmed and repeated many of the findings of Chevreul. Being an artist of fair ability himself, he discussed colored shadows, the appearance of colors under bright and feeble light, the natural gradations of colors as they moved from highlight to shadow. This promised and suggested a new epoch for color which Seurat and the Neo-Impressionists would introduce to the world.

The Impressionists themselves, now in advancing years, were skeptical of the radical "chromo-luminarism." It was the genial Camille Pissarro who became enthralled. In a letter to his dealer he wrote that he wanted "to seek a modern synthesis by methods based on science, that is, based on the theory of colors developed by Chevreul, on the experiments of Maxwell and the measurements of O.N. Rood; to substitute optical mixture for the mixture of pigments, which means to decompose tones onto their constituent elements; for this type of optical mixture stirs up luminosities more intense than those created by mixed pigments." (Rewald, *The History of Impressionism.*)

Pissarro enthusiastically gave himself—for a while—to the divisionist technique. He enlisted the attention of other artists. Prominent among them was Vincent van Gogh who did a number of canvases in this style. Others who experimented with the technique were Emile Bernard, Toulouse-Lautrec, Paul Gauguin—friend of van Gogh, Henri Matisse—friend of both Seurat and Signac. These artists, however, quickly went on to other forms of color expression.

The school of Neo-Impressionism lasted but a short while. The principles upon which it was founded supposedly had a sound scientific basis. But this proved invalid. Visual mixtures of color—in daubs—were not equivalent to light mixtures of color. For example, mixtures of red and green light form a bright yellow, whereas mixtures of red and green spun on a disk form a dull olive. Chevreul had clearly explained this but his counsel had been overlooked at the time. After trying his hand at the techique, Pissarro sadly wrote, "I believe it is my duty to write you frankly and tell you how I regard the experiment I made with systematic divisionism by following our friend Seurat. Having tried this theory for four years and having then abandoned it, not without painful and obstinate efforts to regain what I had lost and not to lose what I had learned, I can no longer consider myself one of the Neo-Impressionists who abandon movement and life for a diametrically opposed esthetic which, perhaps, is the right thing for the man who has the temperament for it, but which is not for me, anxious as I am to avoid all narrow and so-called scientific theories. Having found after many attempts (I speak for myself) that it was impossible to be true to my sensations and consequently to render life and movement, impossible to be faithful to the effects, so random and so admirable, of nature, impossible to give an individual character to my drawing, I had to give up. And none too soon! Fortunately it appears that I was not made for this art which gives me the impression of the monotony of death!"

Robert Delaunay (1885-1941). See color plate page 24. The spirit of Chevreul remained alive. After Neo-Impressionism came Fauvism, the "wild beasts" and the first art movement of the twentieth century. Eminent here were Henri Matisse, André Derain, Maurice de Vlaminck. Colors were impulsively used like "sticks of dynamite." Then came Cubism and Futurism, to be followed up by other lesser creative efforts.

Around 1910 came the color theories of Orphism, its chief exponent being Robert Delaunay. As a young man he came under the influence of Seurat and promptly decided to devote himself to color. He began by imitating the garish color effects of Fauvism. Soon, however, he took it upon himself

to exploit the spectrum and more or less to take it apart and reassemble its parts in dramatic compositions. Instead of relying on divisionist spots of color, he resorted to large, flat patches.

So it was that 70 years after Chevreul's great book appeared, Delaunay resurrected it and put its demonstrations and ideas to bold, esthetic uses. To him Chevreul's simultaneous contrast became the clue to powerful chromatic adventures. Indeed, simultaneous contrast was the only sure means of attaining dynamic color, and Chevreul was to be thanked. Delaunay concerned himself with *Unending Rhythms, Colored Rhythms, Cosmic Circular Forms*. This led to early concepts of abstract art—color for the sake of color as apart from realistic form. He met Kandinsky and Klee, and for a while was highly praised by art critics. He was prolific in his output, and in his 50s executed a series of enormous decorative bas-reliefs in color for Paris exhibition halls.

After Delaunay? Chevreul's posterity endures, as the present book confidently believes. Many modern art forms, such as Op Art, still profit from Chevreul's findings and diligence. His principles of color contrast, optical color mixtures, color harmony not only have continued to guide color expression, but his masterwork retains its vitality and no doubt will keep on leading the course of color in art into the indefinite future.

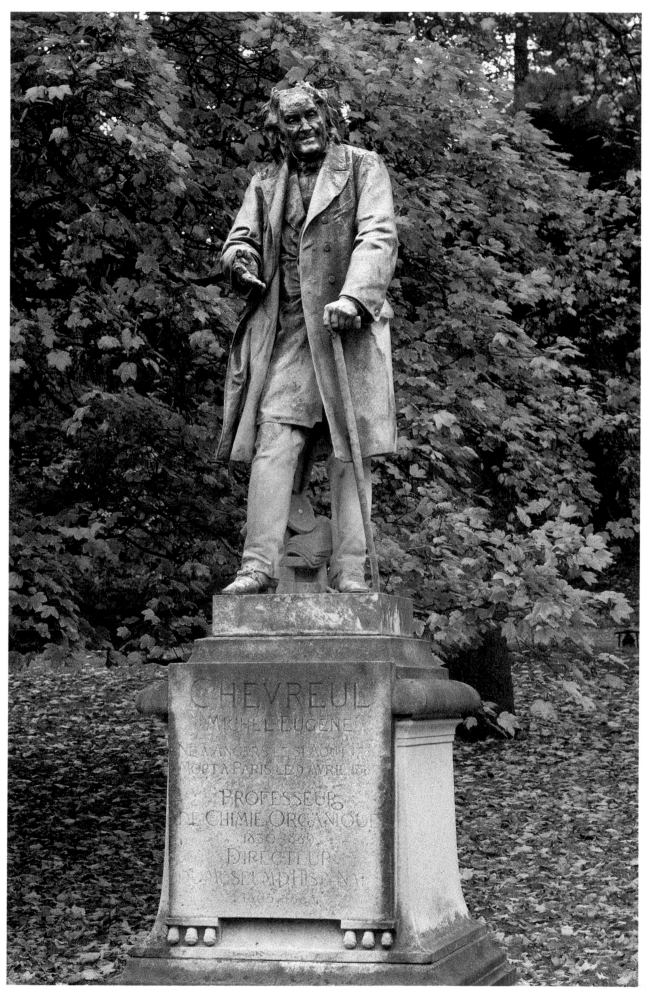

Statue of Chevreul in Jardin des Plantes, Paris.

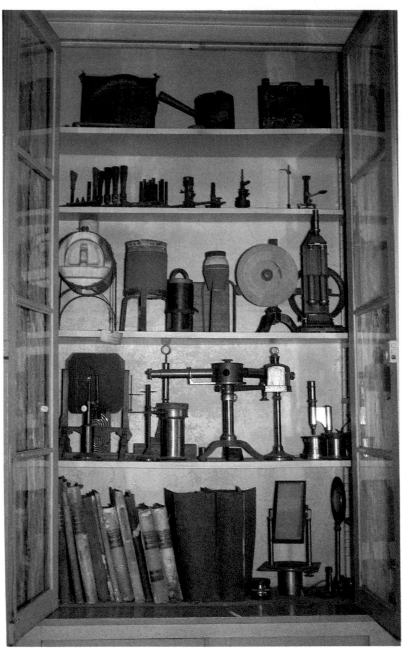

Instruments used by Chevreul: spectroscope, liquid colorimeter, spinning device, microscope, etc.

Opposite page:
These color scales of wool yarns were originally arranged by Chevreul, presumably as part of a color order system.

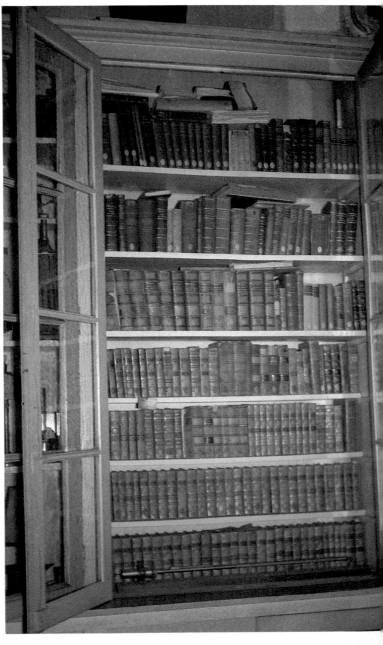

Chevreul's library dating back to his days at Gobelins Tapestry Works, still preserved today.

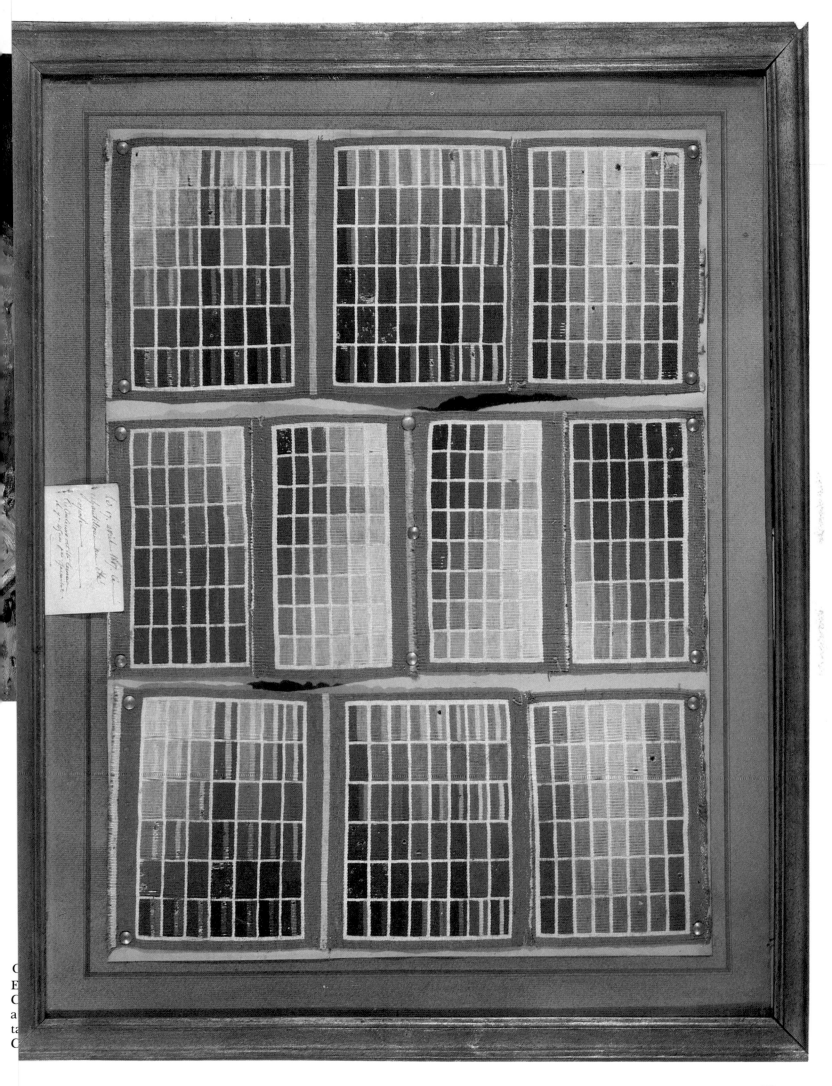

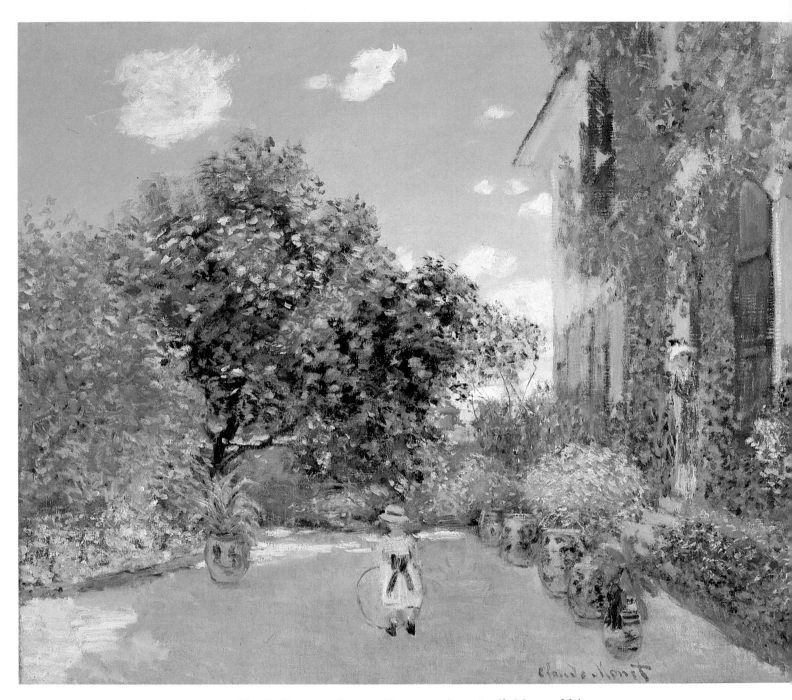

Claude Monet, *Monet's House at Argenteuil.* Many of his color techniques exemplified principles set forth by Chevreul. (Courtesy of The Art Institute of Chicago, Mr. & Mrs. Martin A. Ryerson Collection.)

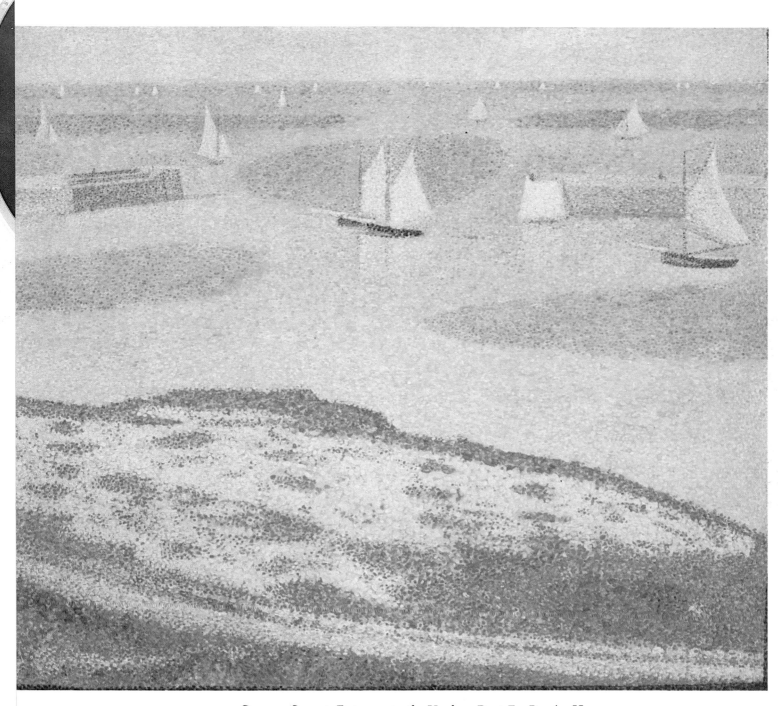

Georges Seurat, *Entrance to the Harbor, Port-En-Bessin*. He studied the principles of visual color mixture as described by Chevreul. (Courtesy of The Museum of Modern Art, Lillie P. Bliss Collection.)

Opp
Rob
and
was
Jose

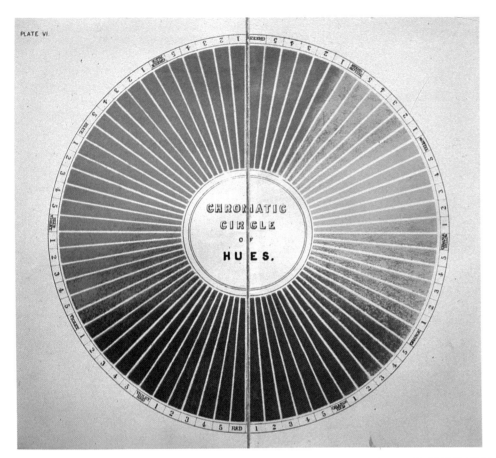

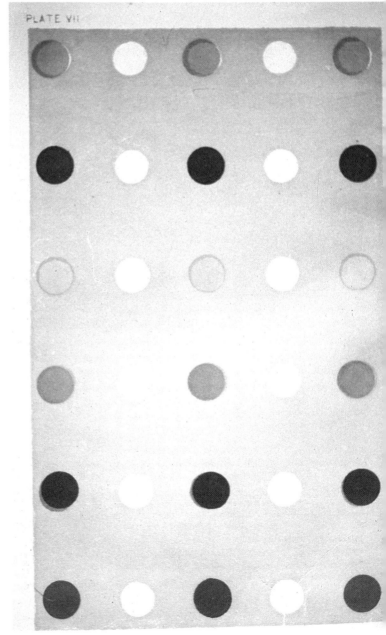

COLOR PLATE VI. This dramatic Chromatic Circle of Hues has been redone from the original 1854 lithograph in modern color reproduction methods. The organization of this is described in (161.).

COLOR PLATE VII. This is used to illustrate color assortments with white. Effects are described in paragraphs beginning with (186.).

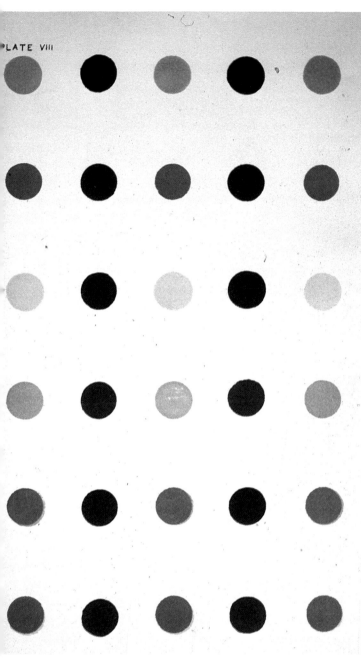

COLOR PLATE VIII. This is used to illustrate color assortments with black. Effects are described in paragraphs beginning with (202.).

COLOR PLATE IX. This is used to illustrate color assortments with gray. Effects are described beginning with paragraphs (219.).

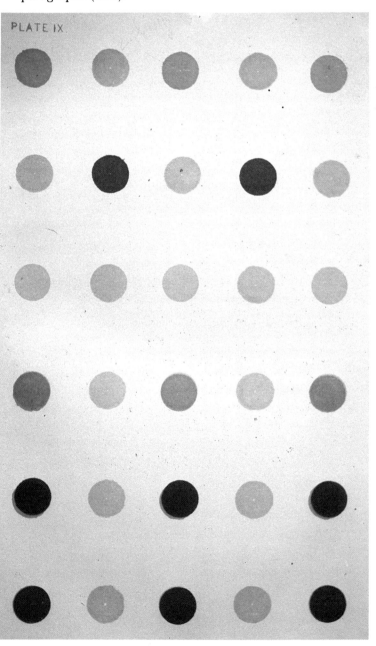

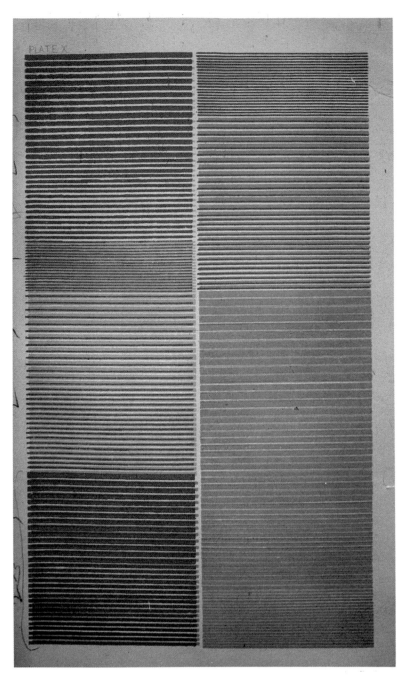

COLOR PLATE X. Visual mixtures of colored yarns in different proportions. These are binary (analogous) combinations. Demonstrations with wool yarns were made for the book. (380.).

COLOR PLATE XI. This refers to visual mixtures of colored yarns in different proportions using complementary combinations. Demonstrations with wool yarns were made for this book (380.).

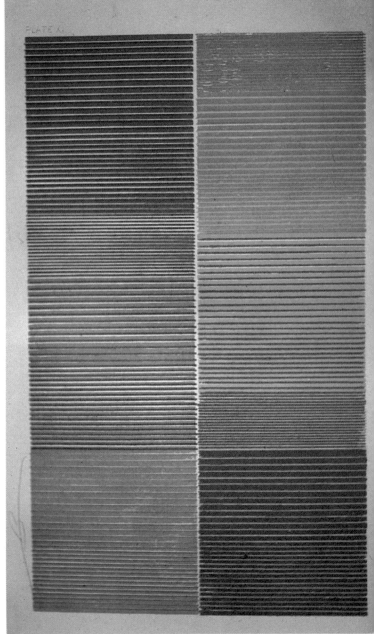

PLATE XII

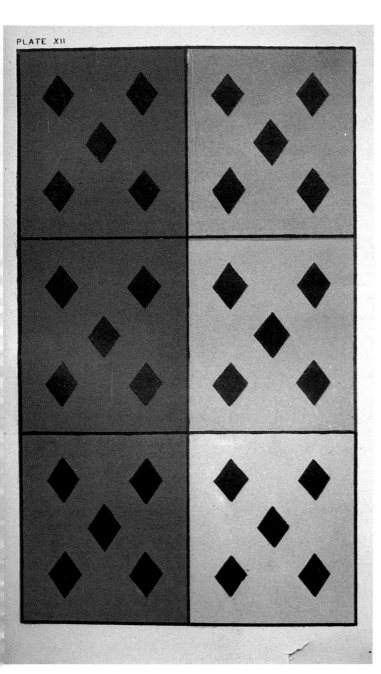

COLOR PLATE XII. In the very beginning of his study of color, Chevreul was concerned with the fact that areas of black in some instances tended to take on complementary tints of hues placed adjacent to it. He used an illustration like this to demonstrate the phenomenon. Chevreul discusses this in paragraph (444.).

COLOR PLATE XIII. An ornamental border with gilt patterns on black and colored grounds could be used to study afterimage effects. See paragraphs (459.) through (473.).

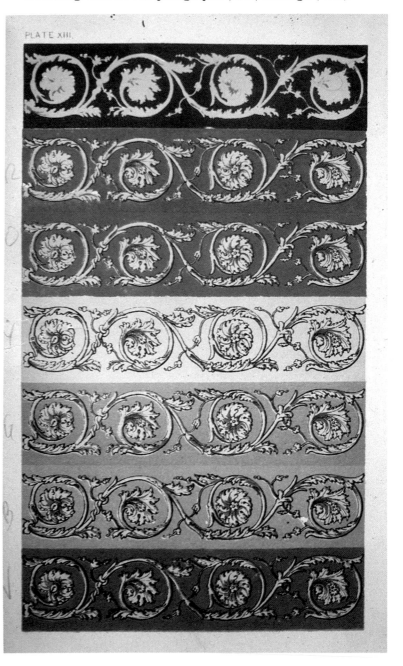

PLATE XIII.

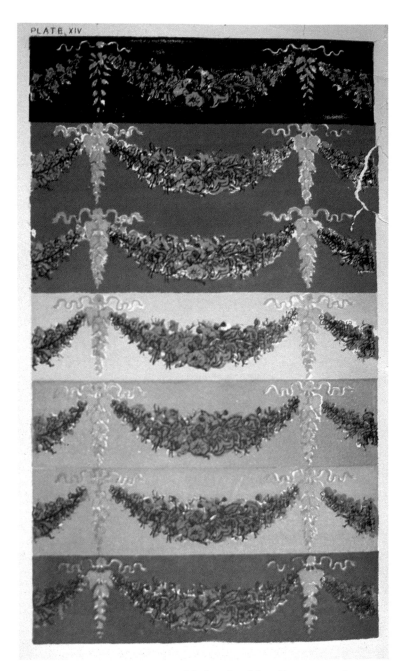

COLOR PLATE XIV. In this border, blue flowers and gray festoons are on black and colored grounds. Afterimage effects could be studied. Results are described in paragraphs (474.) through (481.).

COLOR PLATE XV. Pink roses and green leaves on black and colored backgrounds. This was a common border design in Chevreul's time. He describes good and bad combinations in paragraphs (482.) through (484.).

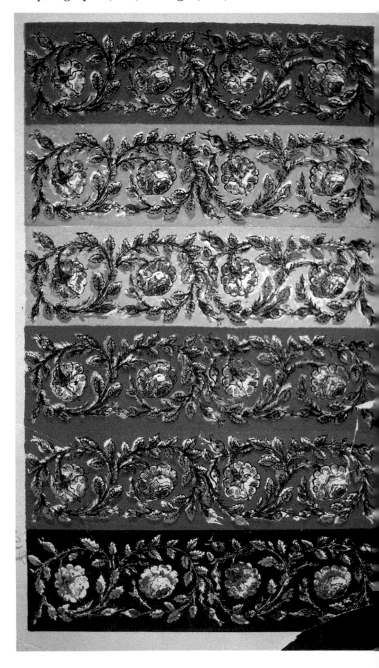

About This Book
The French Edition

Chevreul was 53 when his famous work was published, and with some difficulty. Although in his Preface he tells of the development of his findings and theories, more light on this can be gained from remarks by his son, Henri, who in 1889 told about his father's efforts in a centennial edition of the masterwork which the French government printed to honor the elder Chevreul. (This publication will be described.)

Wrote Henri, "Almost at the outset of his work as Director of Tints, Mr. Chevreul had received complaints on the quality of certain colors emanating from his shop; he was soon convinced that these complaints were well-founded as regards the lack of stability of the blues and light violets, of gray and the brown shades; the same did not hold true in the case of complaints about the lack of strength of the blacks intended to produce shadows in blue and purple draperies; for after having obtained samples of woolens dyed black in the most famous establishments of France and Europe, it was acknowledged that they were in no way superior to those of the Gobelins shops.

"It was then Mr. Chevreul found that the purported lack of strength in the blacks had to do with the phenomenon of color contrast and depended on the color with which it was juxtaposed.

"This observation was the starting point for studies which led my father to setting down the rules of *The Law of Simultaneous Contrast of Colors.*

"Experiments on seeing colored objects, repeated for several months before scholars and artists qualified to judge colors and evaluate the smallest differences, were described as facts added to science. Then, in view of the relationships which these facts might have to one another and in order to seek out the principles from which they flow, Mr. Chevreul was led to giving a generalized explanation of the phenomena observed, which was formulated under the title of *The Law of Simultaneous Contrast of Colors.*

"*The Law of Simultaneous Contrast of Colors* linked the name of its author with that of Newton.

"However, the observations made and the results obtained did not enable Mr. Chevreul immediately to establish the rules of the law of contrast. Many comparative experiments were needed, as well as lengthy reflection, before the consequences of these facts—which were to be the crowning glory of the work—could be deduced.

"I clearly recall, though but a child at the time, hearing the illustrious inventor of the electric telegraph, André-Marie Ampére, cry out in the presence of contrast effects: 'Fine, I see them, my dear friend; but these surprising effects mean nothing to me,' he said to my father, 'until your observations have been summed up in a law.'

"Mr. Chevreul's mind was constantly on the problem to be solved, and this problem was solved spontaneously in singular circumstances.

"Attending a public session of the Academy of Inscriptions and Literature on July 27, 1827, Mr. Chevreul, during a lecture by Mr. Mongez on Hannibal's crossing of the Alps, came back to his *idée fixe* and discovered the principles of the law he had been seeking to establish for so long.

"Upon leaving the Institute, he explained the terms of the law to his two best friends, André-Marie Ampére and Frédéric Cuvier, who were astonished at them. Ampére, always affectionate and demonstrative, embraced my father and said: 'My dear colleague, now I am convinced; it is too simple not to be true.' From that moment on, all of Mr. Chevreul's experiments with colors were revised, described and compiled in book form."

The first edition of Chevreul's work was published in Paris in 1839 when the author was 53. However, the date was somewhat delayed due to Chevreul's problems in getting his efforts properly issued in suitable and impressive form. Note the title page illustrated on these pages. *De la loi du contraste simultané des couleurs et de l'assortment des objets colorés.* The concern of the volume was with color relationships in painting, with tapestries at Gobelins, with Beauvais textiles for furniture, with Savonnerie carpets, with mosaics, ceramics, printing, illumination, decoration of buildings, wearing apparel, and horticulture. Even at the age of 53, Chevreul was identified in his book as a member of The Institute of France, The Royal Society of London, The Royal Society of Sciences of Copenhagen, The Royal Academy of Sciences of Stockholm, The Royal Academy of Sciences of Berlin, The Central Agricultural Society of the Department of the Sein, an officer of the Legion of Honor of France, and Knight of the Danish Order of Danebrog. As the years went on, he received still more honors, awards, and medals.

Si à toutes les époques de la philosophie,
l'idée de classification a occupé les
grands esprits, parmi lesquels brille
le nom d'aristote, cependant elle n'est
devenue vraiment populaire que
dans le XVIII.e siècle où parut
le systema naturæ de Linné qui
fut reçu aux applaudissements de
tous les amis de l'histoire naturelle,
mais alors il arriva aussi que
beaucoup d'esprits médiocres incapables
de comprendre ce que devait être
une classification scientifique,
eurent la prétention de classer
des objets tout à fait en dehors
de ceux sur lesquels s'était fixé
le génie de Linné.

E Chevreul
membre de l'Institut

The handwriting of Chevreul.

Obverse and reverse sides of bronze medal struck by the
French government on the occasion of Chevreul's hundredth
birthday.

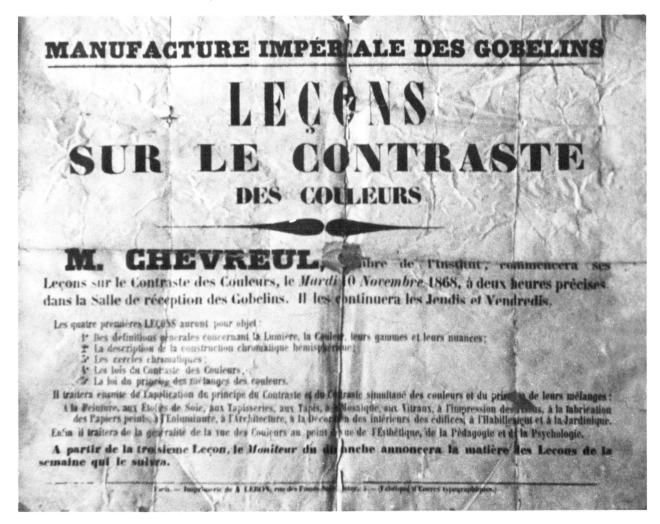

Announcement of one of Chevreul's lectures on color, this
one in 1868 when he was 82.

In America, for example, he became a member of the Academy of Natural Sciences of Philadelphia. Much of the recognition, however, was for his work as a chemist. Still greater fame would attend his accomplishments as a color authority.

Chevreul had lectured widely on color before 1839. Why was the book delayed? Let the reader refer to Chevreul's Postscript which follows his Author's Preface. He notes that he had given public lectures on color at the Gobelins during January of 1836 and 1838. He wanted to have a book published at that time but expenses for color plates were an obstacle. Then thanks to M. Pitois-Levrault (as on the 1839 French title page) the book saw the light of day. He further thanked "an illustrious foreigner for the offer he made of the aid of his sovereign." This remark has been clarified. The "illustrious foreigner" was Count de Pahlen, the Russian ambassador to France, and if Chevreul had agreed, the book project might well have been supported by Czar Nicholas! But for a second time Chevreul kept loyal to his native France.

His dedication, by the way, to J. Berzelius, was in admiration of a contemporary and much admired chemist, the author of numerous books and papers on the physical and chemical sciences.

According to record, Chevreul had been advised by friends to petition the Royal Press. This he had refused to do, probably because of pride—expecting the government to come to him of its accord, not his. Anyhow, he had succeeded on his own.

In brief, when the 1839 French edition appeared it was in two volumes. The text volume measured 5½ x 8½ inches and had 742 pages. A separate Atlas measured 9½ x 11 inches and had 40 plates, some of which folded out to 29 inches. Color printing in the 1830's was unfortunately none too competent and representative. Lithography was costly, and to satisfy Chevreul a great deal of handtinting was done. While some of the key plates were lithographed, many of the color spots (as will be seen) were applied individually. (In the 1854 English edition of this present book, most of the original French plates were redone in richer and cleaner hues, including the redrawing of the diagrams and decorative illustrations.)

A facsimile of the English 1854 edition is presented in this book and is separately referred to later. Needless to say, the text speaks for itself. And explanatory notes are further appended to offer comments on Chevreul's thoughts and conclusions. So perhaps it will be best to let M.E. Chevreul rely on his own words as they appear in this volume and to tell further of some of his other literary accomplishments. References to ages and years, as already introduced, will be repeated.

Age 60, 1846. *Theorie des effets optiques que présente les étoffes de soie.* Chevreul had lectured extensively and had written monographs of his color theories after publication of his book in 1839. Shortly after, in 1846, the Chamber of Commerce of Lyon, a leading center of the silk industry, published at its expense the book mentioned above. In rough translation this work concerned a theory of optical effects as presented in silk materials. This ran to 208 pages, had one color lithograph and measured about 6 x 8½ inches. This was honor for Chevreul who had lectured in Lyon and had been praised for his significant findings.

After Lyon, Chevreul in 1855 (age 69) had a Paris publisher reproduce a series of color circles in full hue, presumably from a new printing method. In 1861 (age 75) another Paris publisher issued a work that attempted to define and name colors of natural substances and artificial materials.

Age 78, 1864. *Des couleurs et de leurs applications aux arts industriels à l'aide des cercles chromatiques,* J.B. Ballière, Paris. Offices of the publisher were listed in London, Madrid, Leipzig, and New York. One may assume that Chevreul had now seen his work cross nations, continents and oceans. This particular book was devoted to color circles that might aid the industrial arts. It was large in size, about 11 x 14½ inches, had relatively few pages of text but a series of striking color plates. There were 27 full-color lithographs of Chevreul's color circles and color scales. Included were a large fold-out reproduction of the spectrum, a full-color circle with continuous gradations, nine graded color circles, each with 72 distinct sectors scaling down to near black, a gray scale of 22 steps, plus 12 vertical scales of color having 22 steps each shading from white through hue down to black. Chevreul's primaries were red, yellow, blue, and his secondaries were orange, green, violet, an arrangement followed since by most artists.

Age 96, 1882. *Memoire sur la vision des couleurs materielles.* Chevreul is getting on in years. That he had a sizable book published at the age of 96 must be quite a record for an author in any field. The volume is not a mere repeat of his earlier contributions, but contains new data. The book measures 9 x 11 inches, has 378 text pages, and 18 black and white and full-color plates. The Publisher is the Institute of France and the printer is the famous French firm of Didot. This time, and with his usual scholarship, Chevreul devotes himself to the results of color mixtures attained by the spinning of disks. When his original treatise came out in 1839, the scientific and revolutionary findings of Helmholtz had not been released (1867). Now Chevreul had profited from the German's amazing revelations and in his new book duly made an acknowledgment. He also

DE LA LOI
DU CONTRASTE SIMULTANÉ

DES COULEURS,

ET

DE L'ASSORTIMENT DES OBJETS COLORÉS,

CONSIDÉRÉ D'APRÈS CETTE LOI

DANS SES RAPPORTS AVEC LA PEINTURE, LES TAPISSERIES DES
GOBELINS, LES TAPISSERIES DE BEAUVAIS POUR MEUBLES,
LES TAPIS, LA MOSAÏQUE, LES VITRAUX COLORÉS, L'IMPRES-
SION DES ÉTOFFES, L'IMPRIMERIE, L'ENLUMINURE, LA DÉCO-
RATION DES ÉDIFICES, L'HABILLEMENT ET L'HORTICULTURE;

PAR

M. E. CHEVREUL,

Membre de l'Institut de France, de la Société royale de Londres, de la
Société royale des sciences de Copenhague, de l'Académie royale des sciences
de Stockholm, de l'Académie royale des sciences de Berlin, de la Société
royale et centrale d'agriculture du département de la Seine, etc.

Officier de la Légion d'honneur et chevalier de l'ordre danois de Danebrog.

*On doit tendre avec effort à l'infaillibilité
sans y prétendre.*

MALEBRANCHE.

PARIS,

Chez PITOIS-LEVRAULT et C.ᵉ, rue de la Harpe, n.° 81.

1839.

Title page of original French edition of Chevreul's master-
work on color, 1839. The English edition appeared later in
1854. Note that Chevreul had previously been honored as a
chemist by scientific societies.

Die

Farbenharmonie,

in ihrer Anwendung

bei der Malerei, bei der Fabrication von farbigen Waaren jeder Art,
von Tapeten, Zeugen, Teppichen, Möbeln, in der Buchdruckerkunst
beim Coloriren von Karten und Bildern,

bei der

Anlegung von Gärten, bei der Dekoration von Kirchen,
Theatern, Wohngebäuden,

in der

Kleidermacherkunst und bei der männlichen und weiblichen Toilette.

Ein

praktisches Lehrbuch

zur Kenntniß der physikalischen Gesetze, nach welchen Farben neben einander gestellt
werden müssen, um einen wohlgefälligen Eindruck zu machen.

Aus dem Französischen

des

E. Chevreul,

Vorsteher der Gobelinsmanufaktur, Mitglied des Institut de France, der Royal Society,
der Gesellschaft der Wissenschaften in Copenhagen, Ritter der Ehrenlegion
und des Dannebrog-Ordens ꝛc.

Von

einem deutschen Techniker.

Stuttgart
1840.
Verlag von Paul Neff.

Title page of original German edition of Chevreul's master-
work on color, 1840. The English edition appeared later in
1854.

referred to the English Thomas Young who developed a theory of color vision, and to the Swedish Holmgren who gave the world a test for color blindness.

Age 103, 1889. Chevreul had outlived a century. After so many decades of creative thinking, hard work and profound application, the French government decided to reprint his classic, 1839 work as a centennial celebration of the great man's eminence. The title page of this memorable volume is reproduced on these pages. The publisher is indicated as Imprimerie Natural, and the page includes the dignified imprint of the seal of the Republic of France.

This was a big book, 586 pages, 9¾ x 12¾ inches, 2½ inches thick, nine pounds. It had all of Chevreul's original plates reproduced in high quality lithography. An introductory note explained as follows:

"In order to guarantee to the plates of this book the stability which their scientific nature requires, and in order not to mar by any physical imperfection the monument which the National Press is raising to the memory of M.E. Chevreul, it was necessary to resort only to mineral colors whose stability was certain. It was even necessary to make some of them which, because of their great price and limited industrial application, were not on the market. Since the three colors chosen by Chevreul as basic, *red, yellow, blue,* cannot be reproduced precisely by means of isolated materials, they were obtained by mixing.

"Naturally, it was necessary to avoid putting into contact with one another agents which might have been mutually altered by prolonged contact. Reduced to the state of the finest possible powders, then mixed with suitable lithographic varnishes, the materials were ground under cylinders of porphyry to prevent any danger of deterioration on contact with a metallic surface. A certain number of these colors were very difficult to transform into lithographic inks, either because of their particular molecular state, or because the varnishes did not properly blend in. A great deal of research has gone into minimizing to every extent possible defects that might evade anticipation and remain in these very special products."

(A facsimile of this substantial work was reprinted in France in 1969.)

This honor and recognition by the French government was deserved tribute indeed to M.E. Chevreul after his full century of learned dedication.

THÉORIE

DES

EFFETS OPTIQUES

QUE PRESENTENT

LES ÉTOFFES DE SOIE;

PAR

M. E. CHEVREUL,

MEMBRE DE L'INSTITUT DE FRANCE, DE LA SOCIÉTÉ ROYALE DE LONDRES, DE LA SOCIÉTÉ ROYALE DES SCIENCES DE COPENHAGUE, DE L'ACADÉMIE ROYALE DES SCIENCES DE STOCKHOLM, DE L'ACADÉMIE ROYALE DES SCIENCES DE BERLIN, DE LA SOCIÉTÉ DES CURIEUX DE LA NATURE DE MOSCOU, DE L'ACADÉMIE DES SCIENCES NATURELLES DE PHILADELPHIE, DE L'INSTITUT NATIONAL DES ÉTATS-UNIS, MEMBRE DE LA SOCIÉTÉ ROYALE ET CENTRALE D'AGRICULTURE DU DÉPARTEMENT DE LA SEINE, MEMBRE CORRESPONDANT DE LA SOCIÉTÉ D'AGRICULTURE, D'HISTOIRE NATURELLE ET DES ARTS UTILES DE LYON, MEMBRE HONORAIRE DE LA SOCIÉTÉ INDUSTRIELLE D'ANGERS, ETC.;

COMMANDEUR DE L'ORDRE ROYAL DE LA LÉGION D'HONNEUR, ET CHEVALIER DE L'ORDRE DANOIS DE DANEBROG.

On doit tendre avec effort à l'infaillibilité sans y prétendre.
MALEBRANCHE.

Ouvrage imprimé aux frais de la Chambre de Commerce de Lyon.

PARIS,

TYPOGRAPHIE DE FIRMIN DIDOT FRÈRES,

IMPRIMEURS DE L'INSTITUT,

RUE JACOB, 56.

1846.

40

DES COULEURS

ET

DE LEURS APPLICATIONS AUX ARTS INDUSTRIELS

A L'AIDE DES

CERCLES CHROMATIQUES

PAR

Michel Eugène

E. CHEVREUL

Directeur des teintures à la manufacture impériale des Gobelins,
Professeur administrateur au Muséum d'histoire naturelle de Paris,
Membre de l'Institut (Académie des sciences).

AVEC XXVII PLANCHES GRAVÉES SUR ACIER ET IMPRIMÉES EN COULEUR

Par René DIGEON

PARIS

J. B. BAILLIÈRE ET FILS,

LIBRAIRES DE L'ACADÉMIE IMPÉRIALE DE MÉDECINE,

Rue Hautefeuille, 19.

Londres,	Madrid,	New-York,
HIPPOLYTE BAILLIÈRE.	C. BAILLY-BAILLIÈRE.	BAILLIÈRE BROTHERS.

LEIPZIG, E. JUNG TREUTTEL, QUERSTRASSE, 10.

1864

Tous droits réservés.

Above and opposite page:

 (Theorie & Des Couleurs)

Title pages of two of Chevreul's several books on color published in 1846 and 1864 when Chevreul was 60 and 78 years of age. Note in 1864 work that publisher had distribution in London, Madrid, New York, Leipzig as well as France.

41

INSTITUT DE FRANCE.

MÉMOIRES DE L'ACADÉMIE DES SCIENCES

EXTRAIT DU TOME XLII

MÉMOIRE

SUR LA

VISION DES COULEURS MATÉRIELLES

EN MOUVEMENT DE ROTATION

ET

DES VITESSES NUMÉRIQUES DE CERCLES

DONT UNE MOITIÉ DIAMÉTRALE
EST COLORÉE ET L'AUTRE BLANCHE, VITESSES CORRESPONDANT
A TROIS PÉRIODES DE LEUR MOUVEMENT
A PARTIR DE L'EXTRÊME VITESSE JUSQU'AU REPOS.

PAR

M. E. CHEVREUL

DOYEN DES ÉTUDIANTS DE FRANCE

On doit tendre avec effort à l'infaillibilité
sans y prétendre.

MALEBRANCHE.

PARIS

TYPOGRAPHIE DE FIRMIN-DIDOT ET Cie

IMPRIMEURS DE L'INSTITUT DE FRANCE, RUE JACOB, 56

—

M DCCC LXXXII

Pl. III.

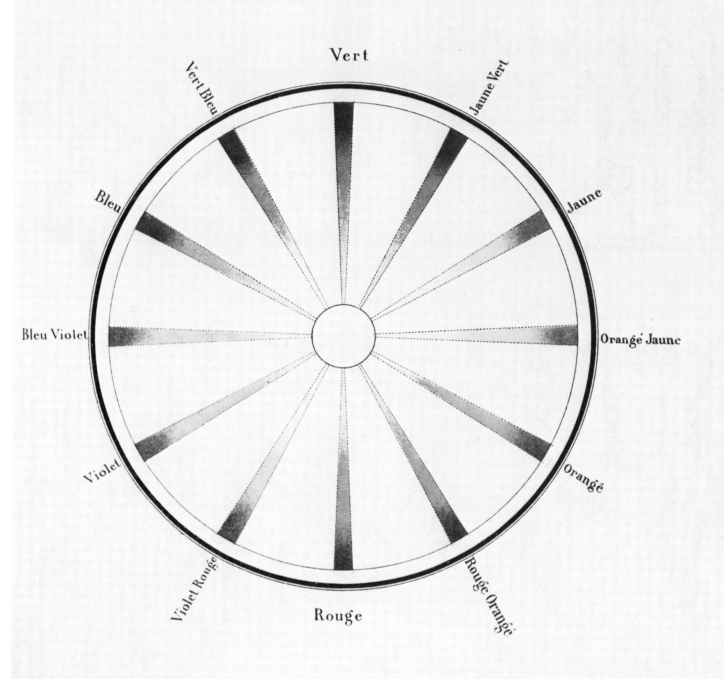

Imp. Lemercier & Cⁱᵉ Paris.

Opposite page and above:

(Memoire)

Title page and plate from a major Chevreul work on color published in 1882 when the author was 96. The material contained was original, not a review.

DE LA LOI

DU CONTRASTE SIMULTANÉ

DES COULEURS

ET DE L'ASSORTIMENT DES OBJETS COLORÉS

CONSIDÉRÉ D'APRES CETTE LOI

DANS SES RAPPORTS AVEC LA PEINTURE, LES TAPISSERIES DES GOBELINS

LES TAPISSERIES DE BEAUVAIS POUR MEUBLES

LES TAPIS, LA MOSAÏQUE, LES VITRAUX COLORÉS, L'IMPRESSION DES ÉTOFFES, L'IMPRIMERIE

L'ENLUMINURE, LA DÉCORATION DES ÉDIFICES, L'HABILLEMENT ET L'HORTICULTURE

PAR

M. E. CHEVREUL

AVEC

UNE INTRODUCTION DE M. H. CHEVREUL FILS

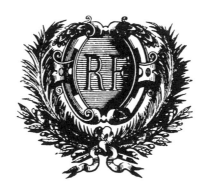

PARIS

IMPRIMERIE NATIONALE

—

M DCCC LXXXIX

Title page of handsome edition of Chevreul's great book, published in his honor by the French government in 1889 the year in which Chevreul died at the age of 103.

About This Book
The English Edition

Chevreul's *The Principles of Harmony and Contrast of Colors* is reproduced in this volume exactly as it was published in the Charles Martel English translation of 1854. Not only is the text the same, but a separate color form also reproduces the 15 color plates that originally appeared. These same color plates are then, in a second color form, shown as brought up to date with modern color engraving and printing methods. The reader may thus compare the two. The newer color plates are meant to convey more accurately the intentions of Chevreul as he first described them in his writings, descriptions and explanations.

As has previously been noted, M.E. Chevreul's classic is beyond doubt one of the greatest books on color ever written. It vies in eminence with Sir Isaac Newton's *Opticks* and Johann Wolfgang von Goethe's *Farbenlehre,* all three of which dominate the venerable literature of color.

But even more noteworthy than the works of Newton and Goethe, the masterwork of Chevreul has had an unprecedented history of success as to number of world editions and printings. Originally published in France in 1839, it promptly went into German in 1840. It was picked up by the English in 1854, with approved translations by Charles Martel (used for this present book) and John Spanton. It had a number of printings for about twenty years. After this it came to America in 1869, with a preface by Martel, and had sixteen printings until 1873.

In 1967, Reinhold Publishing Corporation issued a major edition with full-color plates, followed by a paperback edition in 1981 without color. In 1969 a French publisher reprinted the facsimile Centennial edition of 1889 (produced by the French government in honor of Chevreul's 103rd birthday). And in 1980 Garland Publishing of New York did a Martel facsimile of mediocre quality.

In the original French edition of 1839, M.E. Chevreul himself related the story as to how his writings came to see the light of day. A fairly complete review of this has already been set forth. As to the English edition, there were two translations, both apparently approved by Chevreul. A comparatively short, condensed and edited printing was by John Spanton in 1857. His title was *The Laws of Contrast of Color and Their Application to the Arts.* This ran into several editions up to 1868, a period of eleven years. Spanton was a bookbinder, author and translator specializing in scientific matters. Little is known of his personal life.

The superior edition of Chevreul is that of Charles Martel, and this has been used for this present volume. Martel's title was *The Principles of Harmony and Contrast of Colours.* Originally issued in 1854, it had a number of successful printings up to 1870—and more than Spanton's. Martel, in fact, wrote a book of his own based on Chevreul: *The Principles of Colouring in Painting,* and this had at least ten printings. A variation of the Martel publication came to America in 1869 where it had still more printings. This has been already noted.

Charles Martel was a pseudonym for Thomas Delf, a man of unusual talents. He became a bookseller in London and later did well as a publisher. He issued some British magazines, such as *The Artist, The Children's Journal, The Photographic Art Journal.* Further, he released books on form, ornament, painting materials. Rather surprisingly he authored such unlikely topics as *Love Letters of Eminent Persons, The Detective's Note-Book,* and *A Dictionary of Love.*

However, his translation of Chevreul (probably with literary help) was excellent and had the approval of Chevreul. It will be found herewith.

THE PRINCIPLES

OF

HARMONY AND CONTRAST

OF

COLOURS,

AND THEIR APPLICATIONS TO THE ARTS:

INCLUDING

PAINTING, INTERIOR DECORATION, TAPESTRIES,
CARPETS, MOSAICS, COLOURED GLAZING, PAPER-STAINING,
CALICO-PRINTING, LETTERPRESS PRINTING, MAP-COLOURING, DRESS,
LANDSCAPE AND FLOWER GARDENING, ETC.

BY

M. E. CHEVREUL,

MEMBRE DE L'INSTITUT DE FRANCE, ETC.

TRANSLATED FROM THE FRENCH BY CHARLES MARTEL.

WITH AN ADDITIONAL INTRODUCTION BY THE TRANSLATOR, AND A
GENERAL INDEX.

ILLUSTRATED WITH PLATES.

LONDON:
HENRY G. BOHN, YORK STREET, COVENT GARDEN.

TO

J. BERZELIUS,

IN TESTIMONY OF FRIENDSHIP AND OF PROFOUND ESTEEM

FOR THE MAN!

IN TESTIMONY OF ADMIRATION FOR HIS WORKS!

THE AUTHOR OF THE BOOK,

M. E. CHEVREUL.

Author's Preface

This work is too remote from the science which has occupied the greatest part of my life, too many subjects differing in appearance are treated of, for me not to indicate to the reader the cause which induced me to undertake it: subsequently I shall speak of the circumstances which made me extend the limits within which it first seemed natural to restrain it.

When I was called upon to superintend the dyeing department of the royal manufactories (Gobelins), I felt that this office imposed on me the obligation of placing the dyeing on a new basis, and consequently it was incumbent on me to enter upon minute researches, the number of which I clearly foresaw, but not the variety: the difficulties of my position were greatly increased by numerous perplexing questions proposed to me for solution by the directors of that establishment; I was therefore obliged to arrange my labours differently than if I had been free from every other occupation.

In endeavouring to discover the cause of the complaints made of the quality of certain pigments prepared in the dyeing laboratory of the Gobelins, I soon satisfied myself that if the complaints of the want of permanence in the light blues, violets, greys, and browns, were well-founded, there were others, particularly those of the want of vigour in the blacks employed in making shades in blue and violet draperies, which had no foundation; for after procuring black-dyed wools from the most celebrated French and other workshops—and perceiving that they had no superiority over those dyed at the Gobelins,—I saw that the want of vigour complained of in the blacks was owing to the colour next to them, and was due to the phenomena of contrast of colours. I then saw that to fulfil the duties of director of the dyeing department, I had two quite distinct subjects to treat—the one being the contrast of colours generally considered, either under the scientific relation, or under that of its applications; the other concerned the chemical part of dyeing. Such, in fact, have been the two centres to which all my researches during ten years have converged. In proportion as they are developed, those who read them will be enabled to see how much time and labour they have cost me, and I may venture to add, difficulty also—because undertaking them at a period when my work on *Les Corps Gras d'Origine Animale,* and my *Considérations sur l'Analyse Organique,* had opened to me a field which, so to speak, I had only to reap,—in separating myself from this career, under the necessity of opening a new one; and all who have been in this position know that human weakness is felt mostly by him who would reap from the soil he has himself ploughed and sown.

The work I now publish is the result of my researches on *Similtaneous Contrast of Colours;* researches which have been greatly extended since the lecture I gave on this subject at the Institute on the 7th April, 1828. The extension they have taken is a consequence of the method which directed me in my "Researches on Fatty Bodies," the rules of which have been explained in my *Considérations sur l'Analyse Organique.* To all who are acquainted with these works, it will be evident that the present work cannot be a collection of hypotheses (more or less ingenious) on the assortment of colours and their harmonies, and a perusal of it will doubtless convince them that it is as experimental and as exact as the two preceding works.

In fact, numerous observations on the view of coloured objects made during several months, verified by my pupils, and others much accustomed in their professions to judge of colours, and to appreciate the least difference in them, have first been collected and described as proved facts. Then, in reflecting on the relations these facts have together, in seeking the principle of which they are the consequences, I have been led to the discovery of the one which I have named the *law of simultaneous contrast of colours.* Thus this work is really the fruit of the method *à posteriri:* facts are observed, defined, described, then they become generalised in a simple expression which has all the characters of a law of nature. This law, once demonstrated, becomes an *à priori* means of assorting coloured objects so as to obtain the best possible effect from them, according to the taste of the person who combines them; of estimating if the eyes are well organised for seeing and judging of colours, or if painters have exactly copied objects of known colours.

In viewing the law of simultaneous contrast of colours with reference to its application, and in submitting to experiment all the consequences which appeared to me to result from it, I have thus been led to extend it to the arts of tapestry, to the different kinds of painting, block printing, tinting, horticulture, &c.; but in order to prevent the conclusions which some readers might arrive at upon the value of the opinions I have put forth (2nd part, 2nd division) in relation to the Gobelins and Beauvais tapestries, and to Savonnerie carpets, from the examinations which they will themselves make of these works, I now state that, an entire stranger to the inspection and direction of the works executed in the workshops of the royal manufactories, as well as to the selection of patterns, my views and opinions must only be, for the readers of whom I speak, as those of a private individual who has had frequent opportunities of seeing and examining works of art in the production of which he has no influence to exercise; the duties which attach me to the Gobelins being exclusively those of director of the dyeing department. Instead of this brief review of my researches, I had at first proposed to develop in an introduction, conformably to chronological order, the series of leading

ideas which have presided over the composition of this book, thinking to show by their mutual connection how I have been obliged to treat of subjects which at first sight seemed foreign to the law of simultaneous contrast of colours; but upon reflecting that a great many things are unknown to the reader, I thought a summary of my researches, placed at the end of this work, would possess all the advantages of my first intention without the objections which upon reflection I discovered in it.

I beg the reader never to forget when it is asserted of the phenomena of simultaneous contrast, *that one colour placed beside another receives such a modification from it* that this manner of speaking does not mean that the two colours, or rather the two material objects that present them to us, have a mutual action, either physical or chemical; it is really only applied *to the modification that takes place before us* when we perceive the simultaneous impression of these two colours.

L'Hay, near Paris,
 19th April, 1835.

POSTSCRIPT.

This work, written three years ago, has formed the subject of eight public lectures delivered at the Gobelins in the course of January, 1836, and January, 1838; I should have earnestly desired to publish it as soon as I had finished writing it; but the condition which I set that the price should not be too dear, notwithstanding the expense occasioned by numerous coloured plates, was an obstacle in finding a publisher, just at the time when M. Pitois-Levrault wished to become such. In stating the cause of the delay of this publication, I should certainly neglect a duty, if I did not publicly thank an illustrious foreigner for the offer he made me of the aid of his sovereign to hasten it; although I have not availed myself of it, I shall nevertheless always retain it in grateful remembrance.

Au Musée d'Histoire Naturelle,
 1st June, 1838.

PART I.

ON

THE LAW

OF

SIMULTANEOUS CONTRAST OF COLOURS,

AND ITS

APPLICATIONS IN THE ARTS.

PART I.

THEORETICAL.

PART I.

INTRODUCTION.

FIRST SECTION.—ON THE LAW OF SIMULTANEOUS CONTRAST OF COLOURS, AND ITS DEMONSTRATION BY EXPERIMENT.

SECOND SECTION.—ON THE DISTINCTION BETWEEN SIMULTANEOUS, SUCCESSIVE, AND MIXED CONTRAST OF COLOURS; AND AN ACCOUNT OF THE CONNECTION BETWEEN THE EXPERIMENTS MADE BY THE AUTHOR AND THOSE OF OTHER OBSERVERS.

THIRD SECTION.—ON THE PHYSIOLOGICAL CAUSE TO WHICH THE PHENOMENA OF CONTRAST OF COLOURS WAS REFERRED PREVIOUS TO THE EXPERIMENTS OF THE AUTHOR.

Introduction

(1.) It is necessary, in the first place, to explain some of the optical principles which relate,

 Firstly, to the law of Simultaneous Contrast of Colours; and

 Secondly, to the applications of this law in the various arts which make use of coloured materials to attract the eye.

(2.) A ray of solar light is composed of an indeterminate number of differently-coloured rays; and since, on the one hand, it is impossible to distinguish each particular one, and as, on the other, they do not all differ equally from one another, they have been distributed into groups, to which are applied the terms *red rays, orange rays, yellow rays, green rays, blue rays, indigo rays*, and *violet rays;* but it must not be supposed that all the rays comprised in the same group, *red* for instance, are identical in colour; on the contrary, they are generally considered as differing, more or less, among themselves, although we recognise the impression they separately produce as comprised in that which we ascribe to *red.*

(3.) When light is reflected by an opaque white body, it is not modified in proportion to the differently-coloured rays which constitute white light; only,

A. *If this body is not polished,* each point of its surface must be considered as dispersing, in every direction through the surrounding space, the white light which falls upon it; so that the point becomes visible to an eye placed in the direction of one of these rays. We may easily conceive that the image of a body in a given position, is composed of the sum of the physical points which reflect to the eye so placed, a portion of the light that each point radiates.

B. *When the body is polished,* like the surface of a mirror, for instance, one portion of the light is reflected irregularly, as in the preceding case; at the same time another portion is regularly or specularly reflected, giving to the mirror the property of presenting to the eye, properly situated, the image of the body which sends its light to the reflector;—one consequence of this distinction is, that if we observe two plane surfaces reflecting white light differing from each other only in polish, it results that in those positions where the *non*-polished surface is visible, all its parts will be equally, or nearly equally, illuminated; while the eye, when it is in a position to receive only that which is reflected irregularly, will receive but little light from the polished surface; on the contrary, it will receive much more when it is in a position to receive light regularly reflected.

(4.) If the light which falls upon a body is completely absorbed by it, as it would be in falling into a perfectly obscure cavity, then the body appears to us *black*, and it becomes visible only because it is contiguous to surfaces which transmit or reflect light. Among black substances, we know of none that are perfectly so, and it is because they reflect a small quantity of white light, that we conclude they have relief, like other material objects. Moreover, what proves this reflection of white light is, that the blackest bodies, when polished, reflect the images of illuminated objects placed before them.

(5.) When light is reflected by an opaque coloured body, there is always

 A reflection of white light,—and

 A reflection of coloured light;

the latter is due to the fact that the body *absorbs* or extinguishes within its substance a certain number of coloured rays, and *reflects* others. It is evident that the coloured rays reflected are of a different colour from those absorbed; and also that, if they were combined with those absorbed, they would reproduce white light. We shall return to this subject in (6.).

Further, it is also evident that opaque coloured bodies, when unpolished, reflect irregularly both white and coloured light, by which we are enabled to see their colours; and that those which are polished reflect only one portion of these two lights irregularly, while they reflect another portion in a regular manner.

(6.) Let us now return to the relation which exists between the coloured light *absorbed,* and the coloured light *reflected,* by an opaque body, which makes it appear to us of the colour peculiar to this light.

It is evident, from the manner in which we have considered the physical composition of solar light (2.), that if we reunited the total quantity of the coloured light *absorbed* by a coloured body, to the total quantity of coloured light *reflected* by it, we should reproduce white light: for it is this relation that two differently coloured lights, taken in given proportions, have of reproducing white light, that we express by the terms.

 Coloured lights complementary to each other, or *Complementary colours.*

It is in this sense we say,

That Red is complementary to Green, and *vice versâ;*

That Orange is complementary to Blue, and *vice versâ;*

That Greenish-Yellow is complementary to Violet, and *vice versâ;*

That Indigo is complementary to Orange-Yellow, and *vice versâ.*

(7.) It must not be supposed that a red or yellow body reflects only *red* and *yellow* rays besides white light; they each reflect *all kinds* of coloured rays: only those rays which lead us to judge the bodies to be *red* or *yellow*, being more numerous than the other rays reflected, produce a greater effect. Nevertheless, those other rays have a certain influence in modifying the action of the red or yellow rays upon the organ of sight; and this will explain the innumerable varieties of *hue* which may be remarked among different red and yellow substances. It is also difficult not to admit that, among the differently coloured rays reflected by bodies, there is a certain number of them which, being complementary to each other, go to re-form white light upon reaching the eye.

SECTION I.

ON THE LAW OF SIMULTANEOUS CONTRAST OF COLOURS, AND ITS DEMONSTRATION BY EXPERIMENT.

CHAPTER I.

METHOD OF OBSERVING THE PHENOMENA OF SIMULTANEOUS CONTRAST OF COLOURS.

Definition of Simultaneous Contrast.

(8.) If we look simultaneously upon two stripes of different tones of the same colour, or upon two strips of the same tone of different colours placed side by side, if the stripes are not too wide, the eye perceives certain modifications which in the first place influence the intensity of colour, and in second, the optical composition of the two juxtaposed colours respectively.

Now as these modifcations make the stripes appear different from what they really are, I give to them the name of *simultaneous contrast of colours;* and I call *contrast of tone* the modification in intensity of colour, and *contrast of colour* that which affects the optical composition of each juxtaposed colour. The following is a very simple method of convincing ourselves of the twofold phenomena of simultaneous contrast of colours.

Experimental Demonstration of Contrast of Tone.

(9.) Take two portions, *o, o', fig.* 1., of a sheet of unglazed paper of about twenty inches square, coloured light grey by means of a mixture of whiting and lamp-black; fix them in any manner upon a piece of brown-holland, placed opposite to a window, *o* being distant from *o* about twelve inches. Then take two portions *p* and *p* of another sheet of unglazed paper which differs from the first by being deeper, but still a grey composed of the same black and white. Fix *p* next to *o*, and *p'* at about twelve inches from *p*.

If we now look at these four half-sheets, *o, o', p, p'* for some seconds, we shall see that the piece *o* contiguous to *p* will be lighter than *o'*, while *p* will, on the contrary, be deeper than *p'*.

(10.) It is easy to prove that the modification is not equally intense over the whole extent of the surfaces of *o* and *p*, but that it becomes gradually weaker from the line of contact. It is sufficient to place a piece of card, *fig.* 2., cut out in the centre, upon *o p*, in such manner that *o* and *p* each present three grey stripes; as is shown in *fig.* 3., the stripes 1, 1, are more modified than the stripes 2, 2; and these latter are more modified than the stripes 3, 3.

For this modification to take place, it is not absolutely necessary for *o* and *p* to be contiguous; for if we cover the stripes 1, 1, we shall see the stripes 2, 2, 3, 3 modified.

(11.) The following experiment, the natural sequence of the two preceding (9. and 10.), is very suitable for demonstrating the full extent of contrast of tone.

Divide a piece of cardboard into ten stripes, each of about a quarter of an inch in width, 1, 2, 3, 4, 5, 6, 7, 8, 9,

10, and cover it with a uniform wash of Indian ink, *fig. 3. (bis.)* When it is dry, spread a second wash over all the stripes except the first. When this second wash is dry, spread a third over the stripes except 1 and 2; and proceed thus to cover all the stripes with a flat tint, each one becoming darker and darker, as it recedes from the first (1.).

If we take ten stripes of paper of the same grey, but each of a different tone, and glue them upon a card so as to observe the preceding gradation, it will serve the same purpose.

On now looking at the card, we shall perceive that instead of exhibiting flat tints, each stripe appears of a tone gradually shaded from the edge *a a* to the edge *b b*. In the band 1, the contrast is produced simply by the contiguity of the edge *b b* with the edge *a a* of the stripe 2; in the stripe 10 it is simply by the contact of the edge *a a* with the edge *b b* of the stripe 9. But in each of the intermediate stripes 2, 3, 4, 5, 6, 7, 8, and 9, the contrast is produced by a double cause: one, the contiguity of the edge *a a* with the edge *b b* of the stripe which precedes it; the other by the contiguity of the edge *b b* with the edge *a a* of the darker stripe which follows it. The first cause tends to raise the tone of the half of the intermediate stripe, while the second cause tends to lower the tone of the other half of this same stripe.

The result of this contrast is, that the stripes, seen from a suitable distance, resemble channeled grooves (*glyphs*) more than plane surfces. For in the stripes 2 and 3, for instance, the grey being insensibly shaded from the edge *a a* to the edge *b b*, they present to the eye the same effect as if the light fell upon a channeled surface, so as to light the part near to *b b*, while the part *a a* will appear to be in the shade; but with this difference, that in a real channel the lighted part would throw a reflection on the dark part.

(12.) Contrast of Tone occurs with Colours, properly so called, as well as with Grey; thus to repeat our experiment (9. *fig.* 1.) with the two portions *o', o* of a sheet of paper of a light tone of a certain colour, and two portions *p', p* of a sheet of paper of a deeper tone of this same colour, we shall perceive that *o* contiguous to *p* will be lighter than *o'*, and *p* will be deeper than *p'*. We can demonstrate, as we have done before (10.), that in starting from the point of contact the modification is gradually weakened.

Experimental Demonstration of Contrast of Colour

(13.) If we arrange as before (*9. fig.* 1.) two portions *o, o'* of a sheet of unglazed coloured paper, and two portions, *p, p'* of a sheet of unglazed paper of a different colour from the first, but resembling it as nearly as possible in intensity, or rather in *tone* (8.), in looking at these four half-sheets *o', o, p, p'*, for a few seconds, we shall see that *o* differs from *o'*, and *p* from *p'*; consequently the two half sheets *p* appear to undergo reciprocally a modification of tint which is rendered apparent by the comparsion we have made of their colours with those of *o'* and of *p*.*

*Instead of paper we may use lustreless stuffs, or any other material which will present two equal surfaces absolutely identical in colour. Coloured paper answers very well.

(14.) It is easy to demonstrate that the modification which colours undergo by juxtaposition, is a tendency to weakening starting from the line of juxtaposition; and that it may be perceived between two surfaces without their being in contact, it is sufficient to experiment as above (10.).

(15.) I will now cite seventeen observations made in conformity with the method prescribed (9.).

(The colours experimental with must be as nearly as possible of equal intensity.)

Colours experimented with.	Modifications.
1. Red	inclines to Violet.
Orange	" Yellow.
2. Red	" Violet, or is less Yellow.
Yellow	" Green, or is Red.
3. Red	" Yellow.
Blue	" Green.
4. Red	" Yellow.
Indigo	" Blue.
5. Red	" Yellow
Violet	" Indigo
6. Orange	" Red
Yellow	" Bright Green, or is less Red.
7. Orange	" Bright Red, or is less Brown.
Green	" Blue.
8. Orange	" Yellow, or is less Brown.
Indigo	" Blue, or is purer.
9. Orange	" Yellow, or is less Brown.
Violet	" Indigo.
10. Yellow	" Bright Orange.
Green	" Blue.
11. Yellow	" Orange.
Blue	" Indigo.
12. Green	" Yellow.
Blue	" Indigo.
13. Green	" Yellow.
Indigo	" Violet.
14. Green	" Yellow.
Violet	" Red.
15. Blue	" Green.
Indigo	" Deep Violet.
16. Blue	" Green.
Violet	" Red.
17. Indigo	" Blue.
Violet	" Red.

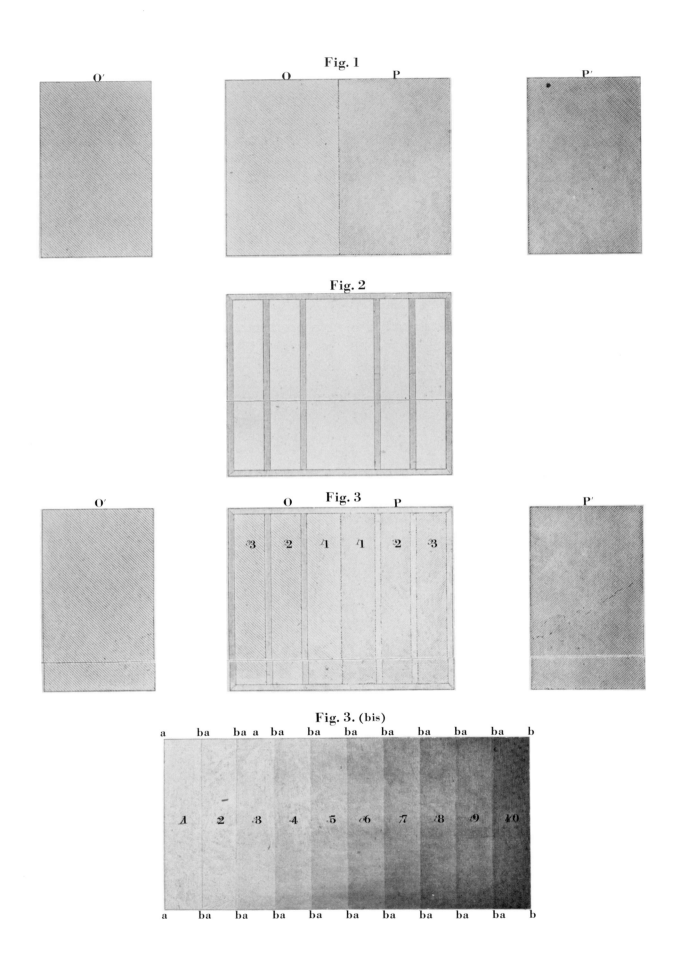

PLATE 1 (A). The Figures in the illustration are reproduced approximately as they appeared in the first Chevreul English edition.

PLATE 1 (B). Here the Figures in the illustrations have been redone in sharper and clearer detail. For text references see (9.) to (12.)

It follows, then, from the experiments described in this Chapter, that two coloured surfaces in juxtaposition will exhibit two modifications to the eye viewing them simultaneously, the one relative to the height of tone of their respective colours, and the other realtive to the physical composition of these same colours.

CHAPTER II.

THE LAW OF SIMULTANEOUS CONTRAST OF COLOURS, AND THE FORMULA WHICH REPRESENTS IT.

(16.) After satisfying myself that the preceding phenomena constantly recurred when my sight was not fatigued, and that many persons accustomed to judge of colours saw them as I did, I endeavoured to reduce them to some general expression that would suffice to enable us to predict the effect that would be produced upon the organ of sight by juxtaposition of two given colours. All the phenomena I have observed seem to me to depend upon a very simple law, which, taken in its most general signification, may be expressed in these terms:

In the case where the eye sees at the same time two contiguous colours, they will appear as dissimilar as possible, both in their optical composition and in the height of their tone.

We have then, *at the same time,* simultaneous contrast of colour properly so called, and contrast of tone.

(17.) For two contiguous colours, o and p, will differ as much as possible from each other when the complementary of o is added to p, and the complementary of p is added to o: consequently, by the juxtaposition of o and p, the rays of the colour p, which o reflects when it is seen separately, like the rays of the colour o which p reflects when viewed separately, rays which are active under these circumstances (7.) cease to be so when o and p are placed in contact; for in this case, each of the two colours losing what is analogous, must differ the more.

The following formula will make this perfectly intelligible,

(18.) Let us represent:

The colour of the stripe o by the colour a whiter by B;

The colour of the stripe P by the colour a' whiter by B';

The complementary colour of a by c;

The complementary colour of a' by c'.

The colours of the two stripes viewed separately are

The colour of o equals a plus B,

The colour of P equals a' plus B'.

By juxtaposition, they become

The colour of o equals a plus B plus c',

The colour of P equals a' plus B' plus c.

Let us now show that what this expression amounts to is, that the taking away from the colour a of o the rays of the colour a', and taking away from the colour a' of P the rays of the colour a, we must suppose

B reduced to two portions: white equals b plus white equals (a' plus c').

B' reduced to two portions: white equals b' plus white equals (a plus c).

The colours of the two stripes viewed separately are

The colour of 0 equals a plus b plus a' plus c',

The colour of P equals a' plus b' plus a plus c.

By juxtaposition, they become

The colour of o equals a plus b plus c',

The colour of P equals a' plus b' plus c,

—an expression which is evidently the same as the first, excepting the values of B and B'.

(19.) I have stated that simultaneous contrast may influence both the optical composition of the colours, and the height of their tone; consequently, when the colours are not of the same degree of intensity, that which is deep appears deeper, and that which is light, lighter; that is to say, the first appears to lose as much of white light as the second seems to reflect more of it.

Therefore, in looking at two contiguous colours, we have

Simultaneous Contrast of Colour, and

Simultaneous Contrast of Tone.

CHAPTER III.

THE LAW OF SIMULTANEOUS CONTRAST OF COLOURS, DEMONSTRATED BY THE JUXTAPOSITION OF A GIVEN NUMBER OF COLOURED SUBSTANCES.

(20.) Let us now apply the formula to the seventeen observations of Chapter I, and we shall see that the modifications of contiguous colours are precisely such as would result from the addition to each of them of the colour which is complementary to its neighbour (18.), remarking, that I shall not review these observations in the order they were arranged above: the reader will learn the reason in Chapter IX. But it will always be easy to find the position they in Chapter I, because I have appended to each its consecutive number. For the complementaries of these colours, I refer to the Introduction to Part I (6.).

Orange and Green No. 7.

(21.) Blue, the complementary of Orange, added to Green, makes it bluer, or less yellow.

The complementary of Green (Red), added to Orange, the latter becomes redder, or less yellow, and brighter.

Orange and Indigo. No. 8

(22.) Blue, the complementary of Orange, added to Indigo, makes it bluer, or less red.

The complementary of Indigo (Orange-Yellow), added to Orange, renders it yellower, or less red.

Orange and Violet. No. 9.

(23.) Blue, the complementary of Orange, added to Violet, makes it incline to indigo.

The complementary of Violet (Greenish-Yellow), added to Orange, the latter becomes yellower.

Green and Indigo. No. 13.

(24.) Red, the complementary of Green, added to Indigo, makes it redder, or more violet.

The complementary of Indigo (Orange-Yellow), added to Green, makes it yellower.

Green and Violet. No. 14.

(25.) Red, the complementary of Green, added to Violet, makes it redder.

The complementary of Violet (Greenish-Yellow), added to Green, makes it yellower.

Orange and Red. No. 1.

(26.) Blue, the complementary of Orange, added to Red, makes it incline to violet or crimson.

The complementary of Red (Green), added to Orange makes the latter incline to yellow.

Violet and Red. No. 5.

(27.) Greenish-Yellow, the complementary of Violet, added to Red, makes it yellower, or inclining to orange.

The complementary of Red (Green), added to Violet, makes the latter incline to indigo.

Indigo and Red. No. 4.

(28.) Orange-Yellow, the complementary of Indigo, added to Red, makes it incline to orange.

The complementary of Red (Green), makes the Indigo bluer.

Orange and Yellow. No. 6.

(29.) Blue, the complementary of Orange, added to Yellow, makes it incline to green.

The complementary of Yellow (Indigo inclining to violet), makes the Orange redder.

Green and Yellow. No. 10.

(30.) Red, the complementary of Green, added to Yellow, makes it incline to orange.

Indigo inclining to violet, the complementary of Yellow, added to Green, makes it bluer.

Green and Blue. No. 12.

(31.) Red, the complementary of Green, added to Blue, makes the latter incline to indigo.

The complementary of Blue (Orange), added to Green, makes it yellower.

Violet and Blue. No. 16.

(32.) Greenish-Yellow, the complementary of Violet, added to Blue, causes it to become greenish.

The complementary of Blue (Orange), added to Violet, makes it redder.

Indigo and Blue. No. 15.

(33.) Orange-Yellow, the complementary of Indigo, added to Blue, makes it incline to green.

The complementary of Blue (Orange), added to Indigo, makes it incline to violet.

Red and Yellow. No. 2.

(34.) Green, the complementary of Red, added to Yellow, makes it incline to green.

The complementary of Yellow (Indigo inclining to violet), added to Red, makes it incline to violet.

Red and Blue. No. 3

(35.) Green, the complementary of Red, added to Blue, causes it to incline to green.

The complementary of Blue (Orange), added to Red, makes it incline to orange.

Yellow and Blue. No. 11.

(36.) Indigo, the complementary of Orange-Yellow, added to Blue, makes the latter incline to indigo.

The complementary of Blue (Orange), added to Yellow, makes it incline to orange.

Indigo and Violet. No. 17.

(37.) Orange-Yellow, the complementary of Indigo, added to Violet, makes it incline to red.

The complementary of Violet (Greenish-Yellow), added to Indigo, causes it to appear bluer.

(38.) It is evident that, other things being equal, the greater the difference that exists between a colour and the complementary (c or c') which is added to it, the more striking will be the modification of the juxtaposed colour; for when the complementary c' is added to the colour o it will be identical with it, as the complementary c is identical with the colour P to which it is added; and the modifications of o and P are limited to a simple augmentation of intensity of colour. But do we know, at the present day, of two coloured bodies which are capable of exhibiting to the observer two perfectly pure colours complementary to each other? Certainly not! All those substances which appear coloured by reflection, reflect, as I have said (7.), besides white light, a great umber of differently coloured rays. Therefore we cannot instance *a red pigment and a green*, or *an orange pigment and a blue*, or *an orange-yellow pigment and an indigo*, or, lastly, *a greenish-yellow pigment and a violet*, which reflect simple or compound colours absolutely complementary to each other, so that their juxtaposition would produce only *a simple augmentation of intensity* in their respective colours. If, therefore, it be generally less easy to verify the law of contrast with red and green, or orange and blue substances, &c., than it is with those which have been the object of the seventeen observations mentioned above (15.); yet in endeavouring to verify the first, we shall see that the colours will acquire a most remarkable brilliancy, strength, and purity, and this result, in perfect conformity with the law, is easily understood. For example, an orange-coloured object reflects blue rays, just as a blue object reflects orange rays (7.). Therefore, when we put a blue stripe beside an orange stripe, whether we admit that the first appears to the eye to receive some blue from the proximity of the second, as this latter appears to acquire orange through vicinity of the blue stripe,-or, which is the same thing, whether we admit that the blue stripe appears to destroy the effect of the blue rays of the second stripe, as this latter appears to destroy the effect of the orange rays of the blue stripe,-it is evident that the colours of the two objects in contact will purify each other, and become more vivid. But it may happen that the Blue wll appear to incline to green or to violet, and the Orange to yellow or to red, that is to say, the modifications acts not only upon the intensity of the colour, but also upon its physical composition: whatever it be if the latter effect takes place, it is undoubtedly always much feebler than the first. Besides, if we look a certain number of times at these same coloured bands we shall see that the blue, which at first appeared greener, will soon appear more violet, and that the orange, which at first appeared yellower, will become redder, so that the phenomenon of modification, dependent upon the physical composition of colour, will not be so constant as those which are the subject of the seventeen preceding observations (15.). I will now explain the previous remarks on substances, the colours of which are as nearly as possible complementary to each other.

Red and Green.

(39.) Red, the complementary of Green, added to Red, increases its intensity.

Green, the complementary of Red, added to Green, augments its intensity.

Such is the theoretical conclusion; and experiment confirms it.

When we place a Green inclining more to Yellow than to Blue in contact with

1° a Red slightly Orange,

2° a Red slightly Crimson,

3° an intermediate Red,

and then make a certain number of observations upon each of these groups of colours, we shall witness different results; that is to say, while in one case the Red will appear more orange, and the Green yellower; in another, the Red will appear more violet, and the Green bluer; and we may also remark, that the change is attributable as much to a difference in the intensity of the light illuminating the colours, as to fatigue of the eyes.

When we place a Green inclining more to Blue than to Yellow in juxtaposition with

1° a Red slightly Orange,

2° a Red slightly Crimson,

3° an intermediate Red

the results are the same as with the first green, with this difference, however, that in the combination of bluish-green and crimson-red, looked at for a certain number of times, the Green and the Red almost always appear yellower than when viewed separately, a result easily anticipated.

Orange and Blue.

(40.) Blue, the comtementary of Orange, added to blue, increases its intensity.

Orange, the complementary of Blue, added to Orange, augments its intensity.

On repeating these observations with a deep Blue and an Orange which is not too red, both colours will frequently appear redder than otherwise.

Orange-Yellow and Indigo.

(41.) Orange-Yellow, the complementary of Indigo, added to Orange-Yellow, imparts to it greater intensity.

Indigo, the complementary of Orange-Yellow, added to Indigo, increases its intensity.

The result of observation is almost always in conformity with theory.

Greenish-Yellow and Violet.

(42.) Greenish-Yellow, the complementary of Violet, added to Greenish-Yellow, imparts to it greater intensity.

Violet, the complementary to Greenish-Yellow, added to Violet, increases its intensity.

The result of observation is almost always in conformity with the law.

Conclusion

(43.) According to the Law of Simultaneous Contrast of Colours and the insensible gradation of modification commencing from the contiguous edges of the juxtaposed coloured bands (11.), we can represent by coloured circular spaces the modifications which the principal colours tend to induce in those which are contiguous to them.

Take circular pieces of paper, or other material, coloured red, green, orange, blue, greenish-yellow, violet, indigo, and orange-yellow, of about one inch and a half in diameter; place each one separately on a sheet of white paper; then, with a thin wash of colour, tint the white paper around the circle, with its complementary colour, gradually weaker and weaker as the tint recedes from the coloured circle. These figures are principally intended to represent the effects of contrast in a palpable manner to those persons who, not having studied physics, yet have, nevertheless, an interest in knowing these effects.

The *Red* circle tends to colour the surrounding space with its complementary *Green*.

The *Green* circle tends to colour the surrounding space *Red*.

The *Orange*	"	"	"	*Blue*.
The *Blue*	"	"	"	*Orange*.
The *Greenish-Yellow*	"	"	"	*Violet*.
The *Violet*	"	"	"	*Greenish-Yellow*.
The *Indigo*	"	"	"	*Orange-Yellow*.
The *Orange-Yellow*	"	"	"	*Indigo*.

CHAPTER IV.

ON THE JUXTAPOSITION OF COLOURED SUBSTANCES WITH WHITE.

(44.) White substances contiguous to those which are coloured, appear sensibly modified when viewed simultaneously with the latter. I admit that the modification is too feeble to be determined with entire certainty, when we are ignorant of the law of contrast; but knowing that, and seeing the modification effected by the white upon certain coloured substances, it is impossible to avoid recognising this modification in its *speciality* if at the same time the colours opposed to the white are not too deep.

Red and White

(45.) Green, the complementary of Red, is added to the White. The Red appears more brilliant and deeper.

Orange and White

(46.) Blue, the complementary of Orange, is added to the White. The Orange appears brighter and deeper.

Greenish-Yellow and White

(47.) Violet, the complementary of Greenish-Yellow, is added to the White. The Yellow appears brighter and deeper.

Green and White

(48.) Red, the complementary of Green, is added to the White. The Green appears brighter and deeper.

Blue and White

(49.) Orange, the complementary of Blue, is added to the White. The Blue appears brighter and deeper.

Indigo and White

(50.) Orange-Yellow, the complementary of Indigo, is added to the White. The Indigo appears brighter and deeper.

Violet and White

(51.) Greenish-Yellow, the complementary of Violet, is added to the White. The Violet appears brighter and deeper.

Black and White

(52.) Black and White, which may in some respects be considered as complementary to each other, comformably to the *law* of Contrast of Tone, differ more from each other than when viewed separately: and this is owing to the effect of the white light reflected by the black (4.) being destroyed more or less by the light of the white stripe; and it is by an analogous action that White heightens the tone of the colours with which it is placed in contact.

CHAPTER V.

ON THE JUXTAPOSITION OF COLOURED SUBSTANCES WITH BLACK.

(53.) Before stating the observations to which the juxtaposition of coloured and black substances give rise, we must analyse the part the two contrasts—those of Tone and of Colour—perform in the phenomenon considered in its general bearing.

The black surface being deeper than the colour with which it is in juxtaposition, the Contrast of Tone must tend to deepen it still more, while it must tend to lower the tone of the contiguous colour, for the same reason, exactly, that White, on the other hand, if juxtaposed with it would heighten it. Thus much for Contrast of Tone.

(54.) Black substances reflect a small quantity of white light (4.), and this light arriving at the eye at the same time with the coloured light of the contiguous body, it is evident that the black substances must appear tinted with the complementary of the colured light: but the tint will be very faint, because it is manifested upon a ground having but a feeble power for reflecting light. Thus much for Contrast of Colour.

(55.) The lowering of the tone of a colour in contact with black is always perceptible; but a very remarkable fact is, the weakening of the black itself when the contiguous colour is sombre and of a nature that yields a luminous complementary, such as Orange, Orange-Yellow, Greenish-Yellow, &c.

Red and Black

(56.) Green, the complementary of Red , uniting with the Black, causes it to appear less reddish.

The Red appears lighter or less brown, less oranged.

Orange and Black

(57.) The complementary of Orange (*Blue*), uniting with the Black, the latter appears less rusty, or bluer.

The Orange appears brighter and yellower, or less brown.

Greenish-Yellow and Black

(58.) The complementary of Greenish-Yellow (*Violet*), uniting with the Black, the Black appears tinted Violet.

The Yellow is lighter,—greener perhaps; and there are some samples of Yellow which appear weaker by their Juxtaposition with Black.

Green and Black

(59.) The complementary of Green (*Red*), uniting with the Black, the Black appears more Violet or reddish.

The Green inclines slightly to Yellow.

Blue and Black

(60.) The complementary of Blue (*Orange*), uniting with the Black, the Black becomes brighter.

The Blue is lighter,—greener, perhaps.

Indigo and Black

(61.) The complementary of Indigo (*Orange-Yellow*), uniting with the Black, brightens it con-siderably.

The Indigo becomes brighter.

Violet and Black

(62.) The complementary of Violet (*Greenish-Yellow*), uniting with the Black, brightens it.

The Violet is more brilliant,—lighter,—redder, perhaps.

CHAPTER VI·

ON THE JUXTAPOSITION OF COLOURED SUBSTANCES WITH GREY.

(63.) If one of the principal causes that prevent our seeing the modifications which coloured bodies tend to impart to white bodies juxtaposed with them is, the brightness of the light reflected by the latter;—on the other hand, if the feeble light reflected by black bodies, is on the contrary, less favourable to our perception of the kind of modification they experience from the proximity of coloured bodies, particularly in the case where the complementary of the body is itself not very luminous, we may imagine that Grey bodies, properly selected with respect to height of tone, will, when they are contiguous to coloured substances, exhibit the phenomena of contrast of colour in a more striking manner than either black or white substances do.

Red and Grey

(64.) The Grey appears greener by receiving the influence of the complementary of Red.

The Red appears purer,—less orange, perhaps.

Orange and Grey

(65.) The Grey appears bluer by receiving the influence of the complementary of Orange.

The Orange appears purer, and brighter,—yellower, perhaps.

Yellow and Grey

(66.) The Grey appears inclining to Violet by receiving the influence of the complementary of Yellow.

The Yellow appears brighter, and less green.

Green and Grey

(67.) The Grey appears inclining to Red by receiving the influence of the complementary of Green.

The Green appears brighter,—more yellow, perhaps.

Blue and Grey

(68.) The Grey appears tinged with Orange, by receiving the influence of the complementary of Blue.

The Blue appears brighter,—greener, perhaps.

Indigo and Grey

(69.) The same as the above (68.).

Violet and Grey

(70.) The Grey appears tinged with Yellow, by receiving the influence of the complementary of Violet. The Violet appears purer, less tarnished.

(70bis.) The Grey used in the preceding experiments was as free as possible from all colouring matter foreign to black. It belonged to the scale of *normal black* (see 2nd Part, 164.), that is to say, it resulted from a mixture of black and white substances as pure as could possibly be obtained: in contact with white it rendered it lighter and apparently brighter, while juxtaposed with black, it heightened it, and made it appear lighter and more rusty.

(70.ter.) One rsult of the complementaries of colours juxtaposed with grey being more apparent than when these colours are juxtaposed with white or even with black, is, that if instead of a *normal grey* we juxtapose a tinted grey, either red, orange, yellow, &c., these tints will be singuarly heightened by the complementaries which will be added to them. For example, a bluish—grey will receive a very palpable exaltation of blue from its contiguity to orange, and a yellowish-grey will take a decided green tint from the same contiguity.

CHAPTER VII.

THE CHEMICAL COMPOSITION OF COLOURED SUBSTANCES HAS NO INFLUENCE ON THE PHENOMENA OF SIMULTANEOUS CONTRAST.

(71.) All the experiments I have made with the view of ascertaining if the chemical nature of bodies, when placed beside each other, has any influence on the modification of their colours, have, as I expected, led me to an absolutely negative conclusion. Whatever happened to be the chemical composition of the coloured substances, provided they were identical in colour, they gave the same results. I will cite the following examples:

Indigo or prussian—blue, cobalt, ultramarine, as nearly alike as possible, gave the same kind of modification.

Orange prepared with red lead, with annotto, or with the mixture of wood and madder, gave the same modification to the colours with which they were juxtaposed.

CHAPTER VIII.

ON THE JUXTAPOSITION OF COLURED SUBSTANCES BELONGING TO THE COLOURS OF THE SAME GROUP OF COLOURED RAYS.

(72.) Whenever there is a great difference between two contiguous colours, the different is rendered more appreciable by bringing the same colour sucessively in contact with different colours belonging to the same group. For example:

Orange and Red

When we place near Orange a scarlet-red, a pure red, or a crimson-red, we shall see that the Red acquires a purple, and the Orange a yellow tint.

Violet and Red

Analogous results are obtained with Violet placed in contact with scarlet-red, carmine-red, and crimson-red. The Violet always appears bluer, and the Red yellower, or less purple.

(73.) These observations clearly explain the cause of our obtaining results conformable to the formula, although we may have made use of coloured substances, such as stained papers or stuffs, which are far from exhibiting very pure colours.

(74.) The juxtaposition of coloured bands is a means of demonstrating the diffcuty of fixing the types of pure colours by our pigments, at least if we do not take into consideration the law of simultaneous contrast. For instance:

1. Take Red, and place it in contact with orange-red, the first will appear purple, and the second yellower, as I have before stated; but if we put the first Red in contact with a purple-red, this latter will appear bluer, and the other yellower, or orange; so that the same Red will appear purple in one case, and orange in the other.

2. Take Yellow, and place it near orange-yellow, it will appear greenish, and the other redder; but if we put the first Yellow in contact with a greenish-yellow, this latter will appear greener, and the former more orange; so that the same Yellow will incline to green in one case, and to orange in the other.

3. Take Blue, out it in contact with a greenish-blue; the first will incline to violet, and the second will appear yellower. Put the same Blue in contact with a violet-blue, the first will incline to green, and the second will appear redder, so that the same Blue will in one case appear violet, and in the other greenish.

(75.) Thus we preceive that the colours which painters term simple or primary, Red Yellow, and Blue, pass insensibly by their juxtaposition to the state of secondary or compound colours. Since the same Red becomes purple or orange, the same Yellow is orange or green, and the same Blue is green or violet.

CHAPTER IX.

ON THE APPLICATION OF THE LAW OF CONTRAST TO THE HYPOTHESIS, THAT RED, YELLOW, AND BLUE ARE THE ONLY PRIMARY COLOURS, AND THAT ORANGE, GREEN, INDIGO, AND VIOLET ARE SECONDARY OR COMPOUND COLOURS.

(76.) The experiments to which I have applied the principle of the modification that colours undergo by their juxtaposition, and the explanation which results therefrom, according to the manner in which we consider the physical composition of white light, are also clearly explained in the language used by painters and dyers, who only admit of three primary colours—red, yellow, and blue; and, as it may occur to many

persons, who, partaking of the same opinion, will, nevertheless, desire to understand the phenomena resulting from the juxtaposition of colours, I will now proceed to explain them in conformity with their language; and, for greater perspicuity, I will take five groups of juxtaposed colours, commencing with those which include the observations to which the preceding law most readily applies. I will suppose, then, that Orange is formed of red and yellow, Green of blue and yellow, and Indigo and Violet of blue and red.

FIRST GROUP—*Two Compound Colours having one Simple Colour for their Common Element.*

It is very easy to verify the law by observing two colours comprehended in this group. We see that by their reciprocal influence they lose more or less of the colour which is common to both. It is therefore evident that they will differ from each other in proportion to this loss.

1. Orange and Green.

These two colours having *Yellow* for a common element, lose some by juxtaposition: *the Orange will appear redder, and the Green bluer.*

2. Orange and Indigo.

These two colours having *Red* for a common element, lose some by juxtaposition: *the Orange appearing yellower, and the Indigo bluer.*

3. Orange and Violet.

The same as the preceding.

4. Green and Indigo.

These two colours having *Blue* for a common element, lose some by juxtaposition: *the Green appears yellower, and the Indigo redder.*

5. Green and Violet.

As the preceding.

SECOND GROUP—*A Compound Colour and a Simple Colour which is found in the Compound.*

1. Orange and Red.

The Orange loses its Red, and appears yellower; and the Red becomes more Blue, differing as much as possible from Orange.

2. Violet and Red.

Violet loses its redness, and appears bluer; the Red becomes yellow, differing as much as possible from Violet.

3. Indigo and Red.

The same as the preceding.

4. Orange and Yellow.

Orange loses some yellow, and appears redder; the Yellow becomes bluer, differing as much as possible from Orange.

5. Green and Yellow.

Green loses some yellow, and appears bluer; the Yellow becomes redder, and differs as much as possible from Green.

6. Green and Blue.

The Green loses some blue, and appears yellower; the Blue becomes redder, differing as much as possible from Green.

7. Violet and Blue.

The Violet loses some blue, and appears redder; the Blue becomes yellow, and differs as much as possible from Violet.

8. Indigo and Blue.

As the preceding.

THIRD GROUP—*Two Simple Colors.*

1. Red and Yellow.

Red, in losing yellow, appears bluer; and the Yellow, by losing red, appears bluer; or, in other words, *the Red inclines to Purple, and the Yellow to green.*

2. Red and Blue.

Red, in losing blue, will appear yellower; and the Blue, in losing red, will appear yellower; or, in other words, *the Red inclines to orange, and the Blue to green.*

3. Yellow and Blue.

Yellow, in losing blue, will appear redder; and Blue, in losing yellow, will appear more violet; or, in other words, *the Yellow inclines to orange, and the Blue to violet.*

FOURTH GROUP—*Two Compounds having the same Simple Colours.*

Indigo and Violet.

As Indigo only differs from Violet in containing a larger proportion of blue in comparsion to the red, it follows that the difference will be very considerably increased by the Indigo losing red and inclinging to a greenish-blue, whilst the Violet, acquiring more red, will incline to this colour. It is evident that if the Violet loses its red, or the Indigo gains it, the two colours will approximate; but as they differ from each other, the first-named effect will ensue.

We may further explain the preceding phenomena by considering Indigo, relatively to the Violet, as *blue;* then it will lose its blue, that being common to both colours, and incline to green, and the Violet, in also losing some blue, will appear redder.

FIFTH GROUP—*A Compound Colour and a Simple Colour which is not found in the Compound.*

1. *Orange and Blue.*
2. *Green and Red.*
3. *Violet and Greenish-Yellow.*

If we adopt the hypothesis that orange, green, indigo, and violet are *compound*, and red, blue, and yellow *simple* colours, it necessarily follows, that in opposing them in the order in which they are reciprocally complementary, and in supposing also that the colours thus in juxtaposition are perfectly free from any foreign colour, we cannot see any reason why the compound colour should lose one of its colours rather than the other, or why the simple colour should separate itself from one elementary colour rather than from the other. For example, in the juxtrposition of green and red, we can see no reason why the green should tend to blue rather than to yellow, or why the red should incline to blue rather than to yellow.

SECTION II.

ON THE DISTINCTION BETWEEN SIMULTANEOUS, SUCCESSIVE, AND MIXED CONTRAST OF COLOURS: AND ON THE CONNECTION BETWEEN THE EXPERIMENTS OF THE AUTHOR AND THOSE MADE PREVIOUSLY BY OTHER OBSERVERS.

CHAPTER I.

DISTINCTION BETWEEN SIMULTANEOUS, SUCCESSIVE, AND MIXED CONTRAST OF COLOURS.

(77.) Before speaking of the connection between my own observations and those of others, upon contrast of colours, it is absolutely necessary to distinguish three kinds of contrast.

The first includes the phenomena which relate to the contrast I name *simultaneous*;

The second, those which concern the contrast I call *successive*;

The third, those which relate to the contrast I name *mixed*.

(78.) In the *simultaneous contrast of colours* is included all the phenomena of modification which differently coloured objects appear to undergo in their physical composition and in the height of tone of their respective colours, when seen simultaneously.

(79.) The successive contrast of colours included all the phenomena which are observed when the eyes, having looked at one or more coloured objects for a certain length of time, perceive, upon turning them away, images of these objects, having the colour complementary to that which belongs to each of them.

(80.) I hope to prove by the details which I shall give in the following chapter, that in default of this distinction, one of the subjects of optics, the most fruitful in its applications, has not generally been treated with that precision and clearness necessary to impress its importance on those who, not making any observations of their own, have been contented with reading the result of my researches up to the year 1828, which I presented to the Academy of Sciences. In fact, the distinction of the three contrasts will render it easy to appreciate what new facts my researches add to the history of vision, and to the applications deduced from the study of contrasts. I shall also add, that Dr. Plateau, of Belgium, who has occupied himself for many years in reducing all these phenomena to a mathematical and physiological theory, has adopted the distinction of *simultaneous* and *successive* contrasts in his own writings.

(81.) The distinction of *simultaneous* and *successive* contrast renders it easy to comprehend a phenomenon which we may call the *mixed* contrast; because it results from the fact of the eye, having seen for a time a certain colour, acquiring an aptitude to see for another period the complementary of that colour, and also a new colour, presented to it by an exterior object; the sensation then perceived is that which results from this new colour and the complementary of the first.

(82.) The following is a very simple method of observing the *mixed* contrast.

One eye being closed, the right for instance, let the left eye regard fixedly a piece of paper of the colour A: when this colour appears dimmed, immediately direct the eye upon a sheet of paper coloured B; then we have the impression which results from the mixture of this colour B with the complementary colour (c) of the colour A. To be satisfied of this mixed impression, it is sufficient to close the left eye, and to look at the colour B with the right: not only is the impression that produced by the colour B, but it may appear modified in a direction contrary to the mixed impression C plus B, or, what comes to the same thing, it appears to be more A plus B.

In closing the right eye and regarding anew the colour B with the left eye, many times running, we perceive different impressions, but successively more and more feeble, until at last the left eye returns to its normal state.

(83.) If instead of regarding B with the left eye, which becomes modified by the colour A, we observe B with both eyes, the right eye being in the normal state, the modification represented by C plus B is found much weakened, because it is really C plus B plus B.

(84.) I advise every one who believes he has one eye more sensitive to the perception of colours than the other, to look at a sheet of coloured paper alternately with the left and with the right eye; if the two impressions are identical, he may be certain that he has deceived himself. But if the impressions ar different, he must repeat the same experiment many times in succession; for it may happen that the difference observed in a single experiment arises from one of the eyes having been previously modified or fatigued.

(85.) The experiment of which I speak appears to me to be particularly useful to painters.

I will now give some examples of *mixed contrast*.

(86.) The left eye having seen Red during a certain time, has an aptitude to see in succession *Green*, the complementary to Red. If it then looks at a Yellow, it perceives an impression resulting from the mixture of Green and Yellow. The left eye being closed, and the right, which has not been affected by the sight of Red, remaining open, it sees Yellow, and it is also possible that the Yellow will appear more Orange than it really is.

(87.) If the left eye had first seen the yellow paper, and afterwards the red, this latter would have appeared violet.

(88.) If the left eye first sees red, then blue, the latter appears greenish.

(89.) If it had first seen blue, then red, the latter would have appeared orange-red.

(90.) If the left eye first sees yellow, then blue, the latter appears blue-violet.

(91.) If it had first seen blue, then yellow, this latter would have appeared orange-yellow.

(92.) If the left eye first sees red, then orange this latter appears yellow.

(93.) If it had first seen orange, then red, the latter would have appeared of a violet-red.

(94.) If the left eye first sees red, then violet, the latter appears deep blue.

(95.) If it had first seen violet, then red, the latter would have appeared orange-red.

(96.) If the left eye first sees yellow, then orange, the latter appears red.

(97.) If it had first seen orange, then yellow, the latter would have appeared greenish-yellow.

(98.) If the left eye first sees yellow, then green, this latter would have appeared bluish-green.

(99.) If it had first seen green, then yellow, this latter would have appeared orange-yellow.

(100.) If the eye first sees blue, then green, this latter appears yellowish-green.

(101.) If it had first seen green, then blue, this latter would have appeared violet-blue.

(102.) If the eye first sees blue, then violet, this latter appears reddish-violet.

(103.) If it had first seen violet, then blue, the latter would have appeared greenish-blue.

(104.) If the eye first sees orange, then green, the latter appears greenish blue.

(105.) If it had first seen green, and then orange, this latter would have appeared of a reddish-orange.

(106.) If the eye had first seen orange, and then violet, the latter would have appeared blue-violet.

(107.) If it had first seen violet, and then orange, this latter would have appeared yellowish-orange.

(108.) If the eye first sees green, then violet, the latter will appear red-violet.

(109.) If it had first seen violet, then green, the latter would have appeared of a yellowish-green.

(110.) If the eye first sees red, then green, the latter will appear a little bluer.

(111.) If it had first seen green, then red, this latter would have appeared tinted violet.

(112.) If the eye first sees yellow, then violet, the latter will appear bluer.

(113.) If it had first seen violet, then yellow, this latter would have appeared greenish.

(114.) If the eye first sees blue, and then orange, the latter will appear yellower.

(115.) If it had first seen orange, then blue, the latter would have appeared a little more violet.

(116.) I must remark that all the colours (at least to my eyes) did not undergo equally intense modifications, nor were they equally persistent. For example, the modification produced by the successive view of yellow and violet, or of violet and yellow, is greater and more durable than that produced by the successive view of blue and orange, and still more so than that of orange and blue.

The modification produced by the successive view of red and green, of green and red, is less intense and less persistent.

Finally, I must remark that the *height of tone* exercises much influence upon the modification: for if, after having seen orange, we see dark blue, this latter will appear more green than violet, a contrary result to that presented by a lighter blue.

(117.) I thought that it was the more necessary to mention under a special name the phenomenon which I call *mixed contrast*, as it explains many facts remarked by dealers in coloured stuffs, and is of much incovenience to artists who, wishing to imitate exactly the colours of their models, work at them too long at a time to enable them to perceive all the tones and modifications. I will now state two facts which have been communicated to me by dealers in coloured fabrics, and I shall refer to PART II. for the application of the study of mixed contrast to painting.

(118.) *First Fact.*—When a purchaser has for a considerable time looked at a yellow fabric, and he is then shown orange or scarlet stuffs, it is found that he takes them to be amaranth-red, or crimson, for there is a tendency in the retina, excited by yellow, to acquire an aptitude to see violet, whence all the yellow of the scarlet or orange stuff disappears, and the eye sees red, or a red tinged with violet.

(119.) *Second Fact.*—If there is presented to a buyer, one after another, fourteen pieces of red stuff, he will consider the last six or seven less beautiful than those first seen, although the pieces be identically the same. What is the cause of this error of judgement? It is that the eyes, having seen seven or eight red pieces in succession, are in the same condition as if they had regarded fixedly during the same period of time a single piece of red stuff; they have then a tendency to see the complementary of Red, that is to say, Green. This tendency goes of necessity to enfeeble the brilliancy of the red of the pieces seen later. In order that the merchant may not be the sufferer by this fatigue of the eyes of his customer, he must take care, after having shown the latter seven pieces of red, to present to him some pieces of green stuff, to restore the eyes to their normal state. If the sight of the green be sufficiently prolonged to exceed the normal state, the eyes will acquire a tendency to see red; then the last seven red pieces will appear more beautiful than the others.

CHAPTER II.

ON THE CONNECTION BETWEEN THE AUTHOR'S EXPERIMENTS AND THOSE PREVIOUSLY MADE BY VARIOUS NATURAL PHILOSOPHERS.

(120.) BUFFON was the first who described, under the appellation of *accidental colours*,* several

*See *Mémoires de l' Académié des Sciences*, 1743.

phenomena of vision, all of which he considered to have this analogy, *that they result from too great vibration,* or *from fatigue of the eye;* wherein they differ from the colours with which bodies appear to us usually coloured,† whether these bodies decompose light by acting upon it by *reflection,* by *refractions,* or by *inflection.*

(121.) ACCIDENTAL COLOURS may arise from various causes; for example, they are perceivable under the following circumstances:

1. When the eye is pressed in the dark.

2. In consequence of a blow on the eye.

3. When the eyes are closed after having looked at the sun for a moment.

4. When the eyes are fixed upon a small square piece of coloured paper, placed upon a white ground; then the square, if *red*, will appear bordered with a faint green; if it is *yellow*, by a blue; if it is *green*, by a purplish white; if it is *blue*, by a reddish white; and if it is *black*, by a vivid white.

5. If, after having observed these phenomena for a considerable time, we turn our eyes to the white ground in such a manner as no longer to see the small of coloured paper, we shall then perceive a square of an extent equal to the other, and of the same colour as that which bordered the little square in the preceding experiment (4.)

(122.) I could mention several other circumstances in which Buffon observed accidental colours, but I should depart too widely from the principal object of this book, which is,—"the law of simultaneous contrast of colours and its application;" remarking, that the fourth circumstance in which Buffon observed accidental colours appertains to *simultaneous contrast,* while the fifth relates to *successive contrast.* Buffon never established the law which connects the phenomena he has described.

(123.) Scherffer, in 1754, gave great precision to the phenomena which relate to successive contrast, in demonstrrating *that a given colour produces an accidental colour,* the same we now call ITS COMPLEMENTARY. He also corrected some of the observations of Buffon; and, not content with that, he sought to explain tha cause of the phenomenon, as I shall show in the following section. He only briefly touched upon *simultaneous contrast.* (See his memoir,§ 15, *Journal de Physique,* tom. xxvi.)

(124.) (Oepinus* and Darwin● also occupied themselves with successive contrast.

(125.) Count Rumford‡ made simultaneous contrast an object of experiment and observation, which I must dwell upon, because, among the researches made on this subject, there is none which so much resemble mine. After observing that a shadow produced in a ray of coloured light, *red* for example, on being illuminated by a ray of *white* light equal in intensity to the red, the

shadow did not appear *white*, but was tinted *green*, the complementary of the red ray, when it was near an equal shadow produced in the white ray, this latter shadow being lighted by the red ray, and appearing of that colour, he demonstrated:

1. That the result is the same when the ray of coloured light is replaced by light transmitted through a glass or other coloured medium, or by coloured light reflected by an opaque coloured body.

2. That if in a circle of white paper, placed upon a large sheet of black paper laid upon the floor of a room, two bands of paper of six lines in width and two inches in length are laid side by side, one of which is covered with a powder coloured A, and the other with a grey powder composed of ceruse and lamp-black, in such proportions that the light reflected by it is of equal intensity to the coloured light A, upon looking with one eye through the hand at the two bands, that which is covered with the grey powder will appear tinged with the complementary colour of A, and this complementary of A will appear as brilliant as A itself.

(126.) The author remarks that, in order to ensure success in this experiment, we must take many precautions, not only to avoid the light reflected from surrounding objects, but also to obtain a grey capable of reflecting a light equal in intensity to the coloured light. He adds that the difficulties are very great if we use pigments ground in oil, which gives their colours a brown tinge, as they never possess the purity of the colours of the spectrum.

(127.) If it be true that the experiments of Rumford correspond with those which I have made with colours in connection with white, black, and grey, and that they form a particular instance of the law of simultaneous contrast, as I have established it, it is not less true that the law cannot be deduced without making the series of researches which I have undertaken; for the experiments of Rumford exhibiting the maximum of the phenomenon, we cannot affirm that under ordinary circumstances there would be not only a modification of white, black, and grey by juxtaposed colours, but also a mutual modification of these latter. We have seen that colours become deeper by being placed in contact with white, and that they become fainter when in contact with black, the contrast, as I have demonstrated, embracing both the optical composition of the colour and the height of its tone.

(128.) Struck by observing in his experiments that a coloured ray developed its complementary, Rumford laid it down as a *principle* in the harmony of two colours *that they must respectively present coloured light in the proportions necessary to form white light,* and he advised ladies to choose their ribbons in accordance with this law. He also thought that painters might derive much benefit from an acquaintance with this principle; but it is evident that Rumford's principle of the harmony of colours is nothing more than the production of an ingenious fancy, and that, as he has stated it, it would be difficult to make it throw any light upon the practice of painting. I shall return to this point, however, when treating of the applications of my theory. Meanwhile it is important to mention that

†We must add, *when viewed separately.*

Mémoires de l Académie de Pétersbourg, et journal de Physique, année 1785, tom. xxvi. p. 291.

●*Philosophical Transactions,* vol. l xxxvi., for 1785.

‡*Experiments upon Coloured Shadows, on the Principles of the Harmony of Colours,* &c., in Philosophical Papers, &c., by Count Rumford, London, 1802, vol. i.

Rumford never made an experiment suitable for demonstrating the influence of two contiguous colours, or rather of two colours viewed simultaneously; he was unacquainted with the generality of the phenomenon, of which he had observed one fact; and if it be true that there is a harmony between two colours complementary to each other, this proposition will be entirely incorrect, if, with Count Rumford, we only admit of harmony of colours in the single instance of juxtaposition. I shall return to this subject (174., &c.).

(129.) The last author who, as an observer, has treated of accidental colours is M. Prieur de la Côte-d'Or.* Under the term *contrast*, he has treated of phenomena which belong exclusively to *simultaneous contrast*. For example, a small band of orange-coloured paper when laid upon a yellow ground appears red; while it will appear yellow upon a red ground. According to the principle laid down by M. Prieur, the accidental colour of the little band should be that which results from its own colour, minus that of the ground. *It appears*, says he, *that a certain fatigue of the eye, produced instantaneously by the itensity of the light, or more slowly by prolonged vision, concurs in producing that appearances.* But he recognised *that excessive fatigue of the organ would cause a degeneration of the colours belonging to another scale.* And he finally adds, *that the colours named accidental by Buffon, and upon which Scherffer has given an intersting memoir, belong to the class of contrasts, or at least constantly follow the same law.* It is plain that M. Prieur has not made that distinction between the classes of contrasts which I have established in the preceding chapter.

(130.) Haüy, in his *Traité de Physique*, reviews the observations of Buffon, Scherffer, Rumford, and Prieur; but notwithstanding the lucid style of the illustrious founder of crystallography, there is an obscurity which arises from the fact that he has not observed the preceding distinction, and this obscurity is particularly evident when he relates the explanations previously given of these phenomena, as I shall show in the following section.

(131.) According to what has been said, we see,

1. That the authors who have treated of contrast of colours have described two classes of phenomena, without distinguishing one from the other:

2. That Scherffer has given the law of *successive* contrast:

3. The Count Rumford has given the law of the modification experienced in a particular instance by a grey band placed beside a coloured one:

4. The Scherffer first, and subsequently M. Prieur de la Côte-d'Or, with more precision, have given the law of the modification which a small white or coloured surface experiences from the different colour of the ground upon which it is placed.

(132.) But if it be true, that in this case we perceive in the most striking manner the modification which the colour of the small extent of surfce is susceptible of receiving from that of the ground, we cannot, on the other hand, appreciate the modification experienced in the colour of the ground from that of the small surface, because we see only half of the phenomena, and we should greatly err were we to think that a coloured object cannot be modified by the colour of another, unless it is much larger than the first. The manner in which I have arranged the coloured objects in my observations on simultaneous contrast has enabled me to show:

1. That it is not indispensably necessary to the modification of one colour by another, that the first should be of greater extent than the second, since my observations have been made upon equal and merely contiguous bands.

2. That we may judge accurately of the modifications experienced by contiguous bands, by comparing them with those which are not contiguous; a condition which enables us to see the phenomenon of simultaneous contrast in the most perfect manner, and to establish its *general law*.

3. That in increasing the number of bands not in contact, or which are placed on each side of those which do touch, we see, when the eye is sufficiently distant from the two series of bands, that the influence of one of the contiguous bands is not limited to the next band in contact with it, but that it extends also to the second, and to the third, &c., although fainter in each. *Now, this influence of distance should be noted*, in order to obtain a correct idea of the generality of the phenomenon, and of the applictions which may be deduced from the law which comprehends every case.

* *Annales de Chimie*, tom. liv. p. 5.

SECTION III.

ON THE PHYSIOLOGICAL CAUSE TO WHICH THE PHENOMENA OF CONTRAST OF COLOURS WERE REFERRED, PREVIOUSLY TO THE EXPERIMENTS OF THE AUTHOR.

(133.) SCHERFFER has given a physiological explanation of successive contrast of colours, which appears satisfactory in the cases to which it has been applied. It is based upon the following proposition, that—

If one of our senses receives a double impression, one of which is vivid and strong but the other feeble, we do not perceive the latter. This occurs particularly then they are both of the same kind, or when the powerful action of an object upon one the senses IS FOLLOWED *by another of the same nature, but infinitely weaker or less violent.*

Let us now apply this principle to the three following experiments on Successive Contrast.

FIRST EXPERIMENT.

Look for some time at a small white square placed upon a black ground.

Ceasing to look at this, and directing the eye upon the black ground, we there perceive the image of a square, equal in extent to the white square, but, instead of being brighter than the ground, it is, on the contrary, darker.

Explanation.

The portion of the retina upon which the white light of the square acted in the first part of the experiment, is more fatigued than the remainder of the retina, which has received only a feeble impression from the faint rays reflected by the black ground; the eye being then directed upon the black ground during the second part of the experiment, the feeble light of this ground acts more strongly upon that part of the retina which has not been fatigued, than upon that part which has been: hence the image of the black square seen by that portion of the eye.

SECOND EXPERIMENT.

Look for some time at a small blue square on a white ground.

Turn the eye away from this, and fix it upon the white ground, it then perceives the image of an orange square.

Explanation.

The portion of the retina on which the light of the blue square acted in the first part of the experiment being more fatigued by this colour than the rest of the retina, it happens, during the second portion of the experiment, that the portion of the retina fatigued by the blue is disposed thereby to receive a stronger impression of orange, the complementary of blue.

THIRD EXPERIMENT.

Look for some time at a red square on a yellow ground.

Turning the eye away, fix it upon a white ground, it perceives the image of a green square on a blue-violet ground.

Explanation.

During the first part of the experiment that portion of the retina which sees red become fatigued by this colour, while the portion which sees yellow during tha latter portion os equally fatigued; consequently, in the second part of the experiment, the portion of the retina which had seen red now sees green, its complementary, whilst that portion which had seen yellow, sees blue-violet, its complementary.

(134.) These three experiments, as well as their explanations, taken at random from the memoir by Scherffer, amongst a great many others analogous, will suffice, I think, to demonstrate that it was actually the phenomenon of *successive contrast* which specially occupied that ingenious observer. Considering this, it is surprising that Haüy, in endeavouring to make known the explanation of Scherffer, should have spoken exclusively of a case of *simultaneous contrast*, a phenomenon which the latter philosopher has only casually mentioned, as I remarked above (123.). Moreover, this is Haüy's mode of expressing himself on the subject, taking as an illustration the case in which a small band of white paper is placed upon red paper—

"We may," says he, "consider the white of this band as being composed of a bluish-green and red. But the impression of the red colour, acting with much less force than that produced by the surrounding colour of the same kind, is eclipsed by the latter, so that the eye is only sensible of the impression of the green, which being, as it were, foreign to the colour of the ground, acts upon the organ with all its power."*

(135.) Although this explanation appears to be a natural consequence of the principle set forth by Scherffer, yet this philosopher does not appear to me to have applied it to the explanation of *simultaneous contrast*, and the passage in his memoir, quoted above (133.), is very clear:

"This must principally take place when they (the impressions) are both of the same kind, or when the powerful action of an object on one sense *is followed* by another of the same nature, but much weaker, and less violent."

*Traité de Physique, 3ᵉ édition, tom. ii. p. 272.

(136.) Now let use see what difference exists between Scherffer's explanation of *successive contrast*, and that attributed to him by Haüy in the case of *simultaneous contrast*. All the observations on successive contrast explained by Scherffer exhibit this result,—that the portion of the retina, which in the first part of the experiment is impressed by a given colour, sees in the subsequent part of the observation, the complementary of the given colour, and this new impression is independent of the extent of the coloured object relatively to that of the ground on whch it is placed, or rather, of the objects surrounding the former.

(137.) This is not expressed in the explanation that Haüy attributes to Scherffer; in fact—

1. The portion of the retina that sees the white band placed on a red ground, sees it of a bluish-green, that is to say, of the complementary colour of the ground. Now, according to the experiments of Scherffer, this portion, fatigued by white light, *has a tendency to see, not bluish-green, but black,* which is, in a manner, the complementary of white.

2. For, to admit the explanation attributed to Scherffer, it would be necessary that the object whose colour is modified by that of another, should in general be of much smaller extent than the latter, since it is only by this excess of extent in the modifying body that we can conceive *in general* this excess of action which neutralises a part of that of the first object; I say, in general, because there are cases where it maybe said that a much brighter colour might modify another, although it occupied a very small space around it. To resume, we perceive the difference between the explanation Scherffer has given of *successive contrast*, and that of *simultaneous contrast*, attributed to him.

(138.) If we revert to this last experiment in order to test its value—no longer under the circumstances related by these authors, of a small band appearing to be modified only when seen on a ground—but in those where two bands of equal extent are mutually modified, not only when in contact, but when at a distance, as is shown by the result of my experiments—we may readily appreciate the difficulty thus:

1. Let us suppose that the figure 4, Plate 3., represents the image depicted on the retina of a red band R, contiguous to a blue band B; the first will acquire green or lose red. Now, it is the portion of the retina on which the image of the band R is impressed, which, according to the opinion of Scherffer, will lose its sensibility for red, as it is the portion of the retina on which is depicted the image of the band B that will lose its sensibility for blue: consequently, I do not perceive how it can be the part R which in reality loses its sensibility for blue, or how it can be the part B which loses its sensibility for red.

2. In my experiments, the coloured bands being of equal extent, there appears no reason in general (as in the case where a small band being placed upon a ground of large extent), that one of the bands should modify the other, by the greater fatigue it may occasion the retina.

(139.) It was doubtless owing to the difficulties presented in the explanation we have examined, that

the illustrious author of the *Mécanique Céleste* was led to suggest another, which Haüy inserted in his *Traité de Physique* after that which he attributes to Scherffer. The case is still that of a small white band placed upon a red ground. The illustrious geometrician supposed, says Haüy, "that there exists in the eye a certain disposition, in virture of which the red rays forming the predominating red colour of the ground, so that the two impressions form only one, and that of the green colour is enabled to act as if it were alone. According to this method of understanding the subject, the impression of the red decomposes that of the white, and while the actions of the homogeneous rays unite together, the action of the heterogeneous rays, being disengaged from this combination, produces its separate effect."*

(140.) I shall not contest the accuracy of this explanation beyond remarking, that it admits implicity, as a necessary consequence, that the modifying colour occupies a greater extent of surface than the colour modified: but it is probable that such an opinion would not have been given if the illustrious author had been acquainted with the true explanation of Scherffer on successive contrast, and instead of quoting a single experiment of simultaneous contrast, which does not include more than half the phenomenon, and quoted one in which differently coloured bands of equal extent were seen to modify each other, even when not in contact.

(141.) After having shown the insufficiency of these explanations of *simultaneous contrast*, it only remains to speak of the relations which appear to me to exist between the organ of vision and this phenomenon observed in the circumstances under which I have studied it. Every author who has treated of accidental colours, agrees in considering them being the result of fatigue of the eye. If this be incontestably true in the case of *successive contrast*, I do not believe it to be so of *simultaneous contrast*; for, in arranging the coloured bands in the manner I have done, as soon as we succeed in seeing all four together, the colours are observed to be modified before the eye becomes in the least degree fatigued; although I admit that it often requires several seconds to perceive these modifications. But is not this *time* necessary, as is that which is given to the exercise of each of our senses, whenever we wish to explain to ourselves a sensation that affects them? There is, also one circumstance that explains the necessity of *this time* in many cases, viz.: the influence of the white light reflected by the surface modified—which is sometimes sufficiently strong to greatly weaken the result of the modification; and the greater part of the precautions suggested for seeing the accidental colours of simultaneous contrast are therefore directed to the diminution of this white light.

Moreover, it is owing to this cause that grey and black surfaces contiguous to surfaces of very pure colours, such as blue, red, yellow, are modified more by this contiguity than white surfaces are. The following experiment, accidentally presented to my notice, will give a good illustration of my idea. A coloured paper,

*Traité de Physique, 3ᵉ édition, tom. ii. p. 272.

upon which letters of a pale grey had been traced, was presented to me one evening at twilight: On first looking at it, I could not distinguish a single letter; but in few minutes I contrived to read the writing, which appeared to me to have been traced with an ink of a colour complementary to that of the ground. Now, I ask, if at the moment when my vision was distinct, were my eyes more fatigued than when I first looked at the paper without being able to distinguish the letters upon it, and which were seen to be of the colour complementary to that of the ground?

(142.) Finally, I conclude from my observations, that whenever the eye sees two differently coloured objects simultaneously, the analogous character of the sensation of the two colours undergoes such a diminution, that the difference existing between them is rendered proportionably more sensible in the simultaneous impression of these two colours upon the retina.

PART II.

PART II.

ON THE PRACTICAL APPLICATION OF THE LAW OF SIMULTANEOUS CONTRAST OF COLOURS.

INTRODUCTION

(143.) The observations set forth in the First Part, togehter with the Law of Simultaneous Contrast, which simplifies by generalising them, have doubtless suggested to the reader the numerous applications of which they are susceptible. This expection, I hope, will not be disappointed by the details into which I am now about to enter—details which will prove that this work would not have attained to its aim of usefulness if I had neglected to exhibit them; for, to state them with the precision they possess, it is incumbent on me to give a series of observations altogether as precise as those which form the materials of the First Part.

(144.) The following is a tabular arrangement of the applications I propose making:

FIRST DIVISION

Imitation of Coloured Objects by means of Coloured Materials in a State of Infinite Division.
1st Section.—Painting in Chiar'oscuro.
2nd Section.—Painting in Flat Tints.
3rd Section.—Colouring.

SECOND DIVISION

Imitation of Coloured Objects by Coloured Materials of a certain Size.
1st Section.—Gobelins Tapestry.
2nd Section.—Beauvais Tapestry.
3rd Section.—Savonnerie Tapestry.
4th Section.—Carpets.
5th Section.—Mosaics.
6th Section.—Stained Glass.

THIRD DIVISION.

Printing
1st Section.—Printing Designs upon Textile Fabrics, Calico—Printing, &c.
2nd Section.—Printing Designs upon Paper, Paper-hangings, Paper-staining.
3rd Section.—Printing with Types upon Coloured Paper.

Prolegomena.

(145.) Before entering upon the details of these applications, I think it necessary to offer some remarks as a prolegomena to the Second Part of this Work. They will enable me to establish several propositions or principles to which I shall frequently refer the reader, and thus avoid repetitions which give rise to the objection of apparently diminishing the amount of generalisation the work really possess.

I shall give successively:

1. The definitions of many expressions applicable to colours and to their modifications:

2. The means of representing and defining these colours and their modifications by the aid of a graphic construction or diagram:

3. A classification of the Harmonies of Colours:

4. A view of the associations of the prismatic colours with White, Black, and Grey.

§1.

DEFINITION OF THE WORDS TONES, SCALES, AND HUES.

(146.) The words TONES and HUES (*nuances*) continually occur whenever colours are mentioned, both in common language as well as in that of artists; nevertheless they are not so well defined but that when either of them is used we are sure the other is not meant.

(147.) Feeling the necessity of being able to distinguish the case where one colour—BLUE, for example—is reduced with *White*, or deepened with *Black*, from that where this same colour is modified by another,—for instance, where BLUE is modified by Yellow or Red, added in such small quantities that the BLUE still being *blue*, yet differs from what it was before the addition of Yellow or Red in being Violet or Green, I premise that in the course of this work I never apply indifferently the words Tone and Hue to these two kinds of modifications; consequently,

(148.) The word TONES of a colour will be exclusively employed to designate modifications which that colour, taken at its maximum intensity, is capable of receiving from the addition of White, which weakens its *Tone*, and Black, which deepens it.*

(149.) The word SCALE (*gamme*) is applied to the collection of Tones of the same colour thus modified. The pure colour is the normal time of the scale, if this normal tone does not belong to a broken or reduced scale; *i.e.* to a scale all the tones of which are altered with Black (153.).

(150.) The word HUES (*nuances*) of a colour will be exclusively applied to the modifications which that colour receives by the addition of a small quantity of another colour.

For example, we say, the Tones of the *Blue* Scale, the Tones of the *Red* Scale, the Tones of the *Yellow* Scale, the Tones of the *Violet* Scale, the Tones of the *Green* Scale, the Tones of the *Orange* Scale.

We say Hues of Blue, to designate all the Scales the colour of which, still remaining Blue, yet differs from pure Blue; for each hue will comprehend in itself the tones which constitute a Scale more or less allied to the Blue Scale.

In the same sense we say, *hues*, of Yellow, *hues* of Red, *hues* of Violet, *hues* of Green, *hues* of Orange.

(151.) I have defined TONES (tints and shades) of a colour, the different modifications which this colour, taken at its *maximum of intensity*, it susceptible of receiving from Black or White: it must be remarked that the condition of *the colour taken at its maximum of intensity for receiving Black* is absolutely essential to this definition, for, if Black is added to a Tone which was below the maximum, it passes then into another Scale; and this is the proper place to remark that artists distinguish Colours as *pure, broken, reduced, grey, or dull.*

(152.) The *pure colours* comprehend those which are called *Simple* or *Primary*, Red, Yellow, Blue,— and those which result from their binary compounds, *Secondaries*,—Orange, Green, Violet, and their Hues.

(153.) The *broken colours* comprehend the pure colours mixed with Black, from the highest to the deepest Tone.

From these definitions, it is evident that in all the Scales of simple and binary colours the Tones which stand above the pure colour are *broken Tones*.

(154.) Artists, and particularly painters and dyers, admit that the mixture of the three primary colours in certain proportions produces *Black*, from which it becomes evident that whenever we mix these three colours in such proportions that two of them

*The author employs only one word to explain both these modifications, whereas in English we have two—*Tint* and *Shade*:—by the former, we understand the White is added to a normal colour; by the latter, we recognise the addition of Black to similar colour. To avoid confusion, the author's term *Tones* is retained in the translation.

predominate, Black will result; arising from the mixture of the whole of that colour which is in small quantity with suitable proportions of the two predominant colours.

Thus, if a small proportion of Blue is added to Red and Yellow, a little Black is produced, which goes to reduce or *break* the Orange.

(155.) We must not overlook the fact, that whenever we mix pigments to represent primary colours, we are not mixing the colours of the solar spectrum, but mixing substances which painters and dyers employ as Red, Yellow, and Blue colours.

§2

REMARKS UPON CERTAIN GRAPHIC CONSTRUCTIONS PROPOSED FOR THE REPRESENTATION AND DEFINITION OF COLOURS AND THEIR MODIFICATIONS.

(156.) Several graphic constructions have been proposed, under the denomination of Tables, Scales, Colour-circles, Chromatometers, &c., for the purpose of representing, either by numbers or by a rational nomenclature, colours and their various modifications. They are generally based upon the three following propositions:

1. There are three primary colours,—Red, Yellow, and Blue.

2. Equal parts of any two of these colours mixed together yield a pure secondary colour.

3. Equal parts of the three primary colours mixed together yield Black.

(157.) It is easy to demonstrate that the last two propositions are purely hypothetical, since they cannot be demonstrated by experiment. In fact,

1. We know of no substance which represents a primary colour,—*i.e.* which reflects but one class of coloured rays, whether pure Red, Blue, or Yellow (7.).

If we take Ultramarine for the purest Blue, it may be objected that is it not *pure*, since it also reflects Red and Violet rays as well as Blue rays.

2. From the impossibility of procuring materials of pure colours, how can it be said that Orange, Green, and Violet are composed of two simple colours mixed in equal portions? How can it be asserted that Black consists of the three simple colours mixed in equal portions?

And in this place we may also remark, that the constructors and these chromatic tables, &c., when they come to apply them, only point out mixtures which, to use their own words, do not produce the results that ought to be deduced from their pretended principles.

(158.) We cannot fail to recognise that the greater part of the substances coloured Blue, Red, or Yellow, with which we are acquainted, on being mixed with each other, only produce Violets, greens, and Oranges, inferior in brilliancy and purity of those coloured materials which are found in nature of a pure Orange, Violet, or Green colour. A result which would explain itself if they admitted with us that each of the coloured materials mixed together reflects at least two kinds of coloured rays; and if it is admitted with painters and dyers, that when there is a mixture of materials which separately reflect Red, Yellow, and Blue, there is also produced a small portion of Black, which tarnishes the brilliancy of the mixture. Conformably to this view, it is also certain, that the Violets, greens, and Oranges, resulting from a mixture of coloured materials, are much more brilliant when the respective colours of these materials approach each other. For example:

When we mix Blue and Red to form Violet, the result will be better if we take a Red *tinged with Blue*, and a Blue *tinged with Red*, than if the Red or the Blue inclined to Yellow; in like manner a Blue tinged with Green, mixed with a Yellow, will yield a purer Green than if Red formed a portion of either colour.

(159.) In order to represent all the modifications which I call *Tones* and *Hues of Colours*, as well as the relations which exist between those which are complementary to each other, I have devised the following diagram, which appears to me remarkable for its simplicity.

From a centre, *c*, I describe two circumferences, Y, *y*, Plate 2., and divide each of them by means of three radii, *c a*, *c b*, *c d*, into three arcs of 120 degrees each.

The portion of each radius contained between the two circumferences Y, *y*, I divide into twenty parts, which represent so many tones of the colours Red, Blue, and Yellow.

(160.) In each of the scales of these three colours, there is one tone which, when pure, represents in its purity the colour of the scale to which it belongs: therefore I name it the *normal tone of this scale.*

If we present a unit of the surface *s* covered entirely with the pigment which reflects the normal colour, and if we suppose that this pigment is on the surface in a quantity equal to 1, we can represent the tones *above* the normal tone by the unit of surface covered with 1 of the normal colour *plus* Black, in quantities which increase with the number of the *tones* (shades), and we can represent the tones *below* the normal tone by the unit of surface covered with a fraction of the quantity 1 constituting the normal tone mixed with quantities of White, increasing as the tone is of a lower number; and which contains more White the smaller the number indicated on the tone.

If the tone 15 of the Red scale is the normal tone, the normal tone of the Yellow scale will be a lower number, while the normal tone of the Blue scale will be of a higher number. This depends upon the unequal degree of brilliancy or luminousness of the colours.

(161.) If we divide each arc of 120 degrees into two of 60 degrees, and carry these points of division from the circumference to the centre *y*, and divide these radii into twenty parts, commencing at *y*, it will represent twenty tones of the scales of Orange, of Green, and of Violet; and I may remark, that the colours which lie at the extremity of each diameter are *complementaries* of each other.

It would be easy to divide each arc of 60 degrees into arcs of 30 degrees, and so obtain radii upon which might be represented twenty tones of scales, which I shall name Red-Orange, Orange-Yellow, Yellow-Green, Green-Blue, Blue-Violet, Violet-Red.

By dividing each arc in five, for example, and drawing five radii, which I will divide into twenty parts each, setting out from the circumference Y, we obtain

sixty new scales.

(162.) Commencing with Red, I shall designate them as follows:

a. Red.	e. Yellow.	i. Blue.
1—Red.	1—Yellow.	1—Blue.
2—Red.	2—Yellow.	2—Blue.
3—Red.	3—Yellow.	3—Blue.
4—Red.	4—Yellow.	4—Blue.
5—Red.	5—Yellow.	5—Blue.

b. Red-Orange.	f. Yellow-Green.	k. Blue-Violet.
1—Red-Orange.	1—Yellow-Green.	1—Blue-Violet.
2—Red-Orange.	2—Yellow-Green.	2—Blue-Violet.
3—Red-Orange.	3—Yellow-Green.	3—Blue-Violet.
4—Red-Orange.	4—Yellow-Green.	4—Blue-Violet.
5—Red-Orange.	5—Yellow-Green.	5—Blue-Violet.

c. Orange.	g. Green.	l. Violet.
1—Orange.	1—Green.	1—Violet.
2—Orange.	2—Green.	2—Violet.
3—Orange.	3—Green.	3—Violet.
4—Orange.	4—Green.	4—Violet.
5—Orange.	5—Green.	5—Violet.

d. Orange-Yellow.	h. -Blue.	m. Violet-Red.
1—Orange-Yellow.	1—Green-Blue.	1—Violet-Red
2—Orange-Yellow.	2—Green-Blue.	2—Violet-Red
3—Orange-Yellow.	3—Green-Blue.	3—Violet-Red
4—Orange-Yellow.	4—Green-Blue.	4—Violet-Red
5—Orange-Yellow.	5—Green-Blue.	5—Violet-Red

I do not attach any importance to this nomenclature, but employ it merely as being the simplest to distinguish the seventy-two scales of which I have spoken. We may augment the number indefinitely, by inserting as many as we choose between those already designated.

(163.) Let us now represent the gradation of each of the colours of the scales in the circle by the addition of *Black*, progressively increasing in quantity until we arrive at pure black.

To this end, let us imagine a quadrant the radius of which is equal to that of the circle, and disposed so as to turn upon an axis perpendicular to the centre of the circle. Divide this quadrant:

1. By concentric arcs, Y, y, which coincide with the circumference of the circle marked by the same letters.

2. By ten radii, 1, 2, 3, 4, 5, 6, 7, 8, 9, 10.

Divide each of these radii into twenty parts, representing twenty tones corresponding with each of the tones of the scale represented on the circle.

(164.) I suppose that the tenth radius comprises the gradations of normal Black, which is supposed to envelop the hemisphere described by the motion of the quadrant upon its axis: this Black, mixed in decreasing quantities with increasing quantities of White, gives the twenty tones of normal Grey, which ends by melting into White, situated above the first tone. I suppose also that the normal tone of each of the scales taken upon the radii of the quadrant, 1, 2, 3, 4, 5, 6, 7, 8, 9, is formed of a mixture of Black with the colour of any one of the scales contained in the circle— for example, of the Red scale,—and is such proportion that the normal tone 15 of this scale being represented by a unit of surface covered with 1 or 10/10 of Red,

The tone 15 of the scale of the 1st radius of the quadrant=9/10 Red +1/10 Black
The tone 15 of the scale of the 2nd radius of the quadrant =8/10 Red +2/10 Black
The tone 15 of the scale of the 3rd radius of the quadrant =7/10 Red +3/10 Black
The tone 15 of the scale of the 4th radius of the quadrant =6/10 Red +4/10 Black
The tone 15 of the scale of the 5th radius of the quadrant =5/10 Red +5/10 Black
The tone 15 of the scale of the 6th radius of the quadrant =4/10 Red +6/10 Black
The tone 15 of the scale of the 7th radius of the quadrant =3/10 Red +7/10 Black
The tone 15 of the scale of the 8th radius of the quadrant =2/10 Red +8/10 Black
The tone 15 of the scale of the 9th radius of the quadrant =1/10 Red +9/10 Black

It is understood that these proportions relate to the effect of the mixtures upon the eye, and not to material quantities of the Red and Black substances.

(165.) We see then:

1. That each of these tones 15, composed of Colour and Black, reduced by White and deepened by Black, gives a scale of twenty tones, the more broken the nearer they approach the scale of normal black.

2. That the quadrant, by its motion on the axis of the circle, represents the scales of every other colour besides red, broken with black. These broken scales are equidistant, and each of formed of equip-distant tones.

3. That every colour is thus included in an hemisphere, the circular plane of which comprises the pure colours, the central radius, black and intermediate space, and the pure colours broken by different proportions of black.

(166.) Let us now return to the hemispheric construction, as described, and see the advantages it possesses for representing the reduction of pure colours by white, their gradation by black, and their modifications by mutual mixture comprising the modification of hues and of breaking: let us now examine the possibility of realising them by means of coloured materials.

(167.) To establish the hemispheric construction, we have supposed:

1. That the normal tone of each of the scales comprised in the circular plane is *visually* as pure as possible.

2. That the tones bearing the same number in all the scales, both the pure as well as the broken tones, are *all visually* of the same height.

3. That, if we take three tones of the same number in three consecutive scales, the tone of the intermediate scale is the mean of the colours of the extreme scales.

Consequently, upon these suppositions, it is easy to explain the modifications of a pure colour in departing from its normal tone.

(168.) These modifications are produced in the following manner:

1. *The pure colour goes not out of its scale.*

In this case the modification is in the direction of the radius of the circle; in going from the normal tone towards the centre it takes white, whilst in going from the normal tones towards the circumference it takes black.

2. *The pure colour goes out of its scale by the addition of black.*

Opposite page:
PLATE 2. Chevreul describes and illustrates a well balanced color circle of 72 hues, and a color hemisphere in which he assumed a general world of key colors, tints, shades and tones might be charted. See (156.) and following paragraphs.

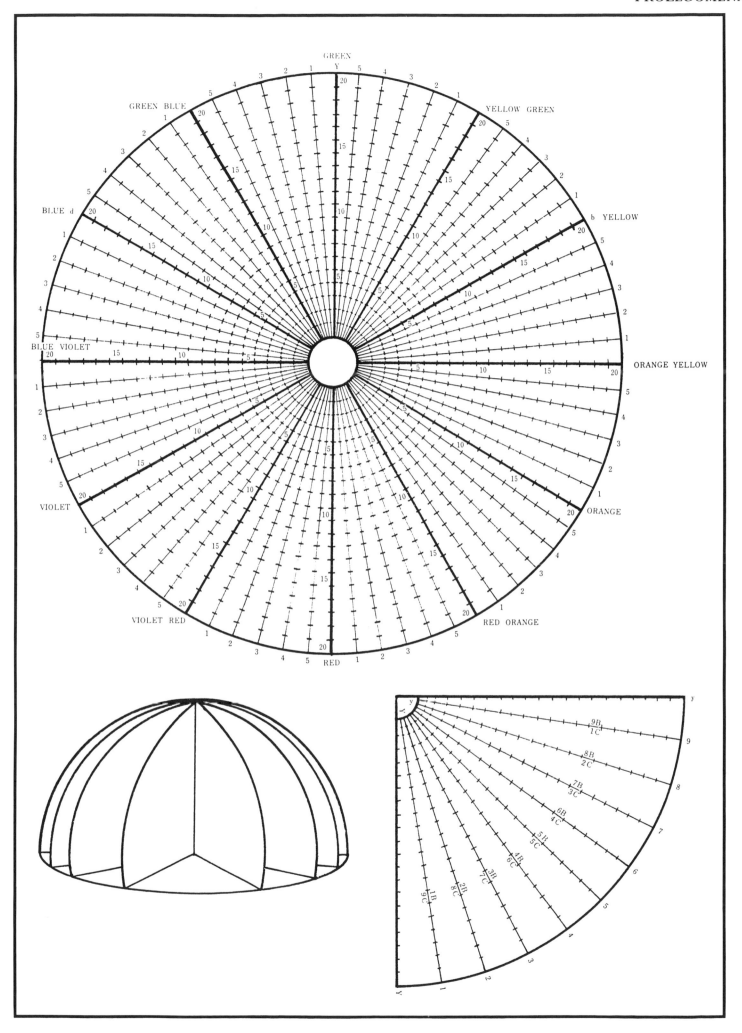

In this case all the normal tones of the different scales compromised in the quadrant perpendicular to the circle have for a starting-point the normal tone of one of the pure scales of the circle with which the quadrant coincides. This normal tone, resulting from a quantity of coloured material represented by unity, covering a unit of surface *s*, the normal tones of the quadrant result from the mixture of black with a fraction of a unit of the coloured matter. These mixtures compose broken colours, each of which covers the unit of surface *s*, and which are at the same height as the normal tone of the pure colour. The fraction of the quantity of coloured material is smaller in all the normal broken tones, the nearer the scales to which these tones belong approach the vertical axis of the hemisphere.

Besides, each normal tone of the scales of the quadrant is modified, like the normal tones of the scales of the circle, by quantities of white increasing towards the centre, and quantities of black increasing towards the circumference.

3. *The pure colour is modified by the addition of another pure colour.*

In this case it forms hues more and more approaching itself, according as the quantities of the second colour are in smaller proportion.

These modifications are made circularly and in such a manner that the tones retain their numbers.

(169.) Thus, if we admit, with painters and dyers, that there are only three primary colours, and that, in combining them in pairs, we obtain all the pure compound colours, and that by combining them in threes, we produce all the broken colours, we perceive how it is possible, under this hypothesis, to represent by the hemispherical construction every modification of colour.

(170.) Another advantage this diagram possesses is that it gives to painters, dyers, decorators, in a word, to all artists who can apply the law of simultaneous contrast, the complementaries of every pure colour, because the colours which are found at the extremities of the same diameter of the circular plane are complementaries of each other. For example, we do not only see that Red and Green, Yellow and Violet, Blue and Orange, are upon the same diameter; but we see also that it is the same with Orange-red and Blue-green, with Orange-yellow and Blue-violet, with Yellow-green and Violet-red, with No.1. Red and No.1. Green,in the same manner all colours opposite to each other are mutually complementary.

(171.) Once we know the complementary of a colour in juxtaposition with another, it is easy, according to the principle of mixing, to determine the modification which the second must receive from the first, since this modification is the result of the mixture of the complementary with the colour juxtaposed. In fact, if there is no difficulty to meet, when the result is that of a mixture *non*-complementary to a simple colour—red, yellow, and blue with a binary, orange, green, and violet (it being understood that we now speak the language of painters) (76.), there is really no greater difficulty when the result is a mixture of two binary colours; because it is sufficient to remark that the complementary being much less intense than the colour with which it is mixed, the result is given if we subtract from the latter binary that portion of its simple colour, which, with the complementary, forms white, or, what amounts to the same thing, neutralises it.

EXAMPLES.

1. Orange added as a complementary to Green neutralises a part of the Blue of this latter, and consequently makes it appear less Blue or more Yellow.

2. Orange added as a complementary to Violet neutralises a portion of the Blue of the latter, and consequently makes it appear less Blue or more Red.

3. Green added as a complementary to Violet neutralises a portion of the Red of this latter, and consequently makes it appear less Red or more Blue.

These three examples, derived from the juxtaposition of Blue and Green, Blue and Violet, Red and Violet, may be easily explained, if we subtract from the binary colour a portion of its simple colour, which is identical with the juxtaposed colour: thus,

1. Blue subtracted from Green makes it appear yellower.

2. Blue subracted from Violet makes it appear redder.

3. Red subtracted from Violet makes it appear bluer.

(172.) What must we now do so that this diagram shall become as useful as, from what procedes, we may imagine it can be? It is to put it in practice everywhere, so as to render the language uniform, as we are in the habit of doing in the determination of temperature by the thermometer.

To this end, we must take invariable types of colour, either from the solar spectrum, from polarised light, from the Newtonian rings, or from colours developed in a constant manner by any method, then imitate them as faithfully as possible by means of coloured materials, which we apply on the circular plane of the chromatic diagram. The number of these types of colour must be sufficiently large to represent the principal colours, so that a practised eye may be enabled, without difficulty, to insert all the tones of a scale, and all the hues of which the types may be wanting. In fact, it is necessary that the hemispherical diagram thus drawn should present terms sufficiently near to enable us to employ the various natural pigments, as well as those prepared artificially.

(173.) Before concluding this article, I must insist upon one point; on the possibility of imitating the *types of colours supposed to be pure,* by using coloured materials, which, as I have said before, are seldom or never so (7.). For it is in this respect that I consider the realisation of my chromatic construction to be entirely different from that in which analogous constructions are conceived in employing Carmine as the type of Red, Gamboge as the type of Yellow, and Ultra marine or Prussian Blue as the type of Blue, &c.

When it is wished to imitate a pure type, take the pigment which approaches nearest to it; if it differs materially, we must endeavour to correct the difference by another pigment, always observing to take the colour differing as little as possible from the one we seek to correct. If a good result is not obtained by this

mixture, we put the pigment on the place it should occupy in the plane. Take, for example, the type of Blue; it is evident that Ultramarine inclines a little to Violet; then we must endeavor to neutralise this latter hue by mixing some Yellow, of a green rather than of an orange hue. If this mixture is unsatisfactory, we must try Saunders's Blue (*la cendre bleue*), of the first quality. If this does not exactly represent the type of Blue, it will come much nearer, but by inclining more to Green than to Violet.

Being unable to imitate the type, we must put Ultramarine and Saunders's Blue in the places they respectively occupy as hues of Blue, and leave the place of the type vacant. I have no doubt that an artist who uses coloured materials as an element of his art, will derive very great advantage from the efforts he may make to put each of these elements in the place it should occupy in the construction.

Let us now recur to the advantages of the hemispheric chromatic construction.

1°. *It represents all the modifications resulting from mixing Colours.*

Thus we see:

(*a.*). How any colour whatever, reduced by white and deepened by black, can, without going out of its scale, give rise to an infinite number of tones; I say infinite, because we can insert as many as we please between the tone 1 and the 20th tone.

(*b.*) How the pure colours, in being modified by each other, can yield an infinite number of hues; for between any two contigous hues of the circle, we may interpose as many as we choose.

(*c.*) How the normal tone of a pure colour, represented by a quantity equal to 1, covering a unit of service, is the point of departure of the normal tones of the scales tending towards black; these normal tones being represented by black and a quantity of colouring matter less than the unit, constitute mixtures which cover the unit of surface *s*, and colour it with a tone which has the same number as the normal tone of the pure scale to which it belongs. It is understood that in setting out from this tone to the corresponding tone of normal black, we can insert as many mixtures of colour and black as we choose. The modifications of colours thus indicated by the hemispheric construction, render it extremely easy to comprehend the definition we have given of the words scales, tones, hues, pure and broken colours.

2°. *It affords the means of knowing the complementary of every Colour, since the names written at the two extremities of the same diameter indicate the colours complementary to each other.*

EXAMPLES

(*a.*) Suppose we place Blue and Yellow in juxtaposition: at one extremity of the diameter we read the word *Blue*, and at the opposite the word *Orange*. By this we see that the Blue tends to impart Orange to the Yellow. Again, at the extremity of the diameter where we read the word *Yellow*, at the opposite we read the word *Violet*. We see by this that the Yellow tends to impart Violet to the Blue.

(*b.*) Suppose we place Green and Blue in juxtaposition; at one extremity of the diameter we read the word *Green*, and at the opposite the word *Red*. We see by this that the Green tends to give Red to the Blue, making it Violet. Again, at the extremity of the diameter where we read the word *Blue*, at the opposite we read the word *Orange*. But what will become of the mixture of Green and Orange? To ascertain this, it will suffice to reflect that the Orange tends to neutralise the Blue (its complementary in the Green), and that as it is always too feeble to neutralise all the Blue, its influence is limited to neutralising a portion of it from whence it results that Green contigous to Blue will appear yellower than it really is.

(*c.*) When we place Green and Yellow in juxtaposition, we may perceive in the same manner that the Green will give Red to the Yellow, and make it incline to Orange, and that Violet, the complementary of Yellow, by neutralising some Yellow in the Green, will make the latter more Blue or less Yellow.

3°. *A third advantage of this diagram, which distinguishes it from the ordinary chromatic constructions is, to present both of the preceding advantages (1° and 2°) without rendering it necessary to colour it.*

We perceive, then, that it has a practical utility, independent of the difficulty attendant upon any attempt to colour it.

4°. *A fourth advantage of this construction is to make apparent to all artists who employ coloured materials of a given size (particularly such as the weavers of Gobelins Tapestry), the relation of number which must exist between the tones of different scales when worked together.*

§ 3.

HARMONY OF COLOURS.

(174.) The eye undoubtedly takes pleasure in seeing Colours, independent of design and every other quality in the object which exhibits them, and a suitable example to demonstrate this is the wainscoting and other wood work of an apartment in one or more flat tints which really only attract the eyes, and affects them more or less agreeably according as the painter has assorted the colours well or ill. The pleasure we experience in this case through the agency of the organ of sight, from the actual impressions of colours, is quite analogous to that experienced through the medium of taste from the actual sensations of agreeable savours.

Nothing can give us so exact an idea of the pleasure we derive through the sense of sight as the distinguishing with reference to the Colours themselves, the several cases in which we experience agreeable impressions.

1st CASE.
View of a single Colour.

(175.) Every person whose eye is well organised has certainly experienced pleasure in fixing his attention upon a sheet of white paper on which fall the rays of coloured light transmitted by a coloured glass, whether it is Red, Orange, Yellow, Green, Blue or Violet.

The same sensation takes place when we look upon a sheet of paper stained with one or another of these colours.

IInd CASE.
View of different Tones of the same Scale of Colour.

(176.) The simultaneous view of the series of tones of the same scale which begins with White and terminates with brown-Black, is undoubtedly an agreeable sensation, especially if the tones are at equal intervals and sufficiently numerous—for example, from eighteen to thirty.

IIIrd CASE.
View of different Colours belonging to Scales near to each other, and assorted conformably to Contrast.

(177.) The simultaneous view of different colours belonging to scales more or less near to each other may be agreeable, but the assortment of the scales which produce this effect is exceedingly difficult to obtain, because the nearer the scales are allied, the more frequently it happens that not only one of the colours injuries its neighbour, but the two injure each other reciprocally. The painter can nevertheless make use of this harmony by sacrificing one of the colours, which he lowers to make the other more brilliant.

IVth CASE.
View of quite different Colours belonging to Scales very widely separated, arranged conformably to Contrast.

(178.) The simultaneous view of complementary colours, or of binary unions of colours, which, without being complementary, are nevertheless very different, is also undoubtedly an agreeable sensation.

Vth CASE.
View of Various Colours, more or less well assorted, seen through the Medium of a feebly coloured Glass.

(179.) Different colours, more or less well assorted according to the law of contrast, being seen through a coloured glass which is not sufficiently deep as to make us see all the colours of the tint peculiar to the glass, afford a spectacle which is not without its charm, and which evidently stands between that produced by tones of the same scale, and that by colours more or less well assorted; for it is evident that if the glass was deeper in colour, it would cause every object to appear entirely of its own peculiar colour.

(180.) We conclude from this that there are six distinct harmonies of colours, comprised in two kinds.

1st KIND
Harmonies of Analogous Colours.

1. The *harmony of scale,* produced by the simultaneous view of different tones of a single scale, more or less approximating.
2. The *harmony of hues,* produced by the simultaneous view of tones of the same height, or nearly so, belonging to scales more or less approximating.
3. The *harmony of a dominant coloured light,* produced by the simultaneous view of different colours assorted conformably to the law of contrast, but one of them predominating, as would result from seeing these colours through a slightly stained glass.

IInd KIND.
Harmonies of Contrasts

1. The *harmony of contrast of scale,* produced by the simultaneous view of two tones of the same scale, very distant from each other.
2. The *harmony of contrast of hues,* produced by the simultaneous view of tones of different height, each belonging to contiguous scales.
3. The *harmony of contrast of colours,* produced by the simultaneous view of colours belonging to scales very far asunder, assorted according to the law of contrast: the difference in height of juxtaposed tones may also augment the contrast of colours.

§4.

ASSORTMENT OF RED, ORANGE, YELLOW, GREEN, BLUE AND VIOLET WITH WHITE, BLACK, AND GREY.

(181.) It will not be contrary to the object proposed in the second part of this work, to introduce in this place some observations relative to the kind of beauty of a certain number of arrangements of primary colours with White, Black, and Grey; but, before stating them, I cannot too strongly insist upon the fact that they are not given as a rigorous deduction from scientific rules, for they are but the expressions of my peculiar idea; yet I hope that many classes of artists, particularly dress-makers, decorators of all kinds, designers of patterns for textile fabrics, paper-hangings, &c., will derive some benefit from consulting them.

(182.) The *Ground,* as well as the *interval* we place between the coloured materials, having some influence upon the effect of colours, I apprise the reader that all my observations have been made with coloured, black, white, and grey circles of 4/10 of an inch in diameter, separated by equal intervals of 4/10 of an inch; thirteen circles arranged in a straight line forming a series.

(183.) The series intended to enable us to appreciate the effect of white was upon a ground of normal *grey;* the one to enable us to appreciate the effect of Black and of Grey was upon a *White* ground slightly tinged Grey. It is necessary to remark that the *coloured* circles placed apart were upon black grounds, which could not but exercise some influence.

(184.) The colours which formed the object of my observations, are Red, Orange, Yellow, Green, Blue, and Violet. When considered in respect to their brilliancy, the differences which they present are sufficiently great to admit of their being divided into two groups: the one containing Yellow, Orange, Red, and bright Green; the other Blue and Violet, which, at the same height of tone, are not so brilliant as the first. I shall call the first group *luminous colours,* the second *sombre colours;* nevertheless, I must observe that the deep and broken tones of the luminous scale may in many cases be assimilated with the sombre colours, in the same manner that the light tones of Blue and Violet

can sometimes be employed as luminous colours in certain assortments.

ARTICLE 1.

Colours with White.

A. BINARY ASSORTMENTS.

(185.) All the primary colours gain by their juxtaposition with White; that is certain; but the resulting binary assortments are not equally agreeable, and we remark that the height of tone of the colour has a great influence upon the effect of its assortment with White.

The binary assortments in the order of greatest beauty are as follows:

Light Blue	and	*White.*
Rose	and	*White.*
Deep Yellow	and	*White.*
Bright Green	and	*White.*
Violet	and	*White*
Orange	and	*White*

Dark Blue and dark Red produce, with White, too strongly a contrast of tone to allow of their association being as agreeable as that of their light tones.

Yellow, being a light colour, for the opposite reason we must take the normal tone, or the highest tone of pure Yellow, to produce the best possible effect.

Dark Green and Violet contrast too much in tone with White to allow of their association being as agreeable as that made with the light tones of these colours.

Finally, the objection which can be made to the combination of Orange with White is, too much brilliancy; nevertheless I should not be astonished if many persons preferred it to the association of Violet and White.

B. TERNARY ASSORTMENT OF COLOURS COMPLEMENTARY TO EACH OTHER WITH WHITE.

(186.) It is to me impossible to establish a beautiful effect between the binary associations of complementary primary colours; what I shall say will reduce itself to an examination of the effect of White interposed, whether it be between the binary complementary assortment or between each of the colours.

Red and Green.

(187.) 1. Red and Green are the complementary colours most equal in height; for Red, under its relation of brilliancy, holds a middle place between Yellow and Blue, and in Green the two extremes are united.

2. The assortment *White, Red, Green, White, &c.,* is decidedly not superior to the preceding (1), still less so when the colours are not deep.

3. The assortment *White, Red, White, Green, White, &c.,* seems to me inferior to the preceding (2).

Blue and Orange.

(188.) 1. *Blue and Orange* are more opposed to each other than Red and Green, because the less brilliant colour, Blue is isolated; whereas the most brilliant are united in Orange.

2. The assortment *White, Orange, Blue, White, &c.,* is agreeable.

3. The assortment *White, Orange, White, Blue, White, &c.,* is the same.

Yellow and Violet.

(189.) 1. Yellow and Violet form the most distinct assortment under the relation of height of tone, since the lightest, or the least intense colour, Yellow, is isolated from the others.

It is from this great contrast of tone that deep greenish-yellow, but at the same time pure, mixes better with light Violet than light Yellow with deep Violet.

2. The assortment *White, Yellow, Violet, White, &c.,* appears to me inferior to the preceding (1).

3. The assortment *White, Yellow, White, Violet, White, &c.,* appears to me inferior to the preceding (2).

C. TERNARY ASSORTMENT OF NON-COMPLEMENTARY COLOURS WITH WHITE.

Red and Orange.

(190.) 1. *Red and Orange* are very bad together.

2. The assortment *White, Red, Orange, White,* is not at all preferable.

3. The assortment *White, Red, White, Orange, White, &c.,* is not so bad as the preceding, because White being favourable to all colours, its interposition between colours which injure each other can only produce an advantageous effect.

Red and Yellow

(191.) *Red and Yellow* do not assort badly, especially if the Red is more Purple than Scarlet, and the Yellow more Green than Orange.

2. The assortment *White, Red, Yellow, White, &c.,* is preferable to the preceding (1).

3. The assortment *White, Red, White, Yellow, White, &c.,* is still better.

Red and Blue

(192.) 1. *Red and Blue* are passable, especially if the Red inclines more to Scarlet than to Crimson.

The dark tones are preferable to the light tones.

2. The assortment *White, Red, Blue, White, &c.,* is preferable to the second (2).

Red and Violet

(193.) 1. *Red and Violet* do not assort well together, nevertheless some natural productions present them to us; for example, the Sweetpea.

2. The assortment *White, Red, Violet, White, &c.,* is not so bad as the preceding (1).

3. The assortment *White, Red, White, Violet, White, &c.,* is preferable to the second (2).

Orange and Yellow

(194.) 1. *Orange and Yellow* are incomparably better than Red and Orange.

2. The assortment *White, Orange, Yellow, White, &c.,* is agreeable.

3. The assortment *White, Orange, White, Yellow, White, &c.,* is not so good as 2, nor perhaps as 1, because there would be too much White.

Orange and Green

(195.) 1. *Orange and Green* do not go badly together.

2. The assortment *White, Orange, Green, White, &c.,* is preferable to 1.

3. The assortment *White, Orange, White, Green, White, &c.,* is perhaps preferable to 2.

Orange and Violet

(196.) 1. *Orange and Violet* are passable, but not so good as Orange and Green: the contrast in the latter case is greater than in the assortment Orange and Violet.

2. The assortment *White, Orange, Violet, White, &c.,* is preferable to the preceding (1).

3. The assortment *White, Orange, White, Violet, White, &c.,* is preferable to the latter (2).

Yellow and Green

(197.) 1. *Yellow and Green* form an agreeable assortment.

2. The assortment *White, Yellow, Green, White, &c.,* is much more agreeable than the preceding (1).

3. The assortment *White, Yellow, White, Green, White, &c.,* is inferior to the preceding, and perhaps to the first.

The inferiority of 3 appears to me to be owing to there being too much light for the Green.

Yellow and Blue

(198.) 1. The assortment *Yellow and Blue* is more agreeable than that of Yellow and Green, but it is less lively.

2. The assortment *White, Yellow, Blue, White, &c.,* is perhaps preferable to the preceding (1).

3. The assortment *White, Yellow, White, Blue, White, &c.,* is perhaps inferior to the preceding (2).

Green and Blue

(199.) 1. *Green and Blue* have a mediocre effect, but less so when the colours are deep.

2. The assortment *White, Green, Blue, White, &c.,* is better.

3. The assortment *White, Green, White, Blue, White, &c.,* is also of a better effect, because the light is more equally divided.

Green and Violet

(200.) 1. *Green and Violet,* particularly when they are light, form an assortment preferable to the preceding, Green and Blue.

2. The assortment *White, Green, Violet, White, &c.,* is decidedly not superior to the preceding (1).

3. The assortment *White, Green, White, Violet, White, &c.,* is certainly inferior to the latter (2).

Blue and Violet

(201.) 1. *Blue and Violet* go badly together.

2. The assortment *White, Blue, Violet, White, &c.,* is scarcely to be preferred to the preceding (1).

3. The assortment *White, Blue, White, Violet, White, &c.,* is not so bad as the latter (2).

ARTICLE 2

Colours with Black.

(202.) I do not know whether the custom of using Black for mourning should be an impediment to our employing it in an infinite variety of cases where it would produce excellent effects; however that may be, it can be allied in a most advantageous manner not only with sombre colours, to produce harmonies of analogy, but also with light and brilliant colours, to produce harmonies of contrast entirely different from the first. The Chinese artists, it appears to me, display excellent judgment in employing them, for I have frequently seen furniture, paintings, ornaments, &c., where they have employed them most judiciously.

I recommend artists, to whom this paragraph is particularly directed, to give some attention to the following observations, not doubting that many will find it profitable to them.

A. BINARY ASSORTMENTS.

(203.) No assortment of the primary colours with Black is disagreeable: but between these assortments there exists a generic difference of harmony, which the binary assortments of White with the same colours do not present in nearly the same degree. For in these latter the splendour of the White is so dominant, that, whatever be the difference of light or of brilliancy observable between the different colours associated, there will always be harmony of contrast, as must follow from what has already been stated (44.—52.) of the influence of White in elevating the tone and augmenting the intensity of the colour which is next to it. If we examine the binary assortments of Black under the relation which now occupies our attention, we shall perceive that the deep tones of all the scales, and also the tones of the Blue and Violet scales, which, properly speaking, are not deep,—form with them harmonies of analogy and not of contrast, as do the unbroken tones of the scales of Red, Orange, Yellow, Green, and the very light tones of the Violet and Blue scales. Finally, we must add, conformably to what has already been said (55.), that the assortment of Black with sombre colours, such as Blue and Violet, the complementaries of which, Orange and Greenish-Yellow, are luminous, may diminish contrast of tone, if the colours are in juxtaposition with Black, or are not far distant; and in this case the Black loses much of its vigour.

Blue and Black, Violet and Black, make assortments which can only be successfully employed when we require obscure colours.

The first assortment is superior to the second.

The bright assortments which present harmonies of contrast appear to me in the rank of beauty.

Red or Rose and Black, Orange and Black, Yellow and Black, lastly *light Green and Black.*

Respecting Yellow, I repeat that it must be brilliant and intense, because Black tends to impoverish its tone (58.).

B. TERNARY ASSORTMENT OF COMPLEMENTARY COLOURS WITH BLACK.

Red and Green.

(204.) 1. *Red, Green, &c.*

2. *Black, Red, Green, Black, &c.*

This arrangment being entirely different from the first, it is very difficult to decide upon their relative

beauty.

3. *Black, Red, Black, Green, Black, &c.*, appears to me inferior to the preceding (2), because there is too much Black.

Blue and Orange.

(205.) 1. *Blue, Orange, &c.*

2. *Black, Blue, Orange, Black, &c.*

I prefer the first to the second, the proportion of obscure colours being too strong relatively to the Orange.

3. *Black, Blue, Black, Orange, Black, &c.*

This arrangement pleases me less than the first.

The effect of Black with Blue and Orange is inferior to that of White.

Yellow and Violet.

(206.) 1. *Yellow, Violet, &c.*

2. *Black, Yellow, Violet, Black, &c.*

3. *Black, Yellow, Black, Violet, Black, &c.*

The second assortment is superior to the third, because the proportion of sombre colours with Yellow is too strong in the latter.

The first appears to me superior to the second.

C. TERNARY ASSORTMENT OF NON-COMPLEMENTARY COLOURS WITH BLACK.

Red and Orange.

(207.) 1. *Red, Orange, &c.*

2. *Black, Red, Orange, Black, &c.*

3. *Black, Red, Black, Orange, Black, &c.*

The Orange and Red injure each other, and it is advantageous to separate them with Black; the third assortment is preferable to the second, and both are preferable to those where White replaces the Black.

Red and Yellow.

(208.) 1. *Red, Yellow, &c.*

2. *Black, Red, Yellow, Black, &c.*

3. *Black, Red, Black, Yellow, Black, &c.*

The two latter assortments appear to me superior to the first and there are certainly many persons who will prefer them to the arrangement where White replaces the Black, I cannot too strongly recommend the assortments 2 and 3 to artists, to whom these observations are particularly directed.

Red and Blue.

(209.) 1. *Red, Blue, &c.*

2. *Black, Red, Blue, Black, &c.*

3. *Black, Red, Black, Blue, Black, &c.*

The assortment 2 is preferable to 3, because there are too many sombre colours in the latter, and they differ too much from Red.

The effect of Black upon the binary assortment Red and Blue is inferior to that of White.

Red and Violet.

(210.) 1. *Red, Violet, &c.*

2. *Black, Red, Violet, Black, &c.*

3. *Black, Red, Black, Violet, Black, &c.*

Red and Violet injure each other reciprocally. There is an advantage in separating them with Black, but this does not produce so good an effect as White. It is difficult to say whether the assortment 3 is preferable to 2, for this reason, that, if in the latter Red is near the Violet, the defect can be more than compensated for in 3, by the predominance of sombre colours over Red.

Orange and Yellow.

(211.) 1. *Orange, Yellow, &c.*

2. *Black, Orange, Yellow, &c.*

3. *Black, Orange, Black, Yellow, Black, &c.*

Orange and Yellow being very luminous, the Black combines very well in the assortments 2 and 3; and if the assortment White, Orange, Yellow, White, is preferred to the assortment 2, I believe that in the assortment 3 the Black has a superior effect to White.

Orange and bright Green.

(212.) 1. *Orange, Green, &c.*

2. *Black, Orange, Green, &c.*

3. *Black, Orange, Black, Green, Black, &c.*

The Black combines very well with Orange and Bright Green, for the same reason that it does with Orange and Yellow. If in the assortment 2 we prefer White to Black, I think we cannot in the assortment 3.

I recommend to artists the alliance of Black with the binary assortments Orange and Yellow, and Orange and Green.

Orange and Violet.

(213.) 1. *Orange, Violet, &c.*

2. *Black, Orange, Violet, Black, &c.*

3. *Black, Orange, Black, Violet, Black, &c.*

Black does not combine so well as White with Orange and Violet, because the proportion of obscure colours is too great relatively to Orange, a very vivid colour.

Yellow and Green.

(214.) 1. *Yellow, bright Green, &c.*

2. *Black, Yellow, Green, Black, &c.*

3. *Black, Yellow, Black, Green, Black, &c.*

For the reason stated above (211.), Yellow and bright Green being luminous colours, Black combines very well with them; and if in the assortment 2, we prefer the effect of White to Black, I think we cannot do so in the assortment 3.

Yellow and Blue.

(215.) 1. *Yellow, Blue, &c.*

2. *Black, Yellow, Blue, Black, &c.*

3. *Black, Yellow, Black, Blue, Black, &c.*

If the assortment 2 is preferable to 3, I think it is inferior to the first. Black does not appear to me to combine so well as White in the Yellow and Blue assortment.

Green and Blue.

(216.) 1. *Green, Blue, &c.*

2. *Black, Green, Blue, Black, &c.*

3. *Black, Green, Black, Blue, Black, &c.*

Although the Green and Blue do not ally very well, yet the addition of Black is decidedly not advantageous, because of the increased proportion of sombre colours. Under this relation White has a better effect than Black.

Green and Violet.

(217.) 1. *Green, Violet, &c.*

2. *Black, Green, Violet, Black, &c.*

3. *Black, Green, Black, Violet, Black, &c.*

If the Black does combine better with Green and Violet than with Green and Blue, still its ternary assortments

are inferior to the binary, and to the ternary assortment in which it is replaced by White.

Blue and Violet.

(218.) 1. *Blue, Violet, &c.*
2. *Black, Blue, Violet, Black, &c.*
3. *Black, Blue, Black, Violet, Black &c.*

If Blue and Violet are colours which do not ally well together, and which it is advantageous to separate from each other, we must recognise that Black in isolating them does not relieve the sombre colour; but, on the other hand, the harmony of the assortments 2 and 3 is more agreeable as a harmony of analogy than the harmony of contrast presented by White with the same colours. There are cases where the combination Black, Blue, and Violet may be advantageous, when it presents to view diversified, but not brilliant, tones.

ARTICLE 3.

Colours with Grey.

(219.) All the primary colours gain in brilliancy and purity by the proximity of Grey; yet the effects are from being similar or even analogous, to those which result from the proximity of the same colours with White. There is nothing surprising in this, when we consider that if White preserves to each colour its character, and even heightens it by contrast, it can never itself be taken for a colour properly so called; as Grey, on the contrary, can be so, it happens that it produces with the darkest colours—such as Blue, Violet, and the deep tones in general—assortments which enter into analogous harmonies; whilst, with colours naturally brilliant—such as Red, Orange, Yellow, and the light tones of Green—they form harmonies of contrast. Now, although White contrasts more with the sombre colours than with those which are naturally luminous, we cannot observe between White and these two classes of colours the difference which we distinguish between Grey and these same colours. Moreover, we might anticipate this result from what I said on the binary assortments with Black (203.).

A. BINARY ASSORTMENTS.

(220.) *Grey and Blue, Grey and Violet,* form assortments, the harmony of analogy of which is agreeable, but less so, however, than that of Black with the same colours.

Grey and Orange, Grey and Yellow, Grey and light Green, form assortments of harmony of contrast, in like manner agreeable: perhaps they are less so than those where Grey is replaced by Black.

Grey and Rose are a little dull, and inferior to the assortment *Black and Rose.*

All the biniary assortments of Grey, except perhaps that of Orange, are inferior to the binary assortments of White.

B. TERNARY ASSORTMENTS OF COMPLEMENTARY COLOURS WITH GREY.

Red and Green.

(221.) 1. *Red, Green, &c.*
2. *Grey, Red, Green, Grey, &c.*
3. *Grey, Red, Grey, Green, Grey &c.*

If it is difficult to say whether the addition of Grey is advantageous to the binary assortment of Red and Green, we cannot say that it is injurious.

The third assortment is, perhaps, inferior to that where Grey is replaced by Black.

Blue and Orange.

(222.) 1. *Blue, Orange, &c.*
2. *Grey, Blue, Orange, Grey, &c.*
3. *Grey, Blue, Grey, Orange, Grey, &c.*
I prefer the first assortment to both the others.

Yellow and Violet.

(223.) 1. *Yellow, Violet, &c.*
2. *Grey, Yellow, Violet, Grey, &c.*
3. *Grey, Yellow, Grey, Violet, Grey, &c.*

Although the assortments 2 and 3 may be brighter than the assortments where Grey is replaced by Black (206.), nevertheless, the binary assortment appears to me preferable to the ternary.

C. TERNARY ASSORTMENTS OF NON-COMPLEMENTARY COLOURS WITH GREY.

Red and Orange.

(224.) 1. *Red and Orange, &c.*
2. *Grey, Red, Orange, Grey, &c.*
3. *Grey, Red, Grey, Orange, Grey, &c.*

The assortments 2 and 3 are preferable to the binary assortment. The third is preferable to the second. Altogether, with Red and Orange, Grey produces a better effect than White, but the effect is inferior to that with Black.

Red and Yellow.

(225.) 1. *Red, Yellow, &c.*
2. *Grey, Red, Yellow, Grey, &c.*
3. *Grey, Red, Grey, Yellow, Grey, &c.*

Although Grey combines well with Red and Yellow, it has not an effect so decidedly advantageous as Black has in the binary assortment.

Red and Blue.

(226.) 1. *Red, Blue, &c.*
2. *Grey, Red, Blue, Grey, &c.*
3. *Grey, Red, Grey, Blue, Grey, &c.*

The assortment 2 is preferable to 3; I dare not say to the first. The effect of Grey is inferior to that of White.

Red and Violet.

(227.) 1. *Red, Violet, &c.*
2. *Grey, Red, Violet, Grey, &c.*
3. *Grey, Red, Grey, Violet, Grey, &c.*

The assortment 3 appears to me superior to 2, and the second to the first; but it is difficult to say if Grey is superior to Black; I am certain it is inferior to White.

Orange and Yellow.

(228.) 1. *Orange, Yellow, &c.*
2. *Grey, Orange, Yellow, Grey, &c.*
3. *Grey, Orange, Grey, Yellow, Grey, &c.*

The assortment 3 appears to me preferable to the assortment 2; the harmony of contrast is less intense than with Black.

The assortment 3 is perhaps superior to the assortment of White, Orange, White, Yellow, White.

Orange and Green.

(229.) 1. *Orange, Green, &c.*
2. *Grey, Orange, Green, Grey, &c.*

3. *Grey, Orange, Grey, Green, Grey, &c.*
Grey combines well with Orange and Green, but it does not contrast so agreeably as Black or White.

Orange and Violet.
(230.) 1. *Orange, Violet, &c.,*
2. *Grey, Orange, Violet, Grey, &c.*
3. *Grey, Orange, Grey, Violet, Grey, &c.*
The binary assortment appears to me preferable to the other two.
The assortment 2 is preferable to 3.
If the Grey is a little dull with Orange and Violet, it has not the same inconvenience as Black in causing too great a predominance of sombre colours.

Yellow and Green.
(231.) 1. *Yellow, Green, &c.*
2. *Grey, Yellow, Green, Grey, &c.*
3. *Grey, Yellow, Grey, Green, Grey, &c.*
Grey allies well with Yellow and Green; but the assortments 2 and 3 are a little dull, and inferior to those in which Black replaces Grey.

Yellow and Blue.
(232.) 1. *Yellow, Blue, &c.*
2. *Grey, Yellow, Blue, Grey, &c.*
3. *Grey, Yellow, Grey, Blue Grey, &c.*
The two assortments 2 and 3 are inferior to the 1st. The Grey is heavy with Yellow and Blue; its effect then is inferior to that of White, and perhaps also to that of Black.

Green and Blue.
(233.) 1. *Green, Blue, &c.*
2. *Grey, Green, Blue, Grey, &c.*
3. *Grey, Green, Grey, Blue, Grey, &c.*
Grey, in its association with Green and Blue, has not the same objection as Black, but it has an inferior effect to White.

Green and Violet.
(234.) 1. *Green, Violet, &c.*
2. *Grey, Green, Violet, Grey, &c.*
3. *Grey, Green, Grey, Violet, Grey, &c.*
Grey is not employed advantageously with Green and Violet; it is inferior to White in ternary assortments, and perhaps I should even give preference to Black.

Blue and Violet.
(235.) 1. *Blue, Violet, &c.*
2. *Grey, Blue, Violet, Grey, &c.*
3. *Grey, Blue, Grey, Violet, Grey, &c.*
The remarks made (218.) on the assortment of Black with Blue and Violet are applicable to the assortment with Grey, taking into account, to a certain extent, the difference of tone which exists between Grey and Black.

RECAPITULATION OF THE PRECEDING OBSERVATIONS.

(236.) 1. I will now give a summary of the observations which appear the most striking on reading the foregoing paragraphs, premising, however, that I do not pretend to establish rules based upon scientific principles, but to enounce general propositions, which express my own peculiar ideas.

1st PROPOSITION.
(237.) *In the Harmony of Contrast the complementary assortment is superior to every other.*
The tones must be, as nearly as possible, of the same height, in order to produce the finest effect.
The complementary assortment in which White associates most advantageously is that of Blue and Orange and the reverse is that of Yellow and Violet.

2nd PROPOSITION.
(238.) *The primaries Red, Yellow, and Blue, associated in pairs, will assort better together as a harmony of contrast than an arrangement formed of one of these primaries and of a binary colour, the primary of which may be regarded as one of the elements of the binary colour in juxtaposition with it.*

Examples.
Red and Yellow accord better than Red and Orange.
Red and Blue accord better than Red and Violet.
Yellow and Red accord better than Yellow and Orange.
Yellow and Blue accord better than Yellow and Green.
Blue and Red accord better than Blue and Violet.
Blue and Yellow accord better than Blue and Green.

3rd PROPOSITION.
(239.) *The assortment of Red, Yellow, or Blue, with a binary colour, which may be regarded as containing the former, contrasts the better, as the simple colour is essentially more luminous than the binary.*
Whence it follows that in this arrangement it is an advantage for the Red, Yellow, or Blue, to be lower in tone than the binary colur.

Examples.
Red and Violet accord better than Blue and Violet.
Yellow and Orange accord better than Red and Orange.
Yellow and green accord better than Blue and Green.

4th PROPOSITION.
(240.) *When two colours are bad together, it is always advantageous to separate them by White.*
In this case we know that it is more advantageous to place White between each colour than in an assortment where the two colours are together between White.

5th PROPOSITION.
(241.) *Black never produces a bad effect when it is associated with two luminous colors. It is therefore often preferable to White, especially in an assortment where it separates the colours from each other.*

Examples.
1. *Red and Orange.*
Black is preferable to White in the arrangements 2 and 3 of these two colours.
2. *Red and Yellow.*
3. *Orange and Yellow.*
4. *Orange and Green.*
5. *Yellow and Green.*
Black with all these binary assortments produces harmony of contrast.

6th PROPOSITION.

(242.) *Black, in association with sombre colours, such as Blue and Violet, and with broken tones of luminous colours, produces harmony of analogy, which in many instances may have a good effect.*

The harmony of analogy of Black associated with Blue and Violet, is preferable to the harmony of contrast of the assortment White, Blue, Violet, White, &c., the latter being too crude.

7th PROPOSITION.

(243.) *Black does not associate so well with two colours, one of which is luminous, the other sombre, as when it is associated with two luminous colours.*

In the first instance the association is much less agreeable in proportion as the luminous colour is more brilliant.

Examples.

With all the following assortments Black is inferior to White.

1. *Red* and *Blue.*
2. *Red* and *Violet.*
3. *Orange* and *Blue.*
4. *Orange* and *Violet.*
5. *Yellow* and *Blue.*
6. *Green* and *Blue.*
7. *Green* and *Violet.*

With the assortment *Yellow and Violet*, if it is not inferior to White, it never produces anything but a mediocre effect in its associations.

8th PROPOSITION.

(244.) *If Grey never produces exactly a bad effect in its association with two luminous colours, in most cases its assortments are nevertheless dull, and it is inferior to Black and White.*

Among the assortments of two luminous colours there are scarcely any besides those of Red and Orange with which Grey associates more agreeably than with White.

But it is inferior to it, and also to Black, in the arrangements *Red and Green, Red and Yellow, Orange and Yellow, Orange and Green, Yellow and Green.*

It is also inferior to White with *Yellow and Blue.*

9th PROPOSITION.

(245.) *Grey, in association with sombre colours, such as Blue and Violet, and with broken tones of luminous colours, produces harmonies of analogy which have not the vigour of those with Black; if the colours do not associate well together, it has the advantage of separating them from each other.*

10th PROPOSITION.

(246.) *When Grey is associated with two colours, one of which is luminous, the other sombre, it will perhaps be more advantageous than White, if this produces too strong a contrast of tone; on the other hand, it will be more advantageous than Black, if that has the inconvenience of increasing too much the proportion of sombre colours.*

Examples.

Grey associates more favourably than Black with—

1. *Orange* and *Violet.*
2. *Green* and *Blue.*
3. *Green* and *Violet.*

11th PROPOSITION.

(247.) *If, when two Colours combine together badly, there is, in principle, an advantage in separating them by White, Black, or Grey, it is important to the effect to take into consideration—*

1. *The height of tone of the Colours, and*

2. *The proportion of sombre to luminous colours, including in the first the broken brown tones of the brilliant scales, and in the luminous colours, the light tones of the Blue and Violet scales.*

Examples.

(a). *Take into consideration the height of tone of the colours.*

(248.) The effect of White with Red and Orange is inferior as their tone becomes higher, especially in the assortment *White, Red, Orange, White, &c.*, the effects of the White being too crude.

On the contrary, Black unites very well with the normal tones of the same colours, that is to say, the highest tones, without any mixture of Black.

If Grey does not associate so well as Black with Red and Orange, it has the advantage of producing a less crude effect than White.

(b.) *Take into consideration the proportion of sombre to luminous colours.*

(249.) Whenever colours differ too much, either in tone or in brilliancy from the Black or White with which we wish to associate them, the arrangement where each of the two colours is separated from the other by Black or White, is preferable to that in which the Black or the White separate each pair of colours.

Thus the assortment White, Blue, White, Violet, White, &c., is preferable to the assortment White, Blue, Violet, White, &c., because the separation of the brilliant from the sombre is more equal in the first than in the second. I should add, that this has something more symmetrical relatively to the position of the two colours, and I must remark that the principle of symmetry influences our judgment of things much more than is generally recognised.

It is also in conformity with the above, that the assortment Black, Red, Black, Orange, Black, &c., is preferable to the assortment Black, Red, Orange, Black, &c.

(250.) Some remarks appear to me also necessary to prevent false conclusions being drawn from the preceding propositions.

(251.) 1°. In all the preceding remarks, the colours, including White, Black, and Grey, are supposed to occupy an equal superficial extent of surface, and placed at equal distances apart; for without these conditions, the results will be different from those described:—for example, I have preferred the assortment White, Red, White, Yellow, White, to the assortment White, Red, Yellow, White. I shall notice those cases where the latter is preferable to the former, in treating of the arrangement of flowers in gardens, on the subject of Yellow and Rose flowers, which present less coloured surface than the White flowers with

which they are associated.

I have spoken of the good effect of Black and Green separated, and I may add that Green designs upon a Black ground are also agreeable; but it does not follow that black lace, superimposed upon a green stuff, will have a good effect, at least on the optical quality of Black, for this acquires a Red tint, which assimilates it with a faded colour.

(252.) 2°. I have said that the more colours are opposed, the easier it is to assort them, because they do not experience by their mutual juxtaposition, any modification which renders them disagreeable, as generally happens to colours which are very nearly alike. Must we then conclude that, with two colours which have in this case been indicated to an artist to be employed with liberty to modify them to a certain point, he must endeavor to increase the effect of contrast rather than that of analogy? Certainly not! for frequently the latter is preferable to the former. For

example:—take Orange-Red, and a pure Red, instead of increasing the Yellow in the Orange-Red, or of giving a Violet hue to the Red, it sometimes will be preferable to incline towards the harmony of scale or of hue by endeavouring to make the Orange one of the light tones of a scale whose Red will be brown.

(253.) 3°. It is in conformity with this manner of observing that, when we would avoid the bad effect of two adjacent colours by White, Black, or Grey, we must see if, instead of a harmony of contrast, there will not be more advantage in obtaining the harmony of analogy.

(254.) 4°. Finally, when in working these associations, we employ not normal Grey, but a coloured Grey, we are always sure of obtaining an effective harmony of contrast, by taking a Grey coloured with the complementary of the colour opposed to it. Thus an Orange-Grey, or Carmelite-Brown, or Marron, has a good effect with light Blue.

FIRST DIVISION

IMITATION OF COLOURED OBJECTS, WITH COLOURED MATERIALS IN A STATE OF INFINITE DIVISION.

INTRODUCTION.

FIRST SECTION.—PAINTING ON THE SYSTEM OF CHIAR'-OSCURO.

SECOND SECTION.—PAINTING ON THE SYSTEM OF FLAT TINTS.

THIRD SECTION.—COLOURING IN PAINTING.

IMITATION OF COLOURED OBJECTS, WITH COLOURED MATERIALS IN A STATE OF INFINITE DIVISION.

INTRODUCTION.

(255.) COLOURED materials (pigments), such as Prussian Blue, Chrome-Yellow, Vermilion, &c., are infinitely divided, so to speak, when ground, either pure, or mixed with a white material, in a gummy or oily liquid.

The reproduction of the images of coloured objects with these pigments is called THE ART OF PAINTING.

(256.) There are two systems of Painting, the one consists in representing as accurately as possible, upon the flat surface of canvas, wood, metal, walls, &c., an object in relief, in such manner that the image makes an impression upon the eye of the spectator similar to that produced by the object itself.

(257.) From this we learn that we must manage the light, the vivacity of colour for every part of the image which in the model receives direct light, and which reflects it to the eye of one who regards the object from the point where the painter placed himself to imitate it; while the parts of the image corresponding to those which, in same object, do not reflect to the spectator as much light as the first,—either because they reflect it in another direction, or because the salient points protect them more or less from the daylight,—must appear in colours more or less dimmed with black, or, what is the same thing, by shade.

It is, then, by the vivacity of White or coloured light, by the enfeebling of light by means of Black, that the painter manages, with the aid of a plane image, to attain all the illusion of an object in relief. The art of producing this effect by the distribution of light and shade constitutes essentially what is termed the art of *Chiar'oscuro.*

(258.) There exists a means of imitating coloured objects much simpler by the facility of its execution than the preceding. It consists in tracing the outline of the different parts of the model, and in colouring them uniformly with their peculiar colours. There is no relief, no projections; it is the plane image of the object, since all the parts receive a uniform tint: this system of imitation is *painting in flat tints.*

SECTION I.

PAINTING ON THE SYSTEM OF CHIAR'OSCURO.

CHAPTER I.

ON THE COLOURS OF THE MODEL.

(259.) Are the modifications which we perceive in a single coloured object—for example, in a blue or red stuff, &c.—indeterminable when these stuffs are seen as the drapery of a vestment or as furniture, presenting folds more or less prominent, or are they determinable under given circumstances? This is a question which I shall undertake to resolve. First, let us distinguish three cases where these modifications of colours may be observed.

1st CASE. *Modifications produced by coloured lights falling upon the model.*

2nd CASE. *Modifications produced by two different lights—as, for example, the light of the sun, and diffused daylight—each lighting distinct parts of the same object.*

3rd CASE. *Modifications produced by diffused daylight.*

(260.) To render these matters easier of comprehension, we will suppose that in the two first cases the lighted surfaces are plane, and that all their superficial parts are homogeneous, and in the same conditions, except that of lighting in the second case. In the third case we shall consider the position of the spectator viewing an object lighted by diffused daylight, the surface of which is so disposed as not to act equally in all its parts upon the light which it reflects to the eye of the spectator.

ARTICLE 1.

Modifications produced by Coloured Lights.

(261.) These modifications result from coloured rays emanating from any source whatever, falling upon a coloured surface, which is at the same time lighted by diffused daylight.

(262.) The following observations have been made by partially exposing coloured stuffs to the sun's rays transmitted through coloured glass. the portion of stuff protected from these rays was lighted by the direct light of the sun. It is important to remark that the portion of stuff which received the action of the coloured rays being exposed to diffused daylight, reflected also rays of that light which it would have reflected in case it had been protected from the influence of the rays transmitted to it through coloured glasses.

(263.) 1°. *Modifications produced by Red Light.*

When Red rays fall upon a Black stuff, it appears of a Purple-Black, deeper than the rest, which is lighted directly by the sun.

Red rays falling upon a White stuff, make it appear Red.

Red rays falling upon a Red stuff, make it appear redder than upon that part lighted at the same time by the sun.

Red rays falling upon an Orange-coloured stuff, make it appear redder than the part lighted at the same time by the sun.

Red rays falling upon a Yellow stuff, make it appear Orange.

Red rays falling upon a Green stuff, produce different effects, according to the tone of the Green: if it is deep, it produces a Red-Black; if it is light, there is a little Red reflected, which gives a reddish grey.

Red rays falling upon a light Blue stuff, make it appear Violet.

Red rays falling upon a Violet stuff, make it appear Purple.

(264.) 2°. *Modifications produced by Orange Light.*

Orange rays falling upon a Black stuff, make it appear of a Maroon or Carmelite-Brown colour.

Orange rays falling upon a White stuff, make it appear Orange.

Orange rays falling upon an Orange stuff, make it appear of an Orange more vivid, more intense than the part lighted at the same time by the sun.

Orange rays falling upon a Red stuff, make it appear Scarlet.

Orange rays falling upon a Yellow stuff, make it appear Orange-Yellow.

Orange rays falling upon a Green stuff, make it appear of a Yellow-Green, if the Green is light; and of a rusty-Green, if it is deep.

Orange rays falling upon a Blue stuff, make it appear of an Orange-Grey, if the Blue is light; and of a Grey in which the Orange is less vivid, if it is deep, which is not the colour given to a black stuff by the same Orange rays.

Orange rays falling upon a dark Indigo-Blue stuff, make it appear of an Orange-Maroon.

Orange rays falling upon a Violet stuff, make it

appear of a Red-Maroon.

(265.) 3°. *Modifications produced by Yellow Light.*

Yellow rays falling upon a Black stuff, make it appear of an Olive-Yellow.

Yellow rays falling upon a White stuff, make it appear of a light Yellow.

Yellow rays falling upon a Yellow stuff, make it appear (relatively to the part lighted by the sun) of an Orange-Yellow colour.

Yellow rays falling upon a Red stuff, make it appear Orange.

Yellow rays falling upon an Orange Orange stuff, make it appear more Yellow than the part lighted by the sun.

Yellow rays falling upon a Green stuff, make it appear Yellow-Green.

Yellow rays falling upon a Blue stuff, make it appear Green-Yellow, if it is light, and of a Green-Slate if it is deep.

Yellow rays falling upon a deep Indigo stuff, make it appear of an Orange-Yellow.

Yellow rays falling upon a Violet stuff, make it appear Yellow-Maroon.

(266.) 4°. *Modifications produced by Green Light.*

Green rays falling upon a Black stuff, make it appear of a Green-Brown.

Green rays falling upon a White stuff, make it appear Green.

Green rays falling upon a Green stuff, make it appear more intense and brilliant.

Green rays falling upon a Red stuff, make it appear of a Brown.

Green rays falling upon an Orange stuff, make it appear of a faint Yellow, a little Green.

Green rays falling upon a Yellow stuff, make it appear of a very brilliant Yellow-Green.

Green rays falling upon a Blue stuff, make it appear Greener, according to its depth.

Green rays falling upon a dark Indigo stuff, make it appear a dull Green.

Green rays falling upon a Violet stuff, make it appear of a Bluish-Green-Brown.

(267.) 5°. *Modifications produced by Blue Light.*

Blue rays falling upon a Black stuff, render it of a Blue-Black, deeper than the part lighted by the sun.

Blue rays falling upon a White stuff, make it appear Blue.

Blue rays falling upon a Blue stuff, render the colour more vivid than the part lighted by the sun.

Blue rays falling upon a Red stuff, make it appear Violet.

Blue rays falling upon an Orange stuff, make it appear of a Brown having an exceedingly pale tint of Violet, if the glass transmits Violet rays with the Blue.

Blue rays falling upon a Yellow stuff, make it appear Green; if the rays are transmitted by a deep Blue glass, coloured with oxide of cobalt, the stuff will appear of a Brown, having a Violet tint, less apparent if the light is vivid.

Blue rays falling upon a Green stuff, make it appear of a Blue-Green; but feebler than when they fall upon a White stuff.

Blue rays falling upon a deep Indigo stuff, make it appear of a dark Blue-Indigo.

Blue rays falling upon a Violet stuff, make it appear of a dark Blue-Violet.

(268.) 6°. *Modifications produced by Violet Light.*

Violet rays falling upon a Black stuff, render it of a very faint Violet-Black.

Violet rays falling upon a White stuff, make it appear Violet.

Violet rays falling upon a Violet stuff, make it appear of a deeper Violet.

Violet rays falling upon a Red stuff, make it appear of a Red-Violet-Purple.

Violet rays falling upon an Orange stuff, make it appear of a light Red.

Violet rays falling upon a Yellow stuff, make it appear Brown with an exceedingly pale tint of Red.

Violet rays falling upon a Green stuff, make it appear light Purple.

Violet rays falling upon a Blue stuff, make it appear of a fine Violet-Blue.

Violet rays falling upon a dark Indigo stuff, make it appear of a very deep Violet-Blue.

(269.) It is understood that to represent the preceding phenomena correctly we must take into account: the facility with which coloured light penetrates every kind of glass—the colour more or less intense of the stuff upon which the coloured light falls—and the kind of scale to which the coloured stuff and that of the transmitted coloured light respectively belong.

ARTICLE 2.

Modifications produced by two Lights of different Intensity.

(270.) I shall distinguish two modifications of this kind.

1. The modification produced by the light of the sun falling upon one part of the surface of a coloured body, while the other part is lighted by diffused daylight.

2. The modification produced when two parts of the same object are unequally illuminated by diffused light.

1st MODIFICATION.

An Object lighted partly by the Sun, and partly by diffused Daylight.

(271.) To observe this kind of modification properly we must extend upon a table exposed to the sun a piece of stuff, A B, 2 1/2 inches square (Plate 3. fig.1.), and place in the middle a piece of Black wire *f,f*; then put parallel to this wire, and in the middle, between A and B, two blackened iron bands, *e, e*, and *g,g*, of about 3/10 of an inch in width. The extremity, *g*, is fixed upon a perpendicular plane, *h, h*, of 1 and 2/10 of an inch in length, and sufficiently high, so that *f,f*, being in the plane of the direction of the solar rays, the plane *h, h*, covers exactly with its shadow all the part B of the stuff.

(272.) 1°. *If the stuff is Red,* the lighted portion A is more Orange or less Blue than the part B, which is

in shade; and the portion *a* is more Orange than the portion *a*, as the portion *b* is Bluer or more Crimson than the portion *b*.

(273.) 2°. *If the stuff is Orange,* the lighted part is more Orange or less Grey than the part which is in the shade, and the portion *a* is deeper, more vivid than the portion *a*, as the portion *b* is more Grey, and duller than *b*.

(274.) 3°. *If the stuff is Yellow,* the lighted part is more vivid, more Orange than the part which is in the shade; *a* is more so than *a*, as *b* is duller than *b*.

(275.) 4°. *If the stuff is Green,* the lighted part is less Blue or more Yellow than the part which is in the shade; and the portion *a* is of a yellower Green than the portion *a'*, as the portion *b* is Bluer than *b'*.

(276.) 5°. *If the stuff is Blue,* the lighted part is less violet or more Green than the part which is in the shade; and the portion *a* is greener than the portion *a'*, as *b* is more Violet or less Green than *b'*.

(277.) 6°. *If the stuff is Indigo,* the lighted part is redder or less Blue than the part in the shade; and the portion *a* is redder than the portion *a'*, as the portion *b* is deeper or Bluer than the portion *b'*.

(278.) 7°. *If the stuff is Violet,* the lighted part is redder or less Blue than the part in the shade; and the portion *a* is redder than the portion *a'*, as *b* is bluer than *b'*.

IInd MODIFICATION.

Two contigous parts of the same object viewed simultaneously, when they are unequally lighted by the same diffused Light, differ from each other not only in height of tone, but also in the optical composition of Colour.

(279.) Although this modification cannot be essentially different to the preceding, nevertheless, seeing the disposition there has been hitherto to neglect it, it will, I believe, be useful to describe how we can observe it, and repeat in what direction are the modification of Red, Orange, Yellow, Green, Blue, and Violet.

Place half a sheet of coloured paper (Plate 3. fig.2.) upon the partition *b*, of a chamber, receiving diffused daylight by a window, *f:* place another half-sheet upon the partition *a* in such a manner that it will be lighted directly by the diffused light; while the other is only indirectly lighted by the light diffused from the walls, floor, and ceiling; it being understood that the diffused light thus reflected must be only White light, then stand at *c,* so as to see both half-sheets at once. I shall designate that which is upon the partition *a*, and the most lighted, by A, and the other which is upon the partition *b*, and less lighted, by B, letters which in the plate indicate the respective positions of the half-sheets.

EFFECTS.

Red Colour.
The half-sheet B is deeper and more of a Crimson-Red, or less Yellow, than the half-sheet A.

Orange Colour.
The half-sheet B is deeper, and of an Orange redder or less Yellow than the half-sheet A.

Yellow Colour.
The half-sheet B is duller, and of a greener Yellow than the half-sheet A.

Green Colour.
The half-sheet B is deeper, and of a Green less Yellow or more Blue than the half-sheet A.

Blue Colour.
The half-sheet B is deeper, and of a Blue, I shall not say more Violet, but less Green than the half-sheet A.

Violet Colour.
The half-sheet B is deeper, and of a Violet less Red, or more Blue, than the half-sheet A.

(280.) The deduction from these observation is, that the colour of the same body varies not only in intensity or *tone,* but also in *hue,* according as it is lighted directly by the sun, by diffused daylight, or by diffused reflected light. This result must never be overlooked whenever we attempt to define the colours of material objects.

ARTICLE 3.

Modifications produced by diffused Daylight, reflected by a surface, all the parts of which are not in the same position relatively to the spectator.

(281.) Distant bodies are rendered sensible to the eye, only in proportion as they radiate, or reflect, or transmit the light which acts upon the retina.

According to the laws of reflection (for it is useless, in the object I propose to myself, to treat of cases where the light which penetrates the eye has been refracted), it happens that those portions of a surface which are in relief or intaglio, must reflect light in such manner that the eye of a spectator, in a given position, will see these parts very diversely lighted, with respect to the intensity of the reflected light, so that the parts of this surface will be, relatively to the eye, in the same condition as the homogeneous parts of a plane surface, which are illuminated by lights of unequal intensity.

There will be this difference nevertheless; that the parts of the surface of a body which appears to us in intaglio, or especially in relief, being but feebly varied in the greater number of contigous parts, there will generally be a gradual diminution in the effects which were presented to us by the case where the modifications which appear when two plane homogeneous surfaces are lighted by diffused lights of unequal intensity. The sphere presents a remarkable example of the manner in which light is distributed upon a convex surface relatively to the eye of an observer who view it from a given position.

(282.) I shall not occupy myself with this gradation of white light between parts illuminated thereby and those which do not appear so, I only regard the principal modifications, and take for examples the cases where they are as apparent as possible. These modifications may be reduced to the four following:

1st MODIFICATION, *produced by the maximum of white light which the surface of a coloured body is capable of reflecting.*

(283.) Other things being equal, the more the surface of a body is polished the more it will reflect white and

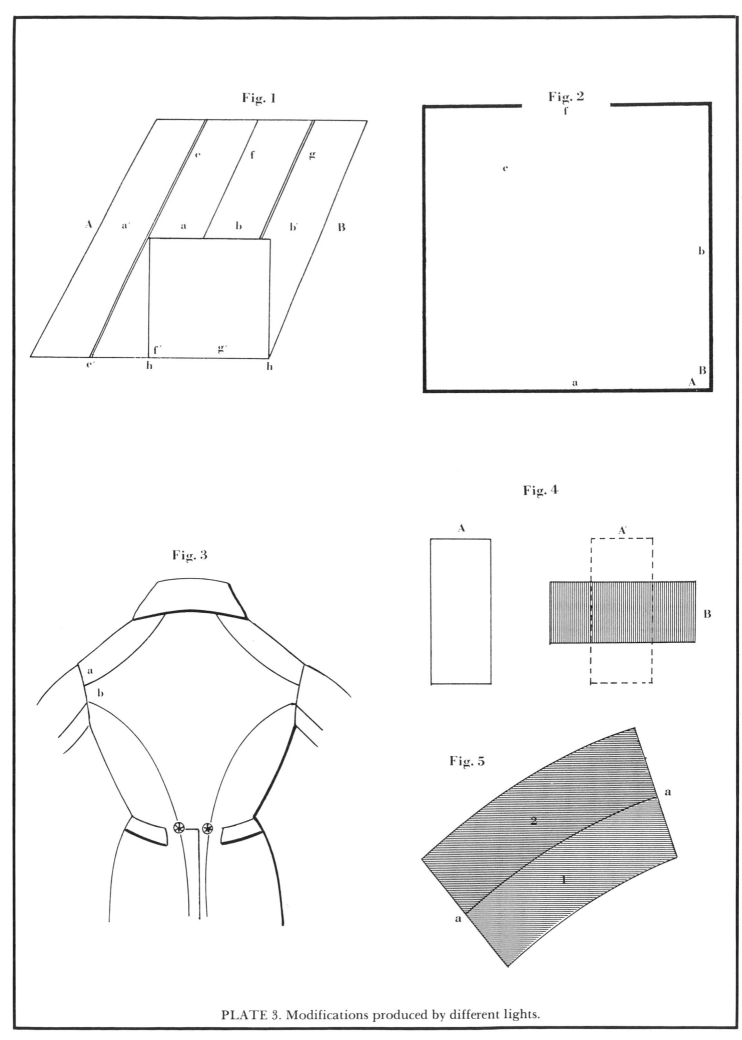

Fig. 1

Fig. 2

Fig. 3

Fig. 4

Fig. 5

PLATE 3. Modifications produced by different lights.

coloured light: thus, a stick of red sealing-wax when broken, presents in the fractured parts a duller and more tarnished colour than the outside. On the other hand, if we observe this same outside surface suitably placed, we shall perceive a white stripe parallel to the axis of the cylinder, produced by a quantity of colourless reflected light, so considerable that the red light reflected from this stripe is insensible to the eye which observes it. The white light reflected by a coloured body can therefore be of sufficient intensity to render the colour of the body invisible in some parts.

2nd MODIFICATION, *produced by those parts of a coloured surface which send to the eye, in proportion to the coloured light, less of white light than the other parts differently lighted, or differently placed in relation to the spectator.*

(284.) When the eye sees certain parts of the surface of a polished coloured object, or one more or less smooth if not polished, which reflects, proportionally to the coloured light, less white light than the other parts differently illuminated, or differently placed in relation to the spectator, the first parts will appear, in most cases, of a more intense tone of colour than the second.—We will cite the following

Examples.

1. *Example.* A cylinder of red sealing-wax presents, starting from the white stripe mentioned above, a red colour, deeper in proportion as less white light reaches the eye. Thus, in a certain position where the white stripe appears to be in the middle of the cylinder, the part most lighted will appear coloured, reflecting a red inclining to scarlet, while that which is the least lighted, reflects a red inclining to crimson.

2. *Example.* If the eye is directed into a gold vase of sufficient depth, the gold does not appear yellow, as on the exterior surface, but of a red-orange, because less white light in proportion to coloured light reaches the eye in the first case than in the second. It is for this reason that the concave parts of gold ornaments appear redder than the convex.

3. *Example.* The spiral thread of a piece of twisted silk or wool held perpendicularly before the eye, so that it can be viewed in a direction opposite to the light, appears of a colour much more decided than the rest of the surface.

4. *Example.* The folds of bright draperies present the same modification to an eye properly placed: the effect is particularly remarkable in yellow silk stuffs, and in sky-blue; for we can easily understand that it is less marked when the stuffs are not so bright, and of dark colours.

Opposite page:
PLATE 3. Figure 1 illustrates a way of studying the effects of sunlight and diffused daylight on colors (271.). Figure 2 proposes a "chamber" in which lighting effects on colors placed on different walls could be studied (279.). Figure 3 illustrates different effects of daylight on a blue coat (287.), (299.). Figure 4 describes afterimage effects when colors are overlapped at right angles (138.). Figure 5 concerns contrast effects of colors of different tones placed in juxtaposition (333.).

5. *Example.* There are some stuffs which appear to be of two tones of the same scale of colour, and sometimes also of two tones of two contiguous scales, although the weft and the warp of these stuffs are of the same tone and the same colour. The cause of this appearance is very simple: the threads which, parallel to each other, form the design, are in a different direction to the threads which constitute the ground of the stuff. Thence, whatever may be the position of the spectator with regard to the stuff, the threads of the design will always reflect coloured and white light in a different proportion to the threads of the ground; and according to the position of the spectator, the design will appear to be now lighter, now darker, than the ground.

3rd MODIFICATION, *produced when one part of the surface of an object, coloured or not coloured, reflects little or no light to the eye of the spectator.*

(285.) When one part of the surface of a body which is in the field of vision of the spectator sends little or no light to his eyes, either because this part is not directly lighted, or because the light it reflects is not in a suitable direction, then it appears black, or more or less dark.

4th MODIFICATION. *The colour complementary to that of a coloured object, developed in one of its parts in consequence of simultaneous contrast.*

(286.) A natural consequence of the law of simultaneous contrast in general, and of the effect of a colour upon grey and black in particular, is, that since the same object presents some parts more or less obscure, contiguous to parts where we see the colour peculiar to the object, the first part will appear tinted with the complementary to this colour; but to observe this effect, it is necessary that the grey part reflects to the eye white light, and little or none of the coloured light which the object naturally reflects.

(a.) 4th *Modification in a single-coloured stuff.*
(287.) For example, if the eye is directed from the back of a chamber towards a window which admits daylight, and a person clothed in a new blue coat, dyed with indigo or Prussian blue, looks through the window at objects outside (Plate 3. fig. 3.), the eye will see the part *b* of the coat different from the part *a*, because the nap of the cloth is disposed in a contrary direction to *b* in *a*: *a* appears of a fine blue, while *b* will be of an orange-grey, by the effect of contrast of the blue part with a part that reflects very little white light to the eye, without, or almost without, blue light.

Besides, the pile of the nap loses it regular position; in fact, as it wears, the cloth becomes dull and tarnished, the coloured light is reflected irregularly from all points, and if the effect is not absolutely destroyed, it is at least much weakened.

If the garment be of a deep green, the grey part will appear reddish: if it be of a violet-maroon or claret, the grey part will appear yellow.

(288.) The complementary is only developed upon cloths of dark and sombre colours; thus, red, scarlet, orange, yellow, and light-blue garments, do not exhibit it, because they have always too much of the essential colour which is reflected. The modification is limited

to that where one of the parts is more strongly illuminated by diffused light than the other (279.).

(289.) It is superfluous to remark that in a drapery where the pile lies all in one direction, but which exhibits folds, these, in changing the direction of the nap, may determine the modification presented by blue and dark-green clothes, as also by violet-maroon.

(290.) There is still another circumstance where the fourth modification will appear evident; it is when we look upon a series of light tones, blue, rose, &c. (belonging to the same scale), of a skein of silk or wool placed upon an easel in such manner that one half of the same skein presents to the eye the threads disposed in a contrary direction to those of the other half. The half of the skein which does not reflect coloured light to the eye appears tinted with the complementary of the other half which does reflect it.

(b.) 4th *Modification in a stuff presenting a deep and a light tone belonging to the same scale.*

(291.) If we place in juxtaposition a deep tone and a light tone of the same scale well assorted, the light tone will appear of the colour complementary to the scale to which it belongs. This modification is too important in the explanation of certain phenomena often exhibited by the products of the calico-printer to permit of my passing it over hastily.

(292.) When we look for several seconds on a fabric dyed with a coloured ground, and on which we put patterns intended to be white, but which, owing to the imperfection of the process employed, retain a light tone of the colour of the ground, the patterns will appear of the complementary to this latter. Thus, upon a ground of yellow chromate of lead, they will appear *violet;* upon a ground of orange chrome they will appear *blue; rose* upon a green ground, &c.: to dispel the illusion, and recognise the true tint of the pattern, it is only necessary to cover the ground with paper perforated with the design of the pattern, which then permits us to see only the pattern coloured like the ground. The influence of the dark tone upon a feeble tone is then such that not only is the latter neutralised, but also the place it occupies upon the cloth appears tinted with its complementary colour.

(293.) From the preceding observations, it may be deduced that we may have a printed cotton, the design of which, although coloured, will appear to most eyes white, and not of the complementary of the ground. For those eyes which see it thus, the perception of the phenomenon of contrast will correct the imperfection of the art of the calico-printer.

(294.) In the lectures upon Contrast which I gave in 1836 at the Gobelins, I remarked that, in applying paper (cut for the purpose) upon the lights of a blue drapery of the Virgin, in a tapestry representing the *Holy Family,* after Raphael, we saw them of blue light, although, when they were seen surrounded with deeper blue tones, they appeared of an orange tint.

(295.) In conclusion, the fourth modification is observed:

 1. Every time that a monochromous object of a dark and not very vivid colour is seen in such manner that one portion reflects to the eye its peculiar colour, while the other portion reflects only a feeble light scarcely coloured.

 2. Every time that a stuff presents two suitably distant tones of the same colour.

(296.) We can conceive, without difficulty, that if the modification is not manifested with monochromous objects of vivid colours, as yellow, scarlet, &c., it is because that part of the surface of these objects which reflects the least light to the eye reflects, nevertheless, always sufficient of its peculiar colour to neutralise the complementary which the coloured light of the illuminated portion tends to develop. If I am not deceived, I believe that this effect tends to enfeeble the coloured light of the shaded part.

(297.) Although in this chapter I do not propose to treat of the modifications presented by coloured stuffs with white patterns, yet, as it is a case which belongs to the developments in which I am engaged, I cannot avoid mentioning them in this place. If we observe a sky-blue silk with white flowers, the weft of which is in an opposite direction to the weft of the blue ground, we shall see the flowers white, if they are placed in the most favourable manner to receive the white light reflected by them: while, in the contrary position, we shall see these flowers absolutely orange. There is still much white light reflected; but it is not sufficiently vivid to neutralise the development of the complementary of the ground.

(298.) In painting, we recognise two kinds of perspective, the *linear* and the *aerial.*
The first is the art of producing, upon a plane surface, the outlines and contours of objects and their various parts in the relations of position and size in which the eye perceives them.
The second is the art of distributing, in a painted imitation, light and shade, as the eye of the painter perceives them in objects placed in different planes, and in each particular object which he wishes to imitate upon a surface.
It is evident that aerial perspective comprehends the observation and reproduction of the principal modifications of colours which I have just examined in succession, and that *true and absolute colouring* in painting can only be as faithful a reproduction of this as possible.

CHAPTER II.

ON THE DIFFERENCE EXISTING BETWEEN A COLOURED OBJECT AND THE IMITATION OF IT MADE BY A PAINTER, WHEN THE SPECTATOR OBSERVES IT FROM A DIFFERENT POINT OF VIEW FROM HIS.

(299.) There is a vast difference between the most perfect imitation of a coloured object and the object itself, upon which we will now dwell a moment, because it is not sufficiently appreciated. Imitation is true, relative to delineation, the distribution of light and shade, and all the resulting modifications of colour, only in the same position where the painter stood in regard to his model: for out of this position, everything relatively to the spectator varies, more or less; while in the imitation he sees the light, shadows,

and lines which circumscribe them, and the modifications of colour, constantly in the same manner, whatever be the point of sight.

For example: a spectator who, in a room opposite a window, observes the back of a person in a new blue coat (Pl.3. fig.3.), which is placed between him and the window, the part *a* of the coat is blue, and the part *b* an orange-grey. Let the spectator advance in such manner as to see the profile of the person; if, then, he looks at the parts *a* and *b*, they will appear to him different from what they were before he changed his position.*

If the painter had painted the coat from the point of view where the spectator was at first, he would have coloured the part *a* of a bright blue, and the part *b* probably of an orange-grey.

If, now, the spectator regards the imitation of the coat from the second position, when he saw the person in profile, he will still see the part *a* blue, and the part *b* of an orange-grey, although in this position the model coat no longer presents these modifications.

Besides, I must insist upon demonstrating a thing which is really very simple.

In fine, because lights, shades, and modifications of colours, and the outlines which circumscribe each part, preserve invariably the same relation in a picture made upon a plane, it evidently follows that this imitation produces the same impression, although we observe it from very different points from that where the painter was placed to represent his model.

(300.) It is for this reason, also, that a person who looks at the painter while he is painting his portrait on the canvas, appears in this portrait to look at the spectator, whatever may be the position of the latter with regard to the picture.

*There is a position where the spectator will see the part *a* of an orange-grey, and the part *b* of a bright blue.

SECTION II.

PAINTING ON THE SYSTEM OF FLAT TINTS.

(301.) In painting in flat tints, the colours are neither shaded nor blended together, nor modified by the coloured rays coming from objects near those imitated by the painter.

In pictures which belong to this kind of painting, the representation of the model is reduced to the observance of liear perspective, to the employment of vivid colours in the foreground, and to that of pale and grey colours in the more distant planes.

If the choice of contigous colours has been made in conformity with the law of simultaneous contrast, the effect of the colour will be greater than if it had been painted on the system of *Chiar'oscuro*. When, therefore, we admire the beauty of the colours of the paintings in flat tints which come from China, we must, in comparing them exactly with ours, take into consideration the system followed in them, otherwise we should exercise an erroneous judgment by comparing pictures painted on different systems.

(302.) If it be indisputable that painting in flat tints preceded that in chiar'oscuro, it will, I think, be an error to believe that at the point we have arrived at in Europe, we must renounce to first to practise the second exclusively, for in every instance where painting is an accessory and not a principal feature, painting in flat tints is in every respect preferable to the other.

(303.) The essential qualities of painting in flat tints necessarily consist in the perfection of the outlines and colours. These outlines contribute to render the impressions of colours stronger and more agreeable, when, circumscribing forms clothed in colours, they concur with them in suggesting a graceful object to the mind, although in fact, the imitation of it does not give a faithful representation.

(304.) We may, in conformity with what has been said, consider that painting in flat tints will be advantageously employed,

1. When the objects represented are at such a distance that the finish of an elaborate picture would disappear.

2. When a picture is an accessory, decorating an object whose use would render it improper to finish it too highly, on account of its price—such are the paintings which ornament screens, workboxes, tables, &c.—in this case, the objects preferable as models are those whose beauty of colours and simplicity of form are so remarkable, as to attract the eye by outlines easily traced, and by their vivid colours: as birds, insects, flowers, &c.

SECTION III.

ON COLOURING IN PAINTING.

CHAPTER I.—ON THE VARIOUS SIGNIFICATIONS OF THE WORD COLOURING IN PAINTING AND IN ORDINARY LANGUAGE.
(305.)—(322.)

CHAPTER II.—UTILITY OF THE LAW OF SIMULTANEOUS CONTRAST OF COLOURS IN THE SCIENCE OF COLOURING.
(323.)—(366.)

SECTION III.
COLOURING IN PAINTING.

CHAPTER I.

ON THE VARIOUS SIGNIFICATIONS OF THE WORD "COLOUR-ING" IN PAINTING AND IN ORDINARY LANGUAGE.

(305.) I have elsewhere (298.) defined *true or absolute colouring* to be—the faithful reproduction in painting of the modifications which light enables us to perceive in the objects which the painter selects for his models. But for want of analyzing these modifications, the word *colouring* usually defined—*the result of the application, upon a plane surface, of coloured materials (pigments) with which the painter imitates a natural, or represents an imaginary object*—receives in its applications to the simplest as well as to the most complex pictures (when we regard them under the twofold relation of the number of colours employed, and of the number of objects painted), significations so diverse, according to the kind of pictures, the taste and knowledge of the persons using this word, that my object will not be attained if to the various significations it has in ordinary language, I do not apply the analysis which I have made of the different elements of *absolute colouring*.

(306.) After what has been stated, I believe that in the ordinary use of the word *colouring*, we allude to the manner, more or less perfect, in which the painter has complied with the rules—

1. *Of aerial perspective relative to white light and to shade, or, in other words, irrespective of colour;*
2. *Of aerial perspective relative to variously coloured light;*
3. *Of the harmony of local colours, and of that of the colours of the different objects composing the picture.*

ARTICLE 1.

Of colouring *with regard to aerial perspective, relative to white light and to shade.*

(307.) We must not suppose that the employment of many colours in a composition is indispensable to give the name of *colourist* to the artist, for in painting in *camaieu*, the simplest of all, in which we only distinguish two colours, including white, the artist will be honoured with the title of *colourist*, if his work presents lights and shades distributed as they are upon the model, leaving out, of course, those modifications arising from colours which he had not on his palette. And, to convince ourselves that the expression is not inaccurate, it will suffice to remark that the model might very well appear to the painter coloured in a single colour, modified by light and shade; in the same sense this name can always be applied to the engraver, who by means of his burin, reproduces a picture as faithfully as possible in respect both to the aerial perspective of its different planes, and to the relief of each particular object.

ARTICLE 2.

Of colouring *with regard to aerial perspective, relative to variously coloured light.*

(308.) It may happen that the imitation is perfectly faithful, or the reverse.

A. *Perfectly faithful imitation.*

(309.) A picture in which the aerial perspective is faithfully reproduced, with all its modifications of white and coloured light and of shade, has a *true or absolute colouring* (298.); but I do not pretend to conclude that the imitation in which this quality is found will be universally judged as perfect as that in which this quality is not found, at least in the same degree.

B. *Imperfectly faithful imitation.*

(310.) This is the place to examine the principal cases which may occur when we observe pictures in which the modifications of differently coloured light are not faithfully imitated.

(311.) FIRST CASE.—*A painter has perfectly seized upon all the modifications of white and coloured light, but in his imitation all the modifications, or a part only, are more prominent than in nature.*

It almost always happens that *true, but exaggerated, colouring* is more agreeable than *absolute colouring*; and we cannot disguise the fact that many persons who experience pleasure in seeing the modifications of exaggerated coloured light in a picture, do not feel the same pleasure from the sight of the model, because the modifications corresponding to those which are imitated in excess, are not sufficiently prominent to be evident to them.

Besides, the relish of the eye for an excess of the exciting cause is essentially analogous to the inclination we have for food and drink of a flavour and odor more or less prominent; and this result is conformable to the comparison I have established (174.) between the pleasure we experience at the sight of vivid colours, leaving out every other quality in the object presenting them, and the pleasure resulting from the sensation of agreeable savours.

In our judgment of a picture whose colours appears *exaggerated,* and which is not in the place for which the

painter destined it, we must not forget to take into account the light of the place which it is to occupy, and the distance from which the spectator views it, otherwise we incur the risk of greatly deceiving ourselves.

(312.) SECOND CASE.—*A painter has perfectly seized all the modifications of light which bring forward the planes and the relief of objects; the modifications of the coloured light of his picture being true, but the colours not those of his model.* This case comprehends those pictures posessing a dominant colour which is not in the model. This dominant colour is often called *the tone of the picture, and the tone of the painter,* if he uses it habitually.

We should form a very correct idea of these pictures if we supposed that the artist had painted them while looking at his model through a glass of precisely the same colour, to enable him to perceive the tint which predominates in his imitation. We can also cite, as an example of this kind of imitation, a landscape painted from its reflection in a black mirror, because the effect of the picture is very soft and harmonious.

We also understand how it happens that a picture comprised under this head may have an agreeable or disagreeable dominant colour; and that the expressions *brilliant or warm colouring* or *cold and dull colouring* apply to those pictures the colours of which are unfaithful to the model, but which have an agreeable or disagreeable effect.

ARTICLE 3.

Of colouring *in respect to the Harmony of Local Colours and to that of the Colours of the different Objects composing the Picture.*

(313.) The colouring of a picture may be *true* or *absolute;* and yet the effect may not be agreeable, because the colours of the objects have no harmony. On the contrary, a picture may please by the harmony of the local colours of each object, by that of the colours of objects contiguous to each other, and yet may offend by the gradation of the lights and shades, and by the fidelity of the colours. In a word, it offends by *true or absolute* colouring; and the proof that it might please is, that pictures in flat tints, the colours of which are perfectly assorted to the eye, although contrary to those which we know belong to the objects imitated, produce, under the relation of general harmony of colours, an extremely agreeable effect.

Result of the preceding Considerations.

(314.) The general conclusion resulting from the analysis just made of the word Colouring in ordinary language is, that the epithet *Colourist* may be applied to painters endowed in very different degrees with the faculty of imitating coloured objects by means of painting.

(315.) They who know all the difficulties of drawing and *chiar'oscuro* will give the name of Colourist to painters remarkable for the skill with which they bring out objects placed upon the different planes of their pictures, by means of correct drawing, and a skillful gradation of light and shade, even when their pictures do not exactly produce every modification of coloured light, and have not that harmony of different colours

properly distributed to complete the effects of perfect colouring.

(316.) They who have no skill in judging of painting, or who are ignorant of the art of *chiar'oscuro,* are generally inclined to refuse the title of Colourist to those painters of whom we have spoken, while they unhesitatingly accord it to others who have reproduced the modifications of coloured light and tastefully distributed the different colours in their pictures. Besides, colour so powerfully influences the eye, that frequently those who are strangers to painting can conceive a Colourist skillful only when his tints are vivid, although he may have failed in the manner in which he has represented differently-coloured objects upon the canvas.

(317.) We see, by this, how the judgment of many persons brought to bear upon the same picture, will differ from each other, according to the importance they respectively attach to one quality of colouring rather than to another.

(318.) Let us now consider what a perfect Colourist must be, or rather the conditions which every painter must fulfill in a picture, to whom this qualification can be applied.

(319.) For a painter to be a perfect Colourist, he must not only imitate the model by reproducing the image faithfully, in respect to aerial perspective relative to the variously coloured light, but also, the harmony of tints must be found in the local colours, and in the colours of the different objects imitated; and this is the place to remark, that if in every composition there are colours inherent to the model which the painter cannot change without being unfaithful to nature, there are others at his disposal which must be chosen so as to harmonize with the first. It is a subject to which we shall return in the next chapter (343.).

(320.) I have now defined what a painter, a perfect Colourist, is—conformably to the analysis I have made of the word *Colouring;* and regarded the painter by himself—that is to say, without comparing him with others; we must now consider this definition in relation to contemporary painters and those old enough for their pictures to have undergone some change, and that the varnish covering them is more or less yellow.

(321.) It is evident that, when the pictures have been recently painted, and they represent familiar objects, we can always see if the painter has fulfilled all the conditions of a perfect Colourist, by comparing the model with his representation.

(322.) After what has been said, it is evident that when a change in the colours of a picture has been effected by time, it is impossible to determine whether the artist who painted it should be called a *perfect Colourist* (319.). But if we recall what I have said of the painter who has correctly seized all the modifications of light adapted to bring out the distances and the relief of objects—who has represented the modifications of coloured light with perfect truth, but which are not those of the model (312.), we may very easily conceive how, at this day, after one, two, or three centuries, we can give the name of *Colourist* to Albano, Titian, Rubens, and others.

In fact, at the present day, the pictures of these great

masters present to us gradations of light and shade more or less perfect, and such harmonies of colours, that it is impossible to misjudge and not to admire them; and the idea that so many pictures not more than twenty or twenty five years old, painted by artists of undoubted skill, have lost more in colour than the preceding, also increases our admiration for the latter.

CHAPTER II.

UTILITY OF THE LAW OF SIMULTANEOUS CONTRAST OF COLOURS IN THE SCIENCE OF COLOURING.

(323.) After having defined the principal modifications which bodies experience when they become apparent by means of the white or coloured light they reflect; after having examined painting, and defined colouring conformably with the study of these modifications—it remains for me to speak of the law of contrast of colours with respect to the advantages the painter will find in it when he requires:

1. To perceive promptly and surely the modifications of light on the model.

2. To imitate promptly and surely these modifications.

3. To harmonize the colours of a composition, by having regard to those which must necessarily be found in the imitation, because they are inherent to the nature of the objects which he must reproduce.

ARTICLE 1.

Utility of this Law is enabling us to perceive promptly and surely the Modifications of Light on the Model.

(324.) The painter must know, and especially *see*, the modifications of white light, shade, and colours which the model presents to him in the circumstances under which he would reproduce it.

(325.) Now what do we learn by the law of *simultaneous contrast of colours?* It is, that when we regard attentively two coloured objects at the same time, neither of them appears of its peculiar colour, that is to say, such as it would appear if viewed separately, but of a tint resulting from its peculiar colour and the complementary of the colour of the other object. On the other hand, if the colours of the objects are not of the same tone, the lightest tone will be *lowered*, and the darkest tone will be *heightened;* in fact, by juxtaposition they will appear different from what they really are.

(326.) The first conclusion to be deduced from this is, that the painter will quickly appreciate in his model the colour peculiar to each part, and the modifications of tone and of colour which they may receive from contiguous colours. He will than be much better prepared to imitate what he sees, then if was ignorant of this law. He will also perceive modifications which, if they had not always escaped him because of their feeble intensity, might have been disregarded because the eye is susceptible of fatigue, especially when it seeks to disentangle the modifications the cause of which is unknown, and which are not very prominent.

(327.) This is the place to return to *mixed contrast* (81. and following), in order to make evident how the

painter is exposed to seeing the colours of his model inaccurately. In fact, since the eye, after having observed one colour for a certain time, has acquired a tendency to see its complementary, and as this tendency is of some duration, it follows, not only that the eyes of the painter, thus modified, will see the colour which he had looked at for some time incorrectly, but will also see another which strikes them while this modification lasts. So that, conformably to what we know of mixed contrasts (81. &c.), they will see—not the colour which strikes him in the second place,—but the result of this colour and of the complementary of that first seen. It must be remarked, that besides the defect of clearness of view which will arise in most cases from the want of exact coincidence of the second image with the first,— for example, the eye has seen a sheet of green paper A (Pl. 3. fig. 4.), in the first place, and in the second place regards a sheet of blue paper B of the same dimensions, but which is placed differently—it will happen that this second image, not coincident in all its surface with the first, A', as represented in the figure, the eye will see the sheet B violet only in the part where the two images coincide. Consequently this defect of perfect coincidence of images will be an obstacle to the distinct definition of the second image and of the colour which it really possesses.

(328.) We can establish three conditions in the appearance of the same object relative to the state of the eye; in the first, the organ simply perceives the image of the object without taking into account the distribution of colours, light, and shade; in the second, the spectator, seeking to properly understand this distribution, observes it attentively, and it is then that the object exhibits to him all the phenomena of simultaneous contrast of tone and colour which it is capable of exciting in us. In the third circumstance, the organ, from the prolonged impression of the colours, possesses in the highest degree a tendency to see the complementary of these colours; it being understood that these different states of the organ are not interrupted, but continuous, and that, if we examined them separately, it was with the view of explaining the diversity of the impression of the same object upon the sight, and to make evident to painters all the inconveniences attendant upon a too prolonged view of the model.

I have no doubt that the dull colouring with which many artists of merit have been reproached, is partly due to this cause, as I shall show more minutely hereafter (366.).

ARTICLE 2.

Utility of this Law in order to imitate promptly and surely the Modifications of Light on the Model.

(329.) The painter, knowing that the impression of one colour beside another is the result of the mixture of the first with the complementary of the second, has only to mentally estimate the intensity of the influence of this complementary, to reproduce faithfully in his imitation the complex effect which he has under his eyes. After having placed upon his canvas the two colours he requires, as they appear to him in the isolated state, he will see if the imitation agrees with his model; and, if he is not satisfied, he must then recognise

the correction which has to be made. Take the following examples:

1st EXAMPLE.

(330.) A painter imitates a white stuff with two contiguous borders, one of which is red, the other blue; he perceives each of them changed by virtue of their reciprocal contrast; thus the red becomes more and more orange, in proportion as it approaches the blue, as this latter takes more and more green as it approaches the red. The painter, knowing by the law of contrast the effect of blue upon red, and reciprocally, will always reflect that the green hues of the blue, and the orange hues of the red, result from contrast, consequently in making the borders of simply red and blue, reduced in some parts by white or by shade, the effect he wishes to imitate will be reproduced. In case it is found that the painting is not sufficiently marked, he is sure of what he must add without departing from the truth, otherwise he will exaggerate a little (311.)

2nd EXAMPLE.

(331.) A grey pattern drawn upon a yellow ground— the ground may be of paper, silk, cotton, or wool; according to contrast, the design will appear of a lilac or a violet colour (66.)

The painter who would imitate this object, which I suppose to be a tapestry, a vestment, or any drapery whatever, can reproduce it faithfully with grey.

(332.) These two examples are appropriate to explain the difficulties encountered by painters who are ignorant of the law of contrast of colours.

For, the painter, ignorant of the reciprocal influence of blue and red, is of opinion that he must represent what he sees; consequently he adds green to his blue, and orange to his red; as, in the second example, he will trace a pattern more or less violet upon the yellow ground; now what will happen? Why, the imitation can never be perfectly faithful; it will be exaggerated; supposing, of course, that at first the painter had perfectly seized the modifications of the model, and subsequently having perceived the exaggeration of his imitation, he has not retouched it sufficiently to produce a perfectly faithful effect. If he had arrived at this latter result, it is evident it would only be after more or less trials, as he will have to efface what was first done.

3rd EXAMPLE.

(333.) I cite a third example of the influence of contrast, no longer relating to colours like the two preceding; but relative to the different tones of the same colour, which are contiguous to each other.

Several bands in juxtaposition, 1, 2, 3, 4 (Pl.I. fig.3.*bis.*), of different tones in flat tints of the same scale, form part of an object which a painter has to reproduce in a picture; to imitate it perfectly, it is evident that he must paint in flat tints; but this object will appear to the eye a channelled surface, the line where the two bands touch will appear like a relief by the effect of contrast of tone (9.—11.), it follows if the painter is ignorant of this, he will reproduce, not an absolute copy of the model, but an exaggerated one; or if, dissatisfied with his first imitation, he arrives at a faithful reproduction of the model, it will be after

attempts more or less numerous. I the more willingly cite this example, because it gave me the opportunity of making one of the most skillful paper-stainers appreciate the utility of the law of simultaneous contrast. In going with him over his factory, he showed me a chimney-board representing a child whose figure stood out from a ground formed of two circular bands in grey flat tints 1 and 2 (Plate 3. fig.5); the first was lighter than the second; the phenomenon of contrast of tone was manifested at the edges *a, a,* of the two bands, in such a manner, that the part of the band 2 contiguous to the band 1, appeared deeper than the rest, as the part of the band 1, contiguous to 2, was lighter than the rest, conformably to what has been stated above (11.). This effect not being what the skillful artist wished to obtain, he inquired of me how it was to be avoided. I replied that the grey of the band 2 must be reduced with white in proportion as it approached the edge *a, a,* and, on the contrary, to strengthen with black in proper gradations the grey of the band 1, setting out from the same edge, and I proved to him *that to imitate the model faithfully, we must copy it differently from what we see it.*

(334.) The manner in which I have examined contrast must convince the painter of the correctness of the six following principles.

1st *Principle.*

(335.) Put a colour upon a canvas, it not only colours that part of the canvas to which the pencil has been applied, but it also colours the surrounding space with the complementary of this colour. Thus:

(*a.*) A Red circle is surrounded with a Green aureola, which grows weaker and weaker, as it extends from the circle.

(*b.*) A Green circle is surrounded with a Red aureola.

(*c.*) An Orange circle is surrounded with a Blue aureola.

(*d.*) A Blue circle is surrounded with an Orange aureola.

(*e.*) A Yellow circle is surrounded with a Violet aureola.

(*f.*) A Violet circle is surrounded with a Yellow aureola.

2nd *Principle.*

(336.) To place White beside a colour is to heighten its tone; it is the same as if we took away from the colour the white light which enfeebled its intensity (44.—52.).

3rd *Principle.*

(337.) Putting Black beside a colour, lowers its tone; in some cases it impoverishes it, such is the influence of Black upon certain Yellows (55.). It is, in fact, to add to Black the complementary of the contiguous colour.

4th *Principle.*

(338.) Putting Grey beside a colour renders it more brilliant, and at the same time it tints this Grey with the complementary of the colour which is in juxtaposition (63.).

From this principle it results that in many cases where Grey is near to a pure colour in the model, the painter, if he wishes to imitate this Grey, which appears to him tinted of the complementary of the pure

colour, need not have recourse to a coloured Grey, as the effect ought to be produced in the imitation by the juxtaposition of the colour with the Grey which is near it.

Besides, the importance of this principle cannot be doubted, when we consider that all the modifications which monochromous objects may present (excepting those which result from the reflections of coloured light emanating from neighbouring objects), belong to the different relations of position between the parts of the object and the eye of the spectator, so that it is strictly true to say, that to reproduce by painting all these modifications, it suffices to have a colour exactly identical to that of the model and black and white. In fact, with White we can reproduce all the modifications due to the weakening of the colour by light, and with Black, those which are necessary to heighten its tone. If the colour of the model in certain parts gives rise to the manifestation of its complementary, because these parts do not return to the eye sufficient of colour and white light to neutralize this manifestation, the modification of which I speak is reproduced in the imitation by the employment of a normal grey tone properly surrounded with the colour of the object.

If the preceding proposition be true, I recognize the necessity in many cases of employing, with the colour of the object, the colours which are near to it; that is to say, the hues of the colour. For example, in imitating a rose we can employ red tinted with a little yellow, and a little blue, or, in the other terms, tinted with orange and violet; but the green shadows which we perceive in certain parts arise from the juxtaposition of red and normal grey.

5th *Principle.*

(339.) To put a dark colour near a different, but lighter colour, is to raise the tone of the first, and to lower that of the second, independently of the modification resulting from the mixture of the complementaries.

An important consequence of this principle is that the first effect may neutralize the second, or even destroy it altogether: for example, a light Blue placed beside a Yellow, tinges it Orange, and consequently heightens its tone; while there are some Blues so dark relatively to the Yellow, that they weaken it, and not only hide the Orange tint, but even cause sensitive eyes to feel that the Yellow is rather Green than Orange; a very natural result, if we consider that the paler the Yellow becomes, the more it tends to appear Green.

6th *Principle.*

(340.) Put beside each other two flat tints of different tones of the same colour, Chiar'oscuro is produced, because in setting out from the line of juxtaposition the tint of the band of the highest tone is insensibly enfeebled; while setting out from the same line, the tint of the band of the lowest tone becomes heightened: there is then a true gradation of light (333.).

The same gradation takes place in every juxtaposition of colours distinctly different.

(341.) If I am not deceived, the observance of these principles, and especially the perfect knowledge of all the consequences of the last three, exercises a very happy influence upon the art of painting, in giving to the artist a knowledge of the colours which he cannot possess before the law of their simultaneous contrast has been developed, and followed in its consequences as it is now.

(342.) The painter, it appears to me, will gain not only in the rapidity with which he will see the model, but also in the rapidity and truth with which he will be able to reproduce the image. Among the details which he endeavors to render, there are many which, due to contrast either of colour or of tone, will produce themselves. I presume that the Greek painters, whose palette was composed of White, Black, Red, Yellow, and Blue, and who executed so many pictures which their contemporaries have spoken of with intense admiration, painted conformably to the simple method of which I speak; applying themselves to great effects, most of the minor ones resulted spontaneously.

ARTICLE 3.

Utility of the Law in order to harmonise the Colours which enter into a Composition with reference to those which must be reproduced, because they are inherent in the Nature of the Object represented.

(343.) In all, or nearly all the compositions delineated in painting, we must distinguish the colours which the painter is under the necessity of using, and those which he is at liberty to choose, because they are not, like the former, inherent in model (319.).

For example, in painting a human figure, the colour of the flesh, the eyes, and the hair, are fixed on the model, but the painter has a choice of draperies, ornaments, background, &c.

(344.) In a historical picture, the flesh colours are, in the majority of the figures, at the choice of the painter, as are also the draperies, and all the accessories, which can be designed and placed as desired.

(345.) In a landscape, the colours are given by the subject, yet not so arbitrarily but we can substitute for the true colour the colour of a neighbouring scale; the artist can choose the colour of the sky, imagine numerous accidental effects, introduce into his composition animals, draped figures, carriages, &c., the form and colour of which may be selected in such manner as to produce the best possible effect with the objects peculiar to the scene.

(346.) A painter is also master of his choice in a dominant colour, which produces upon every object in his composition the same effect as if they were illuminated by a light of the same colour, or, what amounts to the same thing, seen through a coloured glass (179.).

(347.) If the law of contrast affords different methods of imparting value to a colour inherent in the model, genius alone can indicate which method a painter should prefer to others in realizing his idea upon the canvas, and so render it evident to the sight.

(348. Whenever we would attract the eye by colours, doubtless the principle of *harmony of contrast* must be our guide. The law of simultaneous contrast indicates the our guide. means by which the pure colours may be

made to impart value to each other; means which, although spoken of, are but little understood, as may be seen in the crowd of portraits in badly assorted vivid tints, and in those numerous small compositions in tints broken with grey, where we look in vain for a pure tone, which, however, from the subjects represented, are eminently adapted for receiving all the vivid colours which the painter in flat tints employs.

(349.) The contrast of the most opposite colours is most agreeable, when they are of the same tone. But if crudity is feared, by using too great intensity of colours, we must have recourse to the light tones of their respective scales.

(350.) When the painter breaks tones with grey, and wishes to avoid monotony, or when upon planes which are distant, but not sufficiently so to render the differences of colour inappreciable, he wishes every part to be as distinct as possible, he must have recourse to the principle of harmony of contrast, and mix grey with his colours.

This method of bringing out a colour by contrast, in employing either light tones complementary or more or less opposed; or broken tones more or less grey, and of tints complementary to each other; or in employing a broken tone of a tint complementary to a contiguous colour more or less pure,—ought to particularly fix the attention of portrait painters. A portrait of a lady may have a very mediocre effect, because neither the colour of the dress nor of the background have been properly selected.

(351.) The portrait painter must endeavour to find the predominating colour in a complexion he has to paint; once found and faithfully represented, he must seek what among the accessories at his disposal will impart value to it. There is a very prevalent error that the complexion, in women, to be beautiful must consist only of red and white; if this opinion be correct for most of the women of our temperate climate, it is certain that, in warmer climes, there are brown, bronzed, copper-complexions even, endued with a brilliancy, I may say beauty, appreciated only by those who, in pronouncing upon a new object, wait until they have got rid of habitual impressions, which (although the majority of men do not know it) exercise so powerful an influence upon the judgment of objects seen for the first time.

(352.) I had at first intended to introduce here some examples of the colours most advantageous for setting off the complexions of women; but, upon reflection, I have preferred to include them in the section where I have treated of the application of the law of contrast to dress.

(353.) Suppose a painter would always derive the greatest possible advantage from colours without being under the necessity of multiplying them; if he had to paint the draperies of a single colour, he might have recourse advantageously to the coloured rays emanating from neighbouring bodies, whether they are perceptible to the spectator, or out of sight. For example, a green or yellow light falling upon part of a blue drapery makes it green, and by contrast, heightens the blue-violet tone of the rest; a golden yellow light falling on part of a purple drapery imparts to it a yellow tone, which makes the purple of the rest come out, &c.

(354.) The principle of harmony of contrast then procures for the painter who undertakes to produce the effects of chiar'oscuro, the means of realizing, with respect to brilliancy of colours and distinctness of parts, effects which the painter who graduates neither the shadows nor the lights, produces without difficulty by means of flat tints.

(355.) After having treated of the utility of the law of simultaneous contrast in the employment of pure opposite colours, and of colours broken by grey, opposed in the same manner, when we require to multiply pure and varied colours, either in objects whose very various parts permit this employment, or in a multitude of accessories, it remains for me to treat of the case where the painter, wishing less diversity in the object, less variety in the colours, employs only with reserve the *harmony of contrast*, preferring to it, the more easily to attain his end, the *harmony of scale* and the *harmony of hues*.

(356.) The greater the number of different colours and accessories in a composition, the more the eyes of the spectator are distracted, and the more difficulty is experienced in fixing the attention. If, then, this condition of diversity of colours and accessories is obligatory on the artist, the more obstacles there are to surmount when he wishes to draw and fix the attention of the spectator upon the physiognomy of the figures which he would reproduce, whether these figures represent the actors in one scene only, or whether they are simply portraits. In the latter instance, if the model has a common physiognomy, which recommends itself neither by the beauty nor expression of its features, and still more if he must conceal or dissemble a natural defect, all that is accessory to this physiognomy, all the resources of contrasted colours well assorted together, must come to the aid of the painter.

(357.) But if the inspired artist feels all the purity of expression, all the nobility and loftiness of character pertaining to his model, or if a physiognomy, to most eyes commonplace, strikes him by one of those expressions, which he judges to belong only to men animated by noble ideas in politics, science, arts, and literature, it is to the physiognomy of such models that he should address himself; upon these he should fix his chief attention, so that, in reproducing them upon his canvas, no one can mistake the resemblance, nor overlook the feeling which guided his pencil. Everything being accessory to the physiognomy, the drapery will be black or of sombre colours; if ornaments relieve them, they will be simple, and always in connection with the subject.

(358.) When from this point of view we examine the *chefs-d'oeuvre* of Vandyck, and trace the beauty of their effect to the simplicity of the means by which it is produced, and consider the elegance of their attitudes, which always appear natural, the taste which presides over the selection of the draperies, ornaments, in a word, all the accessories,—we are struck with admiration for the genius of the artist, who has not had recourse to those means of attracting attention so much abused at the present day, either by giving to the most

vulgar person a heroic attitude, to the most common-place physiognomy the pretence of profound thought, or in seeking extraordinary effects of light; for example, in filling the figure with a strong light while the rest of the composition is in shade.

(359.) These reflections fully indicate the point of view a historical painter must take when he would particularly fix the attention upon the physiognomy of the persons who take part in a remarkable scene. Only we must observe that the more he would employ allied scales, the more care he must take to choose such as do not lose too much by their mutual juxtaposition.

(360.) There is another important observation to make; which is to avoid as much as possible the representation of the same kind of images as ornaments of different objects. Thus, figures clothed in draperies with large flower-patterns which a painter has placed in a room where the carpet and porcelain vases repeat the same images to the spectator, have always an objectionable effect, because they make it troublesome for the eye to separate the different parts of the picture, which the similarity of ornaments tend to confound together. It is also on the same principle that the painter must generally avoid placing beside the faithful representation of a model, the reproduction of an imitation which repeats this model. For example, when he paints a vase of flowers, the artist produces most effect, other things being equal (supposing that he wishes to fix the attention upon the flowers he paints from nature), in painting the vase of white or grey porcelain, instead of a vase upon which a profusion of similar objects has already been enamelled.

(361.) Now to finish what I proposed saying upon Colouring, it remains to treat of the case where a painter wishes a certain colour to predominate in his composition; or to speak more correctly, the ease where the scene he represents is lighted by a coloured light diffused over every object. The better to comprehend my meaning, he must not only take simultaneous contrast into consideration, but also the modifications which result from the mixture of colours (171.), comprising the recomposition of white light by means of a proper proportion of the differently-coloured elementary rays.

(362.) Whenever a painter would make a coloured light predominate in a composition, he must attentively study the article in which we have examined the principal cases of the modifications of light resulting from coloured rays falling upon bodies of various colours (263., and following); he must understand that although the coloured light chosen imparts value to certain colours of the objects upon which it falls, it also impoverishes and neutralizes others. Consequently, when the artist is decided upon employing a predominant colour, he must renounce certain others; for if he does not, the effect produced will be false.

(363.) For example, if in a picture the colour orange predominates, for the colouring to be true, it must necessarily follow:

1°. That the purples must be more or less red;

2°. That the reds must be more or less scarlet;

3°. That the scarlets must be more or less yellow;

4°. That the orange must be more intense, more vivid;

5°. That the yellows must be more or less intense and orange;

6°. That the greens lose their blue, and consequently become yellower;

7°. That the light blues become more or less light grey;

8°. That deep indigo becomes more or less maroon;

9°. That the violets lose some of their blue.

We clearly see then, that orange light heightens all the colours which contain red and yellow, while neutralizing a portion of blue in proportion to its intensity, it destroys, wholly or in part, this colour in the body which it illuminates, and consequently disturbs the greens and the violets.

(364.) From the studies which I have made of pictures with reference to the true imitation of colouring, it appears to me that painters of interiors have, other things being equal, more power than historical painters in faithfully reproducing the modifications of light. Supposing that I am not in error, perhaps the following causes will explain this remark.

In the first place, is it not because historical painters attach more importance to the attitudes and physiognomy of their figures than to the other parts of their composition, seeking less to reproduce a number of small details, the faithful imitation of which is the peculiar merit of the painter of interiors?

In the second place, is it not because the historical painter is never in a position to see all the scene he would represent, like the painter of interiors, who, having constantly his model before him, consequently sees it completely, as he would imitate it upon the canvas?

(365.) We shall conclude these reflections by a general remark: it is, that in every composition of small extent, the colours, as well as the objects represented, must be distributed with a kind of symmetry, so as to avoid being what I can express only by the term *spotty*. In fact, it happens, for want of a good distribution of objects, that the canvas is not filled in some parts, or, if it is, there is evident confusion in many places; so, also, if the colours are not distributed properly, it will happen that some of them will be spotty, because they are too isolated from the others. For further consideration of this subject we must call the attention of the reader to what has been said in § 4 of the Prolegomena (249. and 251.).

(366.) From what has been said, I believe that those painters who will study the mixed and simultaneous contrasts of colours, in order to employ the coloured elements of their palette in a rational manner, will perfect themselves in *absolute colouring* (298.), as they perfect themselves in linear perspective by studying the principles of geometry which govern this branch of their art. I should greatly err, if the difficulty in faithfully representing the image of the model, encountered by painters ignorant of the law of contrast, has not with many been the cause of a colouring dull and inferior to that of artists who, less careful than they

in the fidelity of imitation, or not so well organized for seizing all the modifications of light, have given way more to their first impressions. Or, in other words, viewing the model more rapidly, their eyes have not had time to become fatigued; and, content with the imitation they have made, they have not too frequently returned to their work to modify it, to efface, and afterwards reproduce it upon a canvas soiled by the colours put on in the first place, which were not those of the model, and which will not be entirely removed by the last touches. If what I have said is true, there are some painters to whom the axiom, *Let well alone,* will be perfectly applicable.

SECOND DIVISION.

IMITATION OF COLOURED OBJECTS WITH COLOURED MATERIALS OF A DEFINITE SIZE.

INTRODUCTION.

(367.) Imitations resembling more or less those of painting can be made with materials of a certain diameter, such as threads of wool, silk, and hemp, adapted to the fabrication of Gobelins and Beauvais tapestries; the woollen threads exclusively employed in fabricating Savonnerie carpets; the small regular and irregular prisms of mosaics, and the coloured glass of the windows of gothic churches.

(368.) The tapestries of Gobelins and of Beauvais, and also the carpets of Savonnerie and certain very elaborate mosaics, may all be considered as works which resemble the method of painting in *chiar'oscuro;* while the windows of gothic churches correspond more or less exactly to painting in *flat tints.* It is the same also with tapestries for hangings and carpets which, instead of being fabricated with scales of at least sixteen or eighteen tones, as they are in the royal manufactories, are fabricated with scales composed of three or four tones only; and, far from mixing threads of various colours or tones of one scale, with the intention of imitating the effects of *chiar'oscuro,* the coloured objects reproduced present to the eye small monochromous bands of a single juxtaposed tone.

(369.) There are also some works which reproduce coloured designs by a kind of mixed system, because these designs are the result of the juxtaposition of monochromous single-tinted parts of a palpable size; but in juxtaposing these portions, the effects of *chiar'oscuro* have been sought by making use of the gradations of scale or the mixture of hues. Such are ordinary mosaics, carpets, embroidered tapestries, &c.

(370.) Patterns exercise so much influence in the tapestries and carpets of the royal manufactories, that I consider it necessary to offer some reflections, arising from numerous observations I have had occasion to make on the kind of painting best suited to this purpose, hoping they will interest artists who occupy themselves with works of this class, and who seek to understand the principal object of this kind of painting. When they have once determined the principal effects they aim at producing, they will see what points of ordinary painting may be sacrificed to obtain them. They will thus be able to arrive at a conclusion as to what must be done for perfecting the *special portion of their imitation.* It is by starting both from the physical condition of the coloured elements the Gobelins weaver employs, and from the texture of the tapestry, that I deduce the necessity of representing in this kind of work only large well-defined objects, and particularly remarkable for the briliancy of their colours. I prove by analogous reasonings that patterns for hangings must recommend themselves more by opposite colours than by minute finish in the details. Finally, after having regarded in an analogous manner the patterns of carpets, I endeavor to prove by the same considerations that to pretend to rival painting by the coloured elements of mosaics or stained glass, is to establish a confusion most detrimental to the progress of arts absolutely distinct from painting, both in their object and the means of attaining it.

(371.) The principles truly essential to these arts of imitation being deduced from their individual *speciality,* they are found to be established beyond dispute; it therefore becomes easy to distinguish the efforts by which we may hope to attain true perfection from those which can only bring out the opposite result.

SECTION I.

GOBELINS TAPESTRY.

CHAPTER I.

OF THE ELEMENTS OF GOBELINS TAPESTRY.

(372.) The elements of Gobelins Tapestry are two in number:

the warp (la *chaine*), and
the weft (la *trame*).

The *warp* is formed of uncoloured woollen threads, extended vertically in front of the workman.

The *weft* is formed of coloured threads, which entirely cover the threads of the warp.

With variously coloured threads of a certain diameter we imitate all the colours of the most perfect pictures.

(373.) The art of the tapestry-weaver is based upon the *principle of mixing colours*, and on *the principle of their simultaneous contrast.*

(374.) There is a *mixture of colours* whenever materials of various colours are so divided and then combined that the eye cannot distinguish these materials from each other: in which case the eye receives a single impression; for example, if the materials are a blue and a yellow of the same strength, and in proper proportions, the eye receives an impression of green.

(375.) There is a *contrast of colours* whenever differently coloured surfaces are properly arranged and susceptible of being seen simultaneously and perfectly distinct from each other; and we must remember that, if a blue surface be placed beside a yellow surface, instead of inclining to green, they, on the contrary, differ from each other, and acquire red.

CHAPTER II.

ON THE PRINCIPLE OF MIXING COLOURED THREADS, IN ITS RELATIONS WITH THE ART OF WEAVING GOBELINS TAPESTRY.

(376.) With a certain number of scales of different colours, pure and broken with black, we may by mixing them produce an infinite variety of colours.

The mixtures are of two kinds;

(377.) Firstly, we mix a thread of the 4th tone of the scale of a colour A, with a thread of the 4th tone of the scale of a colour A', more or less analogous to A.

This is mixture by Threads.
It is not made upon figured silks.

(378.) Secondly, the weft is worked so as to interweave together either the threads of a scale of the colour A, or the threads of a scale of the colour A' mixed with the treads of a scale B, or with the threads of the scale B mixed with the threads of a scale B' more or less analogous to that of B.

This is mixture by Hatchings.

(379.) We can understand by this, how with these two kinds of mixture we can imitate all the various colours and tones of pictures which serve as patterns for tapestry.

(380.) In the mixtures by threads and by hatchings, it is always indispensable to take into consideration the facts of which I have spoken (158.); and I am the more urgent on this subject, because M. Devrolle director at the Gobelins perfectly understanding the processes of his art, has had the kindness to execute, at my request, different mixtures of coloured silk threads in a piece of tapestry, to enable me to prove the remarks I have made; they lie at the foundation of all the arts the palettes of which, so to speak, are composed of coloured threads, and have also the advantage of referring to the same rules the art of modifying by mixture the colours of coloured substances, whether they are in a state of infinite division or of appreciable extent.

The mixtures which I am about to mention were made with threads of two colours taken at the same tone; each thread covered the warp; they were arranged parallel to each other and stretched perpendicularly to the warp. When the mixture was composed of an equal number of threads of each colour, it presented very narrow stripes of equal size, and alternately of different colours. To make mixtures of coloured threads understandingly, we must satisfy the three following rules. The first two are principal, because they result directly from the observation of facts; the third is secondary, because it is the natural deduction from the facts comprised in the first two.

I. RULE.—CONCERNING THE BINARY MIXTURE OF PRIMARY COLOURS.

When we unite Red with Yellow, Red with Blue, Yellow with Blue, the threads must not reflect a palpable quantity of the third primary Colour, if we would have Orange, Violets, and Greens, as brilliant as it is possible to obtain them by this method.

EXAMPLE.

A. *Red and Yellow.*

3 Red threads with 1 Yellow thread
2 Red threads with 1 Yellow thread
1 Red thread with 1 Yellow thread
3 Yellow threads with 1 Red thread
2 Yellow threads with 1 Red thread

yield mixtures which appear to the eye as they must do in proportion to the two colours mixed. There is no appearance of Grey in any of these mixtures when we employ a Red more inclining to Orange than to Crimson, and a Yellow more inclining to Orange than to Green.

B. *Red and Blue.*

3 Red threads with 1 Blue thread
2 Red threads with 1 Blue thread
1 Red thread with 1 Blue thread
3 Blue threads with 1 Red thread
2 Blue threads with 1 Red thread

give mixtures which appear to the eye as they must do relatively to the proportion of the two colours mixed. If we use a Red and a Blue inclining to Violet, the mixture will contain no Grey.

C. *Yellow and Blue.*

4 Blue threads with 1 Yellow thread
3 Blue threads with 1 Yellow thread
2 Blue threads with 1 Yellow thread
1 Blue thread with 1 Yellow thread

give mixtures which appear to the eye as they must appear relatively to the proportions of the two colours mixed. If we use a Yellow and a Blue inclining to Green more than to Red, the mixture will contain little or no Grey.

Experiment on all the preceding mixtures demonstrates the rule enounced above, or rather this rule is only the expression of a generalization of facts.

II. RULE.—CONCERNING THE MIXTURE OF COMPLEMENTARY COLOURS.

When we mix Red and Green, Orange and Blue, Yellow and Violet, the colours are more or less completely neutralized according as they are more or less perfectly complementary to each other, and as they are mixed in proper proportions. The result is a Grey, the tone of which is generally higher than that of the colours mixed, if these latter are of a suitably high tone.

EXAMPLES.
D. *Red and Green.*

d. 3 Red threads with 1 Green thread give a dull Red.
2 Red threads with a Green thread give a duller and deeper Red than the pure Red employed.
1 Red thread with 1 Green thread give a Reddish Grey, the tone of which is a little higher than that of the preceding mixture.

3 Green threads with 1 Red give a Green Grey, the tone of which is higher than the Green and the Red.
2 Green threads with 1 Red give a Grey less Green, and of a higher tone than the two colours.

d'. In repeating the same mixtures with higher tones of the same scales of Green and Red, we remark that the tone of the mixture of 2 Green threads with 1 Red thread is higher relatively to that of the colours mixed, than it is in the mixtures *d.*

d''. 1 Red thread and 1 Yellowish-Green thread give a *Carmelite* Brown, or an Orange-Grey, the tone of which is equal to that of the colours mixed.

d'''. 1 Red thread and 1 Bluish-Green thread give a copper-coloured mixture, or Catechu-Brown, of a higher tone than that of the colours mixed.

Conclusion.

From this we may conclude that red and green threads, properly assorted and in suitable proportions, yield *grey.*

E. *Orange and Blue.*

e. Orange threads with 1 Blue thread, give a dull Orange.
2 Orange threads with 1 Blue thread, give a duller Orange.
1 Orange thread with 1 Blue thread, give a Chocolate-Grey, browner than the colours mixed.
3 Blue threads with 1 Orange thread, give a Violet-Grey.

2 Blue threads with 1 Orange thread, give a Violet-Grey, redder than the preceding.

e'. The results are the same with deeper tones of the preceding, except that the corresponding mixtures are browner.

e''. 3 Orange threads with 3 Blue threads present a remarkable phenomenon according to the intensity of the light and the position from which they are viewed. The tapestry being placed in a vertical plane opposite incident light, when the warp is horizontal, we perceive *blue* and *orange* stripes; but if the warp be vertical, we may then see the upper part of each blue band *violet,* and its under part, as well as the upper part of each orange band, *green,* while the rest of each of these latter bands will appear *red,* bordered on the lower part with *yellow.* We may also see the upper part of each blue band *violet,* and its under part, as well as the upper part of each orange band, *green,* and the rest of each of these bands *red,* bordered in the lower part with *green,* and in the upper part with *yellow.* We say that they may be seen in this manner, because if the light were strong enough for distinct vision, we should not see the horizontal blue and orange bands.

F. *Yellow and Violet.*

3 Yellow threads with 1 Violet, give a Greyish-Yellow.
2 Yellow threads with 1 Violet, give a Yellow-Grey.
1 Yellow thread with 1 Violet, give a Grey, much nearer *normal grey* than the preceding.
3 Violet threads and 1 Yellow, give a Greyish-Violet.

2 Violet threads and 1 Yellow, give a dull Violet, greyer than the preceding.

It is remarkable that in observing the mixture of a yellow with a violet thread, at a greater distance than that at which their colours appear neutralised, the yellow is so much weakened in proportion to the violet, that the mixture appears of a dull violet.

Yellow and Blue exhibit an analogous result.

III. RULE.—CONCERNING THE MIXTURE OF THE THREE PRIMARY COLOURS, IN SUCH PROPORTIONS THAT THEY DO NOT BECOME NEUTRALIZED, BECAUSE ONE OR THE OTHER OF THEM IS IN EXCESS.

This rule is the result of the first two; but it was indispensable to enounce it, to comprehend all those cases which may be presented in a mixture of coloured threads, relatively to the point of view which occupies us.

For, as Red mixed with a Greenish-Yellow has given a *Carmelite* mixture, as above mentioned (380.*d"*), I shall add the following:

(1.) *Crimson-Red and Greenish-Yellow*, give much duller mixtures, the nearer these colours are being neutralized. A mixture of 1 crimson-red thread with 1 greenish-yellow thread, produces a brick or copper-orange, the tone of which is higher than that of the colours mixed.

(2.) *Scarlet-Red and Greenish-Blue*, give mixtures which are without vigour or purity, relatively to the corresponding mixtures made with crimson-red and violet-blue.

(3.) Red worked with Blue-Grey, gives Violet mixtures, which are not so dull as the preceding, because the colours contain no yellow.

(4.) The Red of the mixture (3), worked with a Green-Grey, gives mixtures much duller than the preceding, as might have been expected on account of the yellow contained in the green-grey.

(5.) Orange and Blue-Violet, give very dull mixtures.

(6.) Orange and Red-Violet, give dull mixtures; but redder or less blue than the preceding.

CHAPTER III.

ON THE PRINCIPLE OF CONTRAST, IN CONNECTION WITH THE PRODUCTION OF GOBELINS TAPESTRY.

(381.) If it is important to understand the law of contrast when we wish to imitate a given coloured object by painting, as I have previously stated (323. and fol.), it is much more so when we proceed to imitate a model picture in tapestry; for if the picture does not faithfully represent the colours of the model, the artist has on his palette the means of correcting any defect he perceives, since he can without much inconvenience frequently efface and reproduce the same part of his picture. The weaver has not this resource; it is impossible for him to alter his colours without undoing his work, and doing over again entirely the defective part. Now this requires more or less time, always considerable; for tapestry-weaving is exceedingly slow work.

What, then, must the Gobelins weaver do to avoid the defect I have pointed out? Why, he must thoroughly understand the effect of contrast to know the influence which the part of the copy he proposes to imitate receives from the colours surrounding it, and so judge what coloured threads it will be proper for him to choose. The following examples will explain, better than the most profound reasoning, the necessity for the tapestry-worker to possess a knowledge of the law of contrast.

1st EXAMPLE.

(382.) A painter has delineated two coloured stripes in a picture, one red, the other blue. They are in contact, and, consequently, the phenomenon of contrast between two contiguous colours would have arisen, if the painter had not sustained the red contiguous to the blue stripe by blue, and if he had not sustained the blue stripe by making it red or violet next to the red stripe (330.).

A weaver wishes to imitate these two stripes: if he is ignorant of the law of contrast of colours, after choosing the wools or silks for imitating the pattern before him, he is sure to make two stripes which will produce the phenomenon of contrast, because he will have selected his wools or silks of only one blue and one red, to imitate two stripes of different colours, each of which appears to the eye as homogeneous throughout, but which the painter has only succeeded in making so by neutralizing the phenomenon of contrast which the stripes would undoubtedly have presented if they had each been painted of a uniform colour.

2nd EXAMPLE.

(383.) Suppose the painter has painted the stripes with uniform colours, then contrast will arise, so that the red contiguous to the blue will appear orange, and the blue contiguous to the red will appear greenish.

If the weaver be ignorant of the law of contrast, in attempting to imitate his model, he will be sure to mix yellow or orange with his red, and yellow or green with his blue, in those parts of the stripes which are in contact. Hence the resulting contrast will be more or less exaggerated than if he had obtained the effect of the painting by working the two stripes with homogeneous colours.

3rd EXAMPLE.

(384.) Suppose a weaver has to copy the series of ten grey bands in flat tints (fig 3.*bis.*) which was described in our First Part (13.), it is evident that, if he is ignorant of the effect of contrast of contiguous bands, he will exaggerate it in the imitation; for, instead of working ten tints of the same scale, so as to produce ten bands in flat tints, he will make ten bands, each of which will be graduated conformably to what he sees; and it is extremely probable that he will have recourse to lighter and darker tones than those which correspond exactly to the model; consequently, it is very probable that he will want a greater number of tones than would have been necessary had he known of contrast, and it is certain that the copy will be an exaggeration of the model.

4th EXAMPLE.

(385.) When we attentively observe the rosy flesh-tints of a great many pictures, we perceive in the shadows a green tint more or less apparent, resulting from the contrast of rose with grey. (I presume that the painter has made his shadows without using green, and that he has not corrected the effect of contrast by using red.) Now a weaver ignorant of the effect of rose upon grey, in imitating the shaded part will have recourse to a green-grey, which will exaggerate an effect that would have been produced naturally by employing a scale of pure grey (without green).

This example serves to demonstrate that if a painter has himself exaggerated the effects of contrast in his imitation, these effects will be still more exaggerated in the copy made in tapestry if we do not guard against the illusions produced by the causes now mentioned.

(386.) Beside these examples, I shall cite, as a new application of the law of simultaneous contrast of colours to the art of the Gobelins weaver, the explanation of a fact mentioned in the Introduction.

For seventy years, to my knowledge, they have complained at the Gobelins of a want of vigour in the black dyes of the workshops of the royal manufactories, when they were used in making the shadows of draperies, particularly those of blue, indigo, and violet; the facts cited concerning the juxtaposition of black and blue, indigo, and violet (60., 61., 62.), and explained conformably to the law, of the extremely brilliant complementaries of these three colours, modifying the black, in making known the true cause of the phenomenon, have proved that the reproach addressed to the dyer was unfounded, and that the inconvenience of these juxtapositions could only be made to disappear or diminish by the art of the weaver.

The following observations were made by M. Deyrolle:

From a pattern of a piece of drapery representing a very deep fold, he executed two pieces of tapestry, differing in this—that the one (No.1) was worked with single tones of the violet scale of wool, while the other (No.2) was worked with these same tones, but the depth of the fold was made exclusively with black instead of violet-brown wool.

In diffused light, rather feeble than strong, and at the first aspect, the effect of No. 1 was more sombre than that of No. 2, and it presented more harmony of analogy; viewed more attentively, an effect of contrast was perceived much more marked in No. 2 than in No. 1, resulting from the black juxtaposed with light violet, which bordered the depth of the fold, rendering this violet lighter, redder, or less blue than the light violet corresponding to No. 1 appeared: the black of No. 2 also, by the influence of the complementary, greenish-yellow, with the contiguous light violet, contrasted more than the deep violet-brown of No.1; I say more; for this latter received from the proximity of its bright tone a light tint of greenish-yellow.

In an intense diffused light, the effect of contrast was greatly increased.

Thus, as might have been expected, there was greater difference of contrast between the light and the shadow in No. 2 than in No. 1, and the different parts of the latter, viewed as dependencies of one whole, presented an effect more harmonious than that presented by No. 2.

Two pieces of tapestry representing the same pattern, the one with the tones of the blue scale, and the other with the same tones and black, gave rise to analogous remarks; but the differences were less marked than those observed between the two violet pieces.

The preceding examples induce me to believe that there are cases in working tapestry, especially with the blue and violet scales, where it appears advantageous to employ the deepest tones of these scales in preference to black; and that if we would have more contrast than we had in the preceding examples, we must juxtapose with the deep tones lighter tones of the same scales than would have been employed if we had used black. In a word, the rule which appears to me must guide us, will be, to produce between the brown and the light of the same scale, the same contrast of tone which would have been produced by the juxtaposition of black.

(387.) The facts stated in this Chapter demonstrate super-abundantly, I think, that whenever the weaver is uncertain about the true appreciation of a colour he wishes to imitate, he must circumscribe this part of his pattern with a paper cut out by which he can exactly compare it with the colour of the threads he proposes to employ.

(388.) I shall terminate this Chapter by affirming that finely coloured models, painted on the system of *chiar'oscuro*, and combining the qualities of perfect colouring, (298.), can be represented in tapestry by employing only the local colour, its nearest hues, white, and normal grey. In fact, every part where the local colour appears with the single modification of its hues, being contiguous to other parts, which, in the original model, present to the painter modifications due to an excess or enfeebling of white light, it necessarily happens, that when these latter parts have been reproduced by the weaver with white and normal grey, they will receive, from the proximity of the first parts (seat of the local colour), the same modifications that the corresponding parts of the model present to the painter.

M.Deyrolle, whom I have many times quoted, has executed, according to this mode of seeing, a very effective piece of tapestry representing flowers. This is, then, another example of the harmony of theory with the practice of art.

CHAPTER IV.

QUALITIES WHICH PATTERNS FOR GOBELINS TAPESTRY MUST POSSESS.

(389.) In order to fully comprehend what are the qualities which model-pictures for Gobelins tapestry must possess, it is indispensable to decide upon the *speciality* in the imitation peculiar to this kind of work.

(390.) The weaver imitates objects with coloured threads of a certain diameter. These threads are applied

round the threads of the warp. The surface produced by them is not uniform, but hollowed in furrows those which are parallel to the threads of the warp being lower than the others which are perpendicular to it; the effect of these furrows is the same as a series of dark parallel lines would produce upon a picture which would be cut at right angles by another series of fine parallel lines, less dark than the preceding. There is this difference, then, between a tapestry and a painting:

1°. That the first never presents those blended colours which the painter obtains so easily, by mixing or dividing his pigments to an infinite degree by means of a more or less viscid vehicle.

2°. That the symmetry and uniformity of the furrows of tapestry are opposed to the lights being as vivid and the shadows as vigorous as they are in a painting; for if the furrows obsure the lights, the salient parts of the threads which are in the shades have the inconvenience of enfeebling the latter by the light they reflect.

3°. That the lines which circumscribe the different objects in a painting, although straight or curved in every direction, may be of an extreme fineness without ceasing to be perfectly distinct; while the threads of the weft and the warp, always crossing at right angles, are an obstacle to a similar result whenever the lines of the pattern do not exactly coincide with these threads.

4°. Let us add that the painter has other resources to increase the brilliancy of the lights and the vigour of the shadows which are denied to the weaver. For instance, he opposes opaque body-colours to glazing-colours (pigments); he modifies an object of a single colour by varying the thickness of the layer of paint he places on the canvas; also, up to a certain point, he can produce modifications by changing the direction of the strokes of his pencil.

(391.) From this state of things, I conclude that to raise the effects of tapestry as nearly as possible to those of painting, it is requisite:

1.°. That the objects be represented of such a size that the point where the spectator must be placed to see them properly, does not permit of his distinguishing the coloured elements from each other, nor the furrows which separate them, so that not only the thread of two mixed scales (377.), and the hatching of different scales more or less distant, interwoven together (378.), are confounded in a colour homogeneous to the eye, notwithstanding the definite dimensions of the variously coloured elements constituting this colour, but also that the cavities and salient parts appear as a uniform surface;

2°. That the colours be as vivid and as contrasted as possible, so that the lines which circumscribe the different objects be more distinct, and that the lights and shadows be as different as possible.

(392.) It is now evident that patterns for tapestry must not only recommend themselves by correct outline, and elegant forms, but they must represent large objects, figures draped rather than nude, vestments decorated with ornaments rather than simple and uniform; lastly, by colours varying and contrasting as much as possible;—consequently everything relating to miniature by minuteness or by finish in details is foreign to the special object of tapestry.

SECTION II.

BEAUVAIS TAPESTRY FOR FURNITURE.

CHAPTER I.

OF THE ELEMENTS OF BEAUVAIS TAPESTRY FOR FURNITURE.

(393.) The elements of Beauvais Tapestry for furniture are essentially the same as those of Gobelins tapestry; but with this difference, that the light and the middle tones of the scales employed are of silk, while in the Gobelins tapestry these tones are almost always of wool; on the other hand, the scales of Beauvais are less varied in colour than those of the Gobelins, and their tones are less numerous. Besides, the working of the threads is the same in both kinds of tapestry, so that the employment of coloured threads resting in like manner on the knowledge and observance of the principle of mixture and the principle of contrast of colours, I need not add to what I have already said on this subject in the preceding Section.*

(394.) I must remark that the furrows caused by the weft and the warp have not the same objection they have in the Gobelins tapestry (390.). In fact, the regular grain of the tapestry for furniture is so far from producing a bad effect in the image represented thereon, that we are obliged to give the appearance of this grain to many paper-hangings by means of parallel lines cutting it, or by points symmetrically placed.

CHAPTER II.

ON THE SUBJECTS REPRESENTED ON THE BEAUVAIS TAPES-TRIES FOR FURNITURE.

(395.) The subjects represented on the tapestries of Beauvais for furniture are simpler than those on the Gobelins tapestry, as they are generally limited to ornaments, flowers, animals, particularly birds and insects; I say generally, because formerly they produced small pictures for screens, chairs, glass doors, &c.

CHAPTER III.

OF THE PATTERNS OF BEAUVAIS TAPESTRY FOR FURNITURE.

(396.) The objects, although generally smaller than those seen on Gobelins tapestry, being of simpler form, often symmetrical, offer less difficulty of execution, in order to be distinctly seen; and the nature of these objects also does not absolutely require the employment of colours much varied in their tones and hues; for I suppose that the Beauvais weaver does not pretend to rival the painter, consequently, when he represents flowers, for instance, he does not require a model painted in the manner which a pupil of Van Spaendonck would make a picture or a drawing for a botanical work.

(397.) In the models of tapestries for furniture, we too often neglect the opposition of grounds with the dominant colour of the subjects placed upon them. For instance, if it is a crimson ground ornamented with a garland of flowers, it is necessary that Blue, Yellow, and White flowers compose the greater part of it. If we place on it Red flowers, they will tend to become Orange rather than Purple;—they must be surrounded with Green leaves contiguous to the ground. When it is a greenish ground, Red and Pink flowers must, on the contrary, predominate over the others. If the ground is dead leaves, then Blue, Violet, White and Pink flowers detach themselves completely.

(398.) The patterns of tapestry for furniture must possess the qualities which we have desired in those of the Gobelins. Thus, graceful and simple forms detaching themselves completely from the ground upon which they stand, clothed with the purest and most harmoniously selected colours, are preferable to all others. The harmonies of contrast of colour must generally predominate over those of analogy.

*Chaps. II. and III.

SECTION III.

SAVONNERIE CARPETS.

CHAPTER I.

SAVONNERIE CARPETS.

(399.) The manufacture of Savonnerie Carpets is entirely different from that of Gobelins Tapestry.

The elements of these Carpets are three in number:

1°. *Woollen Threads*, mostly *white*, forming the warp of the carpet;

2°. *Wollen Threads* of various *tints*, which are knotted to the first;

3°. *Hempen Threads*, which serve to bind the threads of the warp together.

(400.) I. *Warp.* The woollen threads constituting the warp are properly suspended in the loom, parallel to each other, and at equal intervals.

(401.) II. *Dyed Wool.* This is, properly speaking, the coloured element of Savonnerie Carpets.

Although the scales of dyed wool are not so numerous as those of the Gobelins Tapestry, yet they are sufficient for imitating all the hues of painting, as may easily be understood when we know that the thread employed in the production of a carpet must always be complex: it is composed of five or six threads. For, to imitate a pattern painted in various colours on the system of *chiar'oscuro*, the complex thread is composed of threads of 2, of 3, of 4, of 5, and even of 6 different colours; there is, then, a wide latitude in modifying colours according to the *principle of mixing*.

In making a ground, the complex thread is composed of five or six threads of the same tone of the same colour.

The tones of each scale are almost always sixteen or eighteen in number.

When a complex thread is composed of threads belonging to different scales, those which are united must generally have the same number, with respect to their height of tone, in the scales to which they respectively belong. If we deviate from this rule, it is when we take into consideration the different alterability of mixed colours; for instance, when we mix Violet threads with Red threads, the former should be of a higher number than the second, because they change more under the influence of atmospheric agencies.

Every compound thread is fixed to a thread of the warp by means of a peculiar knot, and perpendicularly to the direction of this latter: this is called *le point*. When a certain number of coloured threads are thus fixed, appearing to the eye as a coloured line which is at right angles with the warp, we cut these threads perpendicularly to their axis, so that the coloured surface of a Savonnerie Carpet shows the interior of the coloured wool exposed by this section.

(402.) III. *Hempen Threads.* On attempting to consolidate *le point*, or, in other terms, the threads of dyed wool which have been knotted upon the threads of the warp, we employ a double hempen thread, called *duite*, and a single hempen thread, called *trame*, which is generally coloured Blue, Grey, or Black. These threads form, with those of the warp, a true canvas, which is completely concealed when the carpet is laid; then the spectator only sees a plane parallel to that of the warp, upon which the imitation of the model appears: this plane is the upper surface of a true woollen velvet.

(403.) We see how the weaving of a Savonnerie Carpet differs from that of tapestry; and if we also refer here the beauty of the effects to the knowledge and observance of the principles of the mixture and contrast of colours, there are some remarks to be made relatively to the special application of these principles to carpet making, because this application is not absolutely identical with that of the same principles to the manufacture of Gobelins Tapestry. This will be demonstrated in the two following Chapters.

CHAPTER II.

ON THE PRINCIPLE OF MIXING COLOURS IN ITS CONNECTION WITH THE MANUFACTURE OF SAVONNERIE CARPETS.

(404.) The mixing of colours in the manufacture of Savonnerie carpets is always performed by mixing differently coloured threads, as was mentioned above (401.); consequently we do not, as in the Gobelins Tapestry, make *mixtures by hatchings* (378.). We may easily understand that we can graduate a colour by juxtaposing threads of this colour lighter and lighter, in proportion as they are removed from the highest

tone. In a similar manner we may understand how we can make one colour pass into another, by juxtaposing compound threads in which the proportion of the first colour diminishes, with other compound threads in which the second colour increases.

(405.) The mixture by threads is the most important thing for the beauty and richness of the colours: but if it be true that, in order to make it successfully, it is sufficient to observe the rules laid down before (380.), when speaking of Gobelins Tapestry, and that under this relation it would appear superfluous to refer to this subject—yet, in consequence of the worker in tapestry making use of threads composed of five or six threads, which may be variously coloured (401.), he finds by this that he is much more exposed to error than the Gobelins weaver is, when he proceeds to mix threads which he desires should retain the richness of their colours. Such, then, is the motive which determines me to consider anew the art of mixing coloured threads in making Savonnerie carpets.

I. RULE.—*Respecting the Mixing Red and Yellow threads, Red and Blue threads, and Yellow and Blue threads.*

Whenever the weaver wishes to produce by mixture a vivid Orange, Violet, or Green, he must only mix such threads as in the combination will present these two colours solely. Consequently the compound thread must consist only of threads belonging to the two elementary scales or to their intermediate hues; in the case where he wishes to modify the tone of one of the colours or both, he must mix different tones of the same scale. But it is not useless to remark that the mixture of three threads of the tones 3, 4, and 5, of the same scale well graduated gives the same result as if we had taken three threads of tone 4.

II. RULE.—*Respecting the complementary mixture of Red and Green threads, Orange and Blue threads, Yellow and Violet threads.*

These mixtures giving rise to Grey, the weaver cannot add brilliant colours without the latter being broken or tarnished by the former, precisely as they would be if we had added Grey to them. One consequence of this rule, then, is never to admit complementary colours into mixtures which are intended to compose brilliant colours.

III. RULE.—*Respecting the mixture of threads of complementary colours, but in such proportions that they do not completely neutralize each other.*

The weaver must not have recourse to mixtures which belong to the third rule, except when he intends breaking or tarnishing his colours: and it is evident that the less he retains of a colour in excess over the quantities of those which are mutually complementary, the more this excess in the former will be broken by mixture with the latter.

We see, then, that we can break the colours without having recourse to broken tones, and that if we would

make one colour pass into another without running into Grey, we must avoid every juxtaposition of colours which, by confusing the eye, would produce the effect of mixed complementary colours (380.).

CHAPTER III.

ON THE PRINCIPLE OF CONTRAST OF COLOURS IN ITS CONNECTION WITH THE FABRICATION OF SAVONNERIE CARPETS.

(406.) If it be true that a knowledge of the principle of contrast is less ncessary to the worker of Savonnerie than it is to him of the Gobelins, yet it would be a mistake to suppose that the first can remain ignorant of it without disadvantage.

In fact, although the worker of Savonnerie need not so assiduously copy his model faithfully in its colouring as the Gobelins weaver, and as the five or six differently coloured threads which he can unite to form a compound thread may be very favourable to the gradation, and to the passage of one colour into another, yet this very liberty which permits of a slight departure from the colours of the model, imposes on him the obligation of producing the best possible effect.

Can he follow a better guide than the law of contrast when he seeks to attain this aim?

CHAPTER IV.

CONDITIONS WHICH MUST BE FULFILLED IN THE PATTERNS OF SAVONNERIE CARPETS.

(407.) The Savonnerie weaver working from the same painted patterns as the weaver of the Gobelins and of Beauvais, I next speak of the principal conditions which these patterns must fulfill, in order that the carpet reproducing the pattern may fully realize our intention.

ARTICLE 1.

1st CONDITION—*Respective size of the figured objects.*

(408.) The size of the objects represented must be in proportion to the whole extent of the carpet: great trophies and ornaments suit only large carpets, and simple patterns are best adapted to small ones.

(409.) On the other hand, if the apartment to which the carpet is fitted is defective in the proportions of the breadth to its length, the designer must take care to avoid increasing this defect to the eye by his design and the manner in which he distributes his masses.

ARTICLE 2.

2nd CONDITION—*Distinct View.*

(410.) All the parts vividly coloured, and having well defined patterns, must be visible in their entirety, when

the furniture is placed in the position it is intended to occupy in the chamber to which the carpet is fitted, this apartment being what is commonly called *arranged*.

For example:

The border of a carpet upon which chairs, couches, sofas, &c., are placed, must be black or brown: in the case where preference is given to a ground uniform with the pattern, this latter must be very simple, and composed only of two or three tones of colours much deeper than those of the rest of the carpet, when this does not exhibit large dark masses; and it is by deep tones of the blue and violet scales, and also with those of other scales (218.), that we have the opportunity of recalling the harmonies of analogy.

(411.) The actual border of a carpet must not be under the chairs. It must appear as a continuous frame to all the objects represented upon the carpet, and this framing must not be interrupted by the hearth.

(412.) If a piece of furniture must be placed in the middle of the apartment, or rather of the framing, the figures of the carpet must be executed in conformity; that is to say, in such manner that they commence at the line circumscribing the place occupied by the furniture, and extend beyond this place.

(413.) Every trophy or design presenting a well circumscribed object, or, in other terms, every design without lines parallel to the border, must be seen in all its parts, so that the eye can embrace the whole without difficulty. And it must also always have a sufficient interval between the border and the trophies, or, more generally, the objects circumscribed, to which the artist desires to draw the chief attention.

ARTICLE 3.

3rd CONDITION—*Analogy with places or persons.*

(414.) Other objects than arabesques or imaginary figures, depicted on a large carpet, must possess some analogy with the purpose of the apartment where the carpet is laid, or offer some allusion either to places or persons.

ARTICLE 4.

4th CONDITION—*Distribution of Colours.*

(415.) The colours must be distributed in such manner as to give value to every part of the carpet, not only in each particular object, but also in the union of objects forming a single composition.

Of the local Colours and the Colours of each particular object.

(416.) Every object must be perfectly detached from the ground upon which it is placed. If rose or red predominates in an object, the ground must be neither crimson nor scarlet, nor violet; if blue predominates, the ground must generally be neither violet nor green. If the object is yellow, orange must be forbidden to the ground. For the rest, I shall refer to what I have said above (396., 397., 398.) in speaking of the conditions which must be fulfilled in reference to the patterns for Beauvais tapestry for furniture.

Of the General Harmony of Colour in a Carpet.

(417.) There are some important observations to be made upon the general harmony of colours, which is frequently neglected by the designer of patterns for this kind of fabric; yet without it, the effect in a carpet is injured, whatever may be the perfection with which each particular object is rendered.

(418.) If the carpet represents many separate objects, they must each have a dominant colour which accords with those of the other objects, either by the dominant colours belonging to different tones of the same scale or by these colours contrasting with each other, which produces a more satisfactory effect.

The whole of these objects must detach themselves from the ground, which will generally be duller than they are, the light being almost always diffused from the centre of the composition.

The manner in which the objects are circumscribed, and the nature of the lines circumscribing each of them, contribute greatly to render a composition harmonious or discordant. For instance, squares or parallelograms, which attract the eye by their size and their brilliant colours, have a bad effect with circular or elliptical figures, especially when they are very near together.

ARTICLE 5.

5th CONDITION—*Harmony of the Carpet relatively to the Objects which must concur with it in the Decoration of an Apartment.*

(419.) For a carpet to produce the best possible effect, it is not enough that it be made in the best manner, that the pattern is excellent, and that the distribution of the colours leaves nothing to be desired; it is also requisite that it be in harmony with the decorations of the apartment into which it is put, or, in other terms, that it possesses certain relations of *suitability*, not only of size proportionate to the nature of the ornaments, the facility with which the eye seizes the *ensemble* of the composition, the skill which has governed the distribution of the large masses of colours,—but also in the harmony of these same colours with those of the objects which concur with the carpet to furnish a given apartment; it is under this latter relation only that I shall now make some remarks, which will be concluded further on, when I come to examine the decorations of rooms.

(420.) The method of rendering with respect to the colours the harmony of a large carpet as facile as possible with the other furniture of the same apartment, is at first to make the light commence from the centre of the carpet; it is there—that is to say, in the part most distant from the chairs, hangings, &c.—that we can employ without inconvenience the most vivid and strongly contrasted colours.

In placing a much less brilliant part between this vivid picture in the central part of the framing, we can also give to the framing colours so vivid as to glare upon the contiguous parts, still without injuring the colour of the chair, hangings, &c.

SECTION IV.

CHAPTER I.

ON TAPESTRIES FOR HANGINGS.

(421.) Gobelins tapestry and Beauvais tapestry for furniture, produced on the system of painting in *chiar'oscuro*, require in their production so much time, care, and skill on the part of the artists who execute them, that their price is much too high to permit them to become articles of commerce. Without inquiring if it be right or wrong to prefer stained papers to woollen hangings, fabrics in a single colour, chintzes, or in patterns to tapestries for furniture, I shall say, that with scales of five or six tones at most, we can execute works of the latter kind on the system of flat tints (368.), which have a good effect, and at a price such as, if I am not mistaken, would bring them into commerce if fashion adopted them.

CHAPTER II.

CARPETS.

ARTICLE 1.

Carpets on the System of Chiar'oscuro.

(422.) The taste for carpets, now-a-days so widely extended, far from diminishing, will doubtless increase, just as in modern times has occurred in respect to glazed windows in our houses. If the Savonnerie carpets are too dear for commerce, such is not the case with those others which, made in imitation of them after patterns painted on the system of *chiar'oscuro*, are extensively manufactured in France and other countries.

(423.) These carpets cost much less than those of Savonnerie, because they contain much less wool, which is generally of inferior quality: the colours also are not so durable; they are worked, too, with scales less varied in colour, and of fewer tones; lastly, as these fabrics are not so elaborate, they are made much more rapidly than those of the royal manufactories.

(424.) If the intrinsic qualities of Savonnerie carpets and those of ordinary carpets are really so different, we should be much mistaken if we supposed that the difference is evident on the first superficial examination, or that it can be always recognized on a more prolonged examination by a person ignorant of the difficulties of this class of works. What most persons look for in a carpet is brilliant colours. The manufacturer knowing the taste of his customers, does well to conform to it, and he attains his aim by using fewer broken tones, and more pure and vivid colours than are employed in the royal manufactories. He thus obtains greater appearance of effect at less expense, and I am convinced that in many instances where at Savonnerie they mix a great many coloured threads together, it requires much skill and knowledge in mixing their complementaries, to prevent the brilliant colours extinguishing each other: this danger does not exist, or occurs much less frequently, in the manufacture or ordinary carpets.

(425.) The considerations I have put forth on the mixing of colours, lead to the opinion that every workman who would make himself acquainted with the method of producing the carpets of Savonnerie, will, by very simple means, arrive at results the success of which appears to me certain, when, after being well imbued with the rules prescribed (380. and 405.), he will attain to a system of experience calculated to reveal to him what most of his fellow-workers are ignorant of—the value of the colours of his palette, and in this value we comprise the knowledge of the resulting colour he will obtain, either by mixing a given number of threads of the same scale, but of different tones, or by mixing a given number of different scales.

The first experiments he should make will have for their object the fixing the *minimum* number of the tones of his scales after he has fixed the number of woollen threads which compose his compound threads; for we know that, if he puts three threads into a compound thread, he can, with a scale of the same number of tones, obtain by mixing a greater number of mixed tones than if the compound thread was only binary. Suppose it is a scale composed of ten tones, and that we required to make a triple compound thread; two threads of the tenth tone with one thread of the ninth tone will give a mixed tone nearer to the tenth than if we were obliged to mix one thread of the tenth tone with one thread of the ninth tone to produce a binary compound thread; by which we may learn that by the triple mixture we can obtain many more mixed tones, intermediate between the first and the tenth, that we can obtain from the binary mixture.

After having determined upon the number of tones which shall compose his scales, he will next fit upon the number of unbroken scales which will be necessary for him to compose brilliant hues, bearing in mind rule first: and further, he will employ threads for a complex thread, and other things being equal, he may contrive mixtures which will belong to other distinct scales, and which may be inserted between the scales that have been mixed.

This determination made, he will next prepare his *greys* resulting from the mixture of his complementary scales in conformity with our second rule: taking into account the *breaking*, or the *greying* which the complementary mixtures will give to the threads of

pure colour with which they are combined.

Finally, he will see which are the scales of broken colours, as well as the greys more or less pure, it is important for him to have.

In all the preceding it is understood that it is only the question of graduated colours, and not of colours for grounds.

ARTICLE 2.

Carpets on the System of Flat Tints.

(426.) In most cases where it is required to select a carpet for apartments of a medium size, and especially for small rooms, I should give the preference to carpets in flat tints, because it is possible to have a very beautiful effective work, without the price being too high, while in paying much dearer for a carpet of another kind, resembling pictures, we shall be far from having the best in this sort.

Carpets in flat tints are most favourable to the brilliancy of colours; in fact, the straight or undulating bands of the *dessins points* of Hungary, the palms, where Yellow is opposed to Violet, Orange to Blue, Green to Red, &c., produce the most brilliant contrasts. But I only recommend the employment of these carpets for places where their brilliant colours can injure neither the furniture nor the hangings; for instance, in rooms where the hangings, the stuffs of the chairs, are grey, white, black, or selected so as to accord harmoniously with the carpet by their colours and patterns.

(427.) The most effective carpets are also those which present detached flowers upon a brown ground, with a garland in the centre, in flat tints, and perfectly assorted according to the law of contrast.

ARTICLE 3.

Carpets on a System intermediate between Chiar'oscuro and Flat Tints.

(428.) I have no special remarks to add to the preceding on this kind of carpet; I shall only observe that those which approach the nearest to carpets in flat tints, appear to me preferable to those in which the designer has endeavoured to imitate Savonnerie carpets.

SECTION V.

MOSAICS.

(429.) The name *Mosaics*, as is well known, is given to the coloured imitations of a painted pattern, by employing fragments of marble, stones, different coloured enamels, suitably cut, which are united together side by side, and also fastened together by means of a fine mortar or cement.

If it were possible to make a mosaic with elements as fine and as compact as the threads of tapestry, the work would appear to occupy a place between an oil-painting and a Gobelins tapestry: it resembles the latter, because it is the result of the juxtaposition of coloured elements of an appreciable size: and it approaches to the nature of a picture by a uniform surface rendered brilliant by means of the polish it has received; besides, the contrast of opaque and vitreous elements resemble that of opaque and glazing colours in oil painting.

But, in having regard to the preceding considerations relative to the special qualities of each kind of imitation, mosaic being made to serve for pavement, or at least to be exposed to the changes of weather, the humidity of ground floors, &c., resistance to these destructive agents must be its essential quality: on the other hand, the place it generally occupies in edifices does not permit the eye to seize all the details we look for in a picture: we wander from our object when we pretend to give to works of this nature the finish of painting: we then confound two arts entirely distinct in aim, and also in the nature of the coloured elements which each of them makes use of.

SECTION VI.

COLOURED GLAZING OF LARGE GOTHIC CHURCHES.

WINDOWS OF COLOURED GLASS IN LARGE GOTHIC CHURCHES.

(430.) I now proceed to examine, according to the preceding views, the coloured glass windows which combine so powerfully with architecture in giving to vast gothic churches that harmony which we cannot fail to recognize whenever we enter them, after having admired the variety and boldness of their exterior details, and which place these structures among objects of art, in the rank of those which impress most by their size, the subordination of their various parts, and, lastly, by their complete fitness for the purposes to which they are applied. The stained glass of gothic churches, by intercepting the white light which gives too vivid and unsuitable a glare for meditation (as they only transmit coloured light), have always the most beautiful effect. If we seek the cause, we shall find it not only in the contrast of their colours so favourably opposed, but also in the contrast of their transparency with the opacity of the walls which surround them and of the lead which binds them together. The impression produced on the eye, in virtue of this twofold cause, is the more vivid the more frequently and the longer they are viewed each time.

(431.) The windows of a gothic church are generally either circular, or pointed at the tops in *ogive*, with vertical sides. The stained glass of the first usually represent great rose-windows, where yellow, blue, violet, orange, red, and green, appear like jewels of the most precious stones. The windows of the second almost always represent, amid a border or a ground analogous to the rose-windows, a figure of a saint in perfect harmony with those which stand in relief about the portals of the edifice; and these latter figures, to be appreciated at their true value, must be judged as *parts of a whole*, and not as a Greek statue, which is intended to be seen isolated on all sides.

(432.) The glass composing the different parts of a human figure is of two kinds: *the one has been painted on its surface* with pigments, afterwards vitrified (glass painting); *the other is melted with the material that colours it* (glass staining); generally the first enter into the composition of the nude parts of the figure, as the face, hands, and feet; and the second enters into that of the drapery: all the pieces of glass are united by strips of lead. What has struck me as being most effective in windows with human figures is the exact observance of the relations of size of the figures and of the intensity of the light which renders them visible, with the distance at which the spectator is placed; a distance at which the strips of lead which surround each piece of glass appear only as a line, or as a small black band.

(433.) It is not necessary for an effective whole that the *painted glass*, viewed closely, should exhibit fine hatchings, careful stippling, or blended tints; for, with the coloured stained glass for draperies, they must compose a system which compares with painting in flat tints; and certainly we cannot doubt that a painting on glass, executed entirely according to the system of *chiar'oscuro*, will have this disadvantage over the other, without speaking of the cost of execution, that the finish in the details will entirely disappear at the distance at which the spectator must be placed, and that the view of the whole will be less distinct; *for the first condition which must be fulfilled by every work of art intended to attract the eye is, that it be presented without confusion and as distinctly as possible.* Let us add that paintings on glass executed on the method of *chiar'oscuro* cannot receive the borders and grounds of rose-windows (431.) which present so fine an effect of colour, as they have less brilliancy and transparency than the glass in which the colouring material has been incorporated by fusion (432.), and, lastly, they are less capable of resisting the injuries of time.

(434.) Variety of colours in these windows is so necessary for them to attain the best possible effect (as those which represent figures entirely nude, edifices, in a word, large objects of a single colour, or slightly tinted), that, whatever may be the imperfection of their execution under the relation of finish and truth of imitation, they will have an inferior effect to those windows composed of pieces of varied colours suitably contrasted. Yet I must not omit to instance the bad effect which results from the mixture of coloured glass with *transparent* colourless glass, at least when the latter has a certain extent of surface in a window; but at the same time I recognize the effect obtainable by mixing *ground* glass with coloured glass, and also of small pieces of colourless transparent glass framed in lead, so that at the distance at which they must be viewed, they produce the effect of a symmetrical juxtaposition of white parts with black parts.

(435.) I conclude we must refer the causes of the beautiful effects of coloured church windows-

1°. To their representing a very simple design, the different well-defined parts of which may be seen without confusion at a great distance.

2°. To their offering a union of coloured parts distributed with a kind of symmetry, which are at the same time vividly contrasted, not only among themselves, but also with the opaque parts which circumscribe them.

(436.) Coloured windows appear to me to produce all the effect of which they are really capable only in a vast edifice where the differently coloured rays arrive at the eye of the spectator placed on the floor of the church, so scattered by the effect of the conical figure of the rays of

light emanating from a single point, that they impinge upon each other, whence results an harmonious mixture, which is not found in a small structure lighted by stained windows. It is this intimate mixture of the coloured rays, transmitted in a vast edifice, which permits of tapestries being placed on the ground floor when the lower walls have no colourless glass windows; it is evident that if tapestries are placed too near stained windows, they must lose all the harmony of their colours, as when blue rays fall upon red draperies, yellow rays upon blue draperies, &c.

Thus, when we have to put coloured glass in windows, it appears to me necessary to take into consideration not only their beauty, but also the effect which the coloured lights they transmit will have upon the objects they illuminate.

(437.) The coloured windows of a large church appear to me really as transparent tapestries, intended to transmit light, and to ally themselves harmoniously with the sculptures on the exterior, which destroy the monotony of the high walls of the edifice, and with the different ornaments of the interior, among which tapestries must be taken into account.

(438.) I shall sum up my ideas on the employment of stained glass for windows in the following terms:

1°. They produce all the effect of which they are really susceptible, only in rose windows, bay windows, or the pointed windows of large gothic churches.

2°. They produce all their effect only when they present the strongest harmonies of contrast, not of colourless transparent glass with the black produced by the opacity of the walls, iron bars, and strips of lead, but of this Black with the intense tones of Red, Blue, Orange, Violet, and Yellow;

3°. If they represent designs, these must always be as simple as possible, and admit of the harmonies of contrast;

4°. While admiring windows a large number of which consist of paintings upon glass of undoubted merit, especially in examining the difficulties overcome, I maintain that it is a kind which should not be much encouraged; because the product has never the merit of a picture properly so called, as it is more costly, and will produce less effect in a large church than a stained window of much lower price.

5°. Windows of a pale grey ground with light arabesques have a very poor effect wherever they are placed.

I shall recur to the employment of stained windows in churches when I treat of the relations of the law of contrast with the decoration of the interiors of churches.

THIRD DIVISION

COLOUR-PRINTING UPON TEXTILE FABRICS
AND ON PAPER.

FIRST SECTION.—CALICO-PRINTING.

SECOND SECTION.—PAPER-STAINING.

THIRD SECTION.—PRINTING OR WRITING ON
PAPERS OF VARIOUS COLOURS.

SECTION I.

CALICO-PRINTING.

(439.) The object I have in view in this Chapter, is the examination of the *optical* effects produced by patterns when printed upon woven fabrics, but not the *chemical* effects which arise between the pigments and the stuffs upon which they are printed.

For a considerable period of time printing on textile fabrics was limited, so to speak, to cotton cloths: only of late years has it been extended to fabrics of silk and wool for furniture and clothing.

This branch of industry has undergone an immense extension, fashion having accepted these products with much favour; but whatever may be the importance of the subject in a commercial point of view, I must treat it briefly, because this book is not directed exclusively to that branch of inquiry, and, moreover, all the preceding part is intimately connected with it, that to go deeply into details would expose us to the inconvenience of repetition with no compensating advantage. I shall content myself with stating many facts which serve to show that, for want of knowing the law of contrast, the cotton manufacturer and the printers of woollen and silk stuffs are constantly exposed to error in judging the value of recipes for colouring compositions, or rather to mistake the true tint of the designs which they have themselves applied upon grounds of different colours.

A. FALSE JUDGMENT OF THE VALUE OF RECIPES FOR COLOURING COMPOSITIONS.

(440.) At a calico-printer's they possessed a recipe for printing green, which up to a certain period had always succeeded, when they fancied it began to give bad results. They were lost in conjecture upon the cause, when a person, who at the Gobelins had followed my researches on contrast, recognized that the green of which they complained, being printed upon a ground of blue, tended to become yellow, through the influence of orange, the complementary of the ground. Consequently, he advised that the proportion of blue in the colouring composition should be increased, in order to correct the effect of contrast. The recipe modified after this suggestion gave the beautiful green which they had before obtained.

(441.) This example demonstrates that every recipe for colouring compositions intended to be applied upon a ground of another colour must be modified conformably to the effect which the ground will produce upon the colour of the composition. It proves also that it is much easier for a painter to correct an effect of contrast than it is for a calico-printer, supposing that both are ignorant of the law of contrast: for if the first perceives in painting a green pattern on a blue drapery that the green comes too yellow, it is sufficient for him to add a little blue to the green, to correct the defect which strikes him. It is this great facility in correcting the ill effect of certain contrasts which explains why they so often succeed in so doing without being able to account for it.

B. TRUE TINTS OF DESIGNS PRINTED UPON COLOURED GROUNDS MISUNDERSTOOD.

(422.) In treating of the modifications perceptible in bodies through the medium of light, I have instanced cottons of a coloured ground printed with patterns which the calico-printer intended making colourless; but, owing to the imperfection of the process, were really of the colour of the ground, but of an exceedingly light tint (292., 293.); we may be satisfied of this by looking at them after they are isolated from the ground by means of a white paper cut out like the pattern. I have remarked that, notwithstanding their colour, the eye judges them to be colourless, or of the tint complementary to that of the ground.

(443.) I will now explain the cause of these appearance, because they have been the subject of questions frequently addressed to me by manufacturers of printed stuffs and by drapers; it is due to the law of simultaneous contrast of colours. In fact, when the patterns appear white, the ground acts by contrast of tone (9.); if they appear coloured (and this appearance generally succeeds to that where they appear white), the ground then acts by contrast of colour (13.); the manufacturer of printed stuffs, therefore, will not seek to attribute the cause of these phenomena to the chemical actions manifested in his operations.

(444.) Ignorance of the law of contrast has among drapers and manufacturers been the subject of many disputes, which I have been happy to settle amicably, by demonstrating to the parties that they had no possible cause for litigation in the cases they submitted to me. I will relate some of these, to prevent, if possible, similar disputes.

Certain drapers having given to a calico-printer some cloths of a single colour,—red, violet, and blue,— upon which they wished black figures to be printed, complained that upon the *red* cloths he had put *green* patterns, upon the *violet*, the figures appeared *greenish-yellow*,—upon the *blue*—they were *orange-brown* or *copper*-coloured, instead of the *black*, which they had ordered. To convince them that they had no ground for complaint, it sufficed to have recourse to the following proofs:

1°. I surrounded the patterns with white paper, so as to conceal the ground; the designs then appeared black.

2°. I placed some cuttings of black cloth upon stuffs coloured red, violet, and blue; the cuttings appeared like the printed designs,—*i.e.* of the colour complementary to the ground, although the same cuttings,

when placed upon a white ground, were of a beautiful black.

(445.) Finally, the following are the modifications which black designs undergo upon different coloured grounds:

> Upon *Green* stuffs, they appear of a *Reddish-Grey.*
> Upon *Blue* stuffs, they appear of an *Orange-Grey.*
> Upon *Violet* stuffs, they appear *Greenish-Yellow-Grey.*
> Upon *Red* stuffs, they appear *Dark-Green.*

> Upon *Orange* stuffs, they appear of a *Bluish-Black.*
> Upon *Yellow* stuffs, they appear *Black*, the violet tint of which is very feeble, on account of the great contrast of tone.

These examples are sufficient to enable us to comprehend their advantage to the printer of patterns which are complementary to the colour of the ground, whenever he wishes to mutually strengthen contiguous tints without making them go out of their respective scales.

SECTION II.

PAPER-STAINING.

PAPER-STAINING.

CHAPTER I.

GENERAL REMARKS.

(446.) At the point to which the manufacture of paper-hangings has now arrived, we may, without exaggeration, assert that a knowledge of the law of contrast of colours is indispensably necessary to the artists who are engaged in this branch of industry with the intention of carrying it to perfection.

I consider as essential to their instruction the study of the First Division (Part II.), where I have treated of the imitation of coloured objects by means of coloured materials in a state of extreme division, as well as most of the facts treated of in the Second Division directed to the imitation of coloured objects by means of coloured materials of a certain magnitude.

(447.) We cannot really estimate the true relations between the law of contrast and the art of paper-staining without dividing the papers into the several categories to which the law is applicable; it is not applicable to all, as there are some papers of but a single colour.

I rank in the first category papers having figures and landscapes, as well as those representing flowers of different sizes and of varied colours, not intended for borders. Of all kinds of paper-hangings those in this category approach the nearest to painting.

Papers with patterns of one colour, or of colours but slightly varied, form a second category.

Finally, I rank in the third category those employed as borders.

CHAPTER II.

ON THE LAW OF SIMULTANEOUS CONTRAST OF COLOURS IN RELATION TO PAPER-HANGINGS WITH FIGURES, LANDSCAPES, OR LARGE FLOWERS OF VARIED COLOURS.

(448.) The study which I have prescribed (446.) to artists occupied in fabricating paper-hangings is in some measure that of the generalities, and at the same time the specialities immediately applicable to every composition which resembles a picture, or, in other words, the tapestry of figures and landscapes; but, whatever be the merit of paper-hangings of this category, and the difficulty which has to be surmounted in executing them in a satisfactory manner, nevertheless, they are not sought by persons of refined taste, and they do not appear to me destined to be so in future any more than at the present time; for the twofold reason, that the taste for arabesques painted upon walls or upon wood, and that for lithographs, engravings, and paintings is every day increasing. For if these three last objects do not absolutely prohibit, as do arabesque painted on walls, every kind of paper-hangings, they exclude at least all those with figures and landscapes in various colours.

(499.) The applications of the law of contrast to the fabrication of paper-hangings of the first category are so easy when we thoroughly understand the divisions of the book to which I have referred (446.), that, in order to prove the advantage to be derived from knowing this law, I shall be content to refer to the bad effect presented by contiguous bands of two tones of the same scale of grey (serving as the ground to the figure of an infant), in consequence of the contrast of tone arising from their juxtaposition (333.); for we cannot doubt that the artist who consulted me to remove the ill-effect of which I speak, would not have produced it at all had he known the law of contrast, because he would in that case have made the dark band lighter, and the light band darker at the contiguous parts.

CHAPTER III.

ON THE LAW OF SIMULTANEOUS CONTRAST OF COLOURS IN RELATION TO PAPER HANGINGS WITH DESIGNS IN A SINGLE COLOUR, OR IN COLOURS BUT SLIGHTLY VARIED.

(450.) The remarks respecting the modifications to be made in the recipes of colouring compounds used in printing patterns of stuffs upon grounds of another colour (440.), are also applicable to the printing of patterns upon paper-hangings.

(451.) So also with the remarks contained in the same Chapter (444.), which refer to the modifications black patterns undergo through the colour of the grounds upon which they are printed. The remarks to which I refer, although applicable in every case where black is placed upon a coloured ground, have been chiefly suggested by patterns made on woollen stuffs for ladies' mantles, and also upon furniture:—it appears to me that I had better add to these observations all those which concern other designs than black. The reason which prevents me is that the patterns of woollen stuffs for furniture or mantles, which are executed in the best taste, are those with black figures, or more generally of figures much darker than the ground.

Paper-hangings, I do not say the most tasteful, but those most convenient for use, present very light grounds with white or grey figures; I have preferred speaking, as far as they are concerned, of the modifications which similar designs may receive from coloured grounds; and the remarks which I have already made upon them, determine me to proceed in this manner.

(452.) Grey patterns upon papers tinted of a light colour exhibit the phenomenon of maximum contrast; that is to say, the grey appears coloured with the complementary of the ground.

Thus, conformably to the law (63.):

Grey patterns on a *Rose* ground appear - *Green*.
Grey patterns on an *Orange* ground appear - *Blue*.
Grey patterns on a *Yellow* ground appear - *Violet* or *Lilac*.
Grey patterns on a *Green* ground appear - *Pink*.
Grey patterns on a *Blue* ground appear - *Orange-Grey*.
Grey patterns on a *Violet* ground appear - *Yellow*.

(453.) I cite these facts as examples proper to instruct artists, because, to my knowledge, in manufactories of paper-hangings disputes arise between the proprietors and the preparers of the colours; for instance, a few years ago the proprietor of one of the first manufactories in Paris, wishing to print grey patterns upon grounds of apple-green and of pink, refused to believe that his colour-preparer had given *grey* to the printer at all, because the designs printed on these grounds appeared coloured with the complementaries of the colour of the ground. It was only at the period when the colour-preparer attended a lecture I gave for M. Vauquelin, at the Museum of Natural History, in 1829, hearing me speak of the mistakes that these contrasts of colours might occasion, that he suspected the cause of the effects which he had produced without knowing why, and which had really caused him much annoyance.

CHAPTER IV.

OF THE LAW OF SIMULTANEOUS CONTRAST OF COLOURS, RELATIVELY TO THE BORDERS OF PAPER-HANGINGS.

(454.) Every uniform paper, or one belonging to the second category, must receive a border, generally darker and more complex in design and colour than the paper which it frames.

The assortment of two papers exercises a very great influence on the effects they are capable of producing, for each of them may be of a fine colour, ornamented with designs in the best taste, yet their effect will be mediocre or even bad, because the assortment will not conform to the law of contrast. I shall return to this subject in the Fifth Division, because this chapter is exclusively devoted to the consideration of the borders themselves.

455.) The ground of a border contributes greatly to the beauty of the pattern, whether flowers, ornaments, or any other object that the designer puts upon it. We cannot treat of this influence in an absolute or methodical manner. I shall select a certain number of remarkable facts, which I have had occasion to observe, and I shall principally dwell on those from which we can deduce conclusions, which, apparently not imme-

diately flowing from previous observation, might escape many readers, in spite of the great interest they have in knowing them, without taking into account that the exhibition of these facts will give me occasion to apply the law of contrast to cases where we have designs presenting always many tones of the same scale, and of different hues, and also often of different scales, more or less distant from each other,—that is to say, I shall not occupy myself with simple borders presenting black designs upon a uniform Grey ground, for I have already spoken of the modifications which in this case black designs undergo (445.), and grey designs also (452.), in treating of the printing of designs upon stuffs and paper-hangings, from patterns of a single colour, to those slightly varied.

(456.) The following observations have been made under these circumstances, viz.:

The design of a border, whether ornaments, flowers, or any other object, was cut out and pasted upon a white card.

Designs identical with the preceding which had been pasted upon cardboard were then cut out and placed upon grounds of black, red, orange, yellow, green, blue, and violet, then compared not only by myself, but also by many persons whose eyes were much accustomed to comparing colours. The results were noted in writing when we had perfectly agreed upon their value.

I.—BORDERS OF EIGHT INCHES IN HEIGHT, REPRESENTING GILT ORNAMENTS UPON DIFFERENT GROUNDS.

(457.) These ornaments, executed by the ordinary processes of paper-staining, contained no particle of metallic gold; yellow lakes and oranges of different tones and hues had been exclusively employed in their production. After stating the modifications which the painted gilt-ornaments experience from the colour of the grounds, I shall indicate those which the metallic gilt ornaments receive comparatively from these same grounds; this comparison presenting results which appear to me interesting.

(a.) Black Ground.

(458.) When we look at painted gilt-ornaments placed upon this ground, with the intention of comparing them with the identical ornaments placed on a white ground, the former appear much more distinct than the latter, because the Yellows and Orange-Yellows, colours eminently luminous, and the Black ground, which reflects no light, give rise to contrast of tone, which the White ground, essentially luminous, cannot give with colours, which are themselves luminous.

We perceive, then, as we might expect after what has been said of the effect of Black in contrast (53.), that the colours superimposed upon it are lowered in tone; but it must be noted that Yellows and Orange-Yellows, far from being weakened, according to the remark made above (58.), might cause the Black to gain in purity.

In considering the effects of two ground more attentively, we see that the Black imparts Red to the ornaments, and it is important to remark, that the

brightness of this Red, instead of reddening the Yellows, really gilds them. I call attention to this result, because we shall see (460.) an efect of a Red ground which, without consideration, would lead us to believe it to be contrary to that which now occupies us. Such is the motive that induces me to insist upon this point, so that we may well understand how Black, in taking away some Grey, imparts brilliancy, and how this Grey, which may be considered as a tarnished or broken Blue, may with Yellow produce an Olive colour. It is also necessary to remark that the gilt ornaments in question present an Olive-Grey tint, which, far from being diminished by the White ground, is exalted by it.

Finally, if the Black ground lowers the tone of the colours, while White heightens them, it lowers Yellow more in proportion than Red, and consequently renders the ornaments redder than they appear upon a White ground; finally, in taking away Grey, it purifies the colours, and acts also by giving them some Red, or by taking away some Green.

Metallic Gilt Ornaments.
(459.) Gilt ornaments detach better from Black than from White; but the Orange colour is weakened and really impoverished; the Black ground then does not purify the real gilt as it does the painted ornaments.

(b.) Deep-Red Ground.
(460.) The Yellows are more luminous, the *ensemble* with the painted ornament is clearer, more brilliant, less Grey, than upon a White ground.

Red much deeper than the ornament weakens the tone of it, and this effect is also augmented by the addition of its complementary, Green, a bright colour.

This example has much importance in enabling us to see how the red colour, which appears as though it could be of but little advantage to ornaments, because it tends to weaken them by making them greener, is however, on the whole, favourable, because the lightening or the weakening of the colour is more than compensated for by the brilliancy of the complementary of the ground which is added to the Yellow; we shall return to this effect in a moment (468.). There is this analogy between the influence of the Red ground and that of the Black ground, that the tone of the colours is weakened; but there is this difference, that the ornaments are green upon the first, while they are orange upon the second.

Metallic Gilt Ornaments.
(461.) The Red ground is not so advantageous for gilt ornaments as it is for the painted imitations of them, because the metal loses too much of its Orange colour, and under this relation it appears inferior to gold upon a Black ground.
The Red ground appears darker and more Violet than the ground upon which painted ornaments are placed.
Grounds of a light Red are still less favourable to the gold than Red grounds of a dark tone.

(c.) Orange Ground deeper than the Ornaments.

(462.) The painted ornaments are bluer or rather greener than upon a White ground. The Yellow and Orange are singularly lowered in tone.
This ground then, is very disadvantageous to ornaments, as we might have expected.

Metallic Gilt Ornaments.
(463.) Orange is not favourable to them; the metal becomes too white; on the other hand, the Orange ground is redder and more vivid than that upon which the painted ornaments are placed.

(d.) Yellow Ground of Chromate of Lead, more brilliant than the Yellow of the Ornaments.

(464.) The Yellow of the painted ornaments is excessively enfeebled by the complementary of the ground, Violet, which is added to it; the ornaments appear Grey in comparison with those upon a White ground.

Metallic Gilt Ornaments.
(465.) The Yellow ground is not so unfavourable to gilt ornaments as it is to the painted ones. The first assortment may in certain cases be recommended.
The Yellow appears more intense, and perhaps greener.

(e.) Bright Green Ground.

(466.) The painted ornaments are darker upon a bright Green ground than upon a Red or White ground; they have acquired some Red; but this is not the brilliant tint which is given to them by Black: it is a brick-red tint.

It follows from the comparison of the effects of ornaments upon Red and upon Green grounds, that first is much more advantageous than the second, because it adds an essentially brilliant tint to the colour of the ornaments; while the latter, the adding some Red, or subtracting some Green, produces a brick-red.

Metallic Gilt Ornaments.
(467.) Upon a bright Green ground, they acquire Red, as do the painted ornaments; but the Red, not diminishing the brilliancy of the metal, but, on the contrary, augmenting the intensity of its colour, produces an excellent effect.
The Green ground is more intense and bluer than the same ground upon which the painted ornaments are placed.
(468.) The study of the effects of Red and of Green grounds upon painted ornaments on the one hand, and upon gilt ornaments on the other, is extremely interesting to paper-stainers and decorators; it demonstrates to them the necessity of taking into consideration, in the juxtaposition of bodies which it is proposed to associate, the brilliancy which these bodies naturally possess, and the brilliancy we wish to impart to them when they have none. The preceding examples (460.,

461., 466., 467.) very clearly explain why the paper-stainer will prefer dark Red instead of Green for his gilt ornaments, and why a decorator will prefer Green to Red for the colour of the hangings of a show room of gilt-bronzes; besides, we can appreciate the difference that exists between these two hangings, in seeing how the Green ground is preferable to the Red in warehouses of gilt clocks.

(f.) Blue Ground.

(469.) Observation agrees perfectly with the law; it is relly upon a Blue ground that painted ornaments (the dominant colour of which is the complimentary of this ground) show to the greatest advantage in respect to intensity of the gold-yellow colour; this effect more than compensates for the slight difference which may result from the Red ground giving a little more brilliancy. The ornaments upon the latter ground, compared with those on the Blue, are less coloured, and appear whiter.

Metallic Gilt Ornaments.

(470.) They accord as well as the painted ornaments; the Blue ground is deeper and less Violet than that upon which painted ornaments are placed.

(g.) Violet Ground.

(471.) Conformably to the law, the Violet ground imparting Greenish-Yellow to the painted ornaments is favourable to them; they appear upon this ground less Olive-Grey, more brilliant than upon the White ground, and less Green than upon the Red ground.

Metallic Gilt Ornaments.

(472.) They stand out quite as well from this ground, which is raised in tone, and the Violet appears bluer, or less Red.

(473.) It is remarkable that the gilt ornaments, compared with their painted imitations, heighten all the grounds upon which they are placed. We cannot say that this metal causes the grounds to lose any of their brilliancy; for Orange, taking some Red by the juxtaposition of the gold, appears nevertheless more brilliant than the Orange in juxtaposition with the painted ornaments. The gold, by its Orange colour, gives in addition some Blue, its complementary, to bodies which environ it.

II.—BORDER OF FOUR INCHES IN HEIGHT, REPRESENTING ORNAMENTS COMPOSED OF FESTOONS OF BLUE FLOWERS OF WHICH THE EXTREMITIES ARE ENGAGED IN THE GREY LEAVES OF THE ARABESQUES.

(474.) As a second example, I take these ornaments, opposed in some sort to the preceding by their dominant colour, which is Blue.

Black Ground.

(475.) Grey lowered three tones in comparison with Grey upon White, less reddish.
The Blue flowers lowered two tones at least.

Red Ground.

(476.) The grey is greenish; while upon White it is reddish.
The Blue flowers are lowered three tones, and the Blue inclines to Green.

Orange Ground.

(477.) Grey much lowered; less Red than upon White.
Flowers paler, and of a Blue less Red or less Violet than upon a White ground.

Yellow Ground.

(478.) Grey higher than upon White ground, more Violet.
Flowers of a more Violet-Blue, less Green than upon a White ground.

Green Ground.

(479.) The Grey is reddish, while upon a White ground it appears greenish.
The Blue takes some Red or some Violet, but it loses much of its vivacity; it resembles some Blues of the silk-vat, which, in ceding some Yellow to the water, become Blue-Violet or Slate colour.

Blue Ground.

(480.) The Blue ground being fresher than that of the ornament, it follows that it *Oranges* the Blue of the flowers; that is to say, it *Greys* them in the most disagreeable manner.
The Grey ornament is *Oranged* and lighter than upon the White ground

Violet Ground.

(481.) Grey lowered, yellowed, impoverished, Blue tends to Green, and impoverished.

III.—BORDER OF FIVE INCHES AND A HALF IN HEIGHT, REPRESENTING ROSES WITH THEIR LEAVES.

Black Ground.

(482.) This border is particularly useful to serve as an example of the effect of two colours, Red and Green, which are very common in the vegetable world, and often represented upon paper-hangings.

(483.) The Green is less Black, lighter, fresher, and purer, and its brown tones redder than upon a White ground: with respect to its light tones, I see them yellower; while, on the contrary, they appeared bluer to three persons accustomed to observe colours. This difference, on the other hand, as I at last found, was due to my comparing together the *ensemble* of leaves upon a Black ground with that of leaves upon a White ground; while the other persons instituted their comparison more particularly between the Browns and the light tones of Green placed upon the same ground. This difference in the manner of seeing the same objects will be the subject of some remarks hereafter.
Pink lighter, yellower than upon a White ground.

On a deep Red Ground.

(484.) Green more beautiful, less Black, lighter than upon a White ground.
Pink more Lilac perhaps than upon a White ground. The good effect of the border upon this ground is due chiefly to the greatest part of the Pink not being contiguous to Red but to Green, because the *ensemble* of the border and the ground exhibits flowers the Pink of which contrasts with the Green of their leaves, while the same Green

contrasts with the Red of the ground, which is deeper and warmer than the colour of the flowers.

On an Orange Ground.

(485.) The Green lighter, a little bluer than upon a White ground.

Pink much more Violet than upon a White ground. The general effect is not agreeable.

On a Yellow Ground.

(486.) Green bluer than upon a White ground.

Pink more Violet, purer than upon a White ground. The *ensemble* exhibits a good effect of contrast.

On a Green Ground, the tone of which is nearly equal to that of the lights of the Leaves, and the hue of which is a little bluer.

(487.) Green of the leaves lighter, yellower than upon a White ground.

Pink fresher, purer, more velvety, than upon a White ground. Ground of an agreeable effect, from harmony of analogy with the colour of the leaves, and from harmony of contrast with the rose of the flowers.

On the Blue Ground.

(488.) Green lighter, more golden than upon a White ground.

Pink yellower, less fresh than upon a White ground. Although the green leaves do not exactly produce a bad effect upon the ground, yet the roses lose much of their freshness, and the appearance of the *ensemble* is not agreeable.

On a Violet Ground.

(489.) Green yellower, clearer than upon a White ground.

Pink faded. If the ground does not injure the Green of the leaves, then it injures the pink so much that it is not agreeable.

IV.—BORDER OF SIX INCHES IN HEIGHT, REPRESENTING WHITE FLOWERS, SUCH AS CHINA ASTER, POPPY, LILY OF THE VALLEY, ROSES; SOME RED FLOWERS, SUCH AS THE ROSE, WALLFLOWER; SOME SCARLET OR ORANGE, SUCH AS THE POPPY, POMEGRANATE, TULIP, BIGNONIA; AND VIOLET FLOWERS, SUCH AS LILAC, VIOLETS; AND TULIPS STRIPED WITH YELLOW, WITH GREEN LEAVES.

(490.) This border was remarkable for the pleasing association of the flowers among themselves, and of these flowers with their leaves. In spite of the multiplicity of colours, and of the hues of red and violet, there was no disagreeable juxtaposition, except that of a pomegranate next to a rose; but the contact only took place at a point, and the two flowers were in very different positions.

Black Ground.

(491.) The *ensemble* brighter than upon a White ground.

Orange finer, brighter than upon a White ground. White the same. Green clearer, redder. The roses and the violets gain nothing from the Black.

Red-Brown Ground.

(492.) *Ensemble* brighter than upon a White ground. Whites and Greens effective. An Orange flower, contiguous to the ground, for the reason explained above (460.), acquires a brilliancy which it has not upon a White ground.

Orange Ground.

(493.) *Ensemble* more sombre, more tarnished than upon a White ground.

Orange flowers and roses tarnished, lilacs bluer. This assortment is not good.

Yellow Ground.

(494.) The orange flower contiguous to the ground evidently loses some of its vivacity, in comparison with the White ground.

The Whites are less beautiful than upon a Red ground. The Greens are bluer than upon a White ground. The roses become bluer, the violets acquire some brilliancy. The whole effect is good, because there is but little Yellow in the border, and but little Orange contiguous to the ground.

Green Ground.

(495.) The ground being purer than the Green of the leaves had not a good effect relatively to these latter. On the other hand, the Green in the border was in too small a quantity to produce a harmony of analogy, and it had not sufficient Red for a harmony of contrast.

Blue Ground.

(496.) The Oranges have a good effect; the Greens were reddened as well as the Whites. The roses and the lilacs lost some of their freshness.

This arrangement did not produce a good effect, because there was not sufficient Yellow or Orange in the border.

Violet Ground.

(497.) Orange more beautiful than upon a White ground.

Roses and violets especially less beautiful than upon a White ground. A mediocre assortment.

Grey Ground.

(498.) As might be easily premised, this ground was extremely favourable to all the colours of the border, without exception.

(499.) The examination we have made of four sorts of borders has this twofold advantage, that it enables us to verify exactly the conclusions which are directly deducible from the law of simultaneous contrast of colours, besides presenting to us the effects which we could scarcely have deduced from the same law without the aid of experiment. I now speak-

1°. Of the influence which a complementary exercises by its quality of luminousness upon the colour to which it is added (460.).

2°. Of the very different manner in which not only different people, but even the same person, will judge of the colours of a more or less complex pattern having a certain number of colours, according to the attention the spectator gives at a certain moment to the different parts (483.).

(500.) The examination which we have made of the border of roses with their leaves (No. 3), and especially of that of the border of flowers varied in their forms and hues (No. 4), makes us feel the necessity of a knowledge

of the law of contrast to assort the colours of objects represented upon a border, with the colour which serves as a ground to them. The examination of the border (No. 4) has well demonstrated experimentally that this assortment presents the more difficulty in proportion as we wish to have the grounds of a purer tint, and the objects we intend placing upon them more varied in colour. Besides, in demonstrating the good effect of grey, as a ground for these latter objects, it has furnished the example of a fact which may be deduced from the law, and which is in perfect accordance with what practice has long since taught us.

SECTION III.

PRINTING OR WRITING ON PAPERS OF VARIOUS COLOURS.

CHAPTER I.

INTRODUCTION.

(501.) Having made it a rule in this work never to state any observations which I have not myself verified, whenever I do not quote the name of the author, I must mention that not possessing every requisite for the examination of the subject of this section, I am obliged to develop certain points only; at the same time I shall indicate those which I have not treated as I desired.

(502.) It is not possible to pass a sound judgment on the different assortments of colours with respect to the use which can be made of them in reading, whether of printed or written characters, or by any other means, so far as regards-

A. The duration of the reading;

B. And the kind of light which illumines the printed or written paper.

A. INFLUENCE OF DURATION IN THE READING.

(503.) From the different conditions in which the eye is found when it is apt to perceive the phenomena of simultaneous, successive, and mixed contrasts of colours (77. and following), we conclude, that, in order to judge of the effect upon the sight of the assortments we can make between the colour of the letters and that of the paper, with regard to the degree of facility that different assortments respectively present in the reading, it is necessary to take into consideration the length of time during which we read; for it may happen that one assortment will be more favourable than another during a brief reading, while the contrary will take place if the reading be prolonged during several hours; besides, the first assortment, presenting the greatest contrast to the second, will, by the same reason, be more favourable in a reading of short duration, while it will be less so in a prolonged reading, because then, in consequence of the intensity of its contrast, it will fatigue the eye more than the second.

B. INFLUENCE OF THE KIND OF LIGHT WHICH ILLUMINES PRINTED OR WRITTEN PAPER.

(504.) The light we employ to supply the place of that of the sun changing the relations of colour under which the same bodies appear to us when they are illumined by this latter light, it is evident that if we neglect this difference of relation it would give rise to error, because any assortment of colours which might be more favourable to the reading under diffused daylight might be less so in the light of a candle, lamp, &c.

(505.) Conformably to the distinction I have just established, I am about to examine in the two following Chapters:

1°. The influence of different assortments of colours which we may make use of in writing and printing to render more or less easy a reading of characters printed or traced in any manner, continued for some minutes or hours, by diffused daylight.

2°. The influence of the same assortments when they refer to a short or prolonged reading made by artificial light.

CHAPTER II.

ON THE ASSORTMENT OF COLOURS WITH RESPECT TO READING BY DIFFUSED DAYLIGHT.

ARTICLE 1.

Reading of a few Minutes' Duration.

(506.) The reading of letters printed or written upon paper is done without fatigue only where there is a marked contrast between the letters and the ground upon which they are presented to the eye. The contrast may be of tone or of colour, or both.

Contrast of Tone.

(507.) Contrast of tone is the most favourable condition for distinct vision, if we consider White and Black as the two extremes of a scale comprehending the gradation from normal Grey; in fact, Black letters upon a White ground present the maximum of contrast of tone, and the reading is made in a perfectly distinct manner, without fatigue, by diffused daylight, affording the proof of what I advance: finally, all those whose sight is enfeebled by age, know how the want of light, or, what amounts to the same thing, how the Grey tint of paper, in diminishing the contrast of tone, renders it difficult to read the letters which they could well do without difficulty in a vivid light, or, what is the same, upon papers Whiter or less Grey than that of which we speak.

(508.) Black characters upon Grey paper are difficult to read: this is the reason we do not print or trace with a coloured ink upon paper of the colour of this ink, even if there be a great difference between the two tones.

Contrast of Colour.

(509.) To appreciate the influence of this contrast, the colour of the letters and that of the paper must be taken at the same height of tone, in order to perceive the effect of mutual contrast of two colours only.

(510.) According to the distinction we have made of luminous and sombre colours in equality of tone (184.), it is evident that the contrast most favourable to distinct vision will be that of a luminous colour, such as Red, Orange, Yellow, with a sombre colour, such as Violet, Blue, and that in this case the effect will be at its maximum, if the colours are complementary, as Orange and Blue, Yellow and Violet, &c.

(511.) I have already remarked that Red and Green afford a complementary assortment which presents the least contrast of luminousness, because under this relation the Red is placed between the elements of Green, of which the one, Yellow, is the brightest colour, and the other, Blue is the most sombre (187.). Thus, Red and Green are complementary colours, the least suitable to be opposed to each other in writing or printing coloured characters upon coloured grounds.

Contrast of Tone and of Colour.

(512.) If the contrast of Black and White is the most favourable to distinct vision, and if the contrast of two colours taken at equal height of tone is favourable only in the degree of one being sombre and the other luminous, then we must necessarily conclude that, whenever we would wish to deviate from the opposition of Black and White, we must at the same time make a contrast of tone and of colour, otherwise the reading of letters which are not in this condition of contrast with their ground, will be fatiguing or difficult.

(513.) Next to the opposition of Black with White, come those of Black with the light tones of luminous colours, such as Red, Orange, and Yellow; then those of these same light tones with deep Blue.

(514.) The opposition of luminous colours such as those of Red and Orange, of Red and Yellow, of Orange and Yellow, yield nothing favourable to view: it will be better, I believe, to avoid their associations.

(515.) In all the preceding, I have spoken only of the opposition of tone and colour existing between the letters and the ground upon which we read them; it remains for me to treat the questions whether it is advantageous for the reader that the letters be darker than the ground, as they generally are in printing and writing with Black ink upon white and coloured paper, or whether the reverse is preferable; or, finally, if the two cases present equal advantages. Not having had at my disposal every requisite for resolving these questions, I have not occupied myself with them. I shall limit myself to the single remark that, the letters presenting much less extent of surface than the paper which serves as their ground, there is a superiority of clearness in the particular assortment generally adopted, and clearness is always favourable to distinct vision.

(516.) I will now give some examples of Black characters printed upon coloured paper; commencing with those which appeared to me the easiest to read.

1°. Black characters upon White paper.
2°. Black characters upon light Yellow paper.
3°. Black characters upon light Yellow-Green paper.
4°. Black characters upon light Orange paper.
5°. Black characters upon light Blue paper.
6°. Black characters upon Crimson-Red paper.
7°. Black characters upon deep Orange paper.
8°. Black characters upon deep Red paper.
9°. Black characters upon deep Violet paper.

I shall remark that I read almost as well upon light Orange as upon light Yellow-Green paper.

(517.) I have every reason to believe that other eyes than mine would require some change in the order I have assigned to the preceding assortments.

ARTICLE 2.

Reading of some Hour's Duration.

(518.) The order which may be established between different assortments of colours relatively to the greater or less facility which they respectively present for a reading of some minutes' duration will doubtless differ among some persons from the order in which the same persons would range them in a reading of some hours' duration.

Thus, there may be such an assortment of black letters with coloured paper which, being less favourable to a reading of a quarter of an hour than the assortment of black letters on white paper, will be preferred to this latter by a person to whom the contrast of black and white, seen during many hours, would cause more fatigue than would be occasioned by reading the same letters upon yellow, green, blue, &c., paper, properly selected both as to the height of tone and hue. Unfortunately, I have not been able to make comparative proofs sufficiently prolonged for me to state positive results; for I have only had at my disposal a few loose sheets of paper of different colours upon which black characters were printed.

(519). I have not yet touched upon an element appertaining to the subject that now occupies us, which seems to me worthy of consideration. I allude to a property possessed in variable degrees by colours,— viz.: that of leaving upon the organ which has perceived them during a certain time the impression of their respective complementaries (116.). It is clear that the more durable this impression is, other things being equal, the less will the organ be disposed to receive distinctly new impressions, for there must necessarily be superpositions of different images, as in the mixed contrast (327.), which, not being coincident, will tend to render the actual effect less marked than it might otherwise be.

CHAPTER III.

ON THE ASSORTMENT OF COLOURS WITH RESPECT TO READING BY ARTIFICIAL LIGHT.

(520.) I have made but very few observations on the subject of this chapter. Yet, I believe, I am right in affirming that by diffused daylight I read for some minutes black letters printed on yellow paper more easily than black letters printed upon pale yellow-green paper, while with the light of a lamp the contrary took place.

INTERVAL AND INTRODUCTION
TO PART III

This present volume has omitted the Fourth and Fifth Divisions of Part II (521.) to (828.). These pages and paragraphs are of lesser interest and for the most part repeat Chevreuls' Laws of Contrast in terms of Map Coloring, Colored Engravings, Colors in Architecture and Interior Decoration, Colors in Clothing, and Colors in Horticulture. Much of this is dated, and while it may have some historical interest, it otherwise would have little application today.

Part III of Chevreul's remarkable work, however, is reprinted in its entirety in the pages that follow. Here the reader will encounter essays rather than expositions on color. He may find pleasure in browsing through the text for unique references to general subjects such as volume, form, stability, variety, symmetry, repitition, and to color associations with sounds, taste, smell. He saw weak affinities between sounds and colors. There are intriguing remarks about the Louis XIV gardens at Versailles.

In the last paragraph of his book (1010.) he makes a highly perceptive observation in the psychological realm of color. A red color would appear different if juxtaposed with white, black or other hues such as blue or yellow. Identical red patterns or areas would have different appearances under different surrounding conditions. If different persons were to have different opinions as to the precise appearance of the red, any one person would be wrong "if he pretends that the others ought to see the red as he himself does."

PART III.

EXPERIMENTAL AESTHETICS OF COLOURED OBJECTS

INTRODUCTION.

PART III.

INTERFERENCE OF THE PRECEDING PRINCIPLES IN JUDG OF COLOURED OBJECTS WITH RESPECT TO THEIR COLO CONSIDERED INDIVIDUALLY AND IN THE MANNER UN WHICH THEY ARE RESPECTIVELY ASSOCIATED.

INTRODUCTION.

(829.) The object of this division of my book is pu critical; being, that the exact conclusions at whi have arrived upon the assortment of colours, so a derive the best possible result for a determined a become rules adapted to guide those who would jud work of art where this assortment is found. generalizations established in the preceding Parts, the object of aiding the numerous artists who emp colours to address the eye, now considered und critical point of view, should serve as the basis conscientious and sound judgment upon the merit work which grows out of these generalizations, at in some of its parts. They must, if I am not mista possess the double advantage of all the rules which derived from the nature of the things which concern; they guide the workman who does not disc them, as they direct the critic who judges the wor which these rules govern some element. We can then, refuse to recognize the utility of such examination for the authors of works to whom they submitted, and for the public to which it is m particularly addressed, in the hope that a c demonstration of what is laudable or censurable form its taste, and which, in teaching it to abando first impressions, will itself become capable of exp ing a sound judgment, and that from that time we not hope to enlist its suffrages by falling into bizarre, or in wandering from the truth.

(830.). If a subject exists worthy of being stu under the critical relation on account of the freque and variety of the opportunities it offers, it is unq tionably that upon which I am now engaged; whether we contemplate the works of nature or of the varied colours under which we view them is or the finest spectacles man is permitted to enjoy. explains how the desire of reproducing the colo images of objects we admire, or which under any n interest us, has produced the art of painting; how imitation of the works of the painter, by mean threads or small prisms, has given birth to the ar weaving tapestry and carpets, and to mosaics; how necessity for multiplying certain designs economic has led to printing of all kinds, and to colour Finally, this explains how man has been led to p the walls and woodwork of his buildings, as well dye the stuffs for his clothing, and for the inte decoration of his dwellings.

(831.) The sight of colours, so simple a thing for the greater part of mankind habituated to it from infancy is, according to some philosophers, a phenomenon entirely out of the domain of positive knowledge, because they consider that it varies with the organization and imagination of individuals; consequently they think that there is no induction to be drawn from the manner in which two men see an object similarly under the same exterior circumstances: they believe that no generalization deduced from observation can direct the artist with certainty, either in the art of seeing his model, or in faithfully reproducing a coloured image of it: they also think that no useful generalization concerning the physiological nature of man can be derived from a profound study of the modifications his organs experience from the sight of colours that bodies present to him.

(832.) On principle, I cannot admit that we ought to abstain from studying a subject because it presents variable phenomena. I go further: I believe that all those who are engaged in the study of the positive sciences should inquire if they cannot discover in their labours some fact susceptible of illustrating the study of these phenomena, and put us in the way of determining the cause of one of them: for, what renders the scientific study of agriculture and medicine so difficult is the obstacles which we encounter whenever we would trace to their respective causes the different phenomena presented to the physician and agriculturist by organized bodies. The history of the sciences completely demonstrates that we are not led to this knowledge by synthesis, but rather by the analysis of phenomena which we can scarcely, I think, attempt with hope of success, if we have not made a special study of the causes to which we refer the phenomena of inorganic nature: not that I necessarily recognize these causes to be immediately those of the phenomena of living nature, although this opinion appears to me extremely probable for a certain number of them to be related to physiology properly so called, but because the researches for the causes of the phenomena of inorganic nature appear to me must serve as the right standard to direct works undertaken with the intention of separating certain complex results and tracing them to their respective causes. It is in this state of mind that I have undertaken the subject of this book, not after having spontaneously chosen it, but because it appeared to me indispensable to study it before pretending to establish a sound judgment on the beauty of the colours which the dyer had fixed upon his stuffs. As soon as I felt the necessity for this study in my capacity of director of the dyeing department of the royal manufactories, I wished to understand the ground I trod upon, and my first care was to discover if I saw colours like the generality of persons: I was not long in being perfectly convinced of it, and it was not till then that I ventured to make my researches the objects of public lectures, which have had for auditors, and I may even add for *spectators*, artists, artisans, and the general public. These lectures have been repeated before the students of the Polytechnic School. Certain questions addressed to my auditors to satisfy me that they saw the things I put before their eyes as I saw them myself, have, in the majority of cases, always proved them to be so, and yet my demonstrations were given in the reception hall at the Gobelins, but ill adapted for the exhibition of the phenomena of contrast to a large audience. Certain observations made by myself, tested by a great number of persons in my laboratory, and afterwards publicly exhibited, form the subject of this book: all those who would, I do not say *read*, but *study* it, by repeating my experiments, will discover if my opinion is well founded, or one which pretends that the sight of colours is not susceptible of giving a general positive result, and if, because they can instance some individual whose organ of sight is so imperfect that he cannot distinguish green from red, or who confounds blue with grey, &c., we must write our treatises on optics without mentioning either red, green, or blue, and sweep these colours from the palette of the painter! Truly, human nature is but too limited to allow of our making such a sacrifice to a common infirmity of organization.

(833.) In order to clearly comprehend how, after I had separated the causes which exercise a determinate influence upon the sight of colours, experiment and observation led me to adopt the opinion that these phenomena are perfectly defined by the law of contrast, and the conclusions I have allied to it, doubtless it till suffice,

1°. To consider how

A. The ignorance we had respecting the different states of the eye, which in seeing colours give rise to the phenomena of simultaneous, successive, and mixed contrasts.

B. And the ignorance we had respecting the definite influence that the direct or diffused light of the sun exercises, according to it intensity, upon the colours of bodies,

have led to the establishment of an opinion contrary to my own, that is to say, the opinion that *the same colour appears so diversely to different persons, and even to the same person, that nothing general or precise can be deduced from the sight of coloured objects under the relation of their respective colours.*

2°. To consider how

C. The limited number of ideas we have generally upon the modifications of coloured bodies by their mutual mixtures, or, in other terms, upon the colours resulting from these mixtures, have passively contributed to belief in this opinion.

D. The want of a precise language to convey the impressions we receive from colours.

3°. Of recapitulating how

E. Inexact ideas which are believed to be sound have *actively* contributed to establish belief in this opinion.

A. *(a)* It is indisputable that, if we are ignorant of the regularity with which the eye passes successively through stages the extremes and the mean of which are very different, when we view the colours which put the organ into the condition of perceiving the phenomenon of one of the three contrasts (77. and 328.), we shall be led to consider the sight of colours as a very variable

phenomenon, *while the successive stages through which the organ passes being once distinguished, the variations of the phenomenon become perfectly definite.*

(b) If we are ignorant of the law of simultaneous contrast, we shall see that the same colour varies in hue, according to the colour with which it may be associated, and if we are ignorant that contrast affects the tone as well as the colour, we cannot explain how two similar colours (for instance, blue and yellow taken at the same height) will appear redder by juxtaposition, while if the blue is very deep relatively to the yellow, it will appear black rather than violet, and the yellow will appear more green than orange (663.). Finally, if we are ignorant of the effect of brightness a complementary can give to a dull colour, we cannot explain the great difference there is between the effect of a red ground upon imitation gilt ornaments (painted) and the effect of the same ground upon metallic gilt ornaments (460. and 468.).

(c) Doubtless, also, if we are ignorant that in a complex object the eye can only see at the same moment but a small number of parts clearly (748.), and that the same part may appear to different eyes with different modifications, according as it is seen juxtaposed with one or another colour, as occurred in the instance (483.) when I compared the pattern of a border for paper-hangings (presenting roses with their leaves) placed upon a black ground, with a similar pattern placed upon a white ground; on comparing the two together, I saw the light green on the black ground yellower than upon the white, while three other persons, who compared the light tones of green with its deeper tones on the same ground, judged the light tones to be bluer upon the black than upon the white ground.

B. We might know the regularity of the successive states in which the eye is found during the sight of coloured objects and the law of simultaneous contrast of colours, and yet if we were ignorant of the influence of various degrees of intensity of light in varying the colour of bodies and in rendering the modifications of contrast more or less evident, we should be led to believe in an indefinite variation in the aspect of colours, while this variation is perfectly defined by the following remarks:

(a) If the direct light of the sun or diffused daylight illuminates a monochromous body unequally, the part most vividly lighted is modified as it would be if it received orange, and the modification appears the stronger the greater the difference of light on the parts (280.): thus, the more intense the light the more it gilds the body it illumines; it is thus always easy to foresee the effects of it, when we know the result of the mixture of orange with various colours.

(b) In a very vivid light the phenomena of simultaneous contrast being less evident than in a weaker light (63., 571.), it follows, if we neglected to take account of the difference in the effects, we should greatly deceive ourselves in our appreciation of the phenomena of contrast of similar colours. It is useful to remark that simultaneous contrast which tends to make the differently coloured parts appear as distinct as possible, is carried to a maximum precisely when, the light being feeble, the eye requires the greatest contrast of colour to perceive distinctly the various parts upon which it is fixed.

C. We may perceive the modifications presented by bodies when lighted, and experience much difficulty in accounting for them, for want of knowing how to exactly represent the modifications which the coloured materials experience in their colour, according as they receive light or white, shade or black, or according as they are mixed together. It is partly to make these modifications clearly known that I have designed the *chromatic hemisphere* (159. and following); in describing it I have attached less importance to its material realisation than to the rational principle upon which it rests. On looking at the lines of this diagram independently of all colouring, we understand how any colour is reduced by white; lastly, how by mixture with a pure colour, it produces hues. I shall add subsequently some new considerations, which belong to the gradations of colour we make with coloured materials (841.).

D. The object I have had in view would not have been attained, if the chromatic hemisphere had not given me the means of representing, by a simple nomenclature, the modifications a colour undergoes by the addition of white and black, modifications which produce the *tones of its scale;* those which it receives from black yielding *broken scales;* lastly, those which, resulting from the addition of a pure colour, produce scales which are *hues* of the first colour.

Finally, to the definitions which I have given of the words *tone, scale, hue, broken colour,* I must add the distinction of the associations of colours in *harmonies of analogy*, and *harmonies of contrast* (180.).

I am convinced that all those who accept the small number of definitions I have given, will find much advantage in using them to account for the effects of colours, and to communicate to others the impressions they have received from them; by their aid it will be easy to seize relations which might have escaped observation, or which, in the absence of precise language, could not have been clearly expressed by those who perceived them.

E. It would be ignoring the reality, if I should attribute the opinion combated exclusively to simple ignorance of the facts recapitulated (A. B. C. D.), or to believe that it suffices to dissipate it, in order to establish the contrary opinion I profess: I am under no illusion; if ignorance is passive, and resists only by its inertia, it is quite otherwise with ideas more or less erroneous or pretentious, which exist on the sight of colours and their harmonies; these ideas actively repulse all that is opposed to

them. I am satisfied with pointing out the obstacle, without having the least pretension to overthrow it, except by enouncing what I believe to be the truth.

In conclusion, by means of the positive facts which I have just reviewed, the study of the sight of coloured bodies leads to a certainty which all may acquire who henceforth give themselves up to it; they will see how fruitful it is in applications, and independent of all hypothesis, and that it would be impossible to obtain this result if there did not commonly exist among men an average organisation of the eye, which permits them to perceive (other things being equal) the same modifications in illuminated bodies: the difference, I admit, in the perception of the phenomena by divers individuals who have perfect organs of sight, bears only on the intensity of the perception.

(834.) The series of principles upon which my book is founded being reviewed, I next consider these facts under the three following relations, each of which will be the subject of a section:

1. Under the relation of the certainty they give in judging of the colour of any object whatever.
2. Under the relation of the certainty they give to the judgment we bring to the productions of the various arts which address the eye by coloured materials.
3. Under the relation of the union they establish between the principles common to many arts which address to the eye various languages in employing different materials.

Finally, in the last section, I shall treat of the influence that the disposition of the mind of the spectator may have upon the judgment he brings to any work of art exhibited.

SECTION I.

INTERFERENCE OF THE LAW OF SIMULTANEOUS CONTRAST OF COLOURS WITH THE JUDGMENT WE EXERCISE UPON ALL COLOURED BODIES, VIEWED UNDER THE RELATION OF THE RESPECTIVE BEAUTY OR PURITY OF THE COLOUR AND OF THE EQUALITY OF THE DISTANCE OF THEIR RESPECTIVE TONES, IF THESE BODIES BELONG TO THE SAME SCALE.

INTRODUCTION.

(835.) The most simple and general conclusion deduced from the law of contrast is certainly that which concerns the judgment we exercise, either by taste or profession, on a colour presented by a coloured paper, a textile fabric, a glass, an enamel, a picture, &c. One condition which all those who have some experience in the matter regard as essential to be fulfilled to avoid error, is to compare the colour upon which it is necessary to judge with another colour which is analogous to it. If we are ignorant of the law of contrast, the result of this comparison is not exact, when the objects compared are not identical; I now proceed to demonstrate this by different examples very well adapted to the application of the principle spoken of. Further, one conclusion more apart from the law gives the means of knowing if the tones of a scale of wool or silk intended for tapestry or carpets are equidistant.

CHAPTER I.

ON THE COMPARISON OF TWO PATTERNS OF THE SAME COLOUR.

(836.) When it is a question of two patterns of any kind, which relate to the same colour, be it blue or red, if there is no identity between the tints of the two patterns when compared together, we must take into account the contrast which exaggerates the difference: thus, if the one be greenish blue, it will make the other appear less green or more indigo, or even more violet than it really is; and, reciprocally, the first will appear greener than when viewed isolated; the same with the reds, if one is more orange than the other, this latter

will appear more purple and the former more orange than they really are.

CHAPTER II.

INFLUENCE OF A SURROUNDING COLOUR UPON ONE COLOUR WHEN COMPARED WITH ANOTHER COLOUR.

(837.) Since the contrast of colours which are not analogous tends to their improving and purifying each other, it is evident that whenever we would exercise a correct judgment upon the beauty of the colours of a carpet, tapestry, or picture, &c., after having compared them with the colours of objects analogous to the first, we must take into account the kind of painting and the manner in which they are juxtaposed, if the objects compared are not the exact representation of the same subject. For, other things being equal, the same colours not shaded and which are not sufficiently analogous to mutually injure each other, disposed in contiguous bands, will certainly appear more beautiful than if each were seen on a ground which consisted of it exclusively, and which, consequently, produced only a single impression of colour upon the eye. Colours arranged as palms, like those of Cashmere shawls, or as patterns, as in Turkey carpets, produce a much greater effect than if they were shaded or blended, as they generally are in paintings. Consequently if we wished, for example, to compare a stripe of amaranth red, in a Cashmere shawl of various stripes with the amaranth of a French shawl, we must remove the contrast of colours near to the amaranth stripe, by concealing them with a piece of grey or white paper, cut out, so as to allow us to see only this stripe: it being understood that a piece of paper cut out similar to the first is laid upon the ground, so that the parts compared will be submitted to the same influence from the surrounding parts.

(838.) The same means must be employed when we compare the colours of old tapestries, pictures, &c., with analogous colours recently dyed or painted; and for this reason, time acts very unequally, not only on the different kinds of colours which are applied to stuffs by the dyer, but also upon the tones of the same scale. Thus the deep tones of certain scales—those of violet, for example—fade, while the deep blues of the indigo-blue scale, the deep shades of madder, kermes, cochineal, are permanent. In the second place, the light tones of the same scale fade during a space of time which has no sensible effect in altering its deep tones. Hence the colours which have most resisted the destructive action of time being more isolated from each other, deeper, and less blended, appear by that to have more brilliancy than if they were otherwise disposed. There are many pigments used by painters, particularly most of the lakes, which are in the same condition, relatively to the others, as the changeable

colours of the dyer; such as ultramarine, the oxides of iron, the blacks, which are, so to speak, unalterable by atmospheric agents; but the alteration of the first may, in many case, contribute to heighten the brilliancy of colours less changeable.

CHAPTER III.

ON THE EFFECT OF CONTRAST UPON THE BROWNS AND THE LIGHTS OF MOST OF THE SCALES OF WOOL AND SILK EMPLOYED IN TAPESTRY AND CARPETS.

(839.) When we look at the *ensemble* of tones of most of the scales made use of in the fabrication of tapestries and carpets, the phenomenon of contrast exaggerates the difference of colour which we remark between the extreme tones and the middle tones of the same scale. For instance, in the scale of indigo-blue applied to silk, the lights are greenish, the browns are tinged violet, while the intermediate tones are blue; but the difference of green and violet at the two extremes is found augmented by the effect of contrast. It is the same in the scale of yellow; the light tones appear greener and the browns redder than they really are.

(840.) I cannot speak of a difference existing between the deep and the light tones of most of the scales of wool and silk which is exaggerated by contrast, without adding some remarks relative to the gradations the dyer produces by means of a colouring material which he applies upon a white fabric, supposed to be absolutely void of any material foreign to the nature of the coloured compound with which it is united. It is only very rarely that this gradation is perfect under this mode of viewing it, as the light tones are exactly represented to the eye by the colour taken at its normal tone reduced with white. Thus, a compound which at the normal tone is pure yellow or slightly tinged with orange, will, by reduction, produce light tones of a greenish yellow. An orange-red compound, fixed upon silk or wool, will yield light tones tinged violet-red. To obtain a correct gradation, we must, in most cases, add to the weak tones a new coloured material, adapted to neutralise or weaken the defect spoken of.

(841.) Many of the pigments used in painting produce the same result when reduced with white; and I do not speak here of changes which may be the result of chemical action. I allude only to those which result from an attenuation of the coloured material. For example, the normal tone of carmine is a much purer red than its light tones, which are evidently tinged with lilac. Ultramarine, so beautiful in itself, yields light tones, which, with respect to the blue rays, appear to reflect more violet rays than the normal tone. In consequence of these facts, it is difficult to colour the chromatic diagram, because many attempts must be made to foresee the modification of colour which yields the normal tone of a scale by the addition of coloured materials suited to render the gradation correct to the eye.

CHAPTER IV.

MEANS AFFORDED BY CONTRAST BY WHICH WE MAY BECOME CERTAIN IF THE TONES OF A SCALE OF COLOUR ARE EQUIDISTANT.

(842.) Contrast which augments the difference existing between two tones of the same colour, gives the means of ascertaining with greater certainty than could otherwise be done, if the numerous tones of a scale are at the same distance from each other. Thus, if the tone 2 placed between 3 and 4 appears equal to the tone 1, it follows, if the tones are equidistant, that 3 placed between 4 and 5 will appear equal to 2; that 4 put between 5 and 6 will appear equal to 3, and so with the others. If the tones are too near together to yield this result, we must move them successively, not one degree, but two or three. This means of judging of the equality of distance that separates the tones of the same scale is based upon the fact, that it is easier to establish an equality than to estimate a difference between patterns of the same colour.

SECTION II.

INTRODUCTION.

(843.) After having applied criticism to the judgment we entertain of the colour of a material object, relatively either to its beauty and brilliancy, or to the place its tone assigns to it in the scale of which this object forms part, we must apply it to the judgment concerning the associations of different colours made with the intention of producing an agreeable effect. In order to give the judgment a basis solid beyond all dispute, I shall examine the association of two colours independently of material form, under which the works of nature or of art can offer them to view; and on this occasion I shall sum up many general facts which are found in the Introduction to Part II. of this work (143., &c.), and in several of its divisions. This summary will permit the reader to follow the co-ordinate generalisation, so as to serve as a basis to a critical examination of the products of all the arts which employ coloured materials. After having drawn the principal important conclusions which flow from the binary associations of colours, then I shall occupy myself with their complex associations under the point of view of the harmonies of analogy and of contrast to which they give rise: finally, under a last point of view, I shall take into consideration the influence which the physical nature of the coloured materials the arts employ must specially exercise to attain the aim peculiar to each.

CHAPTER I.

OF THE BINARY ASSOCIATIIONS OF COLOURS CONSIDERED CRITICALLY.

(844.) In order to sum up in a few words the generalities which must serve as the bases of our our judgment, not only on one colour compared with another of the same sort, but on the associations of two colours which any object whatever presents to our eyes, for example, a stained paper, a stuff, a vestment, or which form part of a picture, I shall consider the case where associated colours are mutually complementary, and that where they are not.

1st CASE.—*Association of Complementary Colours.*

(845.) *This is the only association where the colours mutually improve, strengthen, and purify each other without going out of their respective scales.*

This case is so advantageous to the associated colours, that the association is also satisfactory when the colours are not absolutely complementary.

So it is also when they are tarnished with grey.

Such is the motive which has made me prescribe the complementary association, when we have recourse to the harmonies of contrast in painting, in tapestry, in the arrangement of coloured glass windows, in the assortment of hangings with their borders, in that of stuffs for furniture and clothing, and lastly, in the arrangement of flowers in our gardens.

2nd CASE.—*Association of Non-Complementary Colours.*

(846.) *The product of this association is distinguished from the preceding in this, the complementary of one of the juxtaposed colours differing from the other colour to which it is added, there must necessarily be a modification of* HUE *in the two colours, without speaking of the modification of tone, if they are not taken at the same height.*

Juxtaposed non-complementary colours can certainly give rise to three different results:

1°. They mutually improve each other.

2°. The one is improved, the other loses some of its beauty.

3°. They mutually injure each other.

(847.) The greater the difference between the colours, the more the juxtaposition will be favourable to their mutual contrast, and consequently the more analogy they will have, and the more chances there are that the juxtaposition injures their beauty.

1°. *Two non-complementary colours improve each other by juxtaposition.*

(848.) Yellow and blue are so dissimilar, that their contrast is always sufficiently great for their juxtaposition to be favourable, although the juxtaposed colours belong to different scales of yellow and blue.

2°. *One colour, juxtaposed with another which is not its complementary, is improved, while the latter is injured.*

(849.) A blue which is improved by a yellow, being placed beside a violet (blue rather than red), may lose some of its beauty by becoming greenish, while the orange it adds to the violet, neutralising the excess of blue of this latter, improves rather than injures it.

3°. *Two non-complementary colours mutually injure each other.*

(850.) A violet and a blue reciprocally injure each other, when the first greens the second, and the latter neutralises sufficient of the blue in the violet to make it appear *faded*.

(851.) It might also happen that although the colours juxtaposed are modified, both neither gain nor lose in beauty; that the one gains without the other losing; lastly, that the one neither gains nor loses, while the other loses.

(852.) *In the association of two colours of equal tone, the height of the tone may have some influence on the beauty of the association.*

For example, a deep indigo-blue and a red of equal depth gain by the juxtaposition: the first, by losing some violet, will become a pure blue; the second, in acquiring orange, will become brighter. If we take light tones of these same scales, it may happen that the blue will become too green to be good as a blue, and that the red, acquiring orange, will be too yellow to be a pure red.

(853.) *In the association of two coloured objects of tones very distant from each other, belonging to the same scale, or to scales more or less allied, the contrast of tone may have a favourable influence upon the beauty of the light tone,* because, in fact, if the latter is not a pure colour, its juxtaposition with the deep tone upon the whole brightening it, will purify what grey it may have.

(854.) It is very necessary for the correction of our judgment of the principles I set up on the binary associations of colours, not to lose sight of all which precedes from paragraph 846., inclusively, concerning colours flat (*mat*), or deprived of gloss, and that their association be considered independently of the form of the object presenting them, for the twofold reason that *the glossiness of the coloured surfaces and the form of the bodies which these surfaces limit in space,* are two circumstances capable of modifying the effect of two associated colours: consequently the analysis I have made of the optical effects of colours will be incomplete, if I do not now speak of the possible influence of these causes.

Influence of Gloss taken into Consideration in the Effect of Contrast of Two Colours.

(855.) One of the results to which the observation of contrast of *mat* colours leads, is the explanation of how the association of one colour with another is favourable or injurious to the *ensemble*, or only to one of them, in making evident to the eye that, in the most favourable case possible, the optical product of the juxtaposition is composed of two effects:

1°. The effect arising from each of the juxtaposed colours, receiving the complementary of the colour contiguous to it, being strengthened or tinged agreeably by this addition, independently of any augmentation of gloss.

2°. The effect arising from an augmentation of gloss in the two juxtaposed colours. Recalling these results, is to foresee an objection which might have been made to me, namely, that the associations which I have not prescribed, such as those of red with violet, blue with violet, for

instance, have a fine effect in the plumage of certain birds, and upon the wings of certain butterflies; for, according to the preceding distinction, it is evident that in these natural associations, the effect arising from the addition of the complementaries to each of the two colours which would injure the *mat* colours is entirely insensible in injuring colours which acquire *metallic lustre* from the organic structure of the feathers and scales upon which they are found. Finally, I shall add, that it would be necessary, before raising the objection, to demonstrate that the same red associated with green, the same violet associated with yellow, and, lastly, the same blue associated with orange equally glossy, will be less effective than the natural assortments I now take for examples.

Influence of Form taken into Consideration in the Effect of Contrast of two Colours.

(856.) If gloss has so much influence upon the effects of contrast of two juxtaposed colours, the form of the coloured parts presenting them has undoubtedly an influence also; thus the elegance of the form, the arrangements of the parts, their symmetry, the effects of light and shade upon the surfaces independent of all colour, finally the association of ideas which may connect this form with an agreeable recollection, will prevent the perception of the ill effect of two associated colours which are not at all glossy; it is thus, for example, that flowers impress us with associations which, without shocking us, yet, nevertheless, would not produce a good effect if we saw them upon two plain surfaces deprived of gloss. We may instance anew, for example, the flower of the sweet pea, which offers the alliance of red and violet. It cannot be doubted that the red and the violet of this flower, being juxtaposed—the red to green and the violet to yellow—do not produce a finer effect than that resulting from their association in the flower mentioned above.

(857.) The relation of the preceding facts to criticism is easily perceived when we proceed to judge of the association of two colours in themselves, or to compare together different binary associations.

In the first case we can inquire if the association an artist has made of two colours has attained the end he proposed,—that of improving both, or that of improving one and sacrificing the other.

In the second case we can compare together the effects of one colour of the same class—reds, for example—each making part of a binary association, we can compare together the effects of binary associations of different colours, always under the optical point of view, and with the intention, if these associations are the product of art, of judging the artist who has made them. Then the critic must be directed by the considerations which are summed up as follows:

1°. The kind of association: the greater the difference between the colours, the more they mutually beautify each other; and inversely, the less difference there is, the more they will tend to injure one another (845.—851.).

2°. The equality in height of tone (852.)

3°. The difference of tone, the one being deep, the other light (853.).

4°. The glossiness of the surfaces which sends them to the eye (855.).

5°. The form of the body of which these surfaces limit the extent (856.).

CHAPTER II.

OF THE COMPLEX ASSOCIATIONS OF COLOURS REVIEWED CRITICALLY.

(858.) It is evident that the rules prescribed for judging a colour and the associations of two colours in an absolute manner, must serve for judging under the same relation the colours of an association, however complex it may be, when found in a picture, tapestry, carpet, stained-glass window, or in the decoration of a theater, apartment, &c.; but to view the *ensemble,* we must proceed conformably to the distinctions we have established of the harmonies of analogy and the harmonies of contrast; for, otherwise, it would not be possible to express clearly a sound judgment concerning the specialties of the constituent assortments and the general effect of the *ensemble* of all these assortments; besides, before expressing this judgment, we must *know how to see* colours independently of all form or pattern; in a word, independently of all which is not colour, even when it is necessary in a picture.

(859.) In this manner we can see a complex association of colours, such as are presented to us by a picture, for instance, thus taking the most complicated case. We shall consider the masses of colours which are upon the same plane, the extent which each occupies, and the harmony that unites them together. On submitting to a similar examination the colours on the other planes, we then can look at the colours in passing from those of the first plane to the colours of the latter. The critic who is well satisfied with seeing clearly at the same time only a very small number of the objects that a picture presents to him (748., 483.), and who is also accustomed to examine a coloured composition in the manner I have described, is, relatively to things upon which he successively concentrates his attention, in the position of a person who reads in succession three kinds of writing traced on the same side of a sheet of paper; one of them composed of lines across the width of the paper, the other composed of lines crossing the first at right angles, and the third composed of lines running diagonally across the paper. After giving himself up to this examination, the critic must renew the *ensemble* of the picture under the relation of its colours, and then, having fixed upon their particular and general associations, he will be in a condition to penetrate the thought of the painter, and of seeing if he has employed the most suitable harmonies to express it; but this is not the place to treat this subject: it belongs to the following Chapter (865., &c.). I will only remark, that if it is easier to form with opposed colours than with neighbouring colours, binary assortments favourable to the associated colours in a composition where a great number of pure and brilliant colours are employed, it is more difficult to harmonise these latter in allying them to one another, than if we proceeded with a small number of colours, which would add only to the harmonies of analogy or of contrast of scale or of hues.

CHAPTER III.

OF THE TWOFOLD INFLUENCE PRESENTED UNDER THE CRITICAL POINT OF VIEW WHICH THE PHYSICAL CONDITION OF THE COLOURED MATERIALS EMPLOYED IN VARIOUS ARTS, AND THE SPECIALTY OF THESE ARTS, EXERCISE UPON THE PARTICULAR PRODUCTS OF EACH OF THEM.

(860.) I have so deep a conviction that the greatest artists cannot free themselves from certain rules without compromising the art itself, that I believe it useful to insist upon everything which can substantiate my opinion. Such is the motive with which I refer to the results that naturally flow from the physical state of the coloured materials employed in various arts, and of the special object of these arts; results of which I have already shown the importance in the case where we judge if certain innovations have the merit or advantages which their authors promised for them. It is under this connection that I now consider the arts of painting which employ coloured materials in a state of infinite division (so to speak), and the arts which employ them of a certain size, as the threads of the tapestry-weaver, the pieces of the mosaic worker, &c.

§ 1.

OF THE ARTS OF PAINTING WITH COLOURED MATERIALS IN A STATE OF SO CALLED INFINITE DIVISION, CONSIDERED RELATIVELY TO THE PHYSICAL STATE OF THESE MATERIALS AND THE SPECIALTY OF THE ART EMPLOYING THEM.

(861.) In the first place, I must explain the meaning of the expression *in a state of infinite division,* applied to coloured materials employed by painters: in reality, the division of these materials is not infinite, it is not even carried to the point attainable by mechanical means. If it were possible to perceive them in a painting by means of magnifying glasses, we should then see that a coloured surface, which appears of a uniform colour to the naked eye, is composed of distinct coloured particles, disposed in parallel or concentric lines, or in spots, according to the handling of the pencil. By these means we could distinguish in oil-paintings some parts which would resemble an enamel, because they would contain so many opaque particles which the drying oil does not make transparent, while the other parts would resemble a coloured glass, because the oily vehicle does not contain sufficient opaque particles to be entirely deprived of its transparency.

I shall now consider, successively, painting in chiar'oscuro and in flat tints.

ARTICLE 1.

Painting in Chiar'oscuro.

(862.) In commencing with the fact that the pigments of the painter appear to be in a state of infinite division, we come to see clearly the possibility of tracing lines as fine as it is possible to make them, by means of a pencil filled with a fluid charged more or less with colouring materials, of intimately mixing these pigments together,

so as to blend them with each other. From this state of things we deduce the possibility of making *a perfect delineation of the different parts of objects of which the painter wishes to reproduce the image, and represent exactly all the modifications of light which exist in the model.*

(863.) I now recall how satisfactory the study has been which we have made of the modifications under which bodies appear, when they are rendered visible by the direct light of the sun, or by diffused daylight, in enabling us to judge if these modifications have been faithfully reproduced by the painter in a given work. I must refer the reader of this subject to the division of this book concerning painting.

(864.) From the perfection of the drawing, and the gradation of white and coloured light, result the perfection of the imitation of all coloured objects, by means of which their images appear upon a plain surface, as if they were seen with the relief peculiar to them. From this possibility of imitating clearly the minutest details in a model, results the possibility of expressing upon plane figures all the emotions of the heart of man which are manifested by the expression of his countenance. From thence is derived the noblest, the loftiest part of the art which places the painter near the poet, the historian, and the moralist; a part upon which the critic pours his admiration to excite it in others, but which has no rules a master can impart to his pupils. I make this declaration in order that my intention may not be misunderstood, which has dictated to me the developments promised above (859.), relative to the correspondence of the harmonies of colour with the subject upon which they are employed—developments upon which I now enter.

(865.) If harmony of contrast is most favourable to cause two colours to impart value to each other (845.), on the other hand, when we desire to derive the best possible advantage from a union of numerous brilliant colours in any work—a picture, for instance—this diversity presents some difficulties for the harmony of the whole, which a smaller number of colours would not present, and particularly of colours less brilliant (859.). Accordingly, it is evident that if we compare together two effective pictures, well adapted to be judged under the relation of colour, other things being the same, the one which presents the most harmony of contrast of colour will have the greater merit under the relation of the difficulty overcome in the employment of the colours; but we must not conclude that the painter of the other picture is not a colourist; because the art of colouring is composed of various elements, and the talent of opposing pure colours with each other is only one of these elements.

(866.) Let us now consider the relations existing between the subjects of painting and the harmonies they admit. We know that the more pictures address the eye by numerous contrasts, the more difficulty the spectator experiences in fixing his attention, especially if the colours are pure, varied, and skillfully distributed upon the canvas. A result of this state of things then is that, these colours being much more vivid than the flesh-tints, the painter who wishes that his idea should be sought in the *expression* of his figures, and who,

putting this part of his art above the others, is also convinced that the eyes of most people, ignorant of the art of seeing (being carried away by what they see at first), are incapable of returning from this impression to receive another; the painter, I repeat, who knows all these things, and is conscious of his power, will be restrained in the use of harmonies of contrast, and prodigal of the harmonies of analogy. But he will not derive advantage from these harmonies, especially if he selects a scene occupying a vast space filled with human figures, as in the "Last Judgment" of Michael Angelo, unless he avoids confusion by means of correct drawing, by a distribution of the figures in groups skillfully distributed over the canvas, so that they cover it almost equally, yet without presenting a formal symmetry. The eye of the spectator must embrace all these groups easily, and seize the respective positions; lastly, in penetrating one of them, he must find a diversity which will entice him to extend this examination to other groups.

(867.) The painter who misses the effect of the physiognomies when having recourse to the harmonies of analogy, will not have the same advantage in fixing the attention of the multitude as the painter who has employed the harmonies of contrast.

(868.) The harmonies of contrast of colour are especially applicable to scenes illuminated by a vivid light, representing fêtes, ceremonies, &c., which may be sober without being sad; they are also applicable to large subjects, in which we find different groups of men animated with various passions.

(869.) To conclude, in all I have said on the subject of the immediate applications of the law of contrast to painting, I have given precepts adapted to enlighten the artist as well as the critic, since he cannot avoid them without evidently being unfaithful in the imitation of his model. I have stated numerous considerations, in order that clearly separating by analysis the elements of the art which concur with those of which I have given the rules, they will not attribute to me ideas which I do not entertain, but, on the contrary, they will see plainly that I have never misunderstood the qualities which neither instruct nor make the great artist. It is in this spirit that I have spoken of the harmonies of colours; and in distinguishing them into harmonies of analogy, and harmonies of contrast, I have been led to observe that we cannot mistake with respect to the pleasure produced in us by the sight of various colours suitably assorted. When indicating the subjects in which it appeared to me the harmonies of one kind should dominate over the others, I spoke in a general, but not in an absolute manner. I remarked that if the painter, with the intention of attaining the highest rank in his art, would fix attention by the expression of his figures rather than by colour, and if, in consequence, he makes the harmonies of analogy predominate over the others, it will happen that—if he misses his aim—he will have a marked disadvantage in respect to the case where he would have employed vivid and contrasting colours, the expression of his figures remaining the same. On the other hand, I have remarked that the painter who would treat a subject to which the harmonies of

contrast belong, will place himself in an unfavourable position, other things remaining the same, if he has recourse to the harmonies of analogy.

A result of this view is that the critic must never compare two large compositions under the relation of colouring, without taking into account the difference which may exist in the accordance of each subject with one kind of harmony more than with the other.

ARTICLE 2.

Painting in Flat Tints.

(870.) To apply painting in flat tints to historical, portrait, and landscape painting,—in a word, to the imitation of any object of which we can reproduce a faithful representation, would be going back to the infancy of art; but to abandon it to practice exclusively the system of painting where all the modifications of light are reproduced according to the rules of chiar'oscuro would be an error, which can be demonstrated beyond question.

Painting in flat tints as well as painting in chiar'oscuro is based on the two following facts:

1°. That the sight of colours is agreeable.

2°. That the sight of a drawing reproducing an elegant form is also agreeable, particularly when the remembrance of a cherished object is connected with it.

(871.) Let us now see the special advantages of the first system of painting.

1°. One part being of a uniform colour, and circumscribed by a faint or strong outline, it is very easy to distinguish the contiguous parts, and at the same distance it is much easier than if the colour of this part were shaded.

2°. More simple than painting in chiar'oscuro, painting in flat tints is easier of execution and more economical; consequently, in its specialty it is susceptible, at the same cost, of being better executed than the same object would be if painted in chiar'oscuro.

(872.) From which I conclude,

1°. That in every instance where a picture must be placed at such a distance from the spectator that the details of the chiar'oscuro will not be visible, we must have recourse to flat tints; not neglecting, however, to use masses of light and shade adapted to give relief, if it be considered advisable.

2°. That in every case where the picture is accessory to the decoration of an object, flat tints are preferable to chiar'oscuro, because the use of the object almost always prevents the pictures which ornaments it from being clearly seen under all circumstances.

Thus painting in flat tints is preferable to the other,

(a) For ornamenting boxes, tables, screens, which, from the various positions their use requires, only admit of our seeing a part of the pictures which decorate them; or if the paintings are entirely visible, as those of a screen, they will be presented, relatively to the daylight, in a manner quite different from each other, on account of the various positions of the parts of the painted object.

(b) For decorating curved surfaces, as those of vases, the surfaces of which are never plane. Nothing, I think, can justify the expense required by a painting in chiar'oscuro upon a surface, the curvature of which necessarily contradicts the effects of the picture.

3°. That the qualities peculiar to painting in flat tints are:

(a) Purity of outline.

(b) Regularity and elegance of forms.

(c) Beautiful colours properly assorted. Whenever opportunity permits, the most vivid and most contrasting colours may be advantageously employed.

(d) Simplicity in the whole, so as to render clear and distinct view easy.

§ 2.

OF THE ARTS WHICH ADDRESS THE EYE BY EMPLOYING COLOURED MATERIALS OF A CERTAIN SIZE, CONSIDERED RELATIVELY TO THE PHYSICAL CONDITION OF THESE MATERIALS, AND TO THE SPECIALITY OF THE ART EMPLOYING THEM.

(873.) I have remarked, that if we examine paintings with sufficiently powerful magnifying instruments, we shall see that the coloured material, far from being continuous in all its parts, is in separate particles; and, consequently, if the naked eye does not perceive the intervals separating them, it is because these intervals are too small. This remark should be remembered, because it is the basis of the first distinction we must establish in this paragraph. In fact, the coloured threads (elements of tapestries and carpets), and rigid coloured prisms (elements of mosaics), which are visible to the naked eye, and which differ in that particular from the coloured materials employed by the painter, may, nevertheless, be reduced to such a state of division, and so mixed and combined, that at the distance from which we view them united, they appear a coloured surface continuous in all its parts, like a painted surface: whence we conceive the possibility of making with scales of these elements, sufficiently approximating and graduated, works which correspond to those painted in chiar'oscuro; and, therefore, it will be easier to execute such as correspond with those painted in flat tints. This position granted, let us derive from the physical condition of the coloured materials and from the object which is essentially offered by the arts respectively employing them, conclusions adapted to serve as a basis to the judgment we bring to the qualities which the products of these arts must possess; and let us examine successively those which correspond to paintings in chiar'oscuro, and those which correspond to paintings in flat tints.

ARTICLE 1.

Tapestries, Carpets, Mosaics, and Coloured Glass Windows, corresponding to Paintings in Chiar'oscuro.

A. *Tapestries with Human Figures.*

(874.) Tapestries with human figures derive their origin from the taste of mankind for painting. They adorned churches, palaces, and castles, before they appeared in simple dwellings.

From the filamentous condition of the elements constituting them, their size, the direction the weaver gives them in twisting the weft upon each thread of the warp, results a coloured image presenting two systems of lines cutting each other at right angles. From this structure it results—that a tapestry will not produce the effect of a painting (the surface of which is entirely uniform), if the spectator does not view it from a point sufficiently distant, so that these lines ceasing to be visible, the delineation which separates each part of the design from the contiguous parts, will appear like the delineations of a painting, as much so as the indentations of the outlines which are oblique to the weft will permit.

(875.) From this double necessity for the furrows and indentations of the contours oblique to the warp to disappear from sight for the tapestry to produce the effect of a painting in chiar'oscuro, it follows, *that the objects represented by it must be large, of various colours forming harmonies of contrast rather than harmonies of analogy.*

Such are the primary bases upon which the judgment of the critic must rest in the examination of questions concerning the art of the tapestry-weaver, whether it concerns models in the choice of which the weaver is a stranger, or whether it concerns the execution of the reproduction of those models, which exclusively concern the weaver.

(876.) Every model which does not fulfill the previous conditions is bad; and, as it is difficult to meet with the union of pure outline with harmonies of colour sufficiently numerous and contrasted in pictures which have not been painted with the intention of being reproduced in tapestry, it follows that what would be very advantageous to the art, is the execution of pictures intended to serve exclusively as models painted broadly, so as to resemble, in a manner, painting in flat tints.

(877.) The weaver not having, at least at present, models painted on the system alluded to, nor by artists who, imbued with the specialty of the art of tapestry, would have executed a painting susceptible of being copied as faithfully as can possibly be done with coloured threads,—the weaver, I say, is almost always obliged, even when his model is as suitably selected as possible, to make not only, as we say, *a translation,* but also I add, *a free and not a literal translation,* of the model; and it is this, in my opinion, which distinguishes the *artist*-weaver from the mere *workman.* For, it is not by a weaver's knowing how to mix the colours of the painter on his palette, and how to apply them skillfully to the canvas, according to the rules of chiar'oscuro, that he will attain perfection in his art; on the contrary, it is in making the tapestry otherwise than in painting a picture according to this system; and moreover, it is, because a servile imitation of this kind can only give a bad result. Far from contending then with painting, the weaver, on the contrary, must study the circumstances where he should succumb in the contest, so that he may avoid the difficulties with the means at his disposal; and it is then, especially, that he must deviate from his model.

B. *Tapestries for Furniture Hangings.*

(878.) The preceding consideration respecting the size of objects that figured tapestries should reproduce is not applicable to tapestries for hangings, seeing that we have remarked that the threads of the warp produce lines which, far from being disagreeable, are often imitated by the paper-stainer.

(879.) These fabrics being intended for chairs, couches, curtains, screens, &c., the painter charged with composing coloured designs suitable for models in this class of works, must never forget that tapestries may occupy dark places, where they are imperfectly and often indistinctly seen; consequently, he had best select simple and elegant forms, and with harmonies of colour adapted to the objects intended to combine with the tapestry in the decoration of an apartment. These models, even more than those which are intended for tapestries with human figures, must assimilate with painting in flat tints.

(880.) The weaver of hangings for furniture must be impressed with the same ideas, to execute the model quickly and well, according to the preceding observations, without seeking to rival painting in chiar'oscuro: and in many cases he must depart from his model rather than servilely imitate it.

Among the facts I could quote to support this opinion, I shall select the following: it was a deep-rose-red curtain, the centre representing a large bouquet of flowers of various colours, framed, as it were, in a garland of white roses. The artist had painted the model under the idea of executing this garland with silver thread; but this metal being objectionable on account of its tarnishing through sulphurous exhalations, preference was given to white and grey silks imitating the tones yielded by a silver object in relief. An experiment showed that it could not be attained by employing these means, because the contrast of the ground made all the half-tints appear *green-grey,* and these in their turn made the lights appear rusty-pink, in consequence of the greenish colour of their contrast. This inconvenience being communicated to me, I begged M. Deyrolle, in reproducing the model, to make use of only three light tones of the rose scale in silk, and a white linen thread. By this means I expected that the complementary of the ground, neutralising the rose, would produce a greyish half-tint, well adapted to set off the white: the result realized my anticipations. A second copy made with a mixture of the light tones of the pure rose scale, slightly broken, gave an image less white, less *silvery* than the preceding, or, in other terms, appearing in a little greenish when compared with the first, and presenting more harmony; it recalled the effect obtained with rose-red under lace or tulle, which permits us to see a little of the ground. This example shows how to imitate a model, and indicates the means of executing white designs upon any kind of ground; in fact, as a general rule it is easy to arrive at it with light tones of the ground and a bright white.

C. *Savonnerie Carpets.*

(881.) Carpets are larger than tapestries for hangings: on the other hand, being liable from their position to be soiled by the feet, and to receive furniture on some parts, they are in a less favourable condition for being distinctly seen than tapestries. This, then, is one reason why we should choose patterns the design and colour of which are adapted to the circumstances necessitated by custom; and for a carpet to produce the best possible effect, it must be in harmony with what is around it.

D. *Mosaics.*

(882.) Mosaics being constructed with minute prisms, and on the other hand, with materials susceptible of receiving polish, we can rigorously copy very small subjects, and consequently, approach much nearer to painting in chiar'oscuro than by employing threads. But to arrive at this result, without being unfaithful to the specialty of the art, the materials must be sufficiently solid, and joined together so intimately as to resist the agencies which destroy painting; for if this end be not attained, we cannot see the use of copying a picture in mosaic. So that to justify the production of such works, we must make sure that, in the situations where they are placed they will resist the agents which would destroy the works of the painter.

E. *Windows of Coloured Glass.*

(883.) A work executed in small prisms of transparent coloured glass, in imitation of painting in chiar'oscuro, would be a true transparent mosaic. I do not know that such an imitation has ever been executed.

(884.) All the coloured glass windows which I have spoken of as decorations of gothic churches, are composed exclusively of small pieces of glass of uniform colour, united by strips of lead or of iron; or altogether of these small pieces of glass, and of glass upon which we have applied with a pencil materials which afterwards have been vitrified; we can only entertain the question of these latter in this article.

(885.) We may propose two different objects in the production of these windows; the coloured pieces are either altogether secondary in the work—that is to say, occupying a much smaller extent of surface than the others, they do not attain to the perfection of painting: such is the case with the greater part of the windows of large gothic churches—or rather, these pieces are the principal parts; then, predominating over the others, we attach great importance to the design and to the gradation of tints; such are several windows executed at the Royal Manufactory of Sevres. In rendering justice to the undoubted merit of these works, I shall say nothing particular about them, only that the more they resemble the preceding windows by the effect of variety, brilliancy, and opposition of colours, the more they attain the object they must essentially fulfill; for I regard these coloured windows not as pictures, but as simpler works, which I believe are only well placed in large churches.

ARTICLE 2.

Tapestries, Carpets, Mosaics, and Coloured Glass Windows, corresponding to Painting in Flat Tints.

A. *Tapestries with Human Figures.*

(886.) Although I have advised for tapestry models executed on the system of painting in chiar'oscuro to resemble painting in flat tints, yet I shall not recommend taking the models entirely according to this latter system.

B. *Tapestries for Furniture Hangings.*

(887.) It is quite otherwise with patterns of tapestry for furniture: I believe that we can make some very beautiful works in copying patterns in flat tints; and that in the decoration of large apartments, we may obtain an excellent effect from this kind of tapestry. I believe, also, that it would be more suitable for forming part of a general system of decoration, than the kind of tapestry of which I have spoken in the preceding article. Finally, it is more favourable than this latter to the splendour of the colours.

C. *Carpets.*

(888.) The preceding observations (887.) are entirely applicable to the production of carpets.

D. *Mosaics.*

(889.) Mosaics being composed of more rigid and coherent coloured materials than the arts which combine coloured materials employ, I believe that it will be requisite, in judging works of this sort, to consider the resistance of the materials to friction, to water, and to atmospheric agents as essential qualities; the colour will follow afterwards.

E. *Windows of Coloured Glass.*

(890.) According to the manner of considering coloured glass windows under the threefold relation of transmitting light into large gothic churches, of their accordance with the decoration of objects consecrated to the rites of the Church, of transmitting a coloured light entirely in conformity with the religious sentiment, I only prescribe windows of uniform colour for rose windows and straight windows with circular or pointed tops, I prescribe the smallest possible number of colours in the glass; glass of uniform colour must predominate over the other to produce the best possible effects of colour.

SECTION III.

INTRODUCTION.

(891.) This book would have concluded with the preceding section, if I had not been forcibly struck in my own experience with the generality of certain principles relating to very distinct arts, at the time I was arranging objects differing either in colour, form, or size—sometimes in two of these properties, occasionally in all three. It was chiefly when occupied with the arrangement of vegetable forms that I appreciated, more than ever, the aid which the architect had received in perfecting his art by the contemplation of these forms and their arrangements; and numerous instances strengthened my opinion, that our senses can only be affected by a very small number of things at the same time, just as our reason can at once seize but a few affinities in the ideas which occupy our attention at a given moment.

(892.) It seemed to me not without use to show clearly how experience leads to the observation of facts, which, generalized, become principles adapted to establish common affinities between widely different compositions, and to serve as a basis to a deep and critical examination, as well for the progress of art as for the study of the faculties of man, when he experiences deep impressions on beholding works of nature and art.

(893.) It is in this manner that I have been led to distinguish the principles expressing either the intrinsic qualities of objects or the affinities of the parts of which these objects may be composed, or the affinities of subordination which many objects possess amongst themselves; and, finally, the affinities which these objects should have with their destination, and

with whoever contemplates them. In conformity with these ideas, I have established the following principles:

1°. The principle of volume.
2°. The principle of form.
3°. The principle of stability.
4°. The principle of colour.
5°. The principle of variety.
6°. The principle of symmetry.
7°. The principle of repetition.
8°. The principle of general harmony.
9°. The principle of fitness of the object for its destination.
10°. The principle of distinct view.

By the rational application of these principles, we are enabled to distinguish the similitude of the affinities which exist in very different works, and how, when we have to judge of one which is complex, we do not at first see the product of any particular principle, but rather the product of many; and thence how important it is, for the examination of the whole, that each part should be brought back to the principle which governs it.

(894.) But in order to give our analysis the greatest possible precision in showing, on the one part, how we conceive its extension, and on the other part the limits in which we include it, we say that the language of the fine arts being addressed to the eye, is able to present the same object under two general conditions—one in which the object is in *repose;* the other, in which it is in *motion;* and we add, that in both of them the object can be isolated, or made part of an association of objects identical, or at least more or less resembling each other.

Let us cite some examples.

(895.) 1ST CONDITION: IN REPOSE.

First Example.

A. *Isolated.*—An isolated tree may be presented to the eye by the painter, or by the gardener.

B. *Part of an Association.*—A tree may be presented to the eye by the same artists, no longer isolated, but grouped with other trees of the same species, or of the same genus, or different genera, but having some affinity with it in form, size, or colour.

Second Example.

A. *Isolated.*—A human figure may be represented isolated by the painter or the sculptor. The isolation may be absolute, or the figure may be, as in an historical picture, associated with other figures, or it may also be made a portion of a sculptural group.

B. *Part of an Association.*—A human figure making part of an association has no longer individuality, so to speak; it has no name, it becomes part of an aggregation of individuals resembling each other, but which, when the artist has been desirous of avoiding monotony, are not identical.

Such are the soldiers who form a platoon in a picture representing a review or a battle; if the identity is not in the figures, it exists in the uniforms.

Such are the statues which decorate the porch of a gothic church; as we have before remarked (431.), these should not be judged like a Greek statue, but as a whole constituting an architectonic ornament.

Such, moreover, are human figures sculptured in *bas relief* which do not form a picture, but serve as ornament in the decoration of an edifice.

(896.) 2ND CONDITION: IN MOTION.

A body produces very different impressions on us, according as we see it in repose or in motion. It seems as if the arrow which cleaves the air, the bird which flies, invited us to action.

What difference is there not between the view of a calm lake and that of a river? The particles of water incessantly renewed in a spot on which our eyes are fixed, produce in us ideas of succession which are not awakened by the sight of still water. To the child, the animal in repose *sleeps;* and if after having touched it, no sign of motion is perceived, the child pronounces it *dead.*

Military evolutions, bodily exercises, and dancing, which present to us the human figure in motion, exhibit it in a condition very different from that when it is seen in repose. When the condition of the human figure in motion is offered to our view, we have to distinguish between the case in which it is isolated, and that in which it is associated with other figures of its species.

Ã. *Isolated.*—The ballet-master presents to us a dancer, isolated or grouped with one or two others, that is to say, in conditions corresponding to the human figure which the painter and the sculptor represent to us absolutely isolated, or taking part in an action and so making part of a group.

B. *Part of an Association.*—Finally, we see in an assemblage of dancers, in the maneuvers of a batallion, and the evolutions of the line, co-ordinate movements in which the individuals disappear, so to speak, to show themselves as parts of a whole.

(897.) I have entered into these details in order that the extreme difference may be laid hold of which should exist between an object or an individual that the artist presents to us isolated, or making part of an aggregation of objects or of individuals which are more or less analogous to that object or to that individual.

Thus, the gardener should so employ his art that every plant intended to be seen in a state of isolation be large and beautiful, that it receives the light equally on every part; while the specimen of the same species which is to form part of an association composed of specimens similar or co-general, or even of specimens belonging to different genera, should be led by the underwood in such a manner as to connect it with this group. It should not then be judged as if it ought to have the same aspect as the isolated specimen.

Thus, the painter and the sculptor, making a portrait or a statue, or grouping human figures, will give a particular physiognomy to each individual so that it can be named, if it has a name, and that one may know, if it forms part of a picture, that such a passion excites it, or that such a sentiment animates it; whilst in human figures that are associated there will not be so much difference between the individuals. If there are many distinct association, it is amongst these associations that the differences will be sought to be established; hence criticism ought not to judge the isolated individual in the same manner as the associated individual, in the sense we have given to that expression. Consequently human figures assorted for ornamenting works of architecture will not be judged as the Apollo, or the Laocoon, &c.

Thus, the ballet-master will establish a distinction between the dancers who are intended to fix the attention, and those who form part of a group, because in the first case the attention should be concentrated only on one or more individuals.

CHAPTER I.

PRINCIPLE OF VOLUME.

(898.) It has long been said, that in nature nothing is absolutely small, nothing is absolutely large; but whenever we see a new object, we are led to compare it with that which we know to be analogous to it; and it is then, if its size or volume markedly exceeds that of the object with which we compare it, volume becomes a property which strikes us in proportion to that difference. Of two statues or two busts representing the same model, but differing in size, the largest, though of equal merit, will strike us more than the other. But we must not omit to remark, that if we are accustomed for a certain time to see only statues and busts which both surpass the human proportions, then the influence of volume loses its force; and moreover, it may happen that after having seen many of these works, constructed so to speak on the same colossal scale and having less merit than the work which struck us at first, we should be disposed to recur to figures life size.

(899.) But if the volume of an object has undoubted influence in striking spectators forcibly, we must never forget the inconveniences that result from exaggerating a single object which ought to be associated with others; for in this case the exaggeration may have the serious objection of lessening these latter, and thus breaking the harmony they would otherwise possess.

CHAPTER II.

PRINCIPLE OF FORM.

(900.) Form strikes us at the same time as size in objects which we look at; and the influence it exercises on our judgment is well known. The artist should always endeavour to present an object under that form which is most appropriate to the effect he wishes to produce, and criticism should distinguish between the cases in which the object is isolated, and those in which it is associated.

(901.) Certain objects of art being only intended to address the eye, form is their most essential quality; such are triumphal arches, obelisks, columns, or pyramids, erected either as memorials, or to ornament a city, public place, &c. Other objects, on the contrary, having a special destination, their form becomes an accessory, or at least it is not the only essential part. It is from this point of view that we must consider edifices, such as palaces, churches, museums, theaters, &c., in order to ascertain if the architect has attained the end which he proposed to himself.

(902.) We have remarked elsewhere (856.) the influence an agreeable form may have in the judgment we exercise upon objects whose colours have no affinity with an association suited to their reciprocal embellishment.

CHAPTER III.

PRINCIPLE OF STABILITY.

(903.) Whenever any object is to be presented to the eye in a state of immobility or repose, we like to see it in a position of perfect stability, for we are affected by a disagreeable, and even painful impression, if we imagine that a slight effort would suffice to upset it; thence follows the necessity of submitting the *pose* of the figures of a picture, or of a statue, and of architectural monuments, to the principle of equilibrium. The leaning of the tower of Pisa (*il campanile torto*), and of the two towers of Bologna (*degli asinelli* and *de garisendi*), is not an effect of art, but rather the result of the sinking of the soil, which has been greater on the one side than on the other. The remarks which Condamine has made in his Travels in Italy (p.13), in relation to the first of these two towers, it seems to me, carry conviction to every mind.

(904.) A case which has always appeared to me very suitable to show the inconvenience resulting from not observing the principle of stability, is the bad effect of a house built upon a small plane inclining towards a valley or a plain which it commands as an eminence; for a house so placed seems wanting in stability, and that the least effort would push it from the top to the bottom of the inclined plane. To remedy this evil, it is generally only necessary to elevate the earth in such a manner that the edifice stands on a horizontal plane, which should be extended as far as possible towards the valley.

CHAPTER IV.

PRINCIPLE OF COLOUR.

(905.) Colour is seen at the same time as form. It imparts a more agreeable aspect to a smooth body, augments the relief, rendering the parts of a whole more distinct than they would be without it, and efficaciously concurs in increasing the beautiful effects of symmetry, and of connecting the affinities of the parts with the whole, &c.

Taste for colour has led to colouring drawings, to the composition of pictures, to colouring statues, monuments, to dyeing stuffs, &c.

To enter into these details would be a needless repetition, since the object of the preceding part of this book has been to treat of the influence of this principle generally and particularly, under an abstract point of view, and under that of application.

CHAPTER V.

PRINCIPLE OF VARIETY.

(906.) Whenever man seeks distraction from without, whether the pleasures of meditation are unknown to him, or thought fatigues him for a time, he feels the necessity of seeing a variety of objects. In the first case, he goes in quest of excitement, in order to escape from *ennui;* in the second, he is desirous of diverting his thoughts, at least for a time, into another channel. In both cases man flies monotony; a variety of external objects is what he desires. Finally, the artist, the enlightened amateur, and less cultivated minds, all seek variety in works of art and nature.

(907.) It is to satisfy this want that various colours in objects please more than a single colour, at least when these objects occupy a certain space; that our monuments have many accessory parts which are only ornaments; that in furniture we use many things which, without being useful, strictly speaking, please by their elegance of form, their colours, their brilliancy, &c. Assuredly, as I have endeavoured to show, it is the principle of variety which forms the essential distinction between landscape gardening and French gardening; for, as I have before said (819.), whoever walks in the former will notice objects disposed so as to excite in him, as far as possible, new sensations; whilst in the latter, he will find himself affected by a single and continuous impression; but I will add that, if this garden is of large and fine proportions, an idea of grandeur, perhaps even of sublimity, will be excited rather than by the landscape garden, which produces, especially on Frenchmen, and idea of the beautiful. In fact, the idea of the grand and of the sublime, determined by the eye, always reposes upon an idea of noble and majestic grandeur, and hence a succession of other ideas is engendered, which only connect themselves with the external and actually visible world through the medium of the first. Such are the ideas of *immensity*, of *boundless space*, of the *infinite*, which are awakened in us by the view of the heavens sprinkled with brilliant stars in a dark night; such are also the idea of *space* suggested by the sight of the sea; the idea of *force* or *power* which gives motion to its waters; the idea of *time* or of *succession*, presented by the sight of waves which, each in its turn, break on the shore; the ideas relating to astronomy, and to navigation. Finally, such is the affinity even of these great ideas with the weakness of the being who, however, is able to conceive them!....The idea of the beautiful, determined by sight, results from a certain *ensemble* of varied and harmonious ideas, always more or less immediately connected with the objects that have occasioned them, so that this idea, resting on the contemplation of a certain number

of affinities, which the eye perceives in a completely finished object, the mind is no longer under the impression of a single quality, or of a spectacle which, while vast, but little varied, suggests the idea of *infinity*. It is assuredly this idea of the *infinite* springing up in a solitude at the sight of a ruin, which renders such a sight more attractive to many minds than the finest modern structure; in fact, the sight of the latter does not, like the former, transport the imagination back to those distant times when this solitude was covered with structures, to lead it on to the conception that a day may perhaps arrive when the great edifices of the nation will be ruins!.....I am not astonished that a man given up to meditation, and admiring the age of Louis XIV. (938.), should prefer those masses of trees at Versailles, so skillfully arranged at a suitable distance from the palace, to the best arranged landscape garden elsewhere, which can never offer to the sight the imposing harmony of Lenôtre's composition. For, seen from the western facade, these gardens possess a grandeur which results from the fact of the eye discovering only dependent portions of a vast and unique composition. The space to the right and left of the spectator may perhaps appear confined, but by masses of vegetation in front it has all the vastness that may be desired, since the surface of the ground is bounded only by the horizon. If the lover of variety should blame the monotony of this view, and should discover some truth in the Duc de St. Simon's opinion of Versailles, in despite of the very evident bias of its intelligent author, the lover of the grand will always admire the aspects of a powerful unity, which agrees so completely with all that we know of the court and of the person of Louis XIV. While I attach so much importance to the French garden, I must avow a preference for landscape gardening in every, or nearly every, case in which a private person wishes to lay out his grounds. It is also in this point of view that the interior of a gothic church with painted windows, admitting of fewer varied ornaments that the interior of churches with plain glass windows (573.), seems to me more favourable than the second to the power and unity of religious contemplation.

(908.) If the principle of variety recommends itself because it is contrary to monotony, it should be carefully restrained in its applications, because, even without falling into confusion, effects may be produced far less agreeable than if they had been more simple. One thing with which I have been forcibly struck, and which I have had frequent occasions of remarking in the associations of colour I have made, is that although I employed coloured circles of an equal size placed in rectilineal series at the same distance from one another, that is to say in conditions the most favourable to a distinct view (933., and following), I have observed that in employing more than three different colours, exclusive of white, black, and grey, the effect of the series was less satisfactory than when only two colours, properly combined with black or white, were employed; such is the reason for my preference of two colours to three in military uniforms.

It is also for this reason that plants composing a single line should not be much varied, and that everything which tends to group different objects, so as to render them more easy to be grasped, exercises a happy influence upon optical effects.

CHAPTER VI.

PRINCIPLE OF SYMMETRY.

(909.) It is very probable that our organisation, combining as it does two parts paired as identically as is possible in an organised being, enters very much into the pleasure that we obtain from the sight of symmetrical objects.

(910.) There are objects which it is necessary to present to the eye perfectly symmetrical, either because they are so essentially, as a vertebrated animal (mammal, bird, reptile, fish), a radiated animal (star fish, sea urchin), or because symmetry pleases us in the form of an object of art which we see isolated, as a column, a pyramid, a triumphal arch, a temple, &c.; and I may here remark that gothic churches are, for the most part, constructed upon a symmetrical plan.* Symmetry pleases also in a circular or elliptical border of flowers, the whole of which the eye takes in at a single glance (755. [A.*b*.], page 303).

Finally, a symmetrical disposition should be observed in the arrangement of many objects grouped around or before a *principal object*, as the arrangement of such a garden as that of the Tuileries, which has a breadth equal to the façade of the palace, or the arrangement of a much vaster garden which is co-ordinate to a great palace, such as that at Versailles.

(911.) When a whole is subdivided into symmetrical parts of a definite extent, we can, in many cases, without injury to he whole, vary each part without going tbeyond the point at which discord would arise between them. This is what has been done in the park at Versailles, with a portion called *le miroir*, a charming garden, when it is planted with flowers properly assorted.

(912.) The principle of symmetry appears to me valuable for obtaining a general effect from many objects analogous, but differing amongst themselves, like the varieties of one species, or co-general species, or even species of neighbouring genera, belonging to the same family.

(913.) If there are objects to which a symmetrical form is suited, to the exclusion of every other—if there are grounds which must be laid out symmetrically, in order to connect vegetable nature with a grand architectonic composition,—there are also objects to which the symmetrical form is not so essential but that it can be dispensed with; and there are grounds which it is more suitable to lay out on the system of landscape gardening than according to the principle of symmetry, even when they are not designed for the sake of gratifying a taste for variety.

For example, whenever a mass of objects cannot be embraced at a single glance, because it occupies too much space,—or when ground which is made of planes

* See the Chevalier Wiebeking's work, *Les Cathédrales de Reims, de Yorck et les Plans exacts de quarante autres Eglises remarquables, &c.*, published at Munich in 1825.

differently placed in regard to one another, also even when this ground, being flat, is very irregular, and the buildings upon it are not placed as they should be, in a symmetrical composition,—it is convenient to throw aside the principle, not to carry out a *system* of irregularity, but to attain a pleasing distribution of objects, and even to have parts which, considered in detail, will appear less irregular than they would have done as a whole, if confined to a single plane.

(914.) It is in conformity with these ideas that we have subordinated the planting of masses in landscape gardening to principles which are very distinct from those absolute ideas of irregularity which some people maintain.

CHAPTER VII.

PRINCIPLE OF REPETITION.

(915.) The repetition of an object, or of a series of objects, produces greater pleasure than the sight of a single object, or of a single series; but it must be clearly understood that we are here speaking only of an object which addresses the eye by its form or its colour, and which is not intended, like a *chef-d'œuvre* of statuary, to be seen in a state of isolation (895., 896.); we are treating, then, of ornaments, or indeed more of plants and human figures, which are to make part of an association (895., 896.), and not to be presented to the spectator in an isolated state.

(916.) The repetition of a well-assorted series of coloured circles is more agreeable than when only one series is seen; this is an experiment easily made.

The repetition of the same ornament in a border, or in the cornice of a ceiling, is more agreeable than the sight of an ornament not repeated.

The repetition of the human figure serving to decorate the portals of gothic churches (431.) has a fine effect.

(917.) The repetition of the human figure in a platoon, or in battalions performing evolutions of the line, is an agreeable sight to every one.

I shall cite, as a last example, the same movements executed by a number of dancers, because it is particularly well suited to exhibit the extreme difference between the sight of a single dancer executing a *pas*, and the sight of dancers executing the same movement.

(918.) In the pleasure which arises from the sight of objects repeated, I have no doubt that space rendered more apparent by objects placed one after another, and recurring periodically, exercises some influence; it is especially under this relation that I consider the effect produced upon the borders of a long alley, by the repetition of an assortment of five tufts of the same height, or nearly so, but differing in colour, placed between two trees (801., 2nd example).

(919.) We avoid the inconvenience of monotony, when in an extended line the same arrangement is to be repeated, by introducing into this arrangement a greater variety of objects than would be necessary if the line were shorter.

CHAPTER VIII.

PRINCIPLE OF GENERAL HARMONY.

(920.) In order to compose a pleasing *ensemble* it is not enough to combine agreeable objects, it is likewise necessary to establish between them connecting affinities, and it is the suitability of these affinities, more or less easy to recognise, that will show if the principle of general harmony has been more or less thoroughly observed.

(921.) Harmony is observed in a single object, as well as in associated objects, whenever the former exhibits distinct parts. Such is the harmony of proportions in the limbs of an animal.

(922.) Harmony is established between the different parts of the same object, by means of the porportion of the parts, volume or superficies, the form and the colour. Symmetry is indeed one condition of harmony, but if the symmetrical parts of an object are deficient in proportion, this object will want general harmony in the *ensemble* of its parts: symmetry, then, does not always belong to general harmony.

(923.) Harmony is established between different objects by means of an analogy of size, of form, and colour; by means of symmetrical position; and, lastly, by means of the repetition of the same form, of the same colour, or of the same object, or even of objects very analogous, if they are not identical.

(924.) Nothing shows more clearly the influence of position and of repetition at equal intervals, in the general harmony of many widely differing objects, than to make homogenous groups of these objects, and even regular or adjoining each other, or disposing them on a line, and alternately at equal intervals; finally, if these objects are plants, making them subordinate to our principles of planting.

(925.) Conformably to these ideas, we can conceive how harmony will be established between groups, each formed of similar objects.

(926.) The absence of general harmony remarked in many classes of compositions, frequently depends upon the endeavour to introduce too great a number of heterogeneous objects, or such as differ too much; this may be remarked in the decoration of many edifices, particularly in interiors, where the accumulation of more or less precious or elegant objects results in confusion, and a want of general harmony. Another cause of this result is the co-operation of several artists employed on the same work, independently of each other, and frequently with views altogether different; it is evident that the result of this state of things must be incoherence in the final effect of the work.

Such is the cause of the deficiency of harmony observable in buildings on which several architects have been employed either successively or at the same time. Strange as it may appear, some examples may be cited of architects, who, without any views in common, have been simultaneously charged with the execution of different portions of a general plan conceived by another, without the obligation of subordinating these portions to the general plan having been imposed upon them.

CHAPTER IX.

PRINCIPLE OF THE SUITABILITY OF THE OBJECT TO ITS DESTINATION.

(927.) It seems to me that this principle should be found in every art; for every object which springs from every art has its destination; it is necessary, then, for the aim of an artist to be attained, that the object be suitable to its destination. It is in accordance with this principle that I have regarded the qualities of the products of the two systems of painting, of tapestry, of mosaics, and of coloured glass; and in all questions that have been raised on this subject I have distinguished between the *accessory* qualities and the *essential* qualities, and it is upon the appreciation of one or other of these qualities that I have founded the judgment which should be formed on the real value of a work of art; evidently the aim will not have been attained where *essential* qualities are wanting, which is not denying that the work may be of a class to please the eye.

(928.) It is in regarding pictures conformably to the effect which the harmonies of colours produce on us, according as they are analogous or contrasted, that we have considered the difficulties overcome by the painter, and examined whether, in a given work, the harmonies employed are consistent with the effect which the artist has been desirous of producing.

(929.) It is in conformity with the same ideas that we have regarded the interior decorations of churches, palaces, and private houses; that we have indicated the most suitable colours for the decoration of theatres, the interior of picture galleries, and museums of sculpture and the products of nature; but, in order to judge of the value of a theatre in regard to the principle of suitability, we must know whether the spectators are all properly placed for seeing the stage and for hearing the words of the actors. So, to judge of a museum, we must know how the objects preserved therein are presented to view; and here we may recollect that form and decoration are but accessory parts, and not essential to this class of edifices (901.).

(930.) I have no doubt that the faults which may be detected in theatres and museums arise from the fact that the artist has not been impressed with the aim of his work,—that he has not seen that the ornaments should be accessories; so the painter who has presided over the internal decoration of a theatre would seem sometimes to have forgotten that the colours are not to be seen by daylight, and that the seats will be occupied by spectators, amongst whom will be found ladies adorned with gold and jewels, who themselves should be the fairest ornament of the place. The architect of a museum appears to have forgotten that the entire edifice should be subordinate to the objects it is destined to contain, and that all which interferes with the distinct view of these objects and the effect which they should produce is opposed to the principle of the suitability of the object with its destination.

(931.) If the observance of this principle should seem at first sight to require no more than *simple good sense*, it will be seen on reflection that genius ought unceasingly to consider it, because it is by conforming thereto that a true artist will be able, in our day, to stamp with originality a building perfectly suited to its purpose, and commendable by the elegance of its parts, which will be subjected to perfectly definite affinities of co-ordination.

(932.) I may remark that, in teaching architecture, those parts which are connected with physico-chemical knowledge, and with the arts properly so called, are not sufficiently insisted upon; almost all these teachings relate only to form, and the actual knowledge taught on this subject applies to the monuments of a bygone civilisation, erected for customs which are no longer ours. In the study of these monuments, while developing to pupils the relation of parts with the whole, making them perceive that whatever is beautiful attaches itself to rules invariably allied to our organisation, it must be insisted on, that architectonic forms, however beautiful they may appear, should not be reproduced in edifices to which they are altogether foreign; the distinction between monuments which are intended to appeal to the eye only, and those which have moreover another purpose, must be insisted on (901.): we must show clearly to pupils that it is only after having fulfilled all the conditions necessary for satisfying the purposes of modern edifices, that they should exert their powers in giving to their works such a form as will recommend them to future criticism, as the forms of Greek monuments is their recommendation, in our time, to all study based upon positive rules. If I admit that when monuments like those of the Greeks are in question, such as a column or a temple, we cannot do better than imitate them, it will be granted, I think, that when it is intended to build an edifice adapted to modern customs, very different to those of the Greeks, the first condition being to fulfill such purpose, we must seek in the second place only for the most beautiful and grandest form for our projected edifice; and I confess that unless we maintain that the Greek architects have not profited by the knowledge of other nations, that they have not made attempts before arriving at the construction of these monuments we admire, that they have not studied the forms of vegetable nature, I do not see why we should not prescribe to pupils, at least to those whom we believe capable of great things, the study of ancient and modern monuments, to observe the forms of organised beings, particularly those of the vegetable kingdom, in order that they may appreciate how nature varies in her creations without ceasing to be beautiful; finally, why we should not point out to them that it is only after being impressed with the object of a projected building, that they should give themselves up to attempts at producing all the effects they wish to obtain, in order to fulfil all the conditions necessary to satisfy the principle of the suitability of the object with its destination.

CHAPTER X.

PRINCIPLE OF DISTINCT VIEW.

(933.) It is necessary for every work of art to satisfy the principle of distinct view, by which all the parts of a whole intended to be exhibited, should present themselves without confusion and in the simplest manner.

In fact, the spectator always feels some want in those works which do not fulfil this condition. I will cite but one example, the view of the façade of the *Palasi des Beaux-Arts,* facing which are found the *Arc de Gaillon,* and *a column* which, being placed in front of this arch, cuts it in two in the most disagreeable manner to the spectator who looks at the edifice.*

(934.) I have always considered the principle of distinct view as essential to all those arts which address the eye; it is in obedience to this that we make use of colour and of relief, that we are compelled to present but a small number of objects to the sight, that the larger they are the less they should be laboured and the greater their parts should appear. It is, moreover, in conformity with this principle that we have recourse to the principles of symmetry and of repetition, and that, finally harmony of *ensemble* is wanting whenever there is a confusion of parts.

(935.) In a well-organised mind there exists the closest relations between the co-ordination of parts which the artist renders visible, and the co-ordination of ideas upon any subject whatsoever.

* This remark is not a criticism applicable to the architect of the *Palais des Beaux-Arts,* because we know that it was from the fear of its deteriorating one of the *chefs-d'oeuvre* of the Renaissance that he was unwilling the *Arc de Gaillon* should be removed from the place it occupied at the period of its removal to the *Musée des Petits-Augustins.*

SECTION IV.

OF THE DISPOSITION OF THE MIND OF THE SPECTATOR IN RESPECT TO THE JUDGMENT HE FORMS OF AN OBJECT OF ART WHICH ATTRACTS HIS EYE.

(936.) It is not enough to have indicated the rules to be followed and the principle to be observed in the production of effects, and the judgment of them in relation to art; we must also speak of the disposition of the spectator for receiving the impression of those effects in a manner more or less intense; to take no notice of this disposition would be to display ignorance of human nature, and of the utility of the examination which should be impartially pursued also in the judgment of the critic, who may exaggerate blame as well as praise.

Without examining the influence the passions exercise in opinions formed on works of art, I will say a few words upon a predisposition which may be remarked in a portion of the public, at least at certain epochs, and which has its source in man's vanity. Then I will point out the part which the association of certain ideas performs in the formation of opinions.

(937.) When a body of painters, called a *school*, has produced some *chefs-d'œuvre*, it frequently happens that a great number of mediocre works executed under the pretence of continuing them, far from being favourable, are injurious to a portion of the public, on account of the monotony resulting from an imitation, more or less servile, of form, colour, and of the subjects themselves. The public, under these circumstances, is ready to applaud every innovation that will excite emotions which it has not for some time found in contemporary painting; and it is then that, amongst the public, voices are raised against great works which have nothing in common with the tame imitations of them produced by mediocrity. Truly, there comes an epoch when innovation, losing the only advantage it possessed of presenting to the eye images differing from those which it had been a long time accustomed to see, the public returns to the *chefs-dœuvre*, and forgets all the feeble works composed in imitation of them by feeble pupils; and, we will add, that if works *professing to be of the new school*, and endowed with undeniable merit should exist, they would, in the estimation of connoisseurs, takes the places they ought to occupy, whilst those which had arrested attention by innovation only, disappear for ever.

(938.) Finally, I will notice the effect which certain associations of ideas may have on our opinions. For example, any one arriving at Versailles full of admiration for the age of Louis XIV., will repeople the gardens with all the great men that have frequented them, and, recurring in thought to the *fêtes* given by an elegant and polished court, the admiration of Europe, will judge the work of Lenôtre more favourably than he who, without being, however, hostile to the *grand siècle*, sees nothing but a garden subordinated to a palace. There is no doubt, moreover, that the Christian who associates in his mind the architectural form of the gothic church, the brilliancy of its coloured glass, and the religious ceremonies which, when yet a child, he has seen celebrated in it, will be in a disposition of mind to prefer the Cathedral of Cologne to St. Peter's at Rome, or, what amount to the same, will be more disposed to admire the first of these monuments than a Roman would be, whose mind would be filled with ideas of religious ceremonies linked with the idea of the church of St. Peter's.

HISTORICAL REVIEW
OF
MY RESEARCHES,
AND
FINAL CONCLUSION OF THE WORK.

(939). The first opportunity I had of observing the influence of contrast in the juxtaposition of colours was offered me in 1825 by the Directors of the Gobelins. As I have before said (Author's Preface, p. ix.), they inquired of me why the black tints were deficient in vigour when employed for shadows in blue or violet draperies. I found the cause of this effect to lie in contrast; for having compared together two identical black patterns, one of which was placed on a white ground, and the other on a blue ground, I observed that the latter lost much of its intensity. It was after this experiment that I recollected having several times fancied that there was a difference between two portions of the same skein, whenever one was contiguous to a colour different from that which joined the other portion. Having gone, as soon as I remembered this, to the warehouse for coloured wools in the Gobelins, I proved the fact upon red, orange, yellow, green, blue, indigo, and violet skeins, and I speedily comprehended the influence of black and white on the same colours.

(940.) The modifications arising from the juxtaposition of the preceding colours taken in couples being once defined, I sought for an explanation of the phenomenon in scientific works. Amongst the books recently published in France on this subject, the treatise by Haüy only, under the head of *accidental colours*, mentioned contrast. Not only did I read the article devoted to this subject, but I referred to the authorities of the writer. I made extracts from the writings of Buffon, Scherffer, Rumford, Prieur de la Côte-d'Or,

&c., on this subject. But so long as I endeavoured to link together the phenomena which I had observed so as to compromise them in one general expression in conformity with the writings I consulted, I lost my time; yet I was incessantly impelled towards that end by my friend, M. Ampère, who, whenever in the course of my researches I mentioned to him anything relative to contrast, constantly replied, *"So long as the result of your observations is not expressed by a law they are value-less to me."*

On the one hand, the difficulty of finding a law which governed phenomena I had never considered, and which probably I should never have studied, but for the circumstances I have already mentioned,—on the other hand, my being preoccupied by a great number of chemical researches necessary to be undertaken to obtain fixed bases for dyes, caused me to lose sight of the phenomena of contrast, and to forget the details I had read on the subject. It was after having been many months in this state of mind, that one day being present at a literary meeting, the phenomena of simultaneous contrast of colours which I had observed recurred to me during a lecture that failed to occupy my attention: I recalled them so clearly, that I saw their mutual dependence, which I immediately imparted to M. Ampère, who sat beside me.

(941.) The conviction of the correctness of the law of these phenomena being once attained, I re-read whatever had been written on *accidental colours;* I then clearly saw that the obscurity of this subject arose from a great number of facts being confounded under one general denomination, without establishing the fundamental distinctions which I had made between two sorts of contrast under the names of *simultaneous contrast* and *successive contrast* of colours. In fact, it was because I had been unable to find this distinction in writers, that while I had before my eyes, or in my memory, their writings upon *accidental colours,* I could perceive no link between their observations and mine, which at this time I looked upon as a simple extension of the first. It was only after losing sight of what had been done before my time, that I was able to generalise my results, to appreciate at once the frequency of the cases in which they were exhibited, and the peculiarities which distinguishes them from anterior observations; in short, that I was in a position to subject them to a co-ordination that enabled me to fully appreciate all the value of Scherffer's work specially concerning *successive contrast,* when once I had succeeded in disentangling it from subsequent works on simultaneous contrast, which had been associated as connected with accidental colours. To this association I attribute the cause of the obscurity of the article on this subject in Haüy's Physics, and the explanation therein contained of a phenomenon of simultaneous contrast so unworthy of the reputation of the name under which it is given.

(942.) If I have entered into the preceding details, it is not because they particularly relate to myself, but because they present to him who consults the history of the sciences of observation with the intention of tracing the progress of the human mind in its researches after truth, a striking example of the inconvenience produced by the accumulation of facts, which, incompletely seen, although true at bottom, fail in co-ordination. Not only may the inconvenience I wish to point out be a real obstacle to future works, but it may lead so far, during a certain time, as to cause the value of an old work to be misunderstood, to which contemporaries have not given the attention, which for the sake of its origin it deserved. The conclusion I draw from such a fact is very simple; the number of journals which give accounts of scientific matters increasing with the number of learned societies and experimentalists, and on the other hand the temptation to publish being so great that we prefer giving to a variety of researches the time which ought to be devoted to a single profound research, it follows, that while the former lead to questionable results, they give rise to criticisms which, frequently as shallow as the works they relate to, only excite doubts in minds capable of appreciating the insufficiency of both. Finally, we are driven to say that frequently he who draws from a limited experience a conclusion to which he gives the name of *law,* would no doubt have abstained from establishing a generalisation, had he made one experiment more, properly conducted so as to govern that conclusion.

(943.) From the very beginning of my researches on contrast I was convinced of the correctness of my observations by my very mode of experimenting, which, to my knowledge, had never been employed before. In fact, in placing four samples, two of which are identical, as represented in Fig. 1, Pl. 1, we completely establish the phenomenon; and as it is visible with pieces of paper of a foot square or more, we perceive that, in setting out from the line where the juxtaposed papers touch each other, it is much more extensive, with respect to the coloured surfaces, than could have been believed from previous experiments where we had put a very small piece of paper or stuff upon a ground of a different colour, and of indefinite extent.

(944.) My experience tends to show:

That the effect is a radiating, setting out from the line of juxtaposition;

That it is reciprocal between two equal surfaces juxtaposed;

That the effect of contrast still exists when these two surfaces are at a distance from each other, only it is less evident than when they are contiguous;

Finally, that the effects exists when we cannot attribute it to fatigue of the eye.

(945.) Assuredly, if simultaneous contrast of colours had been seen in the circumstances under which I observed it, the universality of the phenomenon would not have been misunderstood even by those who had treated of it, it follows that they would have abstained from employing the name of *accidental colours* to distinguish it, or, what comes to the same thing, if they had employed it, they would have directed attention to the fact that every colour seen simultaneously with another, appears with the modification of an accidental colour; and things being brought to this point, it would be impossible in scientific treatises not to assign a place to the exposition of a phenomenon so frequent as that of which we speak, and which is expressed by a simple and easily verified law. On the other hand, if the

phenomena of simultaneous contrast had been established as they now are, men of science who have attached the greatest importance to the knowledge of its application, would have been conducted to points of view less limited than those at which they paused, and would thereby have proved that the phenomenon had never been to them the object of precise or general observations. In reading, for example, what Count Rumford has written on the harmony of colours, we see how circumspect he is when he has to deal with observations made with coloured materials used in painting, on coloured rays of light emanating directly from the sun; how cautious he is in explaining the phenomena he describes; how limited is the application of his idea of harmony in the assortment of colours, since it consists only in complementary association; finally, how vague it is when he is desirous of detecting in the works of the great masters colours springing from this harmony, which have no actual existence, and which he calls the *magic of painting*, because it is useless to seek them on the canvas, and yet he affirms that they are to be seen under favourable circumstances of light and when we are placed at a proper distance from the pictures.

The numerous experiments detailed in the first portion of this work are more than sufficient to prove that the *magic* spoken of by Count Rumford is to be found in the flat tints of house-painters generally in a more marked manner than in the pictures of the greatest colourists, because the latter in many cases soften the separation of two colours by blending them together. I have entered largely on this subject, in order to show clearly the extreme difference there is in the manner in which Count Rumford has investigated the harmony of colours, and the point of view where I have placed myself for the application of positive knowledge, deduced from established, definite, and generalised facts, independently of all hypothesis, to painting, and to those arts which make use of assortments of colours.

(946.) It is only after having given the law of *simultaneous contrast* of colours, having shown how much this phenomenon differs from *successive contrast*, and, in short, having defined what I mean by the term *mixed contrast*, that I have pointed out the numerous applications which are deducible from the law of simultaneous contrast.

(947.) I have commenced the study of these applications by defining some expressions which, had they retained the vague sense they possess in common language, would have prevented me from communicating my thoughts with precision.

(948.) I have been compelled to present the results of a considerable number of experiments and observations under the forms of *rules* fitted for the guidance of those who, after having repeated my principal experiments, have convinced themselves of the exactness with which I have brought together the generalisations to which they lead.

(949.) All the observations which did not appear to me to possess a character of incontrovertible precision, have been presented with proper reserve, as the expression only of my peculiar views.

(950.) I believe that the rules I have laid down upon the *art of viewing the model* which the painter reproduces, will dispel the notion entertained by many persons, that there is a *great difference* in the manner in which the same colours are seen by eyes of an average organisation, that consequently there will no longer be alleged in favour of this opinion the diversity which may be remarked in the colour of copies made by pupils who have gained no precise notion of the manner of composing mixed colours with the pigments they employ under the names of Prussian blue, ultramarine, grey blue, chromate of lead, nor of the modifications of the local colours of their model under the various conditions in which they should reproduce them on the canvas: finally, to pupils who have not submitted to proofs analogous to those to which I have subjected the dyers whom I have examined to ascertain whether they have a well-formed eye: very simple proofs, since they consist in showing them coloured objects in juxtaposition, and making sure they perceived the modifications given by the law of simultaneous contrast.

Finally, it will be no longer alleged in favour of the opinion I am contesting, that the dominant colour of the pictures of one painter being violet, while that of the pictures of another is blue, the first one must necessarily see violet, and the second blue. Certainly it is not the possibility of the fact that I contest, it is the *general* conclusion drawn from a particular fact: indeed, if the difference between the manner in which various individuals see the same colour is as great and as general as is pretended, there would no longer be any comprehension of colour at all; and if there were a public who saw a picture too violet or too blue in comparing it with the model, another public would certainly exist who would see it as it is pretended the painter must have seen his model; hence for this public there would be no foundation for saying that the picture is too violet or too blue. However, as it is not so, I conclude that the preceding reason has no foundation, and that the general judgment of the public, in distinctly noticing in a picture a dominant colour which is not in the model, proves that the individuals composing this public see, if not in an identical at least in an analogous manner.

(951.) It was while taking the experimental method for a guide, and after having determined by observation the modifications light is subjected to in relation to coloured bodies, that I have been led to conclude that in a monochromous object, or in a monochromous part of a polychromic object, *all modifications except those which may be the result of coloured rays reflected upon this object or on this monochromous part, are susceptible of being faithfully imitated with the coloured material which corresponds to the colour of the model, the neighbouring scales of this colour, normal grey and white*. This conclusion greatly simplifies the art of painting, and at the same time gives a solid basis to the critic who desires to judge of the truthful colouring of any picture.

(952.) To my conviction that the rules laid down in this work will save a great deal of time to such young painters as may follow them, is joined the hope that they will not take advantage of them in order to multiply their pictures, but rather those preliminary

studies which are always demanded by every definitive performance. I have sufficiently explained myself so that the idea of reducing painting merely to the faithful reproduction of each particular object that enters into a picture cannot be attributed to me; not only have I insisted upon the arrangement, the co-ordination of the principal objects, the subordination of those which are secondary, and upon those harmonies of colour necessary to connect them so as to form but one single whole, but in speaking of the expression of figures, I have expounded my opinion upon those qualities which may be gained from a master, and those which are only to be found in oneself, and which are the only ones which mark a work with the stamp of genius.

(953.) I have applied the *conclusion* to which I have been led for the reproduction of the model in painting, to the imitations of painted objects which are made in tapestries and carpets. I have shown that the exact representation of the modifications of colour in these models demands a knowledge of contrast still more imperatively than painting, properly so called, itself demands.

Experience has led me to establish very simple rules suitable for obtaining the most beautiful greens, oranges, violets, by the mixture of blue, yellow and red threads, and to show that the weaver produces black or grey when he mixes together in certain proportion those three colours, or two colours mutually complementary.

I have, consequently, clearly shown in these rules how we may deceive ourselves if, with the intention of harmonising two colours appertaining to different parts of the same object, we do not distinguish the case in which these colours are complementary, and that in which they are not; when, for example, it is a rose surrounded by its leaves, and a stem of periwinkle garnished with leaves and blue flowers: so, if, in order to harmonise the local colours, we mix them in certain parts of the flower and the leaves, we obtain grey by the mixture of the red with the green, while, with regard to the periwinkle, by blending the local colours of the flower and its leaves, we make blue greenish, and green bluish; hence it is in the latter case, and not in the former, that the colours of the two parts approach each other.

Experiments have, moreover, enabled me to discover the method of working, in tapestries on coloured grounds, white shaded designs which do not appear of the complementary colour of these grounds.

(954.) In establishing the great difference which exists between paintings and works executed with materials of a certain size—in insisting on the necessity of employing for the latter, colours purer and less blended than those used in painting—in insisting on the necessity of making the harmonies of contrast predominate over the harmonies of analogy,—I believe I have spoken for the benefit of the painter charged with the execution of the models, and for the interest of the artist who has to copy them. In indicating the qualities these models should possess, in pointing out the dangers arising from a desire to execute paintings with materials of a grosser kind, I have indicated the means of rendering the employment of these materials less servile, and consequently of giving more originality to the works of the weaver.

(955.) I have subordinated to observation and to experiment, and not to any hypothetical view, everything that concerns the decoration of the interiors of edifices; and I have strenuously insisted upon the necessity of subordinating everything to its destination.

(956.) Finally, in applying the experimental method to the arrangement of flowers in gardens conformably with the law of simultaneous contrast of colours, I have had frequent occasions of remarking how much analogy there was in those arrangements between the colours and the forms, in relation to the special effects obtained from each in respect to diversity, symmetry, general harmony, &c., that I have been led to a generalisation which I had not in view when I commenced my work: but all the generalities at which I have arrived are the result of immediate observation, as prescribed by the experimental method, and it was only a long time after having seen many of the products of arts which make use of coloured materials, that I have come to the conclusion that this method to which the physical sciences owe their progress, might be applied in many cases to the practice as well as the theory of the fine arts, and that this extension must necessarily give a precise knowledge of the faculties that place man in connection with the works of nature and art.

(957.) In conclusion, I have sought as much as possible the rules in the nature of the things which they concern; but, in prescribing them, far from being exclusive, I have, on the contrary, avoided presenting a single type of beauty. It is in this spirit that I have spoken of the general effects of the harmonies of contrast and of analogy, leaving to those who employ them, either in painting, or in the assortment of any coloured objects whatever, all the latitude these rules admit of, without injuring the beauty of the assorted objects. In the same spirit I have spoken of Grecian and gothic architecture, of geometric and landscape gardens, and, instead of making these works rest on opposite principles, or of considering some as derived from principles, whilst others are the product of artistic caprice, I have sought for their common affinities and the principles to which the differences that distinguish them actually belong.

Criticism made from this point of view of a work which, although very incorrect, has engaged the attention of a class of men, appears to me useful, if not to the author, at least to the theory of art and to the knowledge of our own nature; because under this double relation it is always interesting to trace out the cause that has attracted the attention of men, of those who are the least enlightened, or who are deficient in the elements of education.

Finally, in conformity with this mode of view, it appears to me that when a people has left traces in history by its annals, its literature, and its monuments, far from disdaining the products of its literary genius and its arts, it is, on the contrary, necessary to assiduously seek out what had led this people to adopt the form it has given to its works, and to see if it is possible to go back to the source of the admiration it entertained for them.

CONCLUDING REMARKS ON CONTRAST.

(958.) I do not intend to finish the historical sketch of the researches composing this work without adding some remarks relative to the extension of which they appear to me susceptible.

These considerations bear on four different points:

The first concerns the observation of several natural phenomena;

The second relates to the contrast presented by two objects differing much in size;

The third relates to the question, if any other senses besides the sight are subjected to the law of contrasts;

Finally, the fourth has reference to the light which, as I belive, the study of contrasts is susceptible of shedding upon several phenomena of the understanding.

§ 1.

OF CONTRAST CONSIDERED IN CONNECTION WITH THE OBSERVATION OF SEVERAL PHENOMENA OF NATURE.

(959.) In contemplating natural objects we discover many opportunities of applying the law of simultaneous contrast to certain phenomena exhibited by them.

(960.) Thus, whenever a surface on a dark ground reflects uniformly a strong light, the edges of the former appear more brilliant than the centre, whilst those portions of the ground contiguous to these edges appear darker than the rest of the ground; hence contrast tends to give relief to uniform surfaces.

(961.) When the sun is on the horizon, and when it strikes opaque bodies with its orange light, the shadows that these bodies project, illuminated by the light which comes from higher parts of the atmosphere, appear blue. This colorisation is not due to the colour of the sky, as many persons believe; for if, instead of the bodies being struck by the orange light of the sun at the horizon, they were struck by red, yellow, green, or violet light, the shadows would appear green, violet, red, or yellow. The explanation of these phenomena is included in that which I have given of the colours which appear on white plaster figures, lighted simultaneously by coloured rays and by daylight (697., and following).

(962.) The greyish footpath which crosses a meadow or a lawn appears reddish because of the juxtaposition of the green grass.

(963.) Whenever we regard two coloured bodies simultaneously in order to appreciate their respective colours, it is necessary (especially if these colours are mutually complementary, and one weaker than the other) to view them separately, otherwise the weakest colour would be visible only by the juxtaposition of the stronger colour. Thus it cannot be affirmed that two neighbouring bodies which appear the one green, and the other red, are so actually, till we have tested the fact that each appears of these respective colours when seen separately.

(964.) It is unquestionable that the colours of the rainbow are modified by their juxtaposition, inasmuch as they appear of different hues when seen isolated.

§ 2.

OF CONTRAST CONSIDERED WITH RESPECT TO THE SIZE OF TWO CONTIGUOUS OBJECTS OF UNEQUAL SIZE.

(965.) We cannot refuse to admit that a contrast of size exists, as well as of two colours of the same scale, taken at different tones. I do not base this solely on the observation that we may daily make relative to the diminution of size apparently presented by an object that we have first seen isolated and afterwards by the side of a greater, but rather on a positive experiment analogous to that which so clearly demonstrates the contrasts of tone and of colour. When we arrange on a black ground of indefinite size two strips of white paper, 7 inches in length and 1/5 of an inch in breadth, and two strips of the same paper 3 inches in length and 1/5 of an inch in breadth, as represented in the following figure:

oo appears smaller than $o'o'$, whilst pp appears larger than $p'p'$. At least so it appeared to many persons besides myself, among whom were two machinists who were not previously acquainted with the proof submitted to them.

(966.) If from the contrast of size we deduce, according to the law of continuity, that an object which would be visible in a state of isolation might cease to be so if placed by the side of a larger object, and if we explain in this manner how it happens that some bodies seen distinctly and without trouble in the microscope, become *extremely difficult to be seen* when they are placed near to larger bodies,—a fact that M. Donné tells me he has frequently noted,—yet, I must remark, that between this phenomenon and that of simultaneous contrast, such as I have already described it, there exists this difference, that in the latter, two objects are seen at the same time very distinctly, which is not the case in the former, where a single object is visible. In fact, without recurring to contrast, and in conformity with what I have before said (748.), and the eye sees at one time but a very limited number of relations in the objects which strike it, we must admit that it occurs when, if an object placed near to another appears much more distinctly than the second, the organ will involuntarily fix itself upon the first, and the second will not be seen, or, if it becomes perceptible, it will only be when, by force of attention, so to speak, we come to receive that impression in ignoring the image of the first.

§ 3.

ARE THE SENSES OF HEARING, TASTE, AND SMELL SUBMITTED TO CONTRAST?

Distinction between the contrast of antagonism and the contrast of simple difference.

(967.) If it is philosophical to seek out those properties which the organs of the senses possess in common in their structure and functions, it is no less philosophical to ascertain the special differences that distinguish them. Under this proposed relation I proceed to examine, in connection with the sense of sight, the senses of hearing, taste, and smell in some one of their operations, after having distinguished, as clearly as possible, *the difference arising from the antagonism of two things, from the difference that arises between two things of greater or less size or intensity in one of their properties.*

(968.) We say that there is antagonism between two properties or between two things each possessing one of these properties, when in virtue of a mutual action these properties disappear. Examples:

1st. Two discs of glass rubbed against each other, then separated, display electrical properties; but one has positive electricity, and the other negative. Upon re-uniting the discs these properties disappear, they mutually neutralise each other, and are consequently *antagonistic.*

2nd. The same result is obtained from two needles of equal magnetic power: on applying the one to the other, so that the different poles touch, there is a neutralisation of their magnetic properties, and we call them two *antagonistic magetisms.*

3rd. Sulphuric acid reddens tincture of violets, whilst potass changes it to green: here are two actions differing in their results; now if we combine the sulphuric acid and the potass in proper proportions, we obtain a compound which has no effect on the colour of the violets. In this case it is said, the acidity of the sulphuric acid and the alkaline properties of the potass are two forces or properties which are *antagonistic,* the one of which can only predominate at the expense of the other.

4th. In conformity with this manner of considering the acid and the alkaline properties in the preceding example, I regard two coloured lights which produce by their mutual combination an uncoloured or white light as being antagonistic: thus, for example,—

Separate the red rays from a ray of white light, and the remaining rays appear to us green, slightly tinged with blue; reunite the red rays and the green rays tinged with blue, white light is re-formed.

In this case I assert there is antagonism, because two things that effect us differently as *colour,* the red rays and the bluish green rays, when united no longer affect us as such, but as *white.*

Materials coloured green, red, yellow, violet, blue, orange, &c., which by their mixture produce black or grey, also present, on account of the disappearance of their colour, an example of antagonism.

(969.) Further, I assert that *antagonism exists whenever two activities, or in other words, two causes of different effects, being opposed to each other, are*

mutually balanced in such a manner that the effects they produced in an isolated state, are no longer manifested after their reaction.

It is in this that two antagonistic things differ from two things we compare under the relation of size, or of intensity of a property, a comparison that gives for result, when there is no equality, a difference in the size or in the intensity of that property.

(970.) From the distinction we have made, contrast of colour, considered under the most general point of view, that is to say, as presenting *contrast of tone and contrast of colour properly so called* (8.), is itself composed of two contrasts:

1°. Of *a contrast of simple difference;* That of tone. In fact, the lightest object augments brightness, as the deepest destroys it.

2°. Of *a contrast of antagonism.* In fact, the modification of two juxtaposed colours, arising from the addition of the complementary of the one to the colour of the other, is really that which can make the two colours widely different, since this addition appears, according to the remarks already made, to take away from the one what it may contain of the other (8.).

(971.) Finally, in successive contrast, simple difference of contrast and contrast of antagonism may exist, as in simultaneous contrast, because

1°. The eye which has first seen a light part *o* by the side of a dark part *o'*, sees at the second view when it has ceased to regard the whole of the two parts *o* and *o'*, the image *o* darker than the image *o'*.

2°. The eye looking first at a body of a certain colour, sees at a second glance, after having abstained from regarding it, an image which is of the complementary or antagonistic colour to that which is really the colour of the body.

(972.) Having brought things to this point, it is evident that, in order to treat the question to which this paragraph is devoted with all the clearness in our power, it is necessary to find out if the hearing, taste, and smell are subject to a contrast of antagonism or to one of difference, and if the contrasts that may affect them are simultaneous and successive. By neglecting to subordinate the subject to these distinctions, I should certainly expose myself to the reproach of obscurity, which would have its cause in the confusion I have pointed out in tracing the critical *résumé* of the history of the works on *accidental colours* (80., and 941.).

OF HEARING.

(973.) Hearing is the sense which passes as having the greatest affinity with sight; for every one knows the comparison that has been instituted between sounds and colours, not only when considered as sensation, but also when it has been sought to explain their propagation by the wave theory.

Comparison between Sounds and Colours.

(974.) Although I am far from disregarding the relation of colours with sounds when it is a question of their acting on our organs, and of the infinite sensations resulting from their mixture and from their co-existence; although I feel great pleasure at the sight of beautiful

colours even when by their delineation they do not recal any determinate object, and when they only affect us by their beauty and splendour; although I have arranged them in various harmonies, and indicated the means of analysing by a sort of reading those which compose a picture, nevertheless I avow that I cannot perceive those close affinities that several authors, particularly Castel, have said they perceive between sounds and colours. I am ignorant what the future may bring forth, relative to the analogy the senses they respectively affect might present from the point of view of the different kinds of contrasts that take place in vision; but at the present time the marked difference between sounds and colours strikes me much more than their generic resemblance.

(975.) The first difference that I remark between the sensations of hearing and seeing, is the existence of sound as a special thing, whether language or music. It is not only in spoken language or in music executed by the voice or by instruments that this existence is evident, but it is, moreover, in the written sentence and in the notation of music; in fact, sounds expressing the words in conversation and sounds marked by musical signs fix themselves in the memory; the speech, the song, and the instruments reproduce them, if not always identical, at least so as to preserve their principal relations. Finally, What is it that gives to these sounds a significance, a real value? In speech it is the succession of words composing the phrase; in music, melody is nothing more than a succession of varied sounds; and harmony presenting the co-existence of several concords, signifying really something like music only by the sounds that have preceded or by those that are to follow it; in a word, I find the essential character of sounds *significant* in their succession, and in the faculty we possess of recalling and reproducing them according to that order of succession, either when they concern speech or music.

(976.) Have colours a special existence similar to that remarked in sounds? I do not believe they have, at least for the generality of men: for if it be true that we can see colours without material forms, so to speak, for example those of a ray of solar light dispersed by the prism and reflected by a white surface, nevertheless, nearly every one confounds colours with the objects exhibiting them; and it is correct to say that they only appear to them as dependent on a material form, since, far from being seen exclusively of these objects, they are, on the contrary, fixed by them as one of their essential qualities, so that if their memory preserves the recollection of the colours, these latter are always connected with the form of some material object.

(977.) If we now examine the impressions of colours under the relations of *succession* and *simultaneity*, the first of which relations corresponds to the melody and the second to the harmony of sounds, it will be evident that we shall not find in the sight of a succession of colours assorted according to the laws of simultaneous, successive, or mixed contrasts, anything that can be justly compared to the pleasure we receive from a melodious succession of sounds; in fine, we are not possessed of the same faculty for retaining a succession of colours as for retaining a succession of sounds. If we

consider the simultaneous view of colours assorted conformably to the rules of contrast, it is evident from what has been said, that it will be the case of the greatest analogy between colours and sounds, because in fact, in the pleasure caused by colours agreeably associated there is something comparable to what we call a concord of harmonious sounds; with this difference, however, that the former pleasure is of a nature to be more prolonged than the latter; for it is well known that the eye can contemplate the various colours of a picture, without experiencing a feeling of monotony, for a much longer time than the ear is capable of sustaining the pleasure of an harmonious concord of the same sounds prolonged without variation. It must be remembered that in every case in which most persons are agreeably affected by the sight of associated colours, these colours address them through the form they have clothed.

(978.) Finally, sounds, at least for the generality of men, have a special existence, which colours have not. *Succession* is particularly essential to the pleasure of musical sounds and to the signification of the sounds of speech, as *simultaneity* in associated colours, which requires some time to be felt, is essential to the pleasure we receive through the medium of sight.

Is there a Contrast of Difference in Sounds?

(979.) Are there contrasts of difference in sounds? and, if there are, are they simultaneous? are they successive? I raise these questions less for resolving them, than with the intention of indicating the characteristics of these contrasts and the elements of knowledge we must possess in order to prove their existence.

(980.) If it be true that a very loud sound prevents our hearing a weak sound which we should otherwise perceive were it alone to reach the ear, if this effect exactly corresponds to that produced by a strong light when it obstructs our perception of a weak light, which, however, we should see very distinctly, if it were isolated from the other; finally, if these two effects may be observed without the loud sound, or the strong light offending the organ they respectively affect, nevertheless the first fact does not necessarily demonstrate the existence of a simultaneous contrast of difference between two sounds which would be analogous to the simultaneous contrast of tone in two colours. It is then only by the law of continuity that we can really deduce it, by admitting that the phenomenon is one of the extreme cases* of a contrast of difference between the two effects, the lesser of which disappears before the greater, as that which occurs when a small object, placed near a greater, ceases to be perceptible from the fact of this very proximity (966.).

(981.) But to demonstrate the existence of a contrast of difference between simultaneous sounds, corresponding to the contrast we perceive at the sight of two

*I say *one of extreme cases* and not *the extreme case*, because the extreme case is that where the organ is vividly disturbed, as happens when we are near a cannon fired off,—when we fix our eyes upon a highly luminous body, the sun, for instance. These circumstances place the organ in a truly abnormal position, in respect to the state in which it should be to receive and appreciate an impression from external things.

colours of different tones, it is necessary to prove by experiment, that in the simultaneous perception of a flat sound and of a sharp sound, the former appears flatter, and the second sharper than they would appear if they differed less from each other. Now it is precisely this contrast between the two sounds that we are unable to prove by the fact quoted (980.), that a loud sound prevents us from hearing a weak one, since perceiving then only a single sound, we are unable to compare it with that which we do not perceive.

(982.) If we pass to the question concerning the existence of a contrast of difference between two successive sounds, we shall still find that the weak sound succeeding a loud sound, is not heard, the same as a weak light is not sensible to the eye which has received the impression of a strong light. To absolutely establish the existence of a successive contrast of difference between two sounds, it is necessary to show by experiment that the difference is greater between two sounds perceived successively, than if the sounds were nearly simultaneous.

Is there a Contrast of Antagonism in Sounds?

(983.) We cannot now form any idea of a difference which would arise in sounds from an antagonism of some one of their individual properties, for, in reality, we know of nothing in them that corresponds to white light and to mutually complementary coloured lights. In the actual state of our knowledge we cannot then imagine the antagonism between two sounds arriving simultaneously at the ear, only in conceiving them to be mutually destroyed: in admitting this result, we should have a product corresponding not to the white arising from the mixture of coloured solar rays mutually complementary, but to the black which may result from the mixture of coloured complementary materials (968.), and hence we should not see that which in hearing corresponds to the successive contrast of antagonism, in virtue of which the sufficiently prolonged sight of a colour determines the tendency to see, on a second view, the complementary of that colour.

OF TASTE AND SMELL.

(984.) I cannot apply the question of the existence of contrasts of taste and smell, without remarking the extreme difference that exists between these senses on the one part, and seeing and hearing on the other. In all the perceptions of the two former there is the contact of savoury and odorous bodies with the organ; that is to say, always a physical, and frequently a chemical action; while in the perception of colours and of sounds, there is never a chemical action; it is a simple impression that the eye receives from the light,—it is a simple vibration that the ear receives from the sonorous body. According to this I have arranged the properties we discover in bodies by the medium of taste and smell, amongst those that I call *organoleptics*,* in order to distinguish the physical properties, amongst which I class all those that are not made known to us by the eye and the ear.

(985.) It is necessary not to forget that all I say of taste and smell only concerns the sensations we perceive

through their medium, when these organs are in contact either with a single kind of savoury or odorous bodies, as marine salt, sugar, camphor, &c., or with several of these sorts at the same time; but in this instance I shall always suppose that the mixed kinds have no mutual chemical action, and when savoury bodies are in question, these latter are not odorous.†

Is there a Conrast of Difference in Taste?

(986.) If we accept as proof of the contrast of difference the non-perception of a weak light or a weak sound, resulting from the effect of a strong light or an intense sound, either in the case of simultaneity or of succession, we shall be led to admit of a contrast of difference for taste, either simultaneous or successive; for it is well known that a strong flavour is opposed to the perception of a weak flavour, in the case of simultaneity, as in the case of succession; and in both cases the effect may take place without the organ leaving the normal state; for example, a strong salt flavour prevents the perception of a sweet flavour which would be perceived in the absence of the first; strongly sugared water renders insensible the flavour of a slightly sugared water drunk after it.

(987.) But if the analogy of the preceding facts with those which relate to the senses of seeing and hearing is evident, we must own that in our day we know of none that correspond to the contrast of difference, in virtue of which two tones of the same scale of colour appear to the eye more different than they really are. To establish this correspondence, it is necessary we should demonstrate, in the case of simultaneity, that two flavours, proceeding from two matters differing in taste, placed on distinct parts of the tongue, differ more than they would if they preceeded from matters differing less in taste. Finally, in the case of succession, it is necessary to show, that two flavours perceived successively would present more difference than if they had been perceived separately, supposing that we are able to retain for some time the recollection of the first flavour.

(988.) Experiments on the contrast of difference of flavours ought to be made:

1°. With the same kind of flavoured substance taken in different quantities;

2°. With two different bodies having the same generic flavour, as cane-sugar, grape-sugar, manna;

3°. With bodies possessed of different flavours, such as sugar, marine salt, citric acid, &c.

Is there a Contrast of Antagonism in Taste?

(989.) Knowing nothing that bears a resemblance to antagonism in the sensations of taste, we cannot cite any fact suitable to exhibit either a simultaneous or successive contrast of antagonism in flavours.

OF SMELL.

(990.) All that I have said on the contrast of taste is applicable to the contrasts of smell: we can, by analogy, admit of a contrast of difference, either simultaneous or

*See M. CHEVREUL'S *Considérations générales sur l'Analyse organique et ses Applications*, 1 vol. 8vo, Levrault, 1824 (pages 31 and 42).
† Idem (page 45, and following).

successive, for odours, but nothing in the perceptions we receive from it corresponds to the contrast of antagonism.

CONCLUSION OF THIS SECTION.

(991.) It follows from what I have said in this section,

1°. That the senses of seeing, hearing, smell, and, I may add, the sense of touch, all present, as I have before remarked, the phenomenon of not recognising a weak impression which is received at the same time as a much stronger one.

2°. That the result is the same when the weak impression immediately, or almost immediately, succeeds the strong one.

3°. That the two preceding phenomena may be observed when the strongest impression does not sufficiently disturb the organ experiencing them, as to admit of our considering the latter as being in an abnormal state.

4°. That if we can deduce these phenomena of a contrast of difference, nevertheless we must own that it will be difficult to quote results from experiments adapted to show clearly that in the simultaneous or successive perception of two sounds, two flavours, and two odours, we remark between the two sensations a greater difference than we should detect if the two sounds, flavours, and odours were less different from each other.

5°. That at the present time we have no idea of what a contrast of antagonism in the perception of sounds, flavours and odours may be.

(992.) We have seen how the study of the contrasts of sight diffuses a light on the history of the other senses. In insisting on the differences of sounds and colours, I believe them to be based on truth; but my readers deceive themselves if they think I believe that ulterior studies would add more to the differences I have remarked between sight on the one part, and hearing, smell, and taste on the other. In speaking of these differences, my intention has been to show clearly that in the present state of our knowledge we have no actual experimental proof which establishes that hearing, smell, and taste, are submitted to simultaneous and successive contrasts corresponding to the contrasts of difference and antagonism which exist in the phenomena of the sight of white, black, and coloured bodies; it does not signify if future researches cannot demonstrate the existence of these affinities: besides, if I did not fear to go in advance of the result of experiments which, although commenced more than twenty years since,* are still far from being terminated, I would say that I should be more disposed to admit affinities than to reject them (974.).

§ 4.

THE LIGHT WHICH THE STUDY OF CONTRAST APPEARS TO ME SUSCEPTIBLE OF SHEDDING UPON SEVERAL OTHER PHENOMENA OF THE UNDERSTANDING.

*This was written in 1838.

(993.) If it is difficult, at the present day, to experimentally demonstrate that in hearing, tasting, and smelling, there exist definite contrasts of as precise a nature as the various contrasts affecting us through the organ of sight,—yet the examination of these latter, in giving the first experimental proof of this fact, that *two different objects, placed side by side, appear by the comparison more different than they really are,* and in placing in its proper aspect a phenomenon generally spoken of under the name of contrast of colours, without knowing either its extent or its importance,—seem to me adapted to throw a light on the study of several of the operations of the human mind.

In fact, when certain persons regard two objects under a relation of difference, does it not happen that the difference exaggerates itself, so to speak, unknown to them, precisely as it happens in regarding two juxtaposed colours, in which all that is analogous between the two colours disappears in a greater or less degree? Does it not happen that these persons, but little accustomed to reflect on the operations of the mind, give themselves up to the judgment they first brought to bear, always retaining some inexact ideas which they would have been able to rectify, in considering objects under new relations adapted to control their first opinion? Are they not in the position of one who, having concluded, at first sight, that a difference of 1-5/100 yard exists between a measure of one yard placed beside a measure of two yards, preserves that opinion in his memory as correct, because, ignorant of the effect of contrast of size (965., 966.), nothing can make him feel the necessity of having recourse to a counter-proof to rectify his judgment, as he would have been led to do had he possessed that knowledge, and moreover, had he felt the necessity for some motive of having exactly the difference of length of the two measures, for then he would have had recourse to measurement.

This example is very well adapted to the comprehension of my ideas respecting the inexactitude of a great number of opinions brought to bear upon certain objects which we compare in respect to qualities, properties, and attributes we have not measured.

(a) Operations of the Mind corresponding to the Contrast of simultaneous Difference.

(994.) The inaccuracy of judgment in question, consisting in the exaggeration of a difference between two objects compared, enters into the contrast of simultaneous difference, whenever the qualities, properties, and attributes we compare, belong to objects before our eyes, or rather to objects more or less remote, in space or time, and then our opinions bear on the notions that memory recals to us or tradition has transmitted.

(b) Operations of the Mind corresponding to the Contrast of successive Difference.

(995.) I am about to examine those mental operations which appear to me to correspond to the contrast of successive difference, because they refer to a comparison established between two objects seen in succession, or between an opinion at present maintained, and a contrary opinion held at some previous period.

(996.) A man easily susceptible of receiving impressions, who travels through a country for the first time, is much disposed to form exaggerated notions, because he is most struck with the differences between the objects he now sees and those which have been presented to him previously in the country where he has long resided. The best method of correcting his judgment, is to revisit in succession the objects compared, and to bestow particular attention upon those qualities which have struck him the most forcibly, that he may regulate his first impression by newly-formed opinions.

(997.) Finally, is not our disposition of mind with regard to an opinion that is entirely abandoned for another, remarkable for this,—that we almost always form an exaggerated judgment of the opinion we have abandoned in the sense least favourable to it, and that hence the mind gives way to an exaggeration of the difference?

Influence exercised by the Condition of our Organs upon many Operations of the Understanding.

(998.) In reflecting upon the condition of our organs under three circumstances, as follows:

1°. When the difference produced by the simultaneous contrast of two tints is carried to its maximum;

2°. When a small object ceases to be perceptible on account of its proximity with a larger;

3°. When in looking at an object, which, however, is not very complex, we perceive, in a given time, only a small number of relations under which it can be presented to the attention of most persons,-I have been led to explain to myself clearly the case in which our mind, when certain ideas have become more familiar to it than others, is led to regard the former to the exclusion of the latter.

(a) When the mind is at work in solitude upon a subject.

(b) When a discussion is entered into by two persons.

Let us examine these two conditions.

(a) Works executed in Solitude.

(999.) A mind constantly occupied in seizing only upon the differences between objects, acquires by this very act a disposition, I will not say to set aside resemblances or analogies between one thing and another, but *a disposition not to perceive them;* while, on the other hand, a man who sets up to establish a broad generality—a so-called universal principle, limiting the examination of the most complex things to a few relations only,—seems *not to perceive a variety of phenomena visible to all those who are moved by a desire to enter into a conscientious and satisfactory investigation of these things.* If the first does not see that the brightest conquest of the human mind in its search after truth, is the discovery of generalities, the second is equally blind to the fact that it is after careful study of details, and consequently after the appreciation of facts widely differing, that we arrive at generalities and at principles, and that the quality of exactitude in these is found in the explanation itself of the variety of phenomena to which these principle refer.

(1000.) When certain ideas have so completely occupied the attention as to become familiar, the brain is so much the more strongly disposed to receive impressions from without which recal the thoughts to these ideas, according as they have been more profound and their mutual connection closer; that as soon as a matter which enters essentially into this system of ideas is presented to the mind under a familiar aspect, the new matter will forthwith be classed in the system; while, should it be presented under an unfamiliar aspect, its classification is delayed, because an ulterior operation is necessary to co-ordinate the new notion with the old ones.

(b) Discussion between two Persons.

(1001.) The difficulty of inserting in a system of ideas certain matters presented for the first time to the mind, or which, having been previously presented, have not been considered of sufficient importance to be co-ordinated with others, which subsequently have composed a body of opinions, explains the following facts.

(1002.) 1st *Fact.* Two able minds are occupied on a subject, but with this difference, that one applies a system of ideas, acquired after long meditation, while the only object of the other is simple inquiry. Now, suppose that in the course of a discussion between them upon this subject, there is presented a new fact capable of being connected thereto by some relation, I say that it may happen, according to the aspect under which this fact is presented, that the former of the disputants may see its relation to the matter in question less promptly and easily than the latter; this is not going so far as to say, that later reflection may not produce changes in the impression the first mind received at the outset, and that it will not appreciate the importance of the new fact for throwing light upon the subject.

(1003.) 2nd *Fact.* Two persons are discussing without auditors; no passion excites them, they are animated solely by the desire of ascertaining the truth on a subject, be it scientific or literary, which is of a nature to divide opinions; after a longer or shorter discussion they separate, neither having yielded a point to the other. I admit, in accordance with the common opinion, that such is the ordinary result of discussions; but under the supposition that I have raised, and provided the discussion has been sufficiently prolonged between two conscientious and enlightened persons, I admit that there is *in general* a mutual reaction, and that, sooner or later, the opinions held by each person before the discussion will be more or less modified.

(1004.) 3rd *Fact.* It is possible for two superior minds, not only not to act upon each other in a prolonged discussion, but, moreover, for the reflection following upon the discussion not to produce any modifications in their opinion, because the ideas of each may be so co-ordinated that it is not possible to intercalate a fact capable of modifying that co-ordination; and more than this, a synthetic mind is less disposed to entertain a fact which forms part of a system of ideas different from its own, when the argument emanates from another synthetic mind, that if that fact were presented to it isolated, or if the argument emanated from some one who had no system to defend.

(1005.) In all that precedes, I have presumed that

passion exercises no influence; if it did, it is evident that the difficulty of arriving at a mutual understanding would be greater.

———————

(1006.) The examples I have cited appertain to the case in which the influence of co-ordinated ideas prevents the mind receiving new notions; I have now to speak of the case in which a mind, after having been long occupied with a subject, suddenly and for the first time perceives, either in the course of discussion or as a consequence of its own reflections, a fact which strikes it so forcibly, as to cause it to pass suddenly from one mode of viewing to another more or less opposite; it is then especially that it is liable to be led astray by the importance it attaches to a newly-formed opinion relatively to one that has been abandoned (997.); this case, far from being opposed to my views, is only an extension of them.

Inconveniences in oral or written Teaching which may arise from the Opposition established between two Facts.

(1007.) There would be a void in the exposition of my views on the extension which the study of contrast appears to me to be susceptible of, if I did not add some remarks applicable to the result which may follow from a teaching in which, while proceeding specially by placing two facts in opposition, the differences only which they exhibit is insisted on without regard to their essential analogies. If such teaching is easier for the professor, and more accessible to most understandings, because it gives more saliency to a very small number of facts, it has, in my opinion, the objection of greatly exaggerating the differences which actually exist between the objects compared; or, which comes to the same thing, of leading to a belief, or to a tendency to believe, that differences have an importance in the distinguishing of these objects which, in truth, they are far from possessing. When a professor in a lecture, or an author in a book, brings forward two different opinions, or two hypotheses, or advances two propositions, it may happen that they will, for the sake of greater clearness, insist upon an opposition, while they omit the analogies that may restrain within its true limits the two terms of the comparison. From this mode of proceeding may result not only an exaggeration of difference, but also a notion altogether incorrect, if, for example, the two terms of the comparison being two propositions, they should be presented to the auditor or reader as altogether opposed, so that if one be true, the other must of necessity be false; whilst to be exact, the boundary which circumscribes each circle within those limits the truth is, should be traced.

(1008.) When we study several objects so as to know them thoroughly, there is every advantage in viewing them in the order of greatest mutual resemblance, instead of placing them in opposition to each other, for the purpose of distinguishing them. Perhaps we cannot insist too strongly upon declaring that, in the study of organised beings, the advantage of the *natural method* over *classifications* or *methods called artificial* belongs, in a great measure, to the exactness the former gives to

the mind, in essentially presenting to it an *ensemble* of beings according to their mutual resemblances, whilst the artificial classifications have for their special aim the distinguishing these beings from each other, and of finding the specific name of each; it proceeds, moreover, in presenting them to the student by the characteristics in which they differ the most. Hence he who habitually employs the artificial method will never obtain a precise idea of the objects he wishes to know, if he neglects to consider them conformably to the order of subordination prescribed by the natural method; and, further, if he does not devote himself at an early period to the study of this latter, the habitual use of the artificial method will render it extremely difficult for him to appreciate the real value of the relations that exist between them (999.). Finally, still in conformity with my ideas, instruction based on the natural method will be more or less exact, according to the manner in which the professor presents the analogies which combine several beings in the same group, and the differences which distinguish them into various groups.

SUMMARY AND CONCLUSION OF THIS SECTION.

(1009.) 1°. If I am under no illusion in the comparison established between objects considered under the relations we do not take into account, there may frequently be an exaggeration of the difference that really distinguishes them, especially if we have already, before establishing the comparison, some tendency to see this difference, and if we do not recur to it after having established all means of controlling the judgment that immediately results from a first comparison. I conclude, then, that a control exercised with this intention is necessary to a severe mind which seeks out every possible means of seeing the differences existing between the objects it compares, such as they are in relation to the most rigorous judgment that we are able to bring to bear on them; for the man with exceedingly limited faculties cannot flatter himself that he knows the absolute truth of things.

2°. I think that, in opinions where exaggerations of a difference exist, the organs that contribute to these operations of the mind find themselves in a physical state corresponding to that of the organs which are affected in the phenomena of the simultaneous contrast of view; so that it is difficult, whilst this state continues, to perceive ideas differing from those to which this state relates. The consequences deduced from this are, that every sound mind that is brought to perceive a relation of non-appreciable difference between objects ought, before retaining them in their thoughts as a precise correctly limited fact, to be careful that the brain is brought into a state that will permit it to control the fact, by calmly submitting it to a verification directed from points of view differing from that in which it was when it first fixed his attention.

(1010.) In this case in which we do not admit the relationship I seek to establish between the physical state of the brain, when on the one hand we compare two objects by the affinities of their abstract qualities, and on the other when we perceive the impressions that give rise to the phenomena of contrasts of vision, it

seems to me that we should not refuse to acknowledge that, in summing up this relationship in these words, *the brain perceives and judges ideas as it judges colours which it perceives by the medium of the eye,* we establish a *comparison* which, by simply attaching value to it as a *figure of rhetoric* suited to enliven some part of a discourse, is not without utility for the light it is susceptible of throwing on the understanding.

It is then to simplify this study that I now consider contrast as *simple comparison;* either when we see two differently coloured monochromous objects, or when a greater number are before our eyes, we can only perceive at one time some of the affinities, instead of the whole, which it would be indispensable to see in order to arrive at a complete and perfect knowledge of these objects.

1°. The well-established fact that red, isolated, appears differently than when it is juxtaposed with a white, black, blue, or yellow surface, and that under these circumstances five *identical* red patterns would appear five *different* patterns, is important as a limit of comparison fitted to show clearly how the same object may give rise to different opinions among those who judge in an absolute manner, without regard to the possible influence of some relative circumstance. We here suppose the opinions are the result of the comparisons of coloured patterns with the tones found in the *chromatic diagram* (159.). The fact in question is applicable to many cases. I will cite two as examples.

(*a*) A person, ignorant of the effects of the juxtaposition of colours, judging that the five red patterns are different, although really identical, presents an example of the circumspection it is necessary to exercise in the opinions formed of compared objects slightly differing from each other, and which are not observed under the same conditions.

(*b*) Five persons know that the same red has been placed in the five conditions indicated, but are ignorant of the influence of juxtaposition, and, consequently, of the influence of these conditions: they have each seen only one of the five patterns; a discussion arises on the optical quality of this red: if the one that has seen the isolated pattern says that it remains as he first saw it, the four others will say that the red, after having been placed in one of the prescribed conditions, does not seem as it did before. But they will not agree when they come to decide upon the kind of modification which the red has experienced; the person who has seen the red juxtaposed with black will maintain that the tone is lowered, whilst he who has observed it juxtaposed with white will, on the contrary, maintain that the tone is heightened, but both of them will agree in asserting that the red has not gone out of its scale; an opinion which the two last will combat, who, having viewed the red in juxtaposition with yellow and blue, have seen it go out of the scale to which

Another result to be deduced from the preceding fact is, that when we must believe in the interference of passion in an opinion differing from our own, by

regarding it closely, we may find that there is only a simple difference of position. After that, in many cases where we have been led to assign a less honourable motive to an opinion or action, it is probable that we shall be nearer to justice and truth by interpreting these things with indulgence rather than with severity.

2°. In considering that the eye sees at one time only a small number of objects that compose a whole, when it desires to penetrate into the details of that whole (748.), and that several individuals are able to see the same part differently modified because they see them in connection with different parts (483.)—in considering, finally, that these differences in the modifications of the same part may be observed by the same individual (499.),—we are led to acquire a clear idea of the manner in which the human mind proceeds in the study of nature. In fact, we see, first, how man, wanting in power to embrace the whole of the objects with which he wishes to be thoroughly acquainted, is forced to have recourse to analysis; how that, by not fixing his attention upon one fact at a time, he can only arrive at his aim by successive efforts, after having studied piece by piece each element of the whole he examines. If we now consider that the human mind is composed of the minds of all—that the edifice of science it has raised up is the product of the efforts of minds which, far from being identical, present the same differences as the forms of the bodies they animate—we shall then comprehend how the various minds that study the same subject consider it under extremely different relations, when the fact that will strike each of them in particular will not be identical, because their diversity of nature is an obstacle to their being equally accessible to the same fact. It will be the thing which strikes them the most that they will then examine; but superior minds will distinguish themselves above others, because they will bring their meditations to bear on facts which, considering the epoch in which their minds labour, it will be more important and more essential for the advancement of human knowledge to know.

If the faculty of reasoning, in order to discover the relations of the phenomena which strike us—if the faculty we possess of communicating the discovery of these relations to our fellow-creatures distinguishes us from the animals properly so called—lastly, if to attain this end we make so extensive a use of the *faculty of abstraction*—it is nevertheless important to remark that this necessity man has for decomposing a whole into its elements in order to understand it is a token of the feebleness of his nature, and that this feebleness is revealed in all the results of his analysis, because it has not yet been permitted to an individual, nor to his contemporaries, to make a complete analysis of any object out of pure mathematics. For the desire which leads man to study nature leads him always, or almost always, to extend the results of his investigations beyond the boundary where he must stop in order not to pass beyond the limits traced by rigorous reasoning.

Classic Plate Reproductions

The fifteen color plates which follow are modern reproductions of the Chevreul classic plates. These may be compared with the same illustrations on pages 25 through 32 which are facsimilie pages of the original English edition as they were printed and published in 1854.

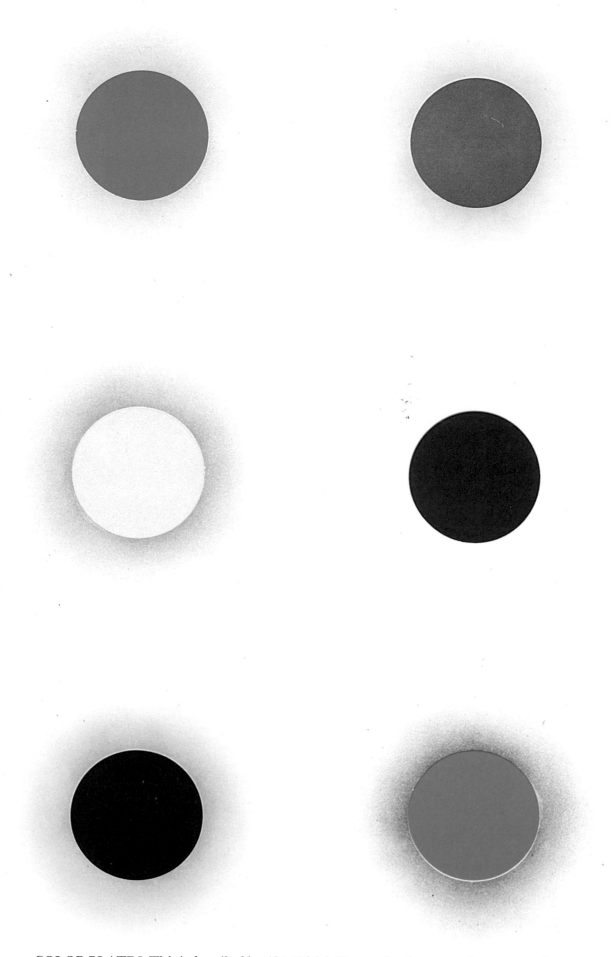

COLOR PLATE I. This is described in (43.). With it Chevreul endeavors to demonstrate the fringe effects of induced colors upon staring at disks of pure colors on a white ground.

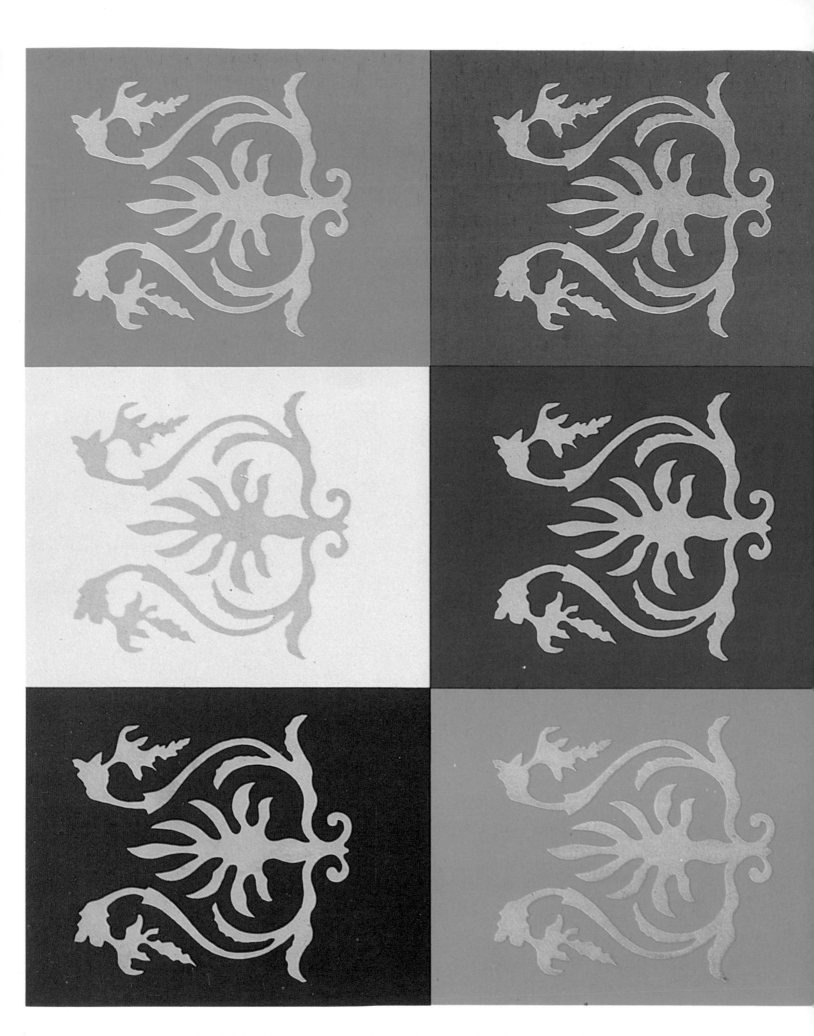

COLOR PLATE II. When pure colors are juxtaposed with gray, complementary tints are seen to pervade the gray. Paragraphs (63.7 through (70.) describe the results.

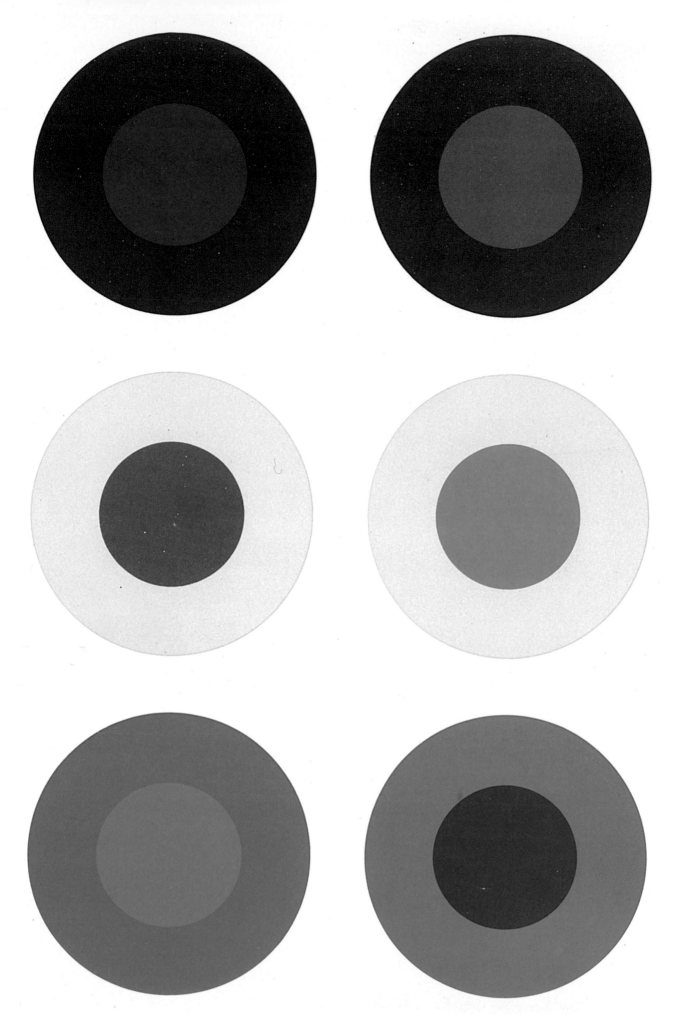

COLOR PLATE III. Afterimage effects are demonstrated with combinations of primary and secondary colors. What happens is described by Chevreul in Second Group of paragraph (76.). Combinations with indigo are not included on the plate.

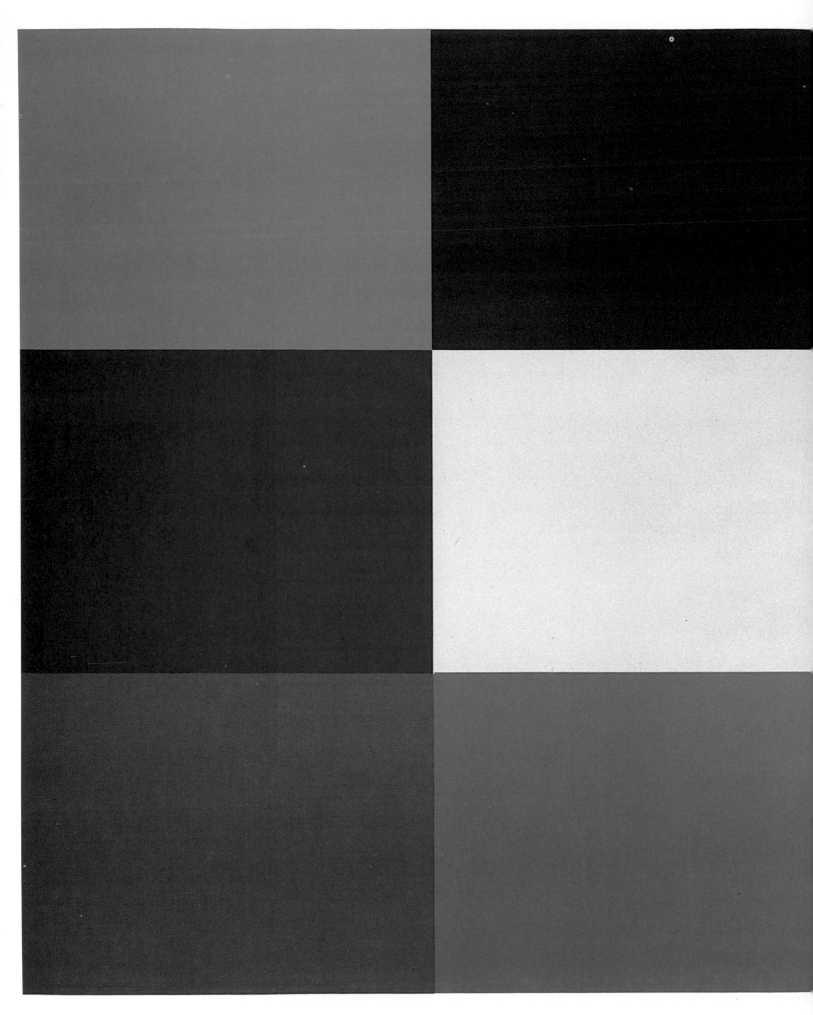

COLOR PLATE IV. These large areas of primary and secondary colors are to be variously stared at from one to the other to see effects of simultaneous, successive and mixed contrast of colors. Elaborate experiments are suggested in paragraphs (78.) through (116.).

CHROMATIC SCALE OF TONES.

21	
20	
19	
18	
17	
16	
15	
14	
13	
12	
11	
10	
9	
8	
7	
6	
5	
4	
3	
2	
1	
0	WHITE

COLOR PLATE V. This illustrates a typical Chevreul color scale which, in his methods, scales a color up toward black and down toward white. See (151.).

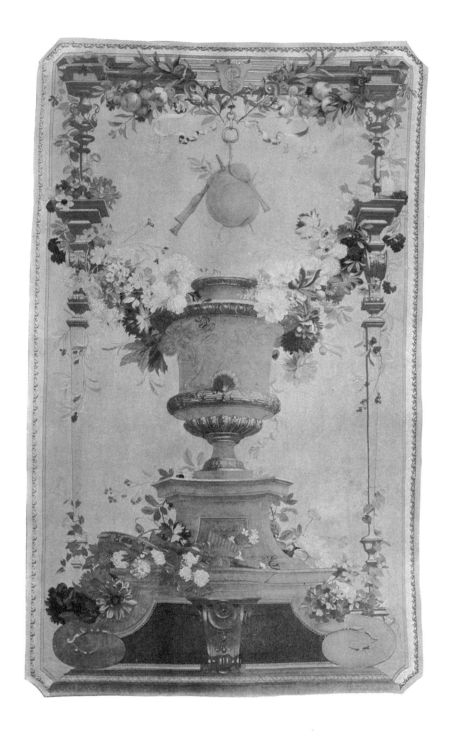

A Gobelins tapestry of 1887, *Victory*. (Photograph by Fernand Dengremont.)

A Gobelins tapestry of 1886, *Marble Vase No. 1*. (Photograph by Fernand Dengremont.)

Opposite page:
COLOR PLATE XII. In the very beginning of his study of color, Chevreul was concerned with the fact that areas of black in some instances tended to take on complementary tints of hues placed adjacent to it. He used an illustration like this to demonstrate the phenomenon. Chevreul discusses this in paragraph (444.).

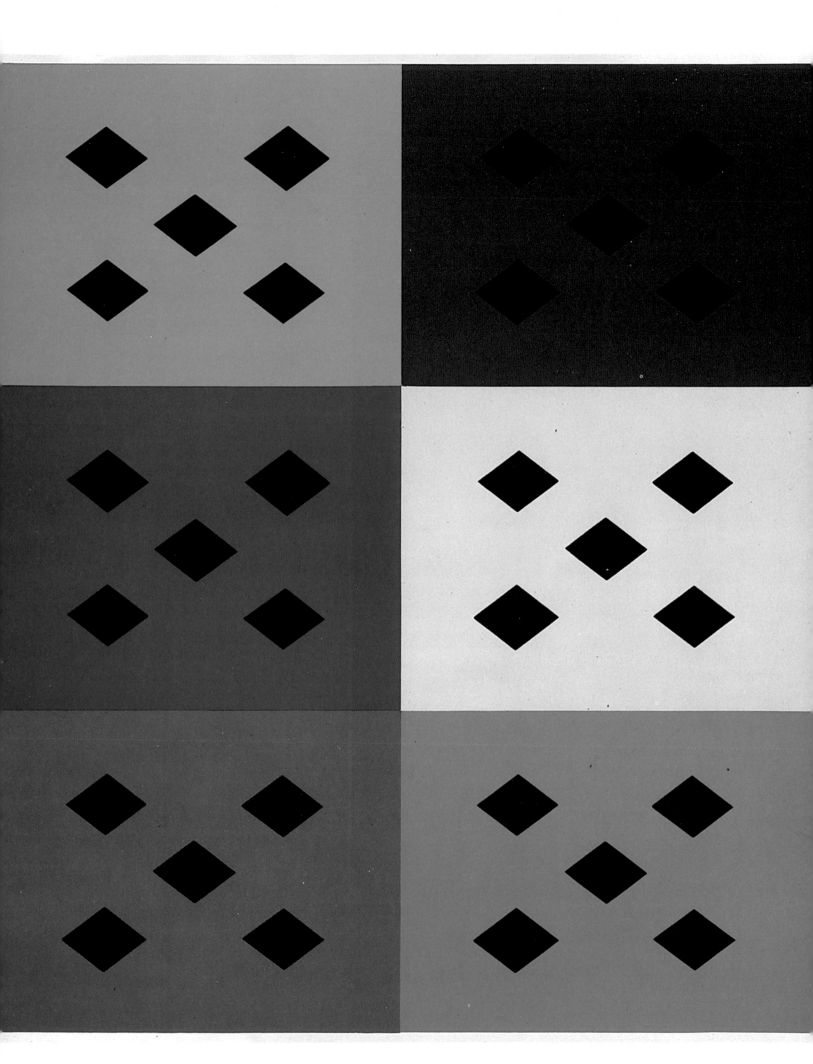

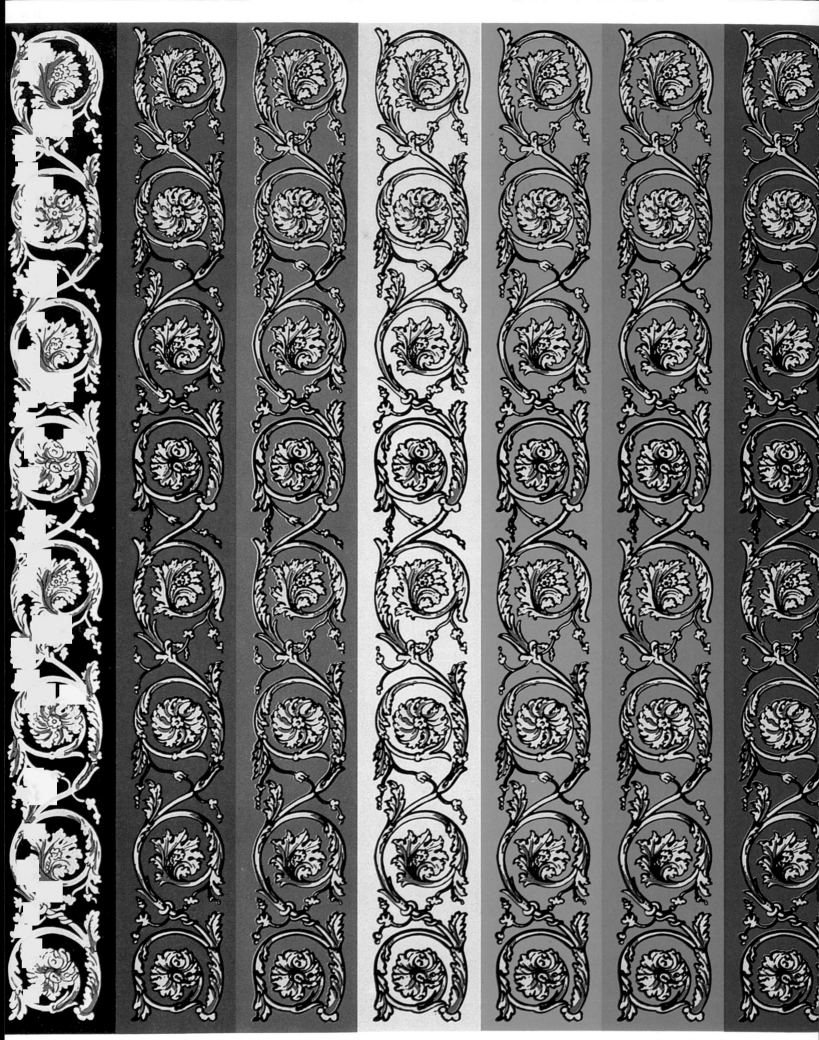

COLOR PLATE XIII. An ornamental border with gilt patterns on black and colored grounds could be used to study afterimage effects. See paragraphs (459.) through (473.).

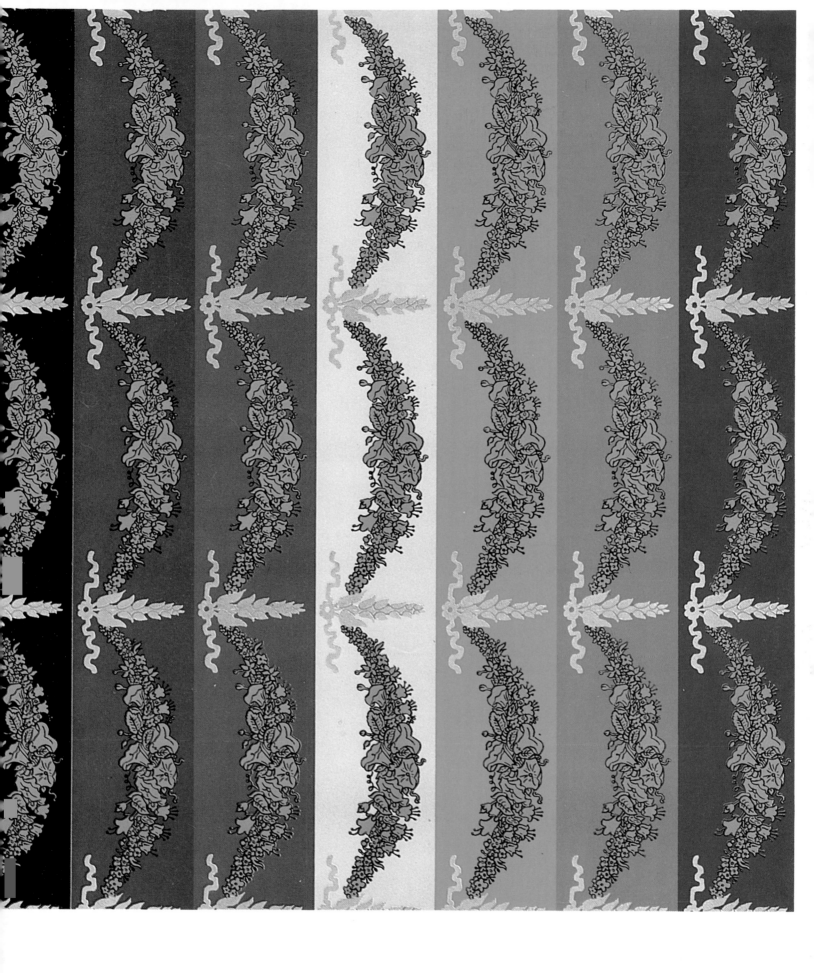

COLOR PLATE XIV. In this border, blue flowers and gray festoons are on black and colored grounds. Afterimage effects could be studied. Results are described in paragraphs (474.) through (481.).

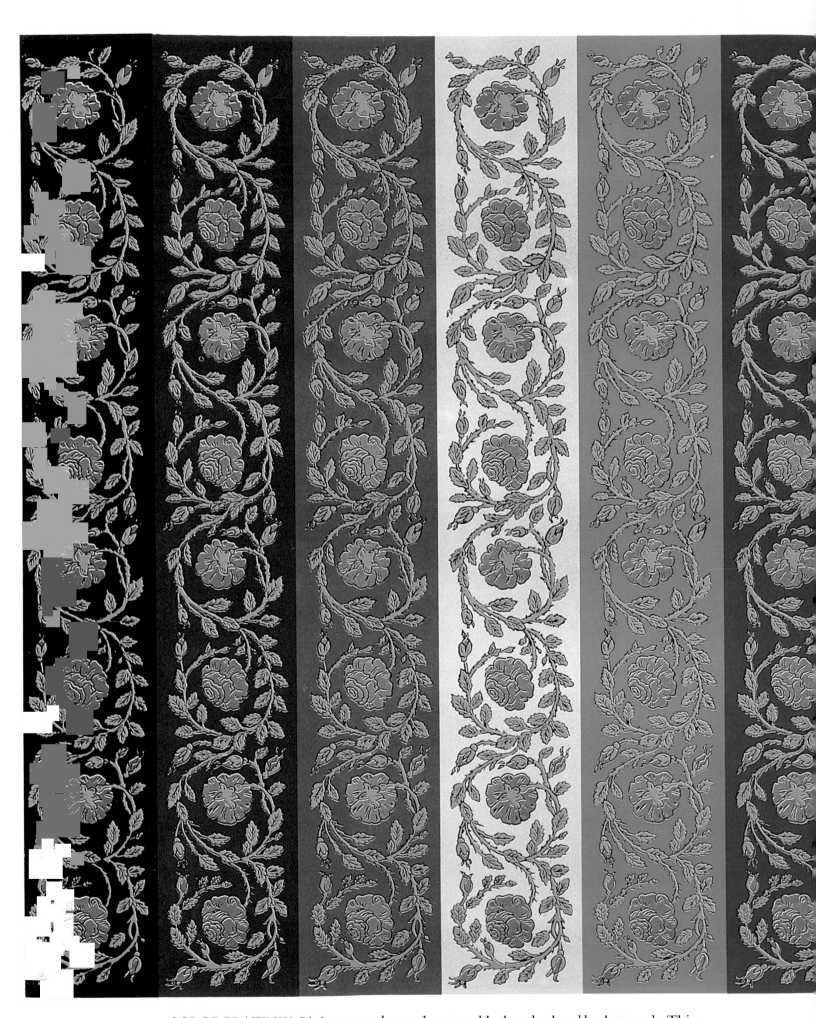

COLOR PLATE XV. Pink roses and green leaves on black and colored backgrounds. This was a common border design in Chevreul's time. He describes good and bad combinations in paragraphs (482.) through (484.).

Notes and Commentary

The 1854 English translation of Chevreul's great book precedes these notes and commentary. While Chevreul was quite thorough and detailed in his writings over a hundred years ago, certain interpretations of what he had to say should be helpful to the readers of today. The text of his masterpiece is repeated verbatim. The color illustrations, however, have been reworked and brought up to modern standards of color reproduction. The object was to make them appear as brilliant and clear as Chevreul had originally intended.

When the reader is immersed in the text of the book, here are a few interpretations and translations of some of the Frenchman's vocabulary.

Tone. Chevreul uses this term widely to indicate "colors" in general or pure hues mixed with black or white.

Tints. Colors mixed with white.

Shades. Colors mixed with black.

Broken colors or tones. Colors that contain mixtures with white or black.

Binary colors. Colors made up of two primaries or groups of colors. Also called compound colors.

Primary colors. Red, yellow, blue.

Secondary colors. Orange, green, violet.

Tertiary colors. Muted colors. These are usually the result of mixtures of secondaries: orange and violet for russet; orange and green for olive; green and violet for slate.

Complementary colors. Red-green, yellow-violet, orange-blue, or other colors opposite each other on Chevreul's color circle.

Luminous colors. Red, orange, yellow, yellow-green.

Sombre colors. Blue and violet.

Intensity. Used freely by Chevreul to indicate brightness, purity, saturation of a color. (Munsell's term would be chroma.)

Height. A height of tone. Used to indicate lightness or darkness of colors. (Munsell's term would be value.)

Accidental colors. These would be afterimages or colors sensed subjectively.

Contiguous. Colors that are side by side.

Simultaneous contrast. This is in the title of Chevreul's book. The visual influence of colors on each other when they are viewed simultaneously.

Successive contrast. The visual influence of colors on each other when viewed separately or one after the other.

Mixed contrast. This can have two meanings: the influence of afterimages on other colors; or the visual and optical mixture of colors on the retina of the eye—a field in which Chevreul had tremendous experience at Gobelins.

Ternary. Groups of three colors.

The text presented follows references to numbered paragraphs (in parentheses) in Chevreul's work. Where such paragraphs are marked with a black dot comments regarding them will be found in the pages herewith.

As a prelude, however, when referring to the dots and numbered paragraphs, consider Chevreul's qualifications as the author of his book. He was essentially a chemist, a scientist who had become well known as such. He had little interest in art or design, despite the fact that his largest influence would be in the esthetic realm of the painter. He had been appointed to the Gobelins "royal manufactories"

because he was a chemist. Yet when he assumed the directorship of the dyeing department, he perhaps surprisingly encountered the visual problems of contrast which so affected the appearance of textiles colors. He had, in 1828, lectured on these new-found mysteries which he named the Law of Simultaneous Contrast of Colors. In his Author's Preface he mentions Gobelins and Beauvais tapestries and Savonnerie carpets, all famous to France. He would be called upon to enhance the beauty of these elegant crafts.

It is quite significant that Chevreul had unknowingly advanced a science that was to become known as physiological optics. Many of his findings and discoveries predate, by 28 years, the highly regarded *Treatise on Physiological Optics* published by the eminent Hermann von Helmholtz in 1867. In fact, Chevreul's dissertations on visual phenomena and contrast effects had set a mark for completeness and authenticity that has not since been exceeded—only improved upon. He was in every way as good a scientist in vision as he was in chemistry.

Now to the black dots and paragraph numbers enclosed in parentheses. Here is the first example.

● (2.) Introduction. Probably influenced by Newton, Chevreul in his Introduction refers to the seven colors of the spectrum originally listed by the English scientist: red, orange, yellow, green, blue, indigo, violet. However, as he proceeds in his book, Chevreul often drops reference to indigo and lists his primaries as three (red, yellow, blue) and his secondaries also as three (orange, green, violet). Newton had been something of a mystic, despite his highly rational mind, and had chosen seven hues in deference to the seven proverbial planets, and seven notes of the diatonic scale. As few may appreciate, Newton had written extensively on religion and had tried his best to reconcile its spiritual beliefs with the facts of science. His indigo, by the way, would correspond to what artists know today as ultramarine blue.

● (6.) In his day, Chevreul saw color as color, so to speak. He made no distinction between color as light and color as reflected "by an opaque body." It would take the discriminating genius of Helmholtz to make the distinction. There are in truth three realms of color. In the physics of light, the primaries are red, green and blue-violet. Here mixtures of light are additive and form white. With pigments and dyes, the primaries are red, yellow, blue, as accepted by Chevreul. (In process printing the base colors are magenta, yellow and cyan.) Mixtures of pigments and dyes are subtractive and form near-black in combination. As further primaries, the eye sees unique qualities in the perception of four colors: red, yellow, green and blue. If these are mixed visually, as segments on a spinning disk, the results seek an average brightness of all four, and toward a neutral gray. In (6.), the complementaries set forth by Chevreul apply to subtractive colors only, not lights. If red and green pigments mixed together tend to cancel each other (even visually) in light these two colors form a bright yellow.

● (8.) The first sentence in Chevreul's Chapter I deserves quoting: "If we look simultaneously upon two stripes of different tones of the same colour, or upon two stripes of the

same tone of different colours placed side by side, if the stripes are not too wide, the eye perceives certain modifications which in the first place influence the intensity of colour, and in the second, the optical composition of the two juxtaposed colours respectively." This is Chevreul's concise statement of his Law of Simultaneous Contrast, his outstanding discovery. To state it again, if two colors of different brightness or value are placed side by side, the lighter color will tend to make the darker *juxtaposed* color appear darker, while the darker color will make the lighter *juxtaposed* color appear lighter. With hues, the *optical* composition of the juxtaposed colors will as well be affected, due (as Chevreul later explains) to afterimages. With red and yellow, for example, *juxtaposed*, the red will tend not only to make the yellow appear lighter, but its afterimage of green will make the yellow seem tinged with green. Conversely, the afterimage of yellow which is blue will make the red appear violet. If this may be confusing, actual experimentation will be enlightening. And Chevreul in his book goes to very elaborate detail regarding his Law. On the phenomena of *intensity* changes with juxtaposed colors, Chevreul includes an explanatory chart in Black and White. Plate 1. This is here shown in original form (A) and as redrawn in clearer detail (B). Look at Fig.3 (bis), a gray scale. To quote Chevreul (11.), "We shall perceive that instead of exhibiting flat tints, each stripe appears of a tone gradually shaded from the edge *a a* to the edge *b b*." And so also for the other stripes in Fig. 3 (bis). This illusion is a visual one and has never been clearly explained. Chevreul in the execution of his diagram goes into detail as to how the stripes were made.

(15.) Indigo is still included as a color but will be dropped later. Indigo is not in his color circle (see Color Plate VI). Chevreul now lists 17 combinations of the colors placed in juxtaposition and the results that occur due to simultaneous contrast. When he writes that they should be of equal intensity, he probably refers to purity of hue. The effects of such contrast have already been described for red and yellow. What happens is that two modifications take place: light and dark "value" or brightness differences are accented, and the afterimages of the hues cast their tints or tones over each other. Let the reader note that combinations of exact complements are not accounted for in the 17 list: red-green, orange-blue, yellow-violet. The reason for this, which Chevreul later explains, is that the afterimages of complements precisely enhance each other. With red-green, the green afterimage of red enhances green, and the red afterimage of green enhances red. (See also (39.) to (42.). The "modifications" given in the list of 17 pairs becomes academic, but at the time of Chevreul, the discoveries no doubt were enlightening if not sensational.

(20.) Chapter III quite repeats what Chevreul has already stated. He tends to elaborate on his discovery which in his day was hardly recognized. Yet his complements were chosen in terms of pigments. Pigment complements are not the same as light complements, nor are either of them the same as visual complements. Chevreul is *right* merely in a *general* way, so his conclusions hold validity. A combination of chrome yellow and ultramarine blue in pigments will form a dull green; in lights the two will form a near-white; when spun on disks they will produce a neutral gray.

(43.) The term afterimage was not used in Chevreul's day. To him the afterimages of colors were their complements. In Color Plate I he suggests a way in which three complementary effects may be illustrated. A series of color discs in red, orange, yellow, green, blue and violet are mounted on a white surface. As a person stares at these discs, complementary fringes will be seen. (Color Plate I has been redone in purer hues than in the original 1854 English edition.) In this way, the effects of simultaneous contrast can be dramatized. The assumption is that in actuality—colors used in art, design—the complementary fringes of hues will definitely shift the apparent brightness and chromatic tint of other adjacent colors.

(63.) Afterimages or complementary effects are hardly noticeable when colors are placed in contrast with white or black. Chevreul discusses this in (44.) and (53.). However, when the contrast is with neutral gray, complementary tones are readily seen in the gray areas. This is demonstrated in Color Plate II in which a gray pattern is placed on areas of red, yellow, blue, green, violet, orange. This famous experiment has been repeated again and again by modern writers. That the gray patterns seem tinted with complementary hues is quite evident. On *brightness*, the gray pattern on yellow seems darker than the gray pattern on blue. In all six instances the complementary effects are to be noted. The gray pattern on red, for example, appears greenish, while the gray pattern on green appears pinkish. As in Color Plate II, if the pattern is gray on colored ground, the entire pattern seems tinted. However, if the pattern were to be colored on a gray ground, only a *fringe* of the complement is likely to be seen.

(76.) Chevreul heads the paragraph with the erroneous statement that "red, yellow, and blue are the only primary colors." He may be freely forgiven in this because of the fact that his many demonstrations with them quite approach the actual visual results of optical mixtures. In (76.) he tells of contrast effects involving compound colors (orange, green, violet) with simple colors (red, yellow, blue) and he presents Color Plate III as a demonstration. He places an orange and a blue center on his red circles; a green and an orange center on yellow; and a violet and green center on blue. His attempt to explain what happens as to afterimages or compliments is none too clear or convincing. Fairly lively effects will be seen if the reader stares for a few seconds at any one disc and then transfers attention to others. Witnessed will be fringes of brightness and hues that become quite exciting visually. These results will be due less to *simultaneous* contrast than to *successive* contrast. Areas of color in a painting, for example, will be influenced by these phenomena.

(77.) In this and following paragraphs in Section II, Chevreul emphasizes distinctions between simultaneous contrast, successive contrast, and mixed contrast. All this very much applies to the fine arts, decorative arts and to visual phenomena at large. Simultaneous effects are seen immediately. In Color Plate II are examples in which gray patterns on hued grounds appear tinted. There will be shifts in color tint as well as brightness. With successive contrast Chevreul offers Color Plate IV. Here relatively large areas of red, yellow, blue, green, violet, orange are placed side by side. If a person stares from one area to another, the influence of afterimages or complements will be noted. An interesting experiment is to cut out a window in an opaque card the size of one of the color areas. Stare at one of the colors. Then pull the card away and note the afterimage effect on other hues. On the matter of mixed contrast, Chevreul in paragraphs (85.) to (116.) suggests some fairly complicated experiments which he says should be "particularly useful to painters." The reader may wish to try these, but effects will be seen only if time is devoted to them—they are not seen instantaneously. (Visual color mixtures will be dealt with later.)

(120.) Accidental colors as defined by Chevreul refer to sensations experienced subjectively, with or without the existence of light. Newton referred to them in his time and added colors in dreams or as a "Mad-man sees things before him which are not there." Aristotle had described "the flight of colors" after staring at a bright image such as the sun. Involved are positive images. Negative sensations are those afterimages already described in which they complement the color stared upon. There are references also (125.) to colored shadows, the mystery of which had been studied by Goethe and many others. The shadow of an object cast upon a white surface by a colored light will be complementary in hue. Red light will cast a green shadow, for example. But some neutral but feeble light must also exist during the procedure.

(133.) Details were important to Chevreul. He doted on them. On the matter of successive contrast he referred to the experiments and findings of others. It is regretable, however, that he was not familiar with the extensive research of Goethe whose *Farbenlehre* had been published in 1810, some 29 years before the Frenchman's masterpiece. Goethe was internationally known. His work went into English in 1840, while Chevreul's came out in 1854. Goethe even more than Chevreul had undertaken elaborate empirical studies of human color perception, and the conclusions of the two men would have meshed neatly. About accidental colors, recently noted responses to the taking of hallucinogenic drugs such as LSD have exposed a vast world of brilliant and pulsating color that lies within the brain and psyche of all persons. If the process of color vision proceeds from the outer world into the eye and brain, it also can proceed from the brain and eye into the outer world. Many visions are like this—lantern slides of the mind projected out front.

(144.) In Part II of his big volume, Chevreul gets down to practical affairs of color, painting, textiles, carpeting, mosaics, stained glass, printing, paper. This broad attitude gives his book wide applications for all artists and artisans in need of education on the mysteries of color. He explains the meaning of his terms (tones, hues, scales). Tones referred to any modifications of color, such as tints or shades. Hues were colors themselves. Scales obviously were neatly stepped gradations of a color or colors. An example of a color scale for red is shown in Color Plate V.

(157.) Having established red, yellow, blue as his primaries, and orange, green, violet as his secondaries, Chevreul proceeds to put order and structure into color organization. Color circles built in this way had been proposed by Moses Harris in 1766, by Goethe in 1810 and later by Sir David Brewster, George Field and more artists right up to modern times. Moses Harris, an English engraver presented what was perhaps the first circle actually illustrated in full color, and it had its basis in red, yellow, blue. This color circle of Chevreul is diagrammed in black and white on Plate 2, and in full color for Color Plate VI. (Note Arabic numbers for black and white plates, and Roman numerals for color plates.) The Frenchman's chart had 72 hues and intermediate hues. He goes on to enumerate these segments or steps in detail (162.) and to develop scales from them (164.). To visualize a three-dimensional "solid," out of them he designed and devised a hemisphere, as in the upper right corner of black and white Plate 2.

(164.) The trouble with Chevreul's hemisphere is that it was basically faulty. Wilhelm Ostwald in later years declared that some modified colors necessarily had to appear twice—and this was unfortunate. Wrote Ostwald,

"The reproduction of his color system in colored wools was only partially executed. A complete rationalization of Chevreul's color system has therefore never been accomplished." Before Chevreul, Philip Otto Runge, a capable German painter, had in 1810 designed a color sphere which came closer to plotting, in three dimensions, the whole world of color variations. Later came the concept of a double cone by Ogden Rood (1879) and a color tree by Albert Munsell (ca.1900).

(173.) But Chevreul persisted that good color organization was essential to progress in the art of color. True complements could be determined. Well graded scales of tones could be established and recorded. The world of color sensations could be charted. Finally, "A fourth advantage of this construction is to make apparent to all artists who employ colored materials of a given size (particularly such as the weavers of Gobelins Tapestry) the relation of number which must exist between the tones of different scales when worked together."

(174.) If Chevreul became famous for his Law of Simultaneous Contrast, a second honor was to be bestowed on him for his formulation of principles for the harmony of colors. Today throughout the western world his laws of harmony are still taught to countless students of color, art and design. In paragraphs (174.) through (179.) he lists and describes "several cases in which we experience agreeable impressions." In the Ist Case, a person finds pleasure in simply looking at a single color "upon a sheet of white paper." In the IInd Case there is pleasure in the scales of a single hue. In the IIIrd Case there is appeal in the simultaneous view of colors or scales "more or less near to each other." This is the traditional harmony of adjacents. In the IVth Case are complementary colors. This is the harmony of opposites—or split complements if binary unions are involved. In the Vth Case are "Various Colours...seen through the Medium of a feebly colored Glass." This is the harmony in which a particular hue dominates an assortment of colors. Countless artists, amateurs, or otherwise, have been exposed to these principles in schoolroom and studio. Then, as usual, Chevreul repeats his thoughts in a review of Harmonies of Analogous Colours and Harmonies of Contrasts.

(181.) Having full confidence in his principles of harmony, Chevreul wrote, "I hope that many classes of artists, particularly dressmakers, decorators of all kinds, designers of patterns for textiles fabrics, paper-hangings, &c., will derive some benefit from consulting them."

(185.) In his masterwork Chevreul includes four charts with dots of his primary and secondary colors, plus white, black and gray. These are in Color Plates VII, VIII and IX. In (185.) he states that all primary colors look good with white (Color Plate VII.) However, binary assortments (secondary or intermediate colors) "are not equally agreeably." He then proceeds to list what he considers to be assortments of "greatest beauty." (The reader may find this confusing, for Chevreul in (185.) lists Violet as good with White, and in the same paragraph objects to it. In this instance *tints* of Violet are preferred with white.)

(186.) In reference to Color Plate VII, Assortment of Colours with White, Chevreul devotes considerable attention to color combinations involving white. The reader may be amused in comparing his own views as against those of the Frenchman. In paragraph (187.) through (201.) Chevreul does not hesitate to express himself. He likes combinations of opposites, red and green, blue and orange, yellow and violet. Yet "Red and

Orange are very bad together (190.), "Red and Yellow do not assort badly" (191.), "Red and Blue are passable" (192.). He continues in this fashion to include all combinations of primaries and secondaries. Incidentally, he uses white to "interpose" between the colors. In (187.), for example, the assortment White, Red, White, Green, White is inferior to White, Red, Green, White. This is frankly difficult to understand. If the pure colors—Red, Green—are together, the effect is not as good as if white were interposed between them.

(202.) Colors with black concern Color Plate VIII. Once again, Chevreul lists pleasing and inferior combinations with black interposed (rather than white). He states, "No assortment of the primary colors with Black is disagreeable." In paragraphs (203.) through (218.) he follows the same procedure as he did with white. This seems academic but may have been given serious attention in his day. Black is ideal as an outline for colors. Other than this, it is doubtful if Chevreul's strict determinations as to good and bad color combinations would be accepted today. Do "Orange and Red injure each other" if not separated by Black? Chevreul's genius is well confirmed (a) through the revelations of his Laws of Contrast, (b) his principles of color harmony, and (c) his observations on visual color mixtures during his work with Gobelins tapestries.

(219.) With Color Plate IX, Chevreul writes of colors with gray—once more with the gray interposed or not interposed. "All the primary colors gain in brilliance and purity by the proximity of Gray." As with white and black, there are paragraphs from (220.) through (235.) which deal with gray combinations. The comments made here may be tolerably reviewed but not literally accepted. There is a recapitulation of his observations about white, black and gray in paragraphs (236.) through (254.). After setting forth rather strict opinions about harmonious and discordant color combinations, he then admits, (236.) "I do not pretend to establish rules based upon scientific principles, but to enounce general propositions, which express my own peculiar ideas."

(255.) A large break now takes place in Chevreul's work. He is to deal with practical matters, such as the art of painting, the weaving of tapestry, upholstery fabrics, carpeting, mosaics, stained glass, cloth printing, paper staining, printing. In his day there was no such thing as abstract art. The painters of his time for the most part were meticulous in their styles. The freedom of Impressionism was yet to come. As one prominent French painter, Ingres, declared, "A thing well drawn is always well enough painted." It was Delacroix who, appreciating the fascinating contributions of Chevreul, grew bold with color and heralded a brighter day in which color would truly come into its own. Painters at the time were supposed "to attain all the illusion of an object in relief" (257.). This was chiaroscuro.

(261.) A first consideration of the painter in the fine arts was to understand or be aware of the effects of colored light on colored surfaces. With his usual attention to small details, Chevreul lists the modifications produced by tinted light in red, orange, yellow, green, blue, violet (263.) through (268.). Tinted light in nature is limited to yellow sunlight, the orange tint of dusk, candlelight and firelight and the pale blue of moonlight. Average daylight is neutral. Chevreul was aware that the effect of colored light on object colors was not the same as a similar mixture of pigments. If an artist were to match *with pigments* the modifications described when colored light falls on object colors, a reverse effect could well

be created—any composition so painted would appear as if seen under tinted light.

(271.) Of value to artists, Chevreul takes up the effects of objects lighted partly by the sun and partly by diffused daylight, a condition that had long before been described by Leonardo da Vinci. He uses a black and white Plate 3, included herewith, to suggest demonstrations. Although instructions are somewhat complicated, the principles involved are quite simple. In Figure 1 of Plate 3, strips of color are laid flat on a table. The strips are divided and separated with bands of wire and iron. The color to the right is thrown into shadow by a vertical partition. If sunlight comes from the bottom of the figure, and if diffused natural light shines from above, the left half of the figure will be pervaded by yellow light of the sun, and the right half by a pale bluish light from the sky. Chevreul thus explains what happens if the flat colors (stuff) is in various hues (272.) through (278.).

(279.) There is reference now to Figure 2 in Plate 3. Chevreul describes a similar experiment to Figure 1. He tells of a "chamber" which receives diffused daylight on one side from a window. Sheets of color are then applied to the interior walls and the viewer is to note the different effects of different degrees of illumination on the walls. Again Chevreul tells what is likely to happen. In his day the phenomenon of color constancy had not been studied and exploited. As is appreciated today, irrespective of light volume or intensity, the human eye and brain struggle to have all colors appear normal. The sense of color seems to be surprisingly indifferent to the actual facts of degrees of radiant energy in an environment.

(281.) In this and following paragraphs Chevreul seeks to be of help to the chiaroscuro painter. He refers to reflections and shadows on colors. There are descriptions of red sealing wax, gold vase, the folds of draperies. In (287.) he refers to Figure 3 in Plate 3 which shows "a person clothed in a new blue coat." Many shifts in color tone and hue take place in cloths of different color, different pile, all of which Chevreul duly describes (287.) to (300.).

(301.) The interest now goes to "painting in flat tints." The discussion here is brief. At the time most art was in highlight and shadow, in modeling to achieve realistic effects. Chevreul admired "the flat tints which came from China." He observes that painting in flat tints probably preceded chiaroscuro but that it would be erroneous for art to go back to the flat technique. None the less, "Painting in flat tints is in every respect preferable to the other." (302.). The day would come, of course, when flat tint styles would be in abundance in the fine arts.

(305.) In Section III Chevreul is greatly concerned with color and the art of painting. His views are naturally dated, writing as he did in the middle of the nineteenth century. He held to the view that "true and absolute coloring" demanded much obesience to nature—to perspective, aerial perspective, light and shade, faithful imitation, and a proper sense of color harmony. If there were to be departure from these ends, then "true but exaggerated coloring is more agreeable than absolute coloring."(311.)

(312.) There are two interesting points in this paragraph. Chevreul suggests that the artist give consideration to effects of dominate color, such as a scene visualized by looking through tinted glass. He also refers to the use of a black

mirror in landscape painting, a common practice then and since. By viewing a scene in a black mirror, specular reflections are reduced by polarizing the light that strikes the mirror.

(322.) In this paragraph Chevreul refers to the art of Albano, Titian, Rubens "and others." It would have been exciting if at the time he had referred to contemporary painters such as Delacroix. He probably hesitated out of fear of having the wrath of temperamental and conservative artists brought down on his head.

(323.) to (342.). In these paragraphs Chevreul tells the painter what should be learned from the Law of Simultaneous Contrast. In (327.) he refers again to black and white Plate 3, Figure 4. If the red afterimage of a vertical strip of green is superimposed on a horizontal strip of blue, the afterimage overlap will appear violet. Here exact complements may not operate. Let the artist be aware of these singular happenings. In (333.) is a final reference to black and white Plate 3, Figure 5. Where two colors of different brightness or value adjoin each other, a "channeled" effect could be avoided by showing gradations between the two areas. He offers principles to dramatize contrast effects: put delicate aureolas around brilliant hues (335.); use white beside a color to heighten its tone (336.); use black beside a color to lower its tone (337.); use gray beside a color to make it more brilliant (338.); use a dark color to raise the tone of a light color, and a light color to lower the tone of a dark color.

(343.) to (366.). Chevreul had admired the limited palettes of the classical painters of antiquity. As to harmony, he preferred contrast of color. He advised, "the contrast of the most opposite colors is most agreeable when they are of the same tone" (349.). In (358.) he speaks well of Vandyck who usually put central figures in strong light and the rest of the composition in shadow. He deals with human complexion in (351.). He noted, in his time, that complexion in women "to be beautiful must consist only of red and white." Then how about "brown, bronzed, copper-complexions"? These could also be beautiful. The artist needed to get "rid of habitual impressions."

(372.) Here is another break in the masterwork. Chevreul is to take up color problems in tapestry, textiles, carpeting, "hangings", mosaics, colored glass. He begins with Gobelins Tapestry, explaining how *weft* colored threads are woven over uncolored *warp* threads. The principle here is that of *mixing* colors. A visual confusion of different colored threads, mixed by the eye, will result in the appearance of a solid color. The French Neo-Impressionists (Seurat, Signac) were to attempt a new technique of divisionism in which reflections from small dots of paint were to mix as if with colored light. (This assumption proved faulty.) There is a visual mixture of *threads* in which filaments of different colors are twisted together, these threads are mixed by the eye and have the appearance of a solid color. There is the mixture of *hatchings* in which the threads of the warp differ from the threads of the weft. Here when both threads are visible, shimmering effects are seen when the fabric is viewed from different angles.

(380.) Visual color mixtures were illustrated in Chevreul's original 1854 English edition. Because they were crudely done at the time due to limitations in color reproduction methods, for this present book they have been repeated with actual yarns and as Chevreul directed. In Color Plate X, there are mixtures of red and yellow, 3 to 1, 2 to 1, 1 to 1, and yellow

to red 3 to 1 and 2 to 1. The same formula is followed for blue and yellow, and for red and blue. These are combinations of primary colors and can be seen in Color Plate X, preferably at a slight distance. Today, the psychologist accepts green as a visual primary, and not a blend of yellow and blue. So if a mixed combination of red and yellow make a fair orange, and red and blue a rich violet, the combination of blue and yellow to make green is less convincing. In Color Plate XI Chevreul is concerned with the visual mixtures of complements. There are three sets of mixtures. First are red and green yarns in ratios of 3 to 1, 2 to 1, 1 to 1, and green to red 3 to 1 and 2 to 1. Combinations of the same ratios are shown for yellow and violet, for orange and blue. With complements there is good evidence of dulling effects, the complementary colors tend to conflict with each other and to lead to more neutrality. Text for paragraph (380.) runs to six pages. In them Chevreul deals at length with visual mixtures. He is somewhat disturbed that analogous and complementary mixtures do not always follow theory. There is a reason for this. His complements, as on his color circle (Color Plate VI) are not true opposites. Better examples are found in the Munsell System, for example, in which red is complemented by blue-green, and in the Ostwald system in which red is complemented by sea green. None the less, Chevreul was facing great problems in the weaving of tapestry and textiles. He was quite sensitive to what took place when threads and yarns were optically blended. If the results did not always agree with his theories about them, as a conscientious researcher and pioneer he did much to advance the art of color in all fields that came under his surveillance.

(381.) In his section devoted to Gobelins tapestries, Chevreul mentions the importance of a clear understanding of visual color mixtures. If a painter ran into color problems, he could correct "any defect he perceives." But the weaver has no such choice once his colored threads or yarns are woven. If in a tapestry design or pattern, the colors are in clearly visible stripes or areas, what Chevreul has already presented in his book on contrast would apply. In a series of examples (382.) through (388.) he deals with this point. He tells again of his early awareness of the fact that black often failed to look black due to the influence of adjacent colors. If black were to be perceived it would be advantageous to use deep colors rather than black itself. In his day Chevreul was not familiar with certain phenomena associated with the optical and visual mixture of small dots or fine lines (as in weaving). First of all, visual mixtures of color are not the same as pigment mixtures. Red and green in light form yellow, but in pigments the result is a dull olive brown. While opposite colors in fair area offer extreme and exciting contrast, if the complements are mixed or confused visually, they cancel each other. This oversight was not well noted by Neo-Impressionist painters such as Seurat. In the divisionist technique, spots of yellow-orange were often placed within spots of green grass under the assumption that sunlight would thus be introduced. However, these yellow-orange spots collided with the green spots and the result went dull and sombre. Besides this, small touches of color, if seen at a distance, tend to go neutral and not to be seen as color at all!

(393.) Chevreul points out that "The Elements of Beauvais Tapestry for furniture are essentially the same as those of Gobelins tapestry." The products of Gobelins were of wool, while those of Beauvais were often of silk. More than this, Gobelins tapestries often depicted personalities. (See Color Plate of *Victory*.) The upholstery textiles of Beauvais "are generally limited to ornaments, flowers, animals, particularly birds and insects." (See Color Plate of *Marble Vase No. 1*.)

(395.) Thus while the Gobelins weaver was frequently expected to duplicate effects achieved by the chiaroscuro painter, the Beauvais weaver worked more as a designer of simple, natural elements.

(399.) A section is now devoted to Savonnerie Carpets, another proud craft of France and of world fame. Chevreul proceeds to explain carpet construction. Based probably on his own keen observations, he cautions against the visual mixtures of complements such as red and green, orange and blue, yellow and violet. "These mixtures giving rise to Gray, the weaver cannot add brilliant colors without the latter being broken or tarnished by the former, precisely as they would be if we had added Gray to them. One consequence of this rule, then, is never to admit complementary colors into mixtures which are intended to compose brilliant colors." (404.) (II Rule.)

(416.) Chevreul was not an artist. In the design and manu-facture of French tapestries, carpeting, the talents of eminent artists and designers were called upon. It was Chevreul's job to do their bidding and to achieve effects that might win their praise. He no doubt talked with artists and designers. At no time, however, did he seem to take a critical attitude. Yet he did suggest principles of color harmony. In a carpet, "Every object must be perfectly detached from the ground upon which it is placed." He advised that closely related colors should not be placed together for fear of unfavorable afterimage influences. In (418.) he set forth a principle which artists before him and ever since have respected in color compositions: "The whole of these objects must detach themselves from the ground, which will generally be duller than they are."

(422.) Savonnerie carpets were expensive. However, cheaper imitations were available, but they contained less wool and were "generally of inferior quality." Nor were the color durable. In (424.) he again points to the danger of com-plementary mixtures, "to prevent the brilliant colors extinguishing each other." There was a greater problem here with expensive carpets like Savonnerie than with "ordinary carpets" which presumably had less esthetic integrity.

(430.) The book now shifts to colored glass in Gothic churches. He notes two methods of glass coloring—the one by painting with pigments which are then vitrified, and the other colored glass itself. The painted glass was used for faces and hands, while the clear colored glass was usually in flat tints, a practice which Chevreul admired. Rich hues of red, blue, violet, orange, yellow, shone dramatically amid black leaded outlines, one of his sure methods of isolating and giving free reign to luminous color. A well designed window became a transparent tapestry and presented the eye with distinction.

(439.) Chevreul is concerned with "optical effects produced by patterns when printed upon woven fabrics, but not the chemical effects which arise between the pigments and the stuffs upon which they are printed." In effect, the whole of his doctrine on the harmony and contrast of colors applies. He notes that color printing on cloth was a new craft. And those who were engaged in it were warned to be careful about the unexpected effects of color conflicts.

(444.) In calico printing, black details or patterns on colored cloth might well cause trouble. Chevreul mentions that he had settled disputes amicably where litigation had been threatened, by explaining how black may appear tinted on colored grounds due to afterimages. He uses Color Plate XII as a demonstration. This has black diamonds on grounds of his primary and secondary colors. If the black diamonds were surrounded by white, rich black was readily seen. Otherwise, on colors, the black might be seen as tinted. These after-images may not appear too evident to the reader on Color Plate XII. Years later, a German scientist, Wilhelm Von Bezold, made the same observation. He laid thin, translucent tissue over colored grounds having black details. This tended to diffuse light, whereupon the afterimages on black were more clearly seen. The reader may perform the same experiment. He may note that "Cold colors are much more powerful in calling forth contrasts than warm colors." The illusion became, with time, credited to Von Bezold rather than to Chevreul.

(446.) Color illustrations regarding paper-staining are shown in Color Plates XIII, XIV and XV. In this present book, these border designs were carefully redrawn from the Chevreul 1854 English work and were printed with the rich colors available today. Chevreul wrote of wallpaper (paper-staining) "We may, without exaggeration, assert that a knowledge of the law of contrast of colors is indispensably necessary to the artists who are engaged in this branch of industry with the intention of carrying it to perfection." What he had already presented in his book offered wise and practical counsel.

(457.) In this and following paragraphs up to (472.) Chevreul describes and illustrates (Color Plate XIII) contrast effects with gilt ornaments on different color grounds. For gold he used a combination of yellow and orange pigments. He then describes what happens to the gold appearances under backgrounds of black and his primary and secondary hues. Gold looks better on black than on white. A red ground is not so advantageous. Nor is an orange ground favorable. With the yellow ground, through complementation, the gold is "excessively enfeebled." Red would be better than green for gold ornaments. Blue is excellent as a ground. It shows "to the greatest advantage in respect to intensity of the gold yellow color." Violet is favorable to the gold.

(474.) This and paragraphs up to (481.) concern Color Plate XIV. It shows festoons of blue flowers and gray ornaments, again on backgrounds of black, red, orange, yellow, green, blue and violet. Chevreul then describes contrast effects. This time he does little more than tell what happens due to afterimages. On a black ground the blue flowers are lowered at least two tones in brightness. On the red ground the gray looks greenish and the blue flowers are lowered three times. On orange, gray is lowered and the blue flowers are paler. A yellow ground makes the gray higher and the blue flowers more violet-blue. With the green ground the gray is reddish and the blue flowers lose vivacity. A blue ground, "being fresher than that of the ornament" tends "to gray the blue in the most disagreeable manner." The gray becomes tinted with orange. As to the violet ground: "Gray lowered, yellowed, impoverished, Blue tends to Green, and impoverished."

(482.) In the final Color Plate XV pink roses and green leaves are imposed on the same grounds as for Color Plates XIII and XIV but with green omitted. Chevreul's descriptions of contrast effects are set forth. In (483.) regarding a black background, he points out that differences may be noted by different persons. However, the green in the border is lighter, fresher and purer. "Pink lighter, yellower than upon a white ground." With a red ground green is "more beautiful," and

"Pink more Lilac." On an orange ground, the green is lighter and bluer, and the pink more violet. On a green ground, (not on Color Plate XV) green leaves become bluer and pink more violet. "The ensemble exhibits a good effect of contrast." With the yellow ground, Chevreul mentions harmonies of analogy and contrast. He likes these combinations. As to the blue background he concludes that "the ensemble is not agreeable." This combination he does not favor. On a violet ground, "If the ground does not injure the Green of the leaves, then it injures the pink so much that it is not agreeable." Discussions of Color Plate XV end with paragraph (489.)

(501.) Chevreul takes up the matter of color printing. In this paragraph he states that he does not make observations which he has not personally verified. In this section of his great book he discusses factors of legibility and reading comfort that have since commanded much attention. He distinguishes differences between "brief reading" and "prolonged reading," and favors combinations of black on yellow or orange. In paragraph (516.) he lists what he considers to be the order of legibility for black type on color, the most desirable grounds being white or yellow, and the least desirable red and violet. In "Reading of some Hours' Duration" (518.) he quite logically concludes that black on white might be fatiguing, whereas tinted papers might be preferred. He admits, however, that he only had at his disposal "a few loose sheets of paper of different color upon which black characters were printed."

The Writings of Chevreul

Pages that follow reproduce in facsimile the writings of Chevreul as cataloged in the *Bibliotheque Nationale* in Paris. If the reader has a knowledge of French, he can promptly discover that Chevreul's interests were remarkably broad and diverse. His was a Renaissance mind fascinated by problems, mysteries and subjects ranging far and wide into human life, culture, history and many of the major concerns of his day.

To review what is reported in the French *Bibliotheque*, Chevreul wrote a good number of books. These included the subject of color (some of his works are noted in the early part of this book). He did a history of chemistry. He wrote biographies, gave reports to the Royal Academy of Sciences of which he had been president, the National Museum of Natural History of which he had been director, plus reports to other distinguished societies and organizations. He discoursed on natural philosophy, on chemistry (his early specialty), and devoted time to the chemical aspects of pigments and vehicles used in oil painting. He was called upon to do obituaries and funeral orations for famous persons.

Now as to subjects and topics that intrigued him, consider the diversity of the following, alphabetically listed: agriculture, animal husbandry, animal fats, (his specialty as a chemist), astronomy, the diving rod, dyestuffs, medicine (the properties of opium), photography, photosynthesis, poisons, spiritualism, visual phenomena.

Much of this erudition has faded into the past. What survives today are his enduring contributions to the mysteries of color and his continued influence in the fields of art, color training and visual perplexities in general.

CHEVREUL (Eugène). — De l'Abstraction considérée relativement aux beaux-arts et à la littérature. Quatrième partie d'un ouvrage intitulé : «De l'Abstraction considérée comme élément des connaissances humaines dans la recherche de la vérité absolue, par M. E. Chevreul, ... — *Dijon, impr. de J.-E. Rabutot,* 1864. In-8°, 54 p. [R. 31350

—— Appréciations historiques et critiques. *Voir* GUILLORY (Pierre-Constant). Le Marquis de Turbilly, agronome angevin du xviii° siècle... 2° édition... — *Paris,* 1862. In-18. [Ln²⁷. 19858

—— Des Arts qui parlent aux yeux, au moyen de solides colorés d'une étendue sensible, et en particulier des arts du tapissier des Gobelins et du tapissier de la Savonnerie. par M. E. Chevreul... — *Paris, Impr. impériale,* 1867. In-4°, 50 p. [V. 13485

(Extrait du *Journal des savants.* 1866.)

—— De la Baguette divinatoire, du pendule dit explorateur et des tables tournantes, au point de vue de l'histoire, de la critique et de la méthode expérimentale, par M. E. Chevreul, ... — *Paris, Mallet-Bachelier,* 1854. In-8°, xvi-258 p. [R. 31354

—— Centenaire de M. Chevreul, 31 août 1886. Principaux travaux de M. Chevreul. — *Paris, Société anonyme des imprimeries réunies,* 1886. In-8°, 28 p. [Ln²⁷. 36556

—— Cercles chromatiques de M. E. Chevreul, reproduits au moyen de la chromocalcographie, gravure et impression en taille douce combinées par R.-H. Digeon. — *Paris, Digeon,* 1855. In-fol., 10 pl. [V. 4527

—— Communication de M. Chevreul, ... à l'Académie des sciences, insérée au «Journal des savants» (sur le système agronomique de M. Goetz). — *Paris, impr. de P. Dupont* (s. d.). In-8°, 16 p. [Sp. 13442

—— Communications sur le guano du Pérou, par M. E. Chevreul, ... — *Paris, G. Masson,* 1874. In-8°, 39 p. [Sp. 4744

—— Considérations générales sur l'analyse organique et sur ses applications, par M. E. Chevreul. — *Paris, F.-G. Levrault,* 1824. In-8°, xxi-256 p. [R. 17051

—— Considérations sur l'enseigne-
ment agricole en général et sur l'en-
seignement agronomique au Muséum
d'histoire naturelle en particulier, par
M. E. Chevreul. — *Paris, Impr. impé-
riale,* 1869. In-8°, 31 p.
[8° S. Pièce. **9066**

—— Considérations sur l'histoire de
la partie de la médecine qui concerne la
prescription des remèdes, à propos d'une
communication faite à l'Académie des
sciences dans sa séance du 29 d'août
1864, par M. Claude Bernard, sur les
propriétés organoleptiques des six prin-
cipes immédiats de l'opium, précédées
d'un examen des Archidoxia de Paracelse
et du livre de Phytognomonica de J.-B.
Porta, par M. E. Chevreul,... — *Paris,
Impr. impériale,* 1865. In-4°, m-57 p.
[Te137. **2**

—— Considérations sur la reproduc-
tion par les procédés de M. Niepce de
Saint-Victor. *Voir* **NIEPCE de SAINT-
VICTOR** (Claude-Félix-Abel). Recherches
photographiques. Photographie sur verre.
Héliochromie... — *Paris,* 1855. In-8°.
[V. **47797**

—— Considérations. *Voir* **NIEPCE
de SAINT-VICTOR** (Claude-Félix-Abel).
Photographic Researches... — *Paris,*
1855. In-8°. [V. **47798**

—— Des Couleurs et de leurs appli-
cations aux arts industriels, à l'aide des
cercles chromatiques, par E. Chevreul,
... — *Paris, J.-B. Baillière et fils,*
1864. In-4°, 86 p. et pl. en couleur.
[V. **4529**

—— Discours et tableau... *Voir*
BARRAL (Jean-Augustin). L'Œuvre
agricole de M. de Béhague... — *Paris,*
1875. In-18. [S. **22818**

—— Discours prononcé au banquet
de la Société centrale d'horticulture, le
22 mai 1882, par M. Chevreul,... —
Paris, G. Masson, 1882. Gr. in-8°, 6 p.
[4° S. Pièce. **380**
(Extrait du *Journal de l'agriculture.* Juillet
1882.)

—— Distractions d'un membre de
l'Académie des sciences... directeur du
Muséum d'histoire naturelle (E. Che-
vreul), lorsque le roi de Prusse assiégeait
Paris. — Complément des distractions
d'un membre de l'Académie des sciences
... — *Paris, Gauthier-Villars (-F. Didot
frères),* 1871. In-4°. [4° R. **11**
(Titres imprimés par E. Chevreul pour
réunir les extraits des *Comptes rendus
des séances* et des *Mémoires de l'Académie
des sciences,* composés par lui pendant
le siège de Paris. Ces extraits sont cata-
logués séparément.)

—— (Un autre ex. du *Complément des
distractions.*) [S. **7144**

—— XIX° Jury. Les Tapisseries et les
tapis des manufactures nationales, par
M. Chevreul,... — (*Paris, Impr. im-
périale,* 1854.) In-8°, 100 p.
[V. **38373**
(Exposition universelle de 1851. Travaux
de la commission française sur l'indus-
trie des nations. T. V.)

—— Examen critique, au point de
vue de l'histoire de la chimie, d'un écrit
alchimique intitulé «Artefii clavis ma-
joris sapientiae» et preuve que cet écrit
est identique avec l'écrit publié sous le
nom d'Alphonse X, roi de Castille et de
Léon, auquel l'astronomie doit les Tables
Alphonsines. Présenté à l'Académie des
sciences, le 2 d'avril 1867, par M. Che-
vreul. — *Paris, impr. de F. Didot frères,*
1867. In-4°, 58 p. [R. **7153**
(Extrait du tome XXXVI des *Mémoires de
l'Académie des sciences.*)

—— Exposé d'un moyen de définir et
de nommer les couleurs, d'après une
méthode précise et expérimentale, avec
l'application de ce moyen à la définition
et à la dénomination des couleurs d'un
grand nombre de corps naturels et de
produits artificiels, par M. E. Chevreul.
— *Paris, F. Didot frères, fils et C°.* 1861.
In-4°, 944 p. [R. **3945** (33)
(Mémoires de l'Académie des sciences.
T. XXXIII.)

Atlas. In-4°, 10 pl. en couleur.
[V. **4528**

—— Extraction et conversion de toutes les farines du froment en pain blanc de première qualité, par Mège-Mouriès,... Rapport fait à l'Institut de France (Académie des sciences), le 12 janvier 1857, par MM. Dumas, Payen, Pelouze, Peligot, Chevreul, rapporteur. —— (*Paris*,) *F. Didot frères* (s. d.). In-4°, 11 p.

3 ex. [Vp. **25097, 25098** et **25099**

—— Histoire des connaissances chimiques, par M. E. Chevreul... —— *Paris, Gide*, 1866. In-8°, 479 p. et pl.

[8° R. **20190**

—— Institut national de France. Académie des sciences. De la Différence et de l'analogie de la méthode *a posteriori* expérimentale, dans ses applications aux sciences du concret et aux sciences morales et politiques, par M. E. Chevreul. —— *Paris, Gauthier-Villars* (s. d.). In-4°, 10 p.

2 ex. [4° R. **11** (1) et 4° R. Pièce. **1044**

(Extrait des *Comptes rendus des séances de l'Académie des sciences*. T. LXXI. Séance du 17 octobre 1870.)

—— Institut national de France. Académie des sciences... Exposé des raisons pour lesquelles l'aliment de l'homme et des animaux supérieurs doit être d'une nature chimique complexe, par M. E. Chevreul. —— *Paris, Gauthier-Villars* (s. d.). In-4°, 22 p. [4° R. **11** (2)

(Extrait des *Comptes rendus des séances de l'Académie des sciences*. T. LXXI.)

—— Institut royal de France. Académie des sciences. Funérailles de M. Audouin. Discours de M. Serres,... (et de MM. Chevreul, Milne-Edwards) le 11 novembre 1841. —— *Paris, impr. de F. Didot frères* (s. d.). In-4°, 20 p. [Ln27. **747**

—— Institut national de France. Académie des sciences. Funérailles de M. de Blainville. Discours de M. Constant Prévost (et de MM. Chevreul et Milne-Edwards),... prononcé... le... 7 mai 1850. —— *Paris, impr. de F. Didot frères* (s. d.). In-4°, 22 p. [Ln27. **2049**

—— Institut royal de France. Académie ... des sciences. Funérailles de M. Alexandre Brongniart. Discours de M. Élie de Beaumont (et de MM. Duméril, Chevreul et Dufrénoy), prononcé aux funérailles de M. Alexandre Brongniart, le 9 octobre 1847. —— *Paris, impr. de F. Didot frères* (1847). In-4°, 28 p. [Ln27. **3068**

—— Institut impérial de France. Académie des sciences. Allocution de M. Chevreul, ... prononcée aux funérailles de M. Flourens, le... 9 décembre 1867. (Suivie des discours de MM. Patin et Élie de Beaumont.) —— *Paris, impr. de F. Didot frères* (1867). In-4°, 8 p.

[Ln27. **23774**

—— Institut royal de France. Académie des sciences. Funérailles de M. Geoffroy Saint-Hilaire. Discours de M. Duméril (et de MM. Chevreul, Pariset, Dumas et Serres),.... prononcé aux funérailles de M. Geoffroy Saint-Hilaire, le 22 juin 1844. —— *Paris, impr. de F. Didot frères* (s. d.). In-4°, 33 p. [Ln27. **43126**

—— Institut royal de France. Académie ... des sciences. Funérailles de M. de Jussieu. Discours de M. de Mirbel (et de M. Chevreul), prononcé aux funérailles de M. de Jussieu, le 19 septembre 1836. —— (*Paris*,) impr. de F. Didot frères (s. d.). In-4°, 6 p. [Ln27. **10513**

—— Institut royal de France. Académie ... des sciences. Funérailles de M. Robiquet. Discours de M. Chevreul, prononcé le 2 mai 1840. —— (*Paris*,) impr. de F. Didot frères (s. d.). In-4°, 6 p.

[Ln27. **43123**

—— Institut impérial de France. Discours de M. Andral, prononcé aux funérailles de M. Serres, au nom de la section de médecine et chirurgie, le... 25 janvier 1868. Discours de M. Chevreul au nom du Muséum. —— *Paris, impr. de F. Didot frères* (1868). In-4°, 14 p.

[Ln27. **23845**

—— Institut de France. Académie... des sciences. Funérailles de M. Sérullas. Discours de M. Chevreul,... prononcé aux funérailles de M. Sérullas, le... 26 mai 1832. —— (*S. l. n. d.*) In-4°, 5 p.

[Ln27. **18868**

—— Institut impérial de France. Académie des sciences. Inauguration de la statue élevée à la mémoire de Buffon à Montbard (Côte-d'Or), le 8 octobre 1865. Discours de M. Chevreul,... prononcé au nom de l'Académie des sciences, du Muséum d'histoire naturelle et de la Société impériale et centrale d'agriculture de France. — *Paris, impr. de F. Didot frères, fils et C^{ie}*, 1865. In-4°, 21 p.
[Lk⁷. **13076**

——Institut royal de France. Académie ... des sciences. Rapport fait à l'Académie royale des sciences par MM. Thénard et Chevreul sur un mémoire de M. Sérullas ayant pour titre : de l'Action de l'acide sulfurique sur l'alcohol et des produits qui en résultent... — *Paris, impr. de F. Didot* (s. d.). In-4°, 15 p.
[Z. **5036** (3)

—— Extrait du rapport fait à l'Académie royale des sciences par MM. Thénard et Chevreul sur un mémoire de M. Sérullas... *Voir* **SÉRULLAS** (Georges-Simon). De l'Action de l'acide sulfurique sur l'alcool et des produits qui en résultent... — (*Paris, s. d.*) In-8°.
[R. **16884-16885**
(Extrait des *Annales de chimie et de physique*.)

—— Institut de France. Académie... des sciences. Rapport sur le bouillon de la Compagnie hollandaise, fait à l'Académie des sciences par M. Chevreul, au nom de la commission de la gélatine... le 19 mars 1832... — (*Paris,*) *impr. de Didot* (1832). In-4°, 42 p.
2 ex. [Vp. **3488** et Z. **5040** (2)

—— Société nationale et centrale d'agriculture. Rapport sur le bouillon de la Compagnie hollandaise, fait à l'Académie des sciences par M. Chevreul, au nom de la commission de la gélatine... le 19 mars 1832. — (*Paris,*) *impr. de M^{me} V^{ve} Bouchard-Huzard* (1850). In-8°, 36 p.
[V. **34719**

—— Institut de France. Académie... des sciences. Extrait du rapport sur le bouillon de la Compagnie hollandaise, fait à l'Académie des sciences par M. Che-

vreul... le 19 mars 1832... — *Paris, impr. de Fain* (s. d.). In-8°. 16 p.
[V. **34718**

—— Rapports de l'Académie des sciences et de la Société d'encouragement, sur le bouillon de la Compagnie hollandaise (par MM. E. Chevreul et Labarraque). — *Paris, impr. de Fain* (s. d.). In-8°, 16 p.
[8° R. Pièce. **7512**

—— Institut impérial de France. Académie des sciences. Rapport sur les allumettes chimiques dites hygiéniques et de sûreté, les allumettes androgynes, et les allumettes chimiques sans phosphore ni poison. Commissaires : MM. Pelouze, Pouillet, Payen, J. Cloquet; Chevreul, rapporteur. — *Paris, impr. de Mallet-Bachelier* (1859). In-4°, 6 p.
[Vp. **25390**
(Extrait des *Comptes rendus des séances de de l'Académie des sciences*. T. XLIX. Séance du 26 septembre 1859.)

—— Institut national de France. Académie des sciences ... Résumé historique des travaux dont la gélatine a été l'objet, par M. Chevreul. — *Paris, Gauthier-Villars* (s. d.). In-4°, 58 p. [4° R. **11** (3)
(Extrait des *Comptes rendus des séances de de l'Académie des sciences*. T. LXXI-LXXII.)

—— Institut de France... Complément d'études sur la vision des couleurs, par M. E. Chevreul,... — *Paris, impr. de Firmin-Didot*, 1879. In-4°, 277 p., fig. et pl. en coul. [4° R. **1604**
(Mémoires de l'Académie des sciences. Extrait du T. XLI.)

—— Institut impérial de France. Distribution des connaissances humaines du ressort de la philosophie naturelle, conforme à la manière dont l'esprit humain procède dans la recherche de l'inconnu en allant du concret à l'abstrait et revenant de l'abstrait au concret, par M. E. Chevreul,... — *Paris, impr. de F. Didot frères, fils et C^{ie}*, 1865. In-4°, 66 p. et pl. [R. **7151**
(Extrait du tome XXXV des *Mémoires de l'Académie des sciences*.)

—— Institut de France. L'Enseigne-
ment devant l'étude de la vision, la loi
du contraste simultané des couleurs.
2ᵉ mémoire par M. E. Chevreul,... —
Paris, impr. de F. Didot frères, fils et Cⁱᵉ,
1865. In-4°, paginé 63-108. [R. **7152**
(Extrait du tome XXXIX des *Mémoires de
l'Académie des sciences.* 1ʳᵉ partie.)

—— Institut de France... Études
des procédés de l'esprit humain dans la
recherche de l'inconnu à l'aide de l'obser-
vation et de l'expérience, et du moyen de
savoir s'il a trouvé l'erreur ou la vérité,
par M. E. Chevreul,... — *Paris, impr.
de F. Didot et Cⁱᵉ,* 1878. 3 mémoires en
1 vol. in-4° de 327 p. [4° R. **94**
(Extrait du tome XXXIX des *Mémoires des
l'Académie des sciences.*)

—— (Un autre ex. du 1ᵉʳ mémoire.)
|4° R. **25**

—— (Un autre ex. du 2ᵉ mémoire.)
|4° R. **75**

—— (S. d.) — (S. l.) In-4°, 59 p.
|4° R. **76**
(1ᵉʳ mémoire.)

—— Institut de France. Explication
de nombreux phénomènes qui sont une
conséquence de la vieillesse. Troisième
mémoire par M. E. Chevreul,... —
Paris, impr. de F. Didot, 1875. In-4°,
paginé 111-327. [R. **7154**
(Extrait du tome XXXIX des *Mémoires de
l'Académie des sciences.* 2ᵉ partie.)

—— Institut impérial de France. Expli-
cation déduite de l'expérience de plusieurs
phénomènes de vision concernant la per-
spective, lue à l'Académie des sciences le
28 mars et le 4 avril 1859 par M. E.
Chevreul. — *Paris, impr. de F. Didot,*
1859. In-4°, 24 p. [R. **8841**
(Extrait du tome XXX des *Mémoires de
l'Académie des sciences.*)

—— Institut impérial de France. His-
toire des principales opinions que l'on a
eues de la nature chimique des corps de
l'espèce chimique et de l'espèce vivante, par
E. Chevreul,... Atlas. — *Paris, impr.
de F. Didot frères, fils et Cⁱᵉ,* 1869. In-4°,
14 pl. [R. **7155**
(Extrait du tome XXXVIII des *Mémoires de
l'Académie des sciences.*)

—— Institut impérial de France. Mé-
moire sur des phénomènes d'affinités ca-
pillaires, par M. E. Chevreul,... lu dans
la séance publique de l'Académie des
sciences du 9 juillet 1866... — *Paris,
impr. de F. Didot frères,* 1866. In-4°,
25 p. [R. **8842**
(Extrait du tome XXXVI des *Mémoires de
l'Académie des sciences.*)

—— Institut de France. Mémoire sur
la vision des couleurs matérielles en
mouvement de rotation et des vitesses
numériques de cercles dont une moitié
diamétrale est colorée et l'autre blanche
... par M. E. Chevreul... — *Paris,
impr. de Firmin-Didot,* 1883. In-4°,
378 p., fig. et pl. [R. **3945** (42)
(*Mémoires de l'Académie des sciences.*
T. XLII. N° 4.)

—— Institut impérial de France. Re-
cherches chimiques sur la teinture, par
M. E. Chevreul, onzième mémoire de la
théorie de la teinture... — *Paris, impr.
de F. Didot frères,* 1861. In-4°, 440 p.
[R. **5787**

—— Institut impérial de France. Re-
cherches chimiques sur la teinture. Dou-
zième mémoire : de l'influence en teinture
que des matières étrangères à la composi-
tion chimique de la laine, de la soie et du
coton, exercent sur des échantillons de
ces étoffes qui contiennent ces matières
étrangères. Treizième mémoire : de l'in-
fluence de l'eau distillée, de l'eau de
Seine et de l'eau d'un puits de Paris sur
la couleur de la laine. Quatorzième mé-
moire : de l'influence de l'eau distillée,
de l'eau saturée de sulfate de chaux pur
... dans la teinture de la laine, de la
soie et du coton. Appendice... Par M. E.
Chevreul,... — *Paris, impr. de F. Didot
frères,* 1863. In-4°, 404 p. [V. **13484**
(Extrait du tome XXXIV des *Mémoires de
l'Académie des sciences.*)

—— Institut de France... Résumé
d'une histoire de la matière depuis les
philosophes grecs jusqu'à Lavoisier inclu-
sivement, par M. E. Chevreul,... —
Paris, impr. de F. Didot, 1878. In-4°,
437 p. et pl. [4° R. **95**
(Extrait du tome XXXIX des *Mémoires de
l'Académie des sciences.*)

—— Institut royal de France. Séance publique annuelle des cinq Académies, du jeudi 2 mai 1839, présidée par M. Chevreul,... (Discours du Président. La découverte de Daguerre, poëme, par M. Lemercier. Fragments d'une histoire de la révolution grecque, par M. Jouffroy. Recherches sur les manuscrits du sire de Joinville, par M. Paulin Pâris. Note sur l'ancien château de Madrid, bâti par ordre de François Ier, par M. Vaudoyer.) —— *Paris, impr. de F. Didot frères,* 1839. In-4°, 81 p. [Z. 5049 (31)

—— Institut de France. D'une erreur de raisonnement très fréquente dans les sciences du ressort de la philosophie naturelle qui concerne le concret expliquée par les derniers écrits de E. Chevreul... —— *Paris, F. Didot frères,* 1871. In-4°, 102 p.
3 ex. [4° R. 11 (4), S. 7143 et 7144
(Extrait du tome XXXIX, 2ᵉ partie des *Mémoires de l'Académie des sciences*.)

—— Introduction à l'histoire des connaissances chimiques. Connexions des sciences du domaine de la philosophie naturelle exposées conformément à la méthode a posteriori expérimentale sous le double rapport de l'analyse et de la synthèse, par M. E. Chevreul,... —— *Paris, L. Guérin,* 1866. In-8°, 461 p. et pl. [R. 34355

—— Leçons de chimie appliquée à la teinture, par M. E. Chevreul,... —— *Paris, Pichon et Didier,* 1829. 2 vol. in-8°. [R. 16667-16668

—— Lettres adressées à M. Villemain, ... sur la méthode en général et sur la définition du mot «fait» relativement aux sciences, aux lettres, aux beaux-arts, etc., etc., par M. E. Chevreul,... —— *Paris, Garnier frères,* 1856. In-18, IV-276 p. [R. 34356

—— De la Loi du contraste simultané des couleurs et de l'assortiment des objets colorés considérés d'après cette loi dans ses rapports avec la peinture, les tapisseries... par M. E. Chevreul,... ——

Paris, Pitois-Levrault, 1839. In-8°, xv-735 p. [V. 20604
Atlas in-4°. [V. 11967

—— De la Loi du contraste simultané des couleurs et de l'assortiment des objets colorés, considérés d'après cette loi dans ses rapports avec la peinture, les tapisseries... par M. E. Chevreul, avec une introduction de M. H. Chevreul fils. (19 avril 1835.) —— *Paris, Gauthier-Villars et fils,* 1889. In-fol., xvi-571 p., pl. en noir et en couleur. [Fol. V. 2239

—— Mémoire sur l'influence que deux couleurs peuvent avoir l'une sur l'autre quand on les voit simultanément, par M. Chevreul. Lu à l'Académie des sciences, le 7 avril 1828. —— (S. l. n. d.) In-4°, 76 p. et pl. [Z. 5038 (25)

—— De la Méthode a posteriori expérimentale et de la généralité de ses applications, par M. E. Chevreul... —— *Paris, Dunod,* 1870. In-18, 405 p.
2 ex. [R. 34357 et Z. Renan. 2697

—— Muséum d'histoire naturelle. Mémoire en réponse au rapport de la commission spéciale instituée par le ministre de l'Instruction publique pour étudier les questions qui se rattachent, soit à l'administration, soit à l'enseignement du Muséum d'histoire naturelle, rapport communiqué par M. le ministre aux professeurs administrateurs du Muséum, le 13 mai 1850. (Signé : E. Chevreul, A. Valenciennes, de Jussieu.) —— (S. l. n. d.) In-4° autographié, 59 p. [S. 8094

—— Muséum d'histoire naturelle. Rapport adressé à S. Exc. le ministre de l'Instruction publique par M. Chevreul, sur le cours de chimie appliquée aux corps organiques, fait en 1867. —— *Paris, Impr. impériale,* 1868. In-8°, 56 p. [8° R. 16232

—— Notice sur M. Ebelmen et sur ses travaux. *Voir* EBELMEN (Jacques-Joseph). Recueil des travaux scientifiques de M. Ebelmen... T. III. —— *Paris,* 1861. In-8°. [V. 37565

—— Opinion émise par M. Chevreul, le 15 janvier 1846, dans le Conseil général des manufactures, sur l'impôt du sel employé dans la préparation des produits chimiques, et sur l'influence du sel dans l'économie animale et végétale. — *Paris, impr. de V^ce Bouchard-Huzard* (s. d.). In-8°, 8 p. [Lf²⁶³. **15**

(Extrait du *Bulletin des séances de la Société royale et centrale d'agriculture*.)

—— Opinion sur la convenance qu'il y aurait d'ajouter l'expression de «Sciences militaires», au titre de la section de «Géographie et navigation», exprimée par M. Chevreul, le 29 juin, à l'Académie, huit jours après que celle-ci se fut prononcée, à une majorité de 34 voix contre 14, sur l'opportunité de porter à six le nombre des membres de cette section (7 juillet 1863). — *Paris, impr. de Mallet-Bachelier* (s. d.). In-4°, 6 p. [Rp. **13354**

—— Rapport de M. Chevreul sur l'ouvrage intitulé «Ampélographie, ou Traité des cépages les plus estimés... par le comte Odart,...» suivi de Considérations générales sur les variations des individus qui composent les groupes appelés... variétés, races, sous-espèces et espèces. — *Paris, impr. de V^ce Bouchard-Huzard*, 1846. In-8°, 110 p. [S. **25131**

(Extrait des *Mémoires de la Société royale et centrale d'agriculture*. Année 1846.)

—— Rapport sur des observations concernant le lait des vaches affectées de la maladie vulgairement appelée la cocotte, présentées à l'Académie par M. le D^r Al. Donné, suivi de considérations générales relatives à la recherche des matières actives sur l'économie animale qui peuvent se trouver dans les produits morbides, l'atmosphère et les eaux, par M. Chevreul, rapporteur. Académie des sciences, séance du 18 de mars 1839... Suivi de considérations sur les réactifs et de réflexions sur le choléra. — *Paris, V^ce Bouchard-Huzard*, 1867. In-4°, 74 p. [Tg³⁰. **240**

—— Rapports faits à l'Académie des sciences, par MM. Chevreul, Thénard et Vauquelin sur les mémoires de MM. Bussy et Lecanu. — *Paris, impr. de Fain* (s. d.). In-8°, 7 p. [R. **47996**

—— Recherches chimiques sur les corps gras d'origine animale, par M. E. Chevreul. — *Paris, F.-G. Levrault*, 1823. In-8°, xvi-484 p. et pl. [R. **17049**

—— Recherches chimiques sur les corps gras d'origine animale, par E. Chevreul, avec un avant-propos de M. A. Arnaud,... — *Paris, Impr. nationale*, 1889. In-fol., xxix-425 p. et pl. [Fol. R. **161**

(Édition imprimée pour le centenaire de 1789.)

—— Recherches chimiques sur plusieurs objets d'archéologie trouvés dans le département de la Vendée, par M. E. Chevreul, présentées à l'Académie des inscriptions et belles-lettres, le 29 décembre 1848, et à l'Académie des sciences, le 29 janvier 1849. — (S. l. n. d.) In-4°, paginé 181-207. [4° V. **2868** (2)

—— Recherches expérimentales sur la peinture à l'huile, par M. E. Chevreul. Premier mémoire, lu à l'Académie des sciences dans la séance du 8 juin 1850. — (S. l. n. d.) In-4°, paginé 655-732. [4° V. **2868** (1)

—— Recherches expérimentales sur la végétation, par M. Georges Ville. Absorption de l'azote de l'air par les plantes. Rapport fait par M. Chevreul à l'Académie des sciences... — *Paris, impr. de L. Martinet*, 1855. In-8°, 31 p. [S. **35451**

(Extrait des *Comptes rendus officiels de l'Académie des sciences*.)

—— Réfutation, par M. E. Chevreul, ... des allégations contre l'administration du Muséum d'histoire naturelle, proférées à la tribune du Corps législatif, dans la séance du 19 juin 1862, suivie d'une lettre du colonel Favé,... — *Paris, Mallet-Bachelier*, 1862. In-4°, 26 p. [Sp. **13222**

—— Réfutation par M. E. Chevreul, ... des allégations contre l'administration du Muséum d'histoire naturelle proférées à la tribune du Corps législatif dans la séance du 19 juin 1862. I. Lettre du colonel Favé, ... à M. Chevreul. II. Lettre du général Allard au rédacteur du journal «L'Opinion nationale». III. Réponse de M. Chevreul. IV. Lettre de M. Chevreul à M. le ministre de l'Instruction publique. V. Épilogue. — *Paris, Mallet - Bachelier, 1863.* In-4°, 37 p. [Lf²⁴². **44**

—— Société nationale et centrale d'agriculture. Discours prononcé par M. Chevreul, ... dans la séance publique du 12 mai 1850. — *Paris, impr. de Vᵛᵉ Bouchard-Huzard* (1850). In-8°, 8 p. [Sp. **11146**

—— Discours prononcé à la séance publique annuelle de la Société impériale et centrale d'agriculture de France, le... 10 avril 1864, par M. Chevreul, ... — *Paris, impr. de Mᵐᵉ Vᵛᵉ Bouchard-Huzard, 1864.* In-8°, 20 p. [Sp. **5368**
(Extrait des *Mémoires de la Société.* Année 1864.)

—— Discours prononcé à la séance publique annuelle de la Société centrale d'agriculture de France, tenue le dimanche 12 mai 1872, par M. Chevreul, ... — *Paris, Vᵛᵉ Bouchard-Huzard, 1872.* In-8°, 15 p. [Sp. **5367**

—— Discours prononcé à la séance publique annuelle de la Société centrale d'agriculture de France, tenue le ... 13 décembre 1874, par M. Chevreul, ... — *Paris, Vᵛᵉ Bouchard-Huzard, 1874.* In-4°, 16 p. [Sp. **12586**

—— Séance publique annuelle de la Société nationale d'agriculture de France, tenue le... 6 juin 1880... Allocution de M. Chevreul, ... — *Paris, impr. de Vᵛᵉ Bouchard-Huzard, 1880.* In-4°, 12 p. [4° S. Pièce. **269**

—— Société nationale d'agriculture de France. (Séance publique annuelle du 19 de juillet 1882.) Allocution de M. Chevreul, ... destinée à être prononcée à l'ouverture de la séance. — *Paris, hôtel de la société, 1882.* In-4°, 14 p. [4° S. Pièce. **383**

—— Société nationale d'agriculture de France. (Séance publique annuelle du 2 de juillet 1884.) Discours prononcé par M. Chevreul, président de la société. — *Paris, hôtel de la société, 1884.* In-8°, 10 p. 2 ex. [8° R. Pièce. **2912** et 8° S. Pièce. **5839**

—— Société impériale et centrale d'agriculture de France. Mémoire sur les eaux naturelles, par M. Chevreul. — *Paris, impr. de Vᵛᵉ Bouchard - Huzard* (s. d.). In-8°, 28 p. [8° S. Pièce. **9065**
(Extrait des *Mémoires de la Société impériale et centrale d'agriculture de France.* Année 1863.)

—— Société impériale et centrale d'agriculture. Mémoire sur plusieurs réactions chimiques qui intéressent l'hygiène des cités populeuses, lu à l'Académie des sciences, le 9 et le 11 novembre 1846, par M. E. Chevreul. — *Paris, impr. de Vᵛᵉ Bouchard-Huzard* (1854). In-8°, 39 p. [Tc⁴⁰. **15**
(Extrait des *Mémoires de la Société impériale et centrale d'agriculture de France.* Année 1853.)

—— Société nationale d'agriculture de France. Études sur le guano, par M. Chevreul. — *Paris, hôtel de la société, 1883.* In-4°, 21 p. [4° S. Pièce. **424**

—— Société nationale d'agriculture de France, séance du 27 août 1879. Note sur la fermentation, par M. E. Chevreul. — *Paris, impr. de J. Tremblay, 1879.* In-4°, 6 p. [4° R. Pièce. **1042**

—— Théorie des effets optiques que présentent les étoffes de soie, par M. E. Chevreul, ... — *Paris, impr. de F. Didot frères, 1846.* In-8°, 208 p. et pl. [V. **34720**

—— La Vérité sur l'invention de la photographie, par M. E. Chevreul ... — *Paris, Impr. nationale, 1873.* In-4°, 41 p. 2 ex. [Vp. **28927** et Z. Renan. **1171**
(Extrait du *Journal des savants.* 1873.)